Museum Bodies

Museum Bodies provides an account of how museums have staged, prescribed and accommodated a repertoire of bodily practices, from their emergence in the eighteenth century to the present day. As long as museums have existed, their visitors have been scrutinised, both formally and informally, and their behaviour calibrated as a register of cognitive receptivity and cultural competence. Yet there has been little sustained theoretical or practical attention given to the visitors' embodied encounter with the museum.

In *Museum Bodies* Helen Rees Leahy discusses the politics and practice of visitor studies, and the differentiation and exclusion of certain bodies on the basis of, for example, age, gender, educational attainment, ethnicity and disability. At a time when museums are more than ever concerned with size, demographic mix and the diversity of their audiences, as well as with the ways in which visitors engage with and respond to institutional space and content, this wide-ranging study of visitors' embodied experience of the museum is long overdue.

Helen Rees Leahy is a Senior Lecturer and Director of the Centre for Museology, University of Manchester, UK. Previously Helen worked as a curator and museum director for over 12 years, and has organised numerous exhibitions of fine art and design. Helen has published on topics relating to national identity, art collecting, the art market and art criticism, and her work has addressed practices of individual and institutional collecting, in both historical and contemporary contexts, including issues of patronage, display and interpretation.

Museum Bodies

The Politics and Practices of Visiting and Viewing

Helen Rees Leahy

ASHGATE

Published by
Ashgate Publishing Limited
Wey Court East
Union Road
Farnham
Surrey, GU9 7PT
England

Ashgate Publishing Company
Suite 420
101 Cherry Street
Burlington, VT 05401-4405
USA

www.ashgate.com

British Library Cataloguing in Publication Data
Leahy, Helen Rees.
 Museum bodies : the politics and practices of visiting and
 viewing.
 1. Museum visitors. 2. Museums--Social aspects.
 3. Museums--Public relations.
 I. Title
 069.1-dc23

Library of Congress Cataloging-in-Publication Data
Leahy, Helen Rees.
 Museum bodies : the politics and practices of visiting and viewing / by Helen
Rees Leahy.
 p. cm.
 Includes bibliographical references and index.
 ISBN 978-1-4094-1861-0 (hardback) -- ISBN 978-1-4094-1862-7 (ebook) 1.
Museums--Evaluation. 2. Museum visitors. 3. Museum attendance. 4. Museum
techniques. I. Title.
 AM7.L39 2012
 069--dc23

 2012012811
ISBN 9781409418610 (hbk)
ISBN 9781409418627 (ebk)

Printed and bound in Great Britain by the
MPG Books Group, UK.

Contents

List of Illustrations *vii*
Acknowledgements *xi*

Introduction 1

1 Making a Social Body 19

2 Not Just Looking 45

3 Walking the Museum 73

4 Performing the Museum 97

5 Bodies of Protest 127

6 Disquieting Bodies 153

Epilogue 177

Bibliography *185*
Index *197*

List of Illustrations

Introduction

1 Thomas Rowlandson, *Viewing at the Royal Academy*, c.1815. Yale Center for British Art, Paul Mellon Collection. The Bridgeman Art Library.

1 Making a Social Body

2 John Hill after Thomas Rowlandson and Augustus Pugin, *Exhibition Room, Somerset House, from The Microcosm of London*, 1808. Private Collection. The Bridgeman Art Library.

3 Admission ticket to the British Museum. Issued to Mr Banks for 'a Sight of the British Museum', 1777. © The Trustees of the British Museum.

4 Henry Thomas Alken, *British Museum. Tom and Bob in search of the Antique*, 1821. © The Trustees of the British Museum.

5 Henry Thomas Alken, *Exhibition Room, Somerset House. Tom and Bob Amongst the Connoisseurs*, 1821. Peter Jackson Collection.

6 Robert and George Cruikshank, *A Shilling Well Laid Out. Tom and Jerry at the Exhibition of Pictures at the Royal Academy*, from *Life in London* by Pierce Egan, 1821. The Stapleton Collection. The Bridgeman Art Library.

2 Not Just Looking

7 *Cubism and Abstract Art*, Museum of Modern Art, New York, 1936. The Museum of Modern Art Archives, NY. Digital Image © 2011, The Museum of Modern Art, New York/ Scala, Florence.

8 Frederick Mackenzie, *The National Gallery*, c.1834. Victoria & Albert Museum, London.

9 Interior of the Art Treasures Palace, *Art Treasures Examiner*, 1857.

10 Henry Wallis, *Chatterton*, 1856. © Tate, London 2012.

11 Photographs illustrating postures 'Much Bent', Benjamin Ives Gilman, *Museum Ideals of Purpose and Method*, 1918.

12 'The Skiascope in Use', Benjamin Ives Gilman, *Museum Ideals of Purpose and Method*, 1918.

3 **Walking the Museum**

13 Joseph Castiglione, *The Salon Carré au Musée du Louvre*, 1861. © Erich Lessing.

14 David Teniers the Younger, *Archduke Leopold's Gallery*, 1651. Petworth House, The Egremont Collection. © NTPL/Matthew Hollow.

15 David Cox, *Interior of the Long Gallery, Hardwick Hall, Derbyshire*, 1838. © Birmingham Museums and Art Gallery. The Bridgeman Art Library.

16 The Public Drill, *Marina Abramović Presents …*, Whitworth Art Gallery, Manchester, 2009.

17 Martin Creed, *Work No. 850*, Tate Britain, London, 2008. Photograph: Shaun Curry © Getty Images.

18 Anna Karina, Sami Frey and Claude Brasseur in *Bande à Part*, directed Jean-Luc Godard, 1964. Copyright British Film Institute (BFI).

4 **Performing the Museum**

19 Art Treasures Exhibition: The Grand Hall, *Illustrated London News*, 9 May 1857.

20 Josef Breitenbach, *Exposition Internationale du Surréalisme*, Galerie des Beaux-Arts, Paris, 1938. © The Josef and Yaye Breitenbach Charitable Foundation, New York, courtesy the Josef Breitenbach Archive, Center for Creative Photography, Tucson.

21 John Schiff, *First Papers of Surrealism*, New York, 1942. Philadelphia Museum of Art: Gift of Jacqueline, Paul and Peter Matisse in memory of their mother Alexina Duchamp.

22 Demonstration photograph displayed at the exhibition, *Robert Morris*, Tate Gallery, London, 1971.

23 *Bodyspacemotionthings*, Tate Modern, London, 2009. Photograph: Shaun Curry © Getty Images.

24 Olafur Elliasson, *The Weather Project*, Tate Modern, London, 2004. Photograph: Chris Young © Press Association Images.

25 Carsten Höller, *Test Site*, Tate Modern, London, 2006. Photograph: Peter Macdiarmid © Getty Images.

26 Doris Salcedo, *Shibboleth*, Tate Modern, London, 2007. Photograph: Edmond Terakopian © Getty Images.

27 *A Sense of Heaven. Boxwood Sculptures for Personal Devotion 1500–1560*, Henry Moore Institute, Leeds, 1999. Photograph: Jerry Hardman-Jones © Henry Moore Institute.

28 *Art on the Line*, Courtauld Institute of Art, London, 2002. By

courtesy of The Samuel Courtauld Trust, The Courtauld Gallery.

29 'Fashions for Ladies – Plate 29 Carriage Dress', *Ackermann's Repository of arts, literature, commerce, manufactures, fashions and politics*, June 1815. Reproduced by courtesy of the University Librarian and Director, The John Rylands Library, The University of Manchester.

30 Drawn and etched by J. Findlay, acquainted by S.G. Hughes, *The Present Fashions. The Company viewing the sculptures in the New Gallery at the British Museum*, 1832. © The Trustees of the British Museum.

31 William Powell Frith, *Private View at the Royal Academy, 1881*, 1883. © Pope Family Trust. The Bridgeman Art Library.

5 Bodies of Protest

32 Prince Albert and the Queen of Portugal at the Royal Academy of Arts, *Illustrated London News*, 22 May 1858.

33 Velazquez's *The Toilet of Venus* (the *Rokeby Venus*), photographed 1914. © Press Association Images.

6 Disquieting Bodies

34 Charles Willson Peale, *The Artist in His Museum*, 1822. Courtesy of the Pennsylvania Academy of the Fine Arts, Philadelphia. Gift of Mrs. Sarah Harrison (The Joseph Harrison, Jr. Collection).

35 Edgar Degas, *Woman Viewed from Behind*, unknown date. Collection of Mr and Mrs Paul Mellon. Image courtesy of the National Gallery of Art, Washington.

36 Edgar Degas, *Visit to a Museum*, c.1879–90. Museum of Fine Arts, Boston. Gift of Mr and Mrs John McAndrew. The Bridgeman Art Library.

37 James Tissot, *L'Esthetique*, 1883–5. Museo de Arte de Ponce, Puerto Rico. Photograog © Whitford & Hughes, London. The Bridgeman Art Library.

38 George Goodwin Kilburne, *At the British Museum*, 1869–84. Private Collection. © Christopher Wood Gallery, London. The Bridgeman Art Library.

39 Charles Green, *A Sunday Afternoon in a Picture Gallery*, published in *The Graphic*, 8 February 1879. Department of Image Collections, National Gallery of Art Library, Washington, DC.

Epilogue

40 Henry Mayo Bateman, *The Boy who breathed on the Glass in the British Museum*, published in *Punch*, 1916. Reproduced with permission of Punch Limited. Courtesy of H.M. Bateman Designs.

41 The Great Court, British Museum, London. © The Trustees of the British Museum.

Acknowledgements

This book has been inspired and enriched by very many museum visits and I am grateful to those curators whose exhibitions have provided me with so much pleasure and inspiration, as well as to those that have made me tired, frustrated and confused. I am equally indebted to them all.

Many people have helped me to formulate the ideas that are explored here, and I am especially grateful to the support and insight I have received from Ken Arnold, Tristram Besterman, Tony Bennett, Sandra Dudley, David Howes, Tony Jackson, Sharon Macdonald, Richard Sandell and Giles Waterfield.

In practical terms, this book would never have appeared without the help of staff in various museums, archives and picture libraries, and I am particularly grateful to my colleagues in the John Rylands University Library's Special Collections for enabling me to bring the words and pictures together.

I would also like to recognize the impeccable research assistance provided by Sophie Everest, Robert Knifton, Christopher Plumb and Halona Norton-Westbrook. Thank you all.

Helen Rees Leahy
Centre for Museology, University of Manchester

Introduction

'This Progress'

It is February 2010. A young man and woman lie entwined in each other's arms on the floor of the rotunda of the Guggenheim Museum, New York. Visitors stand and watch as they writhe together in a sensuous embrace, falling into a series of erotic poses that are both sculptural and balletic. A number of the positions held by the couple are art historical quotations of kisses sculpted by artists including Rodin and Brancusi; this may or may not be apparent to their audience, as there are no explanatory texts on hand to explain the work or give its name. At the end of their three-hour shift, the pair is seamlessly replaced by another couple who take up the choreographed routine.[1] The performance continues: intense, disconcerting and unbroken from the start to the end of the museum day. Moving on to the next exhibit, the informed spectator knows that they have just seen the latest edition of an artwork called *Kiss* (2004) by Tino Sehgal.

Leaving the floor of the rotunda, the visitor begins to climb Frank Lloyd Wright's spiral ramp when they are greeted by a child aged around nine or 10 years. The child introduces herself as Julia and then announces, 'This is a piece by Tino Sehgal'. Taking up the visitor's pace and walking alongside them, Julia asks 'What is progress?' Inevitably, the visitor's answer is vague and unsatisfactory so Julia probes for clarification. By the next curve of the ramp they are joined by a teenager who says his name is David. Julia summarises the visitor's response to her initial question, and then slips away. David picks up the dialogue – or rather, the questioning: it is the visitor who has to provide the answers as David pursues the topic. Moving further up the ramp, David is replaced by Sean, a young man in his thirties. Somewhat to the relief of the visitor, Sean asks a different question: do you think that animals have souls? The exchange between the visitor and Sean is more conversational until, finally, Sean hands over to Jos, a woman in her sixties. She talks about the experience of growing old and her reflections on the nature of memory.

Together, the visitor and Jos complete the final circuit of the rotunda. Then, abruptly and quietly, she says 'The piece is called *This Progress*', shakes the visitor's hand, and walks off.

Standing at the top of the rotunda, the visitor feels oddly alone. Looking down at the groups of people spiralling upwards, it is easy to distinguish those who are engaged in earnest conversation with one of the artwork's interlocutors from those who, for whatever reason, rejected or ignored a child's initial invitation to walk together and are therefore, literally, out of the loop. It is these people, who are walking at their own pace, talking amongst themselves and doing 'normal' museum stuff, who now look out of place as they are cut adrift from the conversational and ambulatory rhythm of Sehgal's piece.

The disorientation and ambiguities provoked by Sehgal's installation at the Guggenheim subverted every conventional expectation of the art museum experience. There were no paintings to look at, only people to talk to: as the museum's emphasis on visuality receded, speech acquired an unexpected focus and intensity. Children accosted adults, and strangers became companions. The visitor answered questions posed by the guide. A key aspect of the work's choreographed sociality involved walking, as well as talking; by denying the visitor their customary freedom to move when and where they choose, Sehgal drew attention to the embodied practices of museum visiting which, through inculcation and habit, we nowadays take for granted. Reflecting on her own experience of the work, the critic Gillian Sneed commented:

> For me, perhaps the most powerful aspect of *This Progress*, was the way in which it engendered a completely new experience of Wright's spiralling rotunda … Despite its prominence, I had never really *noticed* my experience of moving up it before, usually being too absorbed in the art on the walls to pay attention to the feeling of my feet plodding along the sloping and looping ramp. In Sehgal's work, however, I was acutely aware of my own physical circulation.[2]

Sehgal describes *This Progress* as a 'constructed situation': it is an unexpected encounter whose effect is to stimulate visitors' critical awareness of themselves in material, social and institutional space.[3] By thoroughly overturning what we expect to *do* and *feel* when we visit a museum, the work forms a fitting opening to a book about museum bodies. A celebrated exponent of reflexive and relational art practice, Sehgal's work manipulates the relations between space, time and bodies within the museum: specifically, he resets the institution's rules by reinstalling the bodies of artists, enactors and visitors in unexpected and unsettling configurations.

One context for analysing Seghal's work is what Barbara Kirshenblatt-Gimblett describes as a shift from 'an informing to a performing museology'.[4] This reorientation in museum theory and practice, she argues, has arisen from a process of epistemological introspection into the contentious formation

of many museum collections and their related assumptions regarding the transmission of knowledge and cultural value. Thus the development of a *performing* museology enables the institution to adopt a reflexive position in relation to its own operation, thereby revealing its hitherto unacknowledged functions and processes. From the perspective of a book about museum bodies, the shift redirects our attention away from the museum as collection of objects to the museum as a site of social and corporeal practices. According to Kirshenblatt-Gimblett, a performing museology enables us to view the museum 'as a technology in its own right – a set of skills, techniques, and methods. A performing museology makes the museum perform itself by making the museum *qua* museum visible to the visitor'.[5] Specifically, *This Progress* stages a performance of the institution through the performative bodies of its visitors: by restructuring museum habits of walking and talking, the institution is experienced afresh as a site of proprioception (awareness of one's body and its boundaries in space and in relation to other bodies) and of sociality. Through his subversion of conventional expectations of the museum visit, Sehgal draws attention to the taken-for-granted corporeal techniques, skills and methods that visitors bring to the museum. The question is how did a repertoire of bodily practices become so incorporated within the museum audience that Sehgal's alternative choreography of pedestrianism and conversation produces such un-settlement and reflection?

In response to this question, *Museum Bodies* investigates how art museums and exhibitions have inculcated and accommodated different modalities of looking, walking, hearing, sitting and talking (but less frequently, touching, tasting or smelling) from their emergence in the eighteenth century. Successive chapters examine how the visual, ambulatory and performative practices of art spectatorship have been produced via the explicit regulations of the institution, the guidance offered by museum managers and curators, and by the exemplary conduct of more sophisticated and practised visitors. During the course of our excursion through the museum, we will encounter diverse reactions to the museum and its displays, ranging from compliant to resistant and even violent responses. Given the breadth of the museum's ideal and actual public, it is hardly surprising that it engenders mixed reactions. Often these reflect a disparity between the expectations and reality of a visit, but as *Museum Bodies* shows, they are also attributable to degrees of physical comfort and discomfort experienced by individuals as they move around the building. In turn, feelings of confusion or oppression may manifest themselves in physical symptoms, such as nausea and fatigue. A further chapter therefore explores how and why museums sometimes make people feel ill, and in turn, links this to the contexts in which some visitors deliberately damage the museum and its contents.

Preceding all of these issues is, of course, the fundamental question of who should be admitted to the museum, and who should not. The opening

chapter locates this vexed debate in the earliest years of public exhibitions and museums in Britain, from the 1750s to about 1820, when the arguments for and against limiting the institution's audience were hotly contested. And like many themes in this book, questions relating to the social efficacy of the museum (based on the demographic profile of its visitors) persist today: the terms of the debate have changed, but the problematic of who does (and who does not) cross the museum's threshold still remains. Similarly, how visitors conduct themselves inside the exhibition, their navigation of space and their interaction with fellow spectators are as pertinent to the operation of the museum today as they were 250 years ago, as *This Progress* makes clear. The central conundrum of *Museum Bodies* is, therefore, how, why and when did we acquire these embodied habits of art spectatorship?

Learning to Look

From the outset, museum administrators issued regulations governing visitors' admission and conduct, but the questions and anxieties raised by the congregation of diverse participants in the expanding sphere of public art far exceeded the business of enforcing an explicit list of by-laws. The behaviour of visitors to early museums (such the British Museum and the National Gallery) and art exhibitions (such as those organised by the Society of Arts and the Royal Academy) was scrutinised, not only for compliance with the institution's rules of admission, but also for evidence of aesthetic receptivity and cultural competence. As we shall see, the criteria for 'good' behaviour within the museum were not fixed and were continually re-calibrated in response to emerging internal priorities and external pressures, not least the inclusion of new categories of spectators, including women, the working classes and children. At the same time, modes of walking and looking had to be re-tuned in accordance with changing practices of display and conditions of visuality – that is, the practical and the discursive dimensions of seeing – within the institution.[6]

Famously Hegel observed that a museum visitor no longer kneels in front of a Madonna, but when and how did they learn not to?[7] Put another way, if the 'museum effect' works on disparate objects so as to decontextualise and re-aggregate them as artworks for the purposes of display and aesthetic evaluation,[8] when and how were normative practices of attentive viewing and self-restrained comportment inculcated within its public? Pierre Bourdieu observes that the constitution of the 'pure' aesthetic gaze which is 'capable of considering the work of art in and for itself' is linked to the *institution* of the artwork as an object of contemplation.[9] Thus the museum produces both the artwork as an object of attention and also the corresponding gaze of the disinterested viewer. This idealised gaze is prolonged, focused and also

somewhat aloof and detached;[10] although, as we shall see, in practice it was (and is) as often transitory and distracted.

Judging by the appearance of the archetypal dispassionate, self-composed visitor, museum looking seems to be largely divested of emotional intensity. As James Elkins discovered in his study of art historians and museum visitors, crying in front of pictures *in public* is generally perceived as inappropriate and embarrassing.[11] This conditioning in restraint is also part of the museum effect: whilst some display schemata are devised to evoke particularly intense or affective reactions to certain artworks, many more are not. For example, the narration of art history as an evolutionary progression in which secular and sacred subjects are shown side-by-side along a horizontal axis was devised to trigger techniques of comparison and recognition, rather than a spiritual or emotional response.[12] Underpinning such modes of display was the Enlightenment connection between atemporal and transcendental vision and rational cognition;[13] even if, in practice, the eye of the spectator was always attached to a body that was often tired, uncomfortable or standing in the 'wrong' position. As Chris Otter reminds us: in practice, 'visuality is stubbornly delimited by the body'.[14]

The corporeal techniques of the museum visiting involve much more than knowing how to look; or rather, knowing how to look also involves knowing how and where to stand, where and how fast to walk, what to say and what not to say, and what not to touch. Different modalities of display produced different norms of object–body relations, but knowing where to position your body in space has always depended on knowing how to read the exhibition 'script'.[15] For example, the techniques of walking and looking invoked by the chronological display of art history did not apply to the early exhibitions of the Royal Academy where paintings were hung in a mosaic-like pattern on an angled wall so that most works were viewed from below, rather than at eye level. In this space, eyes were encouraged to roam vertically as well as horizontally, and social interaction and lively conversation were equally licensed so that aesthetic judgments could be freely expressed and discrimination could be publicly exercised.[16] By contrast, a very different rhythm of walking and looking was demanded of visitors to the Manchester Art Treasures Exhibition held in 1857 where thousands of artworks were displayed in historical sequence along the walls of long, corridor-like galleries. This was the first large-scale public experiment in the systematic, chronological display of painting in Britain; walking in the 'wrong' direction would therefore undermine both the logic of display and the educational rationale of the exhibition. But, as we shall see, it was an easy mistake to make.

Even these preliminary observations indicate that visuality within the museum involves more than 'just looking'; as Martin Jay notes, being a spectator (or observer) within particular cultural contexts 'means observing the tacit cultural rules of different scopic regimes'.[17] Thus, the eye of the

practised museum spectator is always embodied within a repertoire of actions that reflect and respond to the space of display, the conditions of viewing and the presence of other spectators. Discussing the development of viewing practices within the early Royal Academy exhibitions, Peter de Bolla adds that, 'a pose, a gesture, an attitude, or posture – somatic embodiments of the viewing position' could signify the competence of the spectator and affirm their participation within 'the culture of visibility'.[18] A successful performance of spectatorship therefore invoked and enacted a precise set of socio-cultural coordinates that defined the 'specific activity of looking' within the space of the art exhibition or museum.[19] Added to this, the social topography of the exhibition was (and is) always in flux, and spectatorship required the negotiation of new mores and fashions in visitor practices, as well as in display. For example, Andrew Hemingway describes the short-lived craze for note-taking in early nineteenth-century art exhibitions: according to a report in the *Morning Herald* of 1810, 'all are furnished with tablets, and affecting to write criticisms upon subjects of which they have no knowledge themselves and of course are utterly incapable of communicating to others'.[20] Inevitably, as soon as a practice like this became commonplace, it was dropped by those who started the trend; it was via such nuances of instigation and imitation that the body politics of the museum were continually reproduced.

Marcel Mauss recognised that corporeal practices are acquired and are therefore culturally specific in an essay entitled 'Techniques of the Body' published in 1935.[21] Mauss argued that mundane physical attitudes and activities, such as walking and swimming, are learned techniques. Their enactment is therefore inflected by different methods and principles of instruction, and hence their variation across time, geography, gender and status. For example, Mauss observed that there were fashions in gait and posture, as well as divergent emphases on physical etiquette, between different nationalities. Techniques of the body therefore are distinctive of different 'societies, educations, proprieties and fashions, prestiges'; in other words, of the social *habitus* of the individual.[22] These skills and techniques are inculcated primarily via processes of 'prestigious imitation': according to Mauss, the individual 'imitates actions which have succeeded and which he has seen successfully performed by people in whom he has confidence and who have authority over him'.[23] Thus, the *habitus* of the practised museum spectator is palpable in their demonstration of socially acquired and sanctioned bodily techniques within the exhibition; for example, standing at the 'correct' distance from the artwork, walking at a pace that is neither too fast nor too slow, and judiciously editing the number of artworks deserving their closest scrutiny. Once acquired, these socially learnt dispositions, skills and methods are taken for granted: fully incorporated within the individual, they come 'naturally' and function as 'structuring structures'.[24] Techniques of

viewing are anchored in the body and, in turn, underpin the spectator's self-perception as a viewing subject within the museum.

The emulation of more practised spectators has always been a crucial aspect of social and aesthetic training within the arena of the art museum. Through Mauss's 'prestigious imitation', the acquisition of normative bodily techniques provides the novice visitor with the competence and confidence to navigate its physical and social terrain with ease and self-assurance – at least, in theory. In practice, compliance with the museum's explicit rules and regulations did not always imply the incorporation of its unwritten social and cultural codes. David Carrier points out that modalities of display are historically specific and are devised to be apprehended in particular ways: that is to say, the 'knowledge implicit in the display of art' was not equally accessible to every visitor.[25] Knowing how to read the exhibition script provided the cues for a successful performance of spectatorship, but, as we shall see, this knowledge eluded many visitors who were frequently conscious of their disadvantage as a result.

Similarly, knowing what to do in principle is not the same as having the desire or energy to do it in practice. The history of corporeality in the museum is also a tale of recalcitrant bodies that have rebuked, resisted or ignored the museum's regulations and exhibition script. The corollary of a narrative of acquired equipoise and conditioned restraint is a history of disobedience and disaffection, as well as ignorance of what is expected. In short, museums have made people tired, angry and sick.

The inculcation of embodied practices of spectatorship via 'prestigious imitation' could be accessed within the museum itself, but also from the study of print media, both visual and textual. The regulatory function of the exhibition print was evident in its strategic depiction of diverse viewers, whose responses to the display were delineated through their position, posture and dress.[26] The idea was to interpellate the reader as a viewing subject through their imaginative identification with specific viewers and corresponding critique of others whose responses were evidently vulgar, pretentious or superficial responses. Images such as Thomas Rowlandson's print *Viewing at the Royal Academy* (c.1815) pinpointed the *gaucherie* of those visitors who failed to stand in the correct position to view a painting: what was known as the 'point of sight' (Figure 1). Their failure to master the skill of viewing at a distance, both actual and metaphorical, is satirised in their ridiculous postures, protruding heads and awkward proximity to other spectators.

Direct instruction in visiting and viewing practices was provided by guidebooks and periodicals, often directed to readers deemed most deficient in techniques of self-restraint and attentive viewing: specifically, women and working-class visitors. In 1832, *The Penny Magazine of The Society for the Diffusion of Useful Knowledge* explained how a 'working man' could visit the

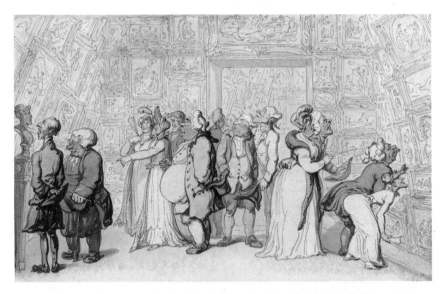

1 Thomas Rowlandson, *Viewing at the Royal Academy*, c.1815.
Yale Center for British Art, Paul Mellon Collection. The Bridgeman Art Library.

British Museum both confidently and profitably, so long as he adhered to a few 'simple rules'.[27] The article directly addressed the magazine's ideal reader: namely, 'an artisan or tradesman … who knows that there are better ways of spending a working-day … than amidst the smoke of a taproom, or the din of a skittle ground'.[28] First, the author assures his reader that the museum's officers will be glad to see him and his family, no matter that their clothing is 'homely' rather than smart: so long as they are cleanly dressed, they need not be embarrassed about their appearance. However, he also acknowledges that the museum entrance could be intimidating, and that the fear of 'surly looks or impertinent glances' from the attendants might well be off-putting to the first-time visitor: 'Go on', he urges, you have come to see your own property and have every right to do so.[29]

Once inside, the observation of three rules will ensure the artisan's enjoyment of the museum, without troubling the authorities or his fellow visitors. The first rule is: 'Touch nothing'. The justification for the prohibition is primarily practical: to avoid damaging or defacing the exhibits, especially by writing on them. The urge to write one's name on an historic artefact is, says the author, infantile: 'Doubtless, these, fellows, who are so pleased with their own weak selves, as to poke their names in every face, are nothing but grown babies'. Secondly, 'Do not talk loud'. Quiet conversation is encouraged: 'for pleasure is only half-pleasure, unless it be shared with those we love'. However, calling loudly from one end of the gallery to the other disturbs everyone's contemplation and enjoyment of the exhibits. The final rule is:

'Be not obtrusive.' In other words, do not bother other people with questions and, especially, do not disturb the artists copying in the galleries: 'it is a real inconvenience to be obliged to give their attention to anything but their work, or to have their attention disturbed by an over-curious person peeping at what they are doing'. The visitor should therefore only direct his questions at the museum attendants, who 'will answer you as far as he knows'. Finally, the author encourages his reader to visit repeatedly and patiently. Here the real lesson of the museum is revealed: 'real knowledge', as opposed to 'the gratification of passing curiosity', can only be obtained through '*self-discipline of the body* as well as the mind' (my italics).[30]

What kind of evidence about past bodily practices is contained in sources such as *The Penny Magazine* article and Rowlandson's print? Both are instructive, rather than descriptive: the print is a caricature and the article idealises the artisan's potential role as member of the museum's inclusive public. Even so, neither would be plausible to its contemporary audience if it bore no resemblance to the lived experiences of actual spectators. Each discloses not only how techniques of museum bodies were inculcated, directly and indirectly, but also that different emphases applied within specific exhibition locales. How the labourer positions himself in relation to the object on display is of less interest to *The Penny Magazine* than his capacity for self-control in terms of touching and talking: the author is most concerned that he does not to embarrass himself in front of other visitors or incur the censure of the museum attendants. By contrast, Rowlandson's print focuses on modes of spectatorship, in particular the relationship between aesthetic competence and techniques of viewing.

Taking such sources as a cue, the aim of this book is to seek out and understand the particular and the empirical, as well as the general and the regulatory. 'Museum Bodies' are both real *and* discursive bodies: that is, actual bodies moving through the gallery, and also bodies that are socially inscribed in space and practice.[31] They include bodies that have mastered techniques, are shaped by convention and are governed by institutional rules, and also bodies that are intractable and untrained. Of course, the immediate problem is that, as Constance Classen acutely observes, the history of the bodily practices is an elusive quest:

> One of the most difficult subjects for an historian to investigate is that of the corporeal practices of earlier eras. Ways of walking, eating, smelling and touching, while laden with social significance, are often so taken for granted that they are little commented on by their practitioners. It takes a very thorough observer to record the ordinary bodily motions of daily life.[32]

This is not, and does not pretend to be, an exhaustive history of bodily practices in the museum: as Classen indicates, such a project would be practically unfeasible, let alone intellectually coherent. My focus therefore inevitably

alights on events and experiences that were perceived as innovative, significant or unfamiliar, either because they were new to everyone or because they were new to the writer. For example, accounts of foreign visitors to England (such as Frederick Wendeborn, Karl Phillip Moritz, Jean-Pierre Grosley and Nathaniel Hawthorne) record the practicalities of museum encounters as part of a broader interest in local customs: usefully, therefore, they describe not only what they saw, but how and with whom they saw it.

Other writers had a professional interest in the subject of museum spectatorship. Both disapproval of and (less often) praise for visitors' behaviour kept journalists' pens busy, including Charles Dickens who was always more interested in the sociology of an exhibition than its contents. Art critics were concerned with both, and the perceived failure of audiences to apprehend the aesthetic lessons of the show was a continual refrain amongst commentators on, for example, the early Royal Academy exhibitions. Raymond Butsch notes that audiences are discussed 'when others considered them problematic'.[33] In this context, from the 1830s to 1850s, successive Parliamentary Select Committees investigated and recorded evidence of diverse aspects of the British cultural state, including the admission, conduct and provision of amenities for the museum's public.

Interwoven with, but also distinguished from, these documentary sources I draw on a range of philosophical and also fictional accounts of the museum encounter. Here 'philosophical' refers to essays by, for example, Paul Valéry and Maurice Blanchot, whose autobiographical form serves as a pretext for the author's wider critique of the museum experience. These do not recount a single event, but offer a more abstract account, which is nonetheless grounded in personal experience and perception. Equally, Charles Dickens visited the Manchester Art Treasures Exhibition just once, but still felt qualified to mount a general evaluation of its audience. Each of these sources constitutes an individual and subjective point of view: they are not mustered as evidence of a universal truth, but as points of provocation and reflection, and, often, as a salutary reminder that even the most accomplished visitors depart from the museum script, through choice rather than ignorance. Museum going is not a homogeneous experience, as these diverse sources amply demonstrate.

Throughout the book, I also draw on passages from works of fiction by, amongst others, Pierce Egan, Emile Zola, Henry James, Charles Rodgers and James T. Staton. Each of these describes the social and corporeal dimensions of a particular museum visit in vivid detail, drawing acute attention to the pressures exerted on the bodies of visitors. Thus, whilst there are plenty of accounts by people who were exhausted after walking round the Louvre – usually along the lines of 'it was impossible!' – most weary diarists do not record the incongruity of 'hobnailed boots' sounding like 'a herd running amok' on the gallery floors. The weariness and embarrassment experienced by Gervaise, Coupeau and their friends when they visit the Louvre in

L'Assommoir, his great novel of working-class Paris, is Zola's alone.[34] The point about these fictive passages is that they each explore the physical, social and cultural dimensions of the museum encounter, and thus enable us to do the same. Ruth Hoberman observes that such 'fictional depictions were always in conversation with institution of the museum itself, which ... was itself the subject of debate, debates that, in turn, shaped literary depictions of museal encounters'.[35] The same is true, I think, of many images of museum visitors that, similarly, constituted a sustained visual critique of institutional contexts and their associated practices of spectatorship.

Some readers may be surprised that there is relatively little discussion in *Museum Bodies* of institutional visitor surveys and their findings. The reasons for this omission are simple: the kinds of questions that I explore here are not the same as those that generally interest the museum and its funders, and which underpin most visitor studies. Rather, I am intrigued by 'problems' that even the most reflexive institution would rather ignore, including the experiences of weary, bored, confused and even violent visitors. Equally, this is not a book about the social efficacy of the museum: my focus is on how the museum visit is enacted by real visitors, not on the codification and aggregation of those experiences for the purposes of evaluation against extrinsic criteria. Having said that, some of the first attempts systematically to study the behaviour of museum visitors, conducted by Benjamin Ives Gilman, Edward S. Robinson and Arthur W. Melton in the United States, find their place here because of their preoccupation with specific techniques of visuality and corporeality, as opposed to the socio-political contribution of the institution or its marketing opportunities.

The category of disabled visitors per se is also absent from these pages: this is partly because disability's histories exceed the confines of this study whose focus is on the production of normative practices of visiting and viewing. Thus, walking through the gallery therefore receives more attention than being wheeled through it, even assuming that a wheelchair user would be able to manage the ascent of a typically imposing flight of stairs leading to the museum entrance. My argument is rather that the egregious disregard for the specific needs of disabled people in the eighteenth- and nineteenth-century museum was symptomatic of a wider disdain for the physical needs of *all* visitors in many institutions, ranging from the lack of female lavatories in the British Museum to the paucity of seating in the Louvre. Having said that, the requirements of a spectrum of visitors, including the elderly and infirm, are acknowledged by, say, the availability of both opera glasses and bath chairs for hire in the Manchester Art Treasures Exhibition. Similarly, the *trottoir roulant* at the 1900 *Exposition Universelle* in Paris followed by the installation of the first elevator in the Louvre in 1905 were intended to relieve general fatigue, rather than address specific issues of access. Gradual improvements in facilities for disabled visitors in the twentieth century have also contributed

to their constitution (and problematisation) as a distinct 'target' within the museum's increasingly differentiated public: their presence is now measured and evaluated as part of the museum's larger project to atone for their past exclusion – or, I suggest, oversight within a larger category of awkward and unwelcome bodies.[36]

As long ago as 1986, *Representations* devoted a special issue to 'the making of the modern body' with the news that: 'Scholars have only recently discovered that the human body itself has a history.'[37] Since then, both cultural historians and social scientists have produced and interrogated the 'corporeal turn' in the humanities in terms of practice, *habitus*, technique, experience and feeling. In terms of museum studies, some of the richest work over the past decade speaks to Kirshenblatt-Gimblett's observation that the museum 'is a school for the senses and that its sensory curriculum has a history'.[38] The idea of the 'sensorium' or 'sensescape' (that is, the entire perceptual apparatus as an operational complex) has drawn attention to the cultural and political dimensions of shifting sensory regimes within the museum, as well as to their historical formation.[39] Thanks to the illuminating work of, amongst others, Constance Classen, David Howes and Fiona Candlin, it is no longer possible to view the museum as a silent and static site of disembodied visuality.[40]

Both Classen and Candlin have mapped the sensory transition from seventeenth- and eighteenth-century encounters with collections, which may well have involved smelling, listening and tasting as well as touching and seeing, to the organisation of the nineteenth-century museum as a primarily visual object-lesson. For example, in the early museum, objects might have been held by visitors in order to ascertain their weight, texture and temperature, thereby verifying evidence of their visual appearance alone.[41] However, by the nineteenth century, seeing alone had become the dominant means of elucidation: as Classen put its, all that the museum visitor could now expect 'was to have a clear, well-lit view of the objects on display'.[42] However, it would be wrong to assume that the Victorian museum was solely concerned with the promotion of objective sight: music recitals in exhibition galleries were not uncommon and even if visitors no longer tasted the objects on display, eating and drinking in refreshment rooms became an increasingly important part of the social ritual of museum visiting from the 1850s onwards. The heat and odour of the rooms and of other visitors were also part of the multi-sensory experience of the nineteenth-century institution, however unpleasant. It was not only decaying specimens in the natural history that smelt, as Michael Levey's description of the interior of the National Gallery in 1839 makes clear: 'Not only were the pictures crowded on the walls, but the crowding of visitors (who often were merely sheltering from the rain), their consumption of food, the general smell and the influx of smoky air, all contributed to make a zoo of the Gallery.'[43]

My investigation into museum bodies is thus intended to complement the attention afforded to the activation and the negation of the senses in the historical and contemporary museum. By exploring the practices of 'ordinary' museum visitors, my aim is to provide an account of how gaining admission, walking, talking, reading, looking and being looked at have constituted a repertoire of bodily techniques that is both distinctive and mundane. And by drawing on wide range of visual and written, documentary and fictional, sources I hope provide a fresh and, at times, oblique angle on practices and experiences that are often overlooked. This is not an account of the emotions engendered by the museum per se, except that feelings are also structured via corporeal experiences, and so expressions of pleasure, frustration, embarrassment and anger are also present here. The interaction between the institution and its audience is a constant theme and tension: how the museum constructs, perceives and manages its audience finds its counterpoint in how the visitor experiences and responds to the museum. My aim has been to ensure that both positions are articulated, whilst erring towards the viewpoint of the visitor, if only to counteract the dominance of institutionally oriented perspectives in museum history and theory.[44]

There is a clear bias in *Museum Bodies* towards the particular techniques of the body engendered and required by large museums, which, I believe, is justified on both conceptual and practical grounds. Major institutions such as the British Museum, the Royal Academy, the Manchester Art Treasures Exhibition and Tate Modern have attracted the largest numbers of visitors, have produced the richest documentary and imaginary sources, and have been most influential in inculcating bodily techniques. Their size and significance also makes particular claims on the bodies and minds of their audience: not surprisingly, levels of pleasurable anticipation amongst visitors are often high, and any subsequent disappointment is correspondingly keenly felt. In addition, the scale and cultural ambition of these institutions pulls into sharp focus the tensions between attentive viewing of the individual artwork and the apprehension of the collection or exhibition en masse. Related to this, what Dario Gamboni terms 'museum pathology' – including fatigue, nausea, dizziness and even violence – is most frequently associated with such sites; no doubt a further corollary of the numbers of visitors and critics whom they attract.[45]

Although the focus of the book is primarily on English institutions, it is not exclusively so: for instance, experiences of the nineteenth-century Louvre are, in many respects, comparable with those of the British Museum, and the same themes appear in visitors' accounts, novels and visual images of both. In addition, historical commentators frequently made comparisons between the two, regarding access, security procedures and visitors' conduct. As the example of Sehgal's *The Progress* at the Guggenheim demonstrates, artists' responses to the institutional, and especially the performative, practices of the

museum resonate beyond a local context. Sehgal himself has re-staged some of his 'constructed situations' in different international settings; whilst each enactment may be inflected with specific local nuances, it is also recognisably the same project. The inculcation of the bodily techniques of the exhibition viewer mirrors the historical and international expansion of the museum field, and, as Sehgal's work shows, bodily practices can be read across a range of sites and locales.

The thematic structure of *Museum Bodies* is designed to enable cross-institutional comparisons and also to show the persistence of particular corporeal debates and practices over a long duration. For example, the problematic of attention endures, despite changing fashions in display and their associated conditions of visuality. Similarly, although the neologism 'museum fatigue' was coined in 1916, we can detect its symptoms amongst eighteenth-century visitors to the British Museum.[46] Again, Stendhal described symptoms of dizziness and palpitations when he visited Florence in 1817, but the 'Stendhal Syndrome' was not written up in the medical literature until 1989.[47] Within this broad chronological compass, I return to a number of institutions across different chapters, so as to investigate and compare practices of, say, viewing, walking and self-display at the Royal Academy and the Manchester Art Treasures exhibitions. My aim here is to provide threads of institutional continuity and growing familiarity within a thematic frame that also accommodates a close reading of the local and specific.

Many of the bodily techniques of the museum have widespread application; however, I have limited my discussion to institutions concerned with the display of art, including classical and Ancient Egyptian sculpture at the British Museum (whose founding collections also included natural history specimens and books). This is not to suggest that practices of, for example, viewing and walking could not be read across a wider range of sites, but there are recurring themes that are specific to the display and reception of art in museums and exhibitions. For example, the art museum's claim to cultural authority seems to place a particular pressure on many visitors: for example, to feel appropriately appreciative and uplifted by a display of masterpieces whereas, in practice, some simply acquire an 'aesthetic headache'.[48] Related to this is a sustained critique of the art museum's apparently insatiable desire for accumulation, its practice of displaying incongruous works in close proximity, and the consequent difficulty of fixing attention on anything for any length of time. Meanwhile, shifting modalities of art display invoked new skills and practices of viewing, which can be mapped against their predecessors and successors. Art museum spectatorship therefore seems to form a distinctive strand within a potentially vast and unwieldy topic.

Within this context, I have also included discussion of some temporary exhibitions and have returned a number of times to a focus on two particularly influential exhibition sites: namely, the Royal Academy of Arts (founded

in 1768) and the Manchester Art Treasures Exhibition (1857). Although not 'museums' in the sense of collecting institutions, both were significant and innovative sites for the display and reception of art, and each engendered innovative techniques of spectatorship. In the years prior to the founding of the National Gallery (in 1824), the Royal Academy was pre-eminent as an officially designated site of aesthetic training although, in practice, it was always a more a complex space of socio-cultural consumption. By contrast, the Art Treasures Exhibition was an ambitious experiment in the accumulation and management of both artworks and people on an unprecedented scale: contemporary opinion was divided on its efficacy in providing an object lesson in art history to its diverse audience, but there was little dispute over its significance as laboratory for assessing the cultural competence of its participants.

The emergence of public exhibitions and museums in the eighteenth and nineteenth centuries constituted a new public arena for looking, walking, standing, talking, listening, reading, writing, sitting and, occasionally, touching. For many (although by no means all) people today, the experience of museum visiting is so familiar that we take these bodily techniques and skills for granted. We are used to being part of the spectacle in a culture of visuality and have forgotten that we had to acquire the habit of conjoined walking and looking in the first place. It is only when a sensation is new or unexpected that it is worthy of comment, or when an artist like Sehgal draws our attention to the taken-for-granted techniques of museum bodies.

Notes

1 Holland Cotter, 'In the Naked Museum: Talking, Thinking, Encountering', *New York Times*, 1 February 2010. Online at: www.nytimes.com/2010/02/01/arts/design/01tino.html?pagewanted=all.

2 Gillian Sneed, 'Tino Sehgal Presents a Work in Progress', *Art in America*, 30 April 2010. Online at: www.artinamericamagazine.com/news-opinion/news/2010-02-04/tino-sehgal-guggenheim-this-progress/.

3 Arthur Lubow, 'Making Art Out of an Encounter', *The New York Times Magazine*, 15 January 2010. Online at: www.nytimes.com/2010/01/17/magazine/17seghal-t.html?_r=1&pagewanted=all.

4 Barbara Kirshenblatt-Gimblett, 'The Museum as Catalyst', *Museum 2000: Confirmation or Challenge?*, Vadstena, 2000. Online at: www.nyu.edu/classes/bkg/web/vadstena.pdf.

5 Ibid.

6 For a discussion of visuality see: Chris Otter, *The Victorian Eye*, Chicago: University of Chicago Press, 2008, p. 24.

7 Georg Wilhelm Friedrich Hegel, *Hegel's Aesthetics. Lectures on Fine Art*, Vol. 1 (trans. T.M. Knox), Oxford: Clarendon Press, 1975.

8 Andre Malraux, 'Museum Without Walls', *The Voices of Silence* (trans. Stuart Gilbert), London: Secker and Warburg, 1954; Paul Valéry, *The Collected Works of Paul Valéry*, edited by J. Matthews, Princeton: Princeton University Press, 1960; Francis Haskell 'Museums and their Enemies', *Journal of Aesthetic Education*, University of Illinois 19.2, 1985, pp. 13–22.

9 Pierre Bourdieu, *The Field of Cultural Production*, edited by Randal Johnson, Cambridge: Polity Press, 1993, p. 36.

10 Norman Bryson, *Vision and Painting. The Logic of the Gaze*, London and Basingstoke: Macmillan Press, 1983, p. 94.

11 James Elkins, *Pictures & Tears*, New York and London: Routledge, 2004.

12 Nicholas Serota, *Experience or Interpretation: The Dilemma of Museums of Modern Art*, London: Thames and Hudson, 1996.

13 Michel Foucault, *The Order of Things*, London and New York: Routledge, 2003. p. 144; Tony Bennett, 'Pedagogic Objects, Clean Eyes, and Popular Instruction: On Sensory Regimes and Museum Didactics', *Configurations*, 6.3, 1998, p. 354f.

14 Otter, *The Victorian Eye*, p. 24.

15 Julia Noordegraaf, *Strategies of Display. Museum Presentation in Nineteenth and Twentieth-Century Visual Culture*, Rotterdam: NAi Publishers, 2004.

16 David Solkin (ed.), *Art on the Line: The Royal Academy Exhibitions at Somerset House, 1780–1836*, New Haven and London: Yale University Press, 2001; Peter de Bolla, *The Education of the Eye*, Stanford: Stanford University Press, 2003.

17 Martin Jay, *Downcast Eyes. The Denigration of Vision in French Twentieth-Century Thought*, Berkeley, Los Angeles and London: University of California Press, 1993, p. 9.

18 De Bolla, *The Education of the Eye*, p. 72.

19 Ibid.

20 Andrew Hemingway, 'Art Exhibitions as Leisure-Class Rituals in Early Nineteenth-Century London', in Brian Allen (ed.), *Towards a Modern Art World*, New Haven and London: Yale University Press, 1995, p. 102.

21 Marcel Mauss, 'Techniques of the Body' (trans. Bill Brewster), *Economy and Society*, 2, 1973, pp. 70–88.

22 Ibid., p. 73.

23 Ibid., p. 73.

24 Pierre Bourdieu, *The Logic of Practice*, Stanford: Stanford University Press, 1990, p. 53.

25 David Carrier, 'The Display of Art: An Historical Perspective', *Leonardo*, 20.1, 1987, p. 83.

26 C.S. Matheson, '"A Shilling Well Laid Out": The Royal Academy's Early Public', in Solkin, *Art on the Line*, p. 39.

27 'The British Museum', *The Penny Magazine of The Society for the Diffusion of Useful Knowledge*, 7 April 1832, pp. 13f.

28 Ibid., p. 14.

29 Ibid.

30 Ibid.

31 Elizabeth Grosz, 'The Body as Inscriptive Surface', *Volatile Bodies*, Bloomington: Indiana University Press, 1994, pp. 138–59.

32 Constance Classen, 'Museum Manners: The Sensory Life of the Early Museum', *Journal of Social History*, 40, 2007, p. 895.

33 Raymond Butsch, *The Citizen Audience: Crowds, Publics and Individuals*, New York and London: Routledge, 2008, p. 1.

34 Emile Zola, *L'Assommoir* (trans. Leonard Tancock), Harmondsworth: Penguin (first published 1876), 1970, p. 90.

35 Ruth Hoberman, *Museum Trouble. Edwardian Fiction and the Emergence of Modernism*, Charlottesville and London: University of Virginia Press, 2011, p. 7.

36 Whilst it is clear from my name that I am a woman, it will not be obvious that I am also disabled and have become used to viewing exhibitions from the horizon of a wheelchair, as well as from standing

on my feet. I mention this simply in a spirit of openness: readers can judge my treatment of these issues for themselves.

37 Editor, 'Introduction', *Representations* (The Making of the Modern Body: Sexuality and Society in the Nineteenth Century), 14, 1986, p. vii.

38 Kirshenblatt-Gimblett, 'The Museum as Catalyst'.

39 Editorial, 'Introducing Sensory Studies', *Senses & Society*, 1.1, 2006, pp. 5–8.

40 Constance Classen and David Howes, 'The Museum as Sensescape: Western Sensibilities and Indigenous Artefacts', in Chris Gosden, Elizabeth Edwards and Ruth Phillips (eds), *Sensible Objects: Colonialism, Museums and Material Culture*, Oxford: Berg Publishers, 2006; Classen, 'Museum Manners'; Fiona Candlin, *Art Museums and Touch*, Manchester: Manchester University Press, 2010.

41 Classen, 'Museum Manners', p. 901.

42 Ibid., p. 907. See also: Fiona Candlin, 'Touch, and the Limits of the Rational Museum or Can Matter Think?', *Senses & Society*, 3.3, 2008, pp. 277–92.

43 Michael Levey, *Brief History of the National Gallery*, London: Pitkins Pictorials, 1967, p. 8.

44 For example, Douglas Crimp, *On the Museum's Ruins*, Cambridge, MA: MIT Press, 1993; Tony Bennett, 'The Exhibitionary Complex', *New Formations*, 4, Spring 1988, pp. 73–102.

45 Dario Gamboni, *The Destruction of Art, Iconoclasm and Vandalism since the French Revolution*, London: Reaktion Books, 1997.

46 Benjamin Ives Gilman, 'Museum Fatigue', *The Scientific Monthly*, 2.1, January 1916, pp. 62–74.

47 Stendhal, *Rome, Naples and Florence* (trans. Richard N. Coe), London: John Calder, 1959; Gabrieilla Magherini, *La Sindrome di Stendhal*, Milan: Feltrinelli Editore, 1989.

48 Henry James, *The American*, London: Penguin Classics (first published 1876–7), 1986, p. 33.

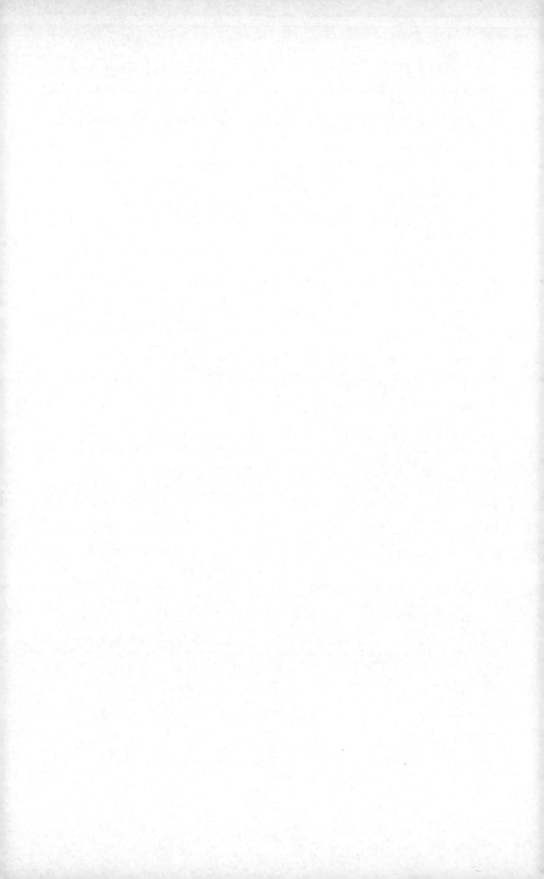

1

Making a Social Body

In the present times of political excitement, the exacerbation of angry and unsocial feelings might be much softened by the effects which the fine arts had ever produced on the minds of men ... The erection of the ... [National Gallery] would not only contribute to the cultivation of the arts, but also to the cementing of the bonds between the richer and poorer orders of the state. (Sir Robert Peel, 1832)[1]

[I must announce my misgivings] to the fitness of the present site for the collections of very valuable pictures, combined with unrestricted access, and the unlimited right to enter the National Gallery, not merely for the purpose of seeing the pictures, but of lounging and taking shelter from the weather; to attempt to draw distinctions between the objects for which admission was sought, to limit the right of admission on certain days might be impossible; but the impossibility is rather an argument against placing the pictures in the greatest thoroughfare of London the greatest confluence of the idle and the unwashed. (Sir Robert Peel, quoted 1853)[2]

These two well-known comments by Sir Robert Peel, separated by some 20 years, eloquently contrast the art museum's idealised production of a cohesive and receptive public with its actual audience of unbiddable, listless and dirty bodies. Such divergent, and apparently contradictory, reflections on the National Gallery's potential and real visitors provide a pithy introduction to the central questions of this chapter: how was a public for art both conceptualised and realised within an expanding sphere of art exhibitions and museums during the late eighteenth and early nineteenth centuries? Specifically, what was the role of visitors' bodies in the negotiation and materialisation of this new art public – or, more accurately, art publics? And how was the unprecedented congregation of diverse bodies managed by the institution and, in turn, experienced by its members?

As Colin Trodd notes, Peel's observations demonstrate how the early National Gallery 'oscillates and hesitates' between polarities of cultural elitism and mass participation.[3] The fact was that, 30 years after the gallery

was founded in 1824, many people evidently had not responded to its displays in quite the way that its administrators had anticipated. The trustees had opened the doors to the disembodied space of the embryonic national art collection with an invitation to an aesthetic encounter that would be both ordered and attentive. In response, according to Peel, 'the idle and the unwashed' had transformed the gallery into a very different social space adapted to their corporeal, rather than their spiritual or intellectual, interests and needs. Evidence presented by members of the National Gallery staff to successive Parliamentary Select Committees from the 1830s to the 1850s confirmed that certain visitors were not really interested in the pictures at all, but used the building for keeping themselves warm and dry, as well as for meeting friends, eating and drinking, and as an indoor playground for their children. By the 1853, the gallery's success in attracting a large and diverse public seemed increasingly incompatible with a curatorial regime that required the protection of the paintings from the dirt of the metropolis and its inhabitants, as well as the redeployment of the collection within an explicit art historical framework.[4] As Peel's second comment indicates, in response to these challenges, rather than restrict admission to the National Gallery, a proposal to move the collection to a more salubrious site was seriously considered: that is, one that would be less convenient for casual use by the undesirable bodies of those who lived and worked close to Trafalgar Square, its nearby military barracks and public wash house. In the event, the idea was not pursued, and the collection stayed where it was, open free of charge to young and old. Visitors were entitled to stay as long as they liked and to wander through the rooms as they pleased.

Institutions such as the fledgling National Gallery did not exist in isolation from other sites of visual display and collective spectatorship across London. Tony Bennett's concept of the 'exhibitionary complex' succinctly embraces the range of commercialised spectacles – including private museums, dioramas, panoramas, dealer's galleries, arcades and department stores – amongst which official museums and exhibitions were positioned.[5] Richard Altick's *Shows of London* describes in detail the diversity and popularity of these diverse sights and also the corporeal excitements that they offered, including 'scare shows', a glimpse of the pictorial sublime and close encounters with wild animals.[6] They were often lively affairs and consequently presented a challenge to the organisers of the first 'serious' public art exhibitions hosted by the Society of Arts in the 1760s: accounts of disorderly and rough behaviour amongst the visitors to the first of these exhibitions were, argues Altick, hardly surprising. As he puts it, '"the opportunity of a show" attracted, amongst others, persons who had no idea of decorum, let alone of art, but shared the universal enthusiasm for seeing something for nothing'.[7] Henceforth, the art exhibition would be a critical site in which the possibility of an inclusive cultural sphere was continuously tested and debated.

According to Bennett, the formation of the exhibitionary complex made access to art and culture progressively more available to more people. In effect, it produced 'the transfer of significant quantities of cultural and scientific property from private into public ownership where they were housed within institutions administered by the state for the benefit of an extended general public'.[8] However, unlike purely commercial ventures whose success (or failure) depended primarily on their popularity and revenue from ticket sales, museums such as the British Museum and the National Gallery were required not only to attract an audience, but also to demonstrate their cultural efficacy by operating on the minds and bodies of their visitors. Similarly, exhibitions held at the Society of Arts (from 1760) and by the Royal Academy of Arts (from 1769) were, ostensibly, directed towards the more serious objectives of promoting British art and providing the public with an opportunity for aesthetic education. Within these spaces of official (or semi-official) display, the 'crowd' was assembled and, in principle, regulated by being rendered 'visible to itself'.[9] There was a necessary self-awareness about becoming a viewing subject within the expanding field of public art, not least because spectators were simultaneously and continually scrutinised for evidence of their good behaviour and cultural competence.

Mary Poovey puts the unprecedented visibility of this emerging art public into a wider social context when she describes how, in the early nineteenth century, new processes of quantification and aggregation of persons were used as a means of 'making a social body' that comprised the entire population.[10] She argues that this process of aggregation went hand in hand with a process of disaggregation, whereby the social sphere was increasingly distinguished from the economic and political spheres. Whilst the arithmetical aggregation of persons (for example, via the accumulation of statistics) enabled the abstract delineation of the social body, it was 'innovations like affordable transportation, cheap publications, and national museums' that enabled its materialisation by bringing 'groups that had rarely mixed into physical proximity with each other and represent[ing] them as belonging to the same, increasingly differentiated whole'.[11] From Poovey's perspective, public participation in museums and exhibitions can be viewed as a critical event in the abstraction of the 'social' within the city; but how was this 'social body' defined and managed *in practice* by institutions? And what did it feel like to be a body amongst other bodies within this new social world?

This chapter explores the early histories of 'museum bodies' in two contrasting exhibition sites in London, both established in the middle of the eighteenth century: the British Museum founded in 1753 and the Royal Academy of Arts founded in 1769. My focus is on the period leading up to the 1820s (broadly coinciding with the reign of George III from 1760 to 1820) when, prior to the creation of the National Gallery, the British Museum was the only state-funded museum in Britain, whilst the Royal Academy was alone

amongst artists' associations and exhibition societies in enjoying the patronage of the monarch. Signifying its official status within the emerging cultural state, from 1780 the Royal Academy, together with a number of learned societies and government offices, was housed in a suite of rooms in the major public building of George III's reign, Somerset House. Unlike contemporary galleries such as John Boydell's Shakespeare Gallery (1789–1805), Robert Bowyer's Historic Gallery (1792–1807) and even the British Institution (1805–67), the Royal Academy's longevity, prominence and cultural ambition enables the comparison with the British Museum; although the Academy was located within an increasingly dense network of art galleries in late eighteenth-century London,[12] this was where habits of exhibition visiting became most visible, where ways of looking were continuously rehearsed and debated, and where museum bodies were produced over a sustained period of time

The question of who should (and should not) be admitted to the British Museum and Royal Academy respectively was a matter of intense argument throughout the long reign of George III: that is, during the decades when the bodies of their visitors were first assembled, mobilised and scrutinised as exhibition spectators. Throughout these years, the two institutions' contrasting practices of delimiting and managing their potential and actual publics were vigorously contested and defended, both internally and externally, amongst critics, politicians and visitors themselves. In turn, debates about the regulation of access to both the British Museum and the Royal Academy were symptomatic of, and constitutive of, the instability of each institution during the second half of the eighteenth century as each negotiated its position within the expanding 'exhibitionary complex'. Questions of what it meant for each organisation to be a 'public body', funded respectively by the state and (at least partly) by the monarch, were both immediate and practical. Was it necessary for a national institution to be accessible to the entire population, and if so, what would such equality of admission entail? Closely related to this was the question as to what a 'social body' might look, sound and smell like in terms of the actual bodies of diverse visitors. For both the British Museum and the Royal Academy, the process of becoming a 'social body' was therefore figuratively and materially enacted via mechanisms of access and exclusion, as well as via the congregation and conduct of those who had both the desire and the means to cross their thresholds.

Although the early histories of these two institutions are well known, most accounts are primarily concerned with their organisational formation.[13] With notable exceptions, including the work of Anne Goldgar, David Solkin and Peter de Bolla, less attention has been paid to the experiences and responses of the people who visited them.[14] Nor have they have been discussed in relation to each other, yet their respective premises were never more than a mile apart across Georgian London.[15] Whilst many more people visited the annual exhibitions at the Royal Academy during the short duration of the

summer season than visited the British Museum from one end of the year to the next,[16] both were at the centre of arguments about access to culture and the development of visiting practices amongst an increasingly heterogeneous audience comprising men and women of different classes.

Both played a strategic and influential role in the production of an expanding art public, through contrasting practices of visiting and spectatorship. In response, each elicited a stream of commentary and debate on the efficacy and meaning of the diverse social, cultural and pedagogic encounters that they provided. At times and for different reasons, both were accused of what Rosie Dias calls 'institutional tyranny':[17] the Royal Academy for its perceived artistic favouritism, bias towards portraiture, and concomitant disregard for the interests of its students and visitors; and the British Museum for the trustees' resistance to broadening public access and for their strict orchestration of the museum visit. Accusations of cultural elitism were directed at both: in light of its royal patronage, the Royal Academy was criticised for charging an admission fee of one shilling; whilst the cumbersome process of applying for a (free) ticket in advance of admission to the British Museum produced a steady stream of frustration and complaint.[18]

Once inside, there was a marked difference in visiting practices at each institution. The complicated procedure for gaining access to the early British Museum meant that a visit had to be carefully planned, as it was scheduled for a specific day and at a fixed time. There was no licence to wander freely through the rooms or to linger over objects of particular interest. Small groups of visitors were conducted through the museum by a member of staff on whom they had to rely for information about the (mostly unlabelled) exhibits. By contrast, the Royal Academy exhibition was open to all with a shilling to spare and a visitor could spend all day there, if they wished. Both eyes and bodies roamed freely around the Great Room which formed the centrepiece of the exhibition and where a dense mosaic of pictures covered the walls from floor to ceiling (Figure 2). Each institution attracted both praise and censure for their accessibility (or lack of it), the diversity (or not) of the public that they attracted, and for the modes of viewing that they staged. In terms of the 'museum bodies' that each site produced, there was a striking contrast between, on the one hand, a highly regulated, linear and didactic experience with, on the other hand, a free-ranging, kaleidoscopic encounter between people, and between people and pictures.

In 1810, the strict process of obtaining admission to the British Museum, which had deliberately limited the number of visitors and closely regulated their experience inside the museum, was finally relaxed. It had taken nearly 60 years since the museum's creation for the trustees fully to acknowledge the implications of the British Museum Act 1753, which had stipulated that the museum collection was to be 'preserved and maintained, not only for the Inspection and Entertainment of the Learned and the Curious, but for

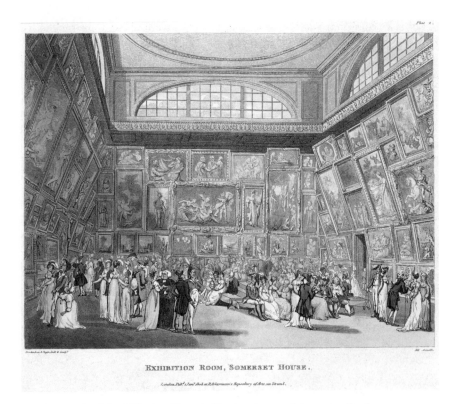

EXHIBITION ROOM, SOMERSET HOUSE.

London, Pub.ᵈ 1 Jan.ᵗ 1808 at Ackermann's Repository of Arts, 101 Strand.

2 John Hill after Thomas Rowlandson and Augustus Pugin,
Exhibition Room, Somerset House, from The Microcosm of London, 1808.
Private Collection. The Bridgeman Art Library.

the General Use and Benefit of the Publick'. Instead of embracing both the
'Publick' *and* the 'Learned and Curious' as having equal right of access to the
museum's resources, from the outset the trustees focused on how the interests
of scholars could be safeguarded from potential depredations to the collections
arising from the unlimited admission of everyone else. In the six years between
foundation of the British Museum in 1753 and its public opening in 1759, the
trustees were preoccupied with the question of how best to provide for, but
also to control, the 'General Use and Benefit' of the collections. At one of their
first meetings, held on 14 January 1754, the trustees established a committee to
frame the rules for visiting and inspecting the museum.[19] The following year,
the committee produced a draft memorandum recommending the following
restrictions for admission to the library collections (pending the opening of
the rest of the collections when they had been prepared for display):

> In Order to prevent as much as possible persons of mean and low Degree and
> Rude or ill Behaviour from Intruding on such who were designed to have free

Access to the Repository for the sake of Learning or Curiosity tending to the Advancement and Improvement of Natural Philosophy and other Branches of Speculative knowledge And in Order to render the said Repository of such Use to the Publick as by the Act for that purpose was meant and Intended That no person or persons whatsoever be admitted to Inspect or View the Collections but by a proper Authority from the Trustees.[20]

The tone and intent of future policy had been set. In May 1757, the trustees approved 'The Statutes and Rules to be Observed in the Management and Use of the British Museum, by Order of the Trustees'. Opening hours were set for weekdays from 9 a.m. to 3 p.m. between September and April, and from 9 a.m. to 3 p.m. on Tuesday to Thursday and from 4 p.m. to 8 p.m. on Monday and Friday between May and August. To gain general admission to the museum, a person had to apply for a ticket, giving their name, 'condition' and place of residence, as well as the time and date when they wanted to visit (Figure 3). Ticket applications had to be made in person, thereby necessitating two visits to the museum: first to apply for the ticket, and then for the visit itself. Only 10 tickets (visitors were divided into two groups of five) were released for each of the guided tours starting in the mornings at 9 a.m., 10 a.m., 11 a.m. and 12 noon, and in the afternoons at 4 p.m. and 5 p.m. If a tour was fully booked, it was possible to apply for a different slot, and people could apply (and visit) as many times as they liked.

3 Admission ticket to the British Museum. Issued to Mr Banks for 'a Sight of the British Museum', 1777. © The Trustees of the British Museum.

In theory, each tour of the museum lasted three hours, although in practice, visitors reported being hurried through more quickly. They were conducted throughout the duration of the tour by a guide who was, in principle, responsible both for the elucidation and the protection of the collections. An hour was spent in each department (Printed Books, Manuscripts and Natural History), irrespective of the interests or preferences of the particular group. Entrance to the museum was free, and servants and officers were prohibited from accepting gratuities or any other payments. As far as scholars who wished to use the Reading Room were concerned, admission for study required the permission of the trustees, and lasted for six months before it had to be renewed.[21]

However, the trustees were themselves divided on the question of access between, on one side, anxiety for the safety of the collections and the needs of bona fide scholars, and, on the other side, acknowledgement of the legitimate public interest in the museum. Eventually the prevailing view held that admission of 'persons of mean and low Degree and Rude or ill Behaviour' would necessarily diminish the enjoyment of those who were better equipped, and thus more entitled, to appreciate its resources. It was this argument that served as justification for the limited opening hours, the onerous system of applying for tickets and the tightly controlled design of the museum visit. As Goldgar observes, the trustees had concluded that: 'The Museum must be open to the public; but the public was not everyone.'[22] In practice, the time-consuming procedure for obtaining a ticket, combined with the limited number of tickets available for any slot, and the freedom to spend three hours in the museum in the middle of a working day, must have acted as an effective deterrent to many. As we shall see, even for those who were determined to make the effort, the experience was often bewildering, frustrating and, ultimately, disappointing.

According to Matthew Maty, Principal Librarian at the British Museum from 1772 to 1776, the system of conducting visitors through the museum in small groups had the unintended effect of bringing diverse strangers together in close proximity and that this 'joining of Companies is often disagreeable, from Persons of different Ranks and Inclinations being admitted at the same Time, and obstructing one another'.[23] This, he felt, constituted an argument for the introduction of an admission fee on the basis that charging would provide a more effective social filter, thereby ameliorating the awkwardness (or worse) of having to spend three hours with people whom one did not know and whose company was distasteful. Maty was an exclusionist who sought to restrict admission to the museum to the working classes, and would find any pretext for doing so. He also represented a minority view: despite his influence and support, a proposal to introduce charging was defeated in the House of Commons in 1774. The idea was again considered and rejected by the trustees in 1800, primarily on the grounds that the museum would lose

something of its cultural authority and national distinctiveness if it appeared to commercialise its operations.

The British Museum was denied the possibility of charging because it had to be seen to belong to everyone, even though, in practice, not everyone was equally welcome to visit it. Goldgar deploys the concept of the 'virtual representation of culture' to explain the eighteenth-century argument which maintained that the national interest was served by investment in cultural resources, even when their consumption was restricted to a social or educational elite. In other words, the very existence of the British Museum was a public good, because the increased erudition of those granted access to its collections would benefit the entire population through an assertion of national prestige and the diffusion of knowledge. Accordingly, restrictions on the right of admission could be justified on the basis of educational, but not financial, entitlement. Holger Hoock suggests that the Royal Academy operated on a similar model of cultural transmission: that is to say, it also claimed to exist in the national interest, even if its actual constituency was demarcated by geography, inclination and access to a spare shilling for the entry ticket.[24]

In contrast to the British Museum, from the outset the Royal Academy charged for admission. No doubt this was an important source of income that helped to secure its survival and its autonomy, as well as to exclude those with neither the money nor the motivation to pay for a ticket. However, given the Academy's claim to cultural authority, as well as the financial support that it received from the king, it was a policy that required careful justification. Accordingly, an advertisement in the catalogue of the first exhibition in 1769 explained the decision to charge as a means of excluding unwelcome bodies:

> As the present Exhibition is Part of the Institution of an Academy supported by Royal Munificence, the Public may naturally expect the Liberty of being admitted without any Expence [sic]. The Academicians therefore think it necessary to declare that this was very much their desire, but they have not been able to suggest any other Means, than that of receiving Money for Admittance, to prevent the Room from being filled by improper Persons, to the entire Exclusion of those for whom the Exhibition is apparently intended.[25]

John Brewer describes this apologia as disingenuous: in fact, the Academicians were happy to retain the receipts from admission and energetically resisted a suggestion that they should disburse their profits to charity.[26] Even so, the need to generate income and the desire to discriminate between more or less welcome applicants to the Academy's public were not incompatible. The question was, what kind of social filter did the charge of a shilling represent? Hoock describes the price as 'inconsequential': as the equivalent cost of entry to Vauxhall Gardens and most theatres, it would not have seemed exceptionable to many.[27] In practice then, the Academy oscillated between its pretensions to

the promotion of aesthetic theory and both moral and cultural improvement, and its need for both publicity and patronage. As Brewer puts it, 'the stentorian message of edification' that emanated from Somerset House was needed 'to drown out the babble of commerce'.[28] Income from admissions enabled the Academy to offset it dependence on royal subsidy, whilst simultaneously relying on its connections with the monarch to maintain its official status. Similarly, it needed to distance itself from the taint of the dealer's shop, whilst also operating as market for luxury goods.

'Come Along': Hurrying through the British Museum

The distinction between scholars and the 'Publick' in the conceptualisation of the British Museum's potential audience was central to the formulation of its admission policy in the eighteenth century. Added to this was considerable concern about the possible bad behaviour of, and damage caused by, visitors who were unaccustomed to the regulatory regime that the trustees would need to enforce. Bennett argues that alarm for the protection of the museum during the Gordon Riots of 1780 had raised the trustees' fear of an uncontrolled mob and haunted their attitude to the public thereafter.[29] Even before these frightening events, one trustee, Dr John Ward, an antiquarian and professor of rhetoric at Gresham College, was worried that if what he termed 'general liberty' was extended to the entire population, then:

> many irregularities will be committed that cannot be prevented by a few Librarians, who will soon be insulted by such people, if they offer to controul or contradict them, & any rules or directions given to the Librarians, to keep such Visitors in order, will by them be treated only with contempt & set at nought.[30]

Ward predicted that 'exerting what they will call their liberty' visitors would steal the exhibits, so that 'every public day may be attended with some diminution of the collection' and would additionally make 'the apartment as dirty as the Street'. The difficulty that he foresaw was that, having permitted the 'common people' to enter the museum, it would be impossible subsequently to withdraw access on account of their lack of discipline. In these circumstances, the museum would need to secure the presence of two magistrates and the local constabulary in order to protect the building and its contents, and 'even after all this many Accidents must and will Happen'.[31] In the event, Ward's pessimistic projections were not realised. According to Derek Cash, the only recorded incident of serious unruliness occurred in 1764 when 'several persons' forced their way into the museum, despite attempts to block their entrance.[32]

As a result of these restrictive measures, during its early years, the British Museum admitted fewer than 60 visitors a day.[33] What did it feel like to be

amongst them? A number of vivid accounts survive of being taken around the museum on a conducted tour prior to 1810 and amongst these, admittedly self-selecting, writers there are recurring themes: first, the difficulty of obtaining tickets and the burdensome process of admission; then, frustration at the speed of the tour and the lack of time and information provided; and overall, a sense of constraint and disappointment brought about by the awkwardness of the occasion and particularly by the manner of the museum staff.

Let us start with the account of Karl Philipp Moritz, a young Prussian clergyman who made a tour of London and parts of England in 1782. An acquaintance with a member of staff of the British Museum enabled him to procure an admission ticket, which he implies might otherwise have been difficult to obtain, no doubt due to having a limited amount of time in the city before the museum closed for the summer:

> I have had the happiness to become acquainted with the Rev. Mr. Woide ... He holds a respectable office in the museum, and was obliging enough to procure me permission to see it, luckily the day before it was shut up. In general you must give in your name a fortnight before you can be admitted.[34]

In fact, people sometimes had to wait months for their ticket applications to be processed: according to Altick, people who had applied in April 1776 were still waiting for their tickets in August.[35] Having obtained his ticket, Moritz anticipated the visit with some pleasure, only to be greatly disappointed. He and his tour party were rushed around the entire building 'in a space of time little, if at all, exceeding an hour' and, as a result, poor Moritz found that he had:

> leisure just to cast one poor longing look of astonishment on all these stupendous treasures of natural curiosities, antiquities, and literature, in the contemplation of which you could with pleasure spend years, and a whole life might be employed in the study of them.

The effect, he noted, 'confuses, stuns, and overpowers one'.[36] As a result, he concluded, 'I am sorry to say, it was the rooms, the glass cases, the shelves, or the repository for the books in the British Museum which I saw, and not the museum itself, we were hurried on so rapidly through the apartments'.[37] He did, however, observe that his companions on this whistle-stop tour were 'various, and some of all sorts; some, I believe, of the very lowest classes of the people, of both sexes; for, as it is the property of the nation, every one has the same right (I use the term of the country) to see it that another has'.[38] As we have seen, this 'right' only existed in practice for those with sufficient time and motivation to organise a visit in the face of bureaucratic obstacles erected by the museum; it is also possible that the extreme haste of his tour was exacerbated by the guide's desire to ensure that those members of the

company from 'the very lowest classes of the people' left the museum as quickly as possible.

Five years earlier, the French writer and local historian of his native city of Troyes, Jean-Pierre Grosley, was even more forthright in identifying what he perceived to be a neglect of men of learning, such as himself, which he attributed to the aristocratic attitude of the board of trustees. He felt that the British Museum could and should do more to make 'foreigner of distinction' welcome, and suggested that a 'principal or chief trustee' should lodge in (or close by) the museum so as to 'keep open house ... and do the honours of the Museum'.[39] Although as a scholar, he clearly distinguished himself from the museum's 'Publick' at large, Grosley also recognised that the complicated ticketing system and the prescribed 'cursory' tours were impractical and off-putting for many people: 'it were to be wished that the public could enjoy the Museum more and at its ease'.[40] Instead of the current arrangements, he proposed that visitors should be able to organise their time in the museum according to their own interests and that they should have access to 'a keeper in each apartment, who should not stir from thence during the hours in which the Museum is open' and whose primary function would be to respond to visitors' queries.[41] At present, visitors were, he said, reluctant to ask questions of their tour guides 'through fear of encroaching upon their compliance' and as a result, they 'overlook a number of objects which deserve to be attentively considered'.[42] Grosley's perception that museum employees rebuffed questions from the public and were scornful of innocent (and perhaps ignorant) enquiries, was echoed by an English visitor, William Hutton.

A dissenting bookseller, writer and founder of the first circulating library in Birmingham, Hutton was 60 years old when he visited the British Museum for the first (and only) time.[43] Like others, his first difficulty was how to obtain a ticket, as his time in London was limited and he had not applied in advance:

> I was unwilling to quit London, without seeing what I had many years wished to see, but how to accomplish it was the question; I had not one relation in that vast metropolis to direct me, and only one acquaintance; but assistance was not with him. I was given to understand, that the door, contrary to other doors, would not open with a silver key; that interest must be made some time before, and admission granted by a ticket, on a future day. This mode seemed totally to exclude me. As I did not know a right way, I was determined to pursue a wrong, which probably might lead me into a right.[44]

Then, by a stroke of 'good fortune', Hutton happened to meet 'a person possessed of a ticket for the next day, which he valued less than two shillings'. A bargain was quickly struck, to the satisfaction of both parties, and Hutton now 'feasted upon ... [his] future felicity'. The following day, Hutton arrived at the museum at the appointed hour: 'Tuesday at 11, December 7, 1784. We assembled on the spot, about 10 [five more than the regulations allowed at the

time] in number, all strangers to me, perhaps to each other.'[45] The tour began, but Hutton's anticipation and curiosity were soon dashed by the haughty attitude of their guide:

> We began to move pretty fast, when I asked with some surprise, whether there were none to inform us what the curiosities were as we went on? A tall genteel young man in person, who seemed to be our conductor, replied with some warmth, 'What? Would you have me tell you very thing in the Museum? How is it possible? Besides, are not the names written upon many of them?' I was too much humbled by this reply to utter another word. The company seemed influenced; they made haste and were silent. No voice was heard but in whispers.[46]

Hutton was not a man to be easily overawed: his sense of being 'humbled' is telling, and his account of the contagious effect of his embarrassment on his companions is entirely plausible. The prospect of either learning or sociability was forestalled as the group signalled their acquiescence by quickening their pace and lowering their voices. No one had a chance to see anything properly before they were ushered into the next room. Hutton observed that: 'If a man spends two minutes in a room, in which are a thousand things to demand his attention, he cannot find time to bestow on them a glance a piece. When our leader opens the door of another apartment, the silent language of that action is, *come along.*'[47]

At the end of this route march, he claimed that at the end of just '30 minutes we finished our silent journey through this princely mansion, which would well have taken 30 days'. And as a result:

> I went out much about as wise as I went in, but with this severe reflection, that for fear of losing my chance, I had that morning abruptly torn myself from three gentlemen, with whom I was engaged in an interesting conversation, had lost my breakfast, got wet to the skin, spent half a crown in coach-hire, paid two shillings for a ticket, been hackneyed through the rooms with violence, had lost the little share of good humour I brought in, and came away completely disappointed.[48]

Complaints about the system of guided tours persisted until it was finally abandoned in 1810, by which time, says Altick, the museum was 'in a practically comatose condition so far as the public was concerned'.[49] In 1805, just 2,500 people (mainly foreigners) had succeeded in visiting.[50] The following year, Benjamin Silliman, Professor of Chemistry and Natural History at Yale College, wrote in his journal that the system was, perhaps, acceptable for casual sightseers, but like Grosley, he found it entirely inappropriate for anyone with a serious interest in the collections.[51] Silliman had visited the British Museum before, but had been so 'dissatisfied with the hurried manner' with which he had been conducted through the galleries on that occasion that he wanted 'to see it again under circumstances more favourable'. Like Moritz

and Hutton, he too seems to have had difficulty in obtaining a ticket, only to be similarly frustrated by both the conduct and pace of the tour:

> Mr Peck of Harvard University and myself had been repeatedly disappointed in our attempts to see the museum, but this morning we succeeded in gaining admission, and were conducted, with some degree of deliberation, through its various departments. But, it is much to be regretted, that more distinction cannot be made between those who go merely-to be amused, and those who seek instruction also; for it is really distressing to be surrounded by a host of things which are full of information, and then to be hurried away from them just as one is beginning to single out particular objects.[52]

He ends on a note of resignation: 'It is however useless to complain of that which we cannot alter.'[53]

Despite Silliman's pessimism, the system did slowly change in response to the growing public interest in the museum, and also, perhaps, to the developing confidence of the trustees in the good behaviour of its visitors. By the early 1800s, the strict system of conducted tours was becoming unsustainable, not least due to the pressures of increased public interest. In 1810, the trustees revised the procedure for admission so that 'all Persons, of decent appearance, without limitation of numbers' could be admitted on 'Mondays, Wednesdays and Fridays from 10 to two' except during the summer and other public holidays when it was closed.[54] Tours continued to be available on Tuesdays and Thursdays.

'Tom and Bob in Search of the Antique'

A slightly later account suggests that, with the lessening of restrictions on admissions, a visit to the British Museum could be a more relaxed and sociable experience, where people were able to linger and talk without being hurried along by an impatient guide. Instead of having to book in advance, visitors could now join the next available tour after they arrived. The prospect of a relatively spontaneous visit realigned the museum within the geography of public spectacles and entertainments that were available to casual cultural consumers in early nineteenth-century London. If you had a morning to spare, an unplanned visit was now possible.

In contrast to the proliferation of prints depicting visitors at the early Royal Academy exhibitions, few images were made of these early tours of the British Museum. A rare example is a bookplate by Henry Thomas Alken for the illustrated novel *Real Life In London. Or, The Rambles And Adventures Of Bob Tallyho, Esq., And His Cousin, The Hon. Tom Dashall, Through The Metropolis* (Figure 4).[55] This anonymous work, published in 1821, recounts the urban adventures of two fashionable young men (the eponymous Bob and Tom) and

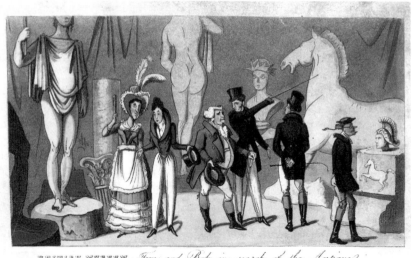

4 Henry Thomas Alken, *British Museum. Tom and Bob in search of
the Antique,* 1821. © The Trustees of the British Museum.

was one of a number of pirate versions of the enormously popular monthly
journal written by Pierce Egan called *Life in London or, the Day and Night Scenes
of Jerry Hawthorn, esq., and his elegant friend, Corinthian Tom, accompanied by Bob
Logic, the Oxonian, in their rambles,* also published in 1821. The 'Tom and Jerry'
craze stimulated by Egan's novel was imitated in the comparable pursuits
of Bob and Tom as the pair romped their way through the gaming houses,
theatres, gardens and boxing rings of late Georgian London. And, as we shall
see, both pairs of friends visited the Royal Academy. In effect, these illustrated
novels provided a guide to the range of fashionable pursuits available to
young men with money in their pockets in an avid pursuit of both high and
low culture.

 However, only Bob and Tom visited the British Museum and the coloured
plate entitled *British Museum. Tom and Bob in search of the Antique* indicates the
satirical tone of their adventures and shows the duo amid an incongruous
gathering of living and sculptural bodies in a gallery of classical antiquities.
The motivation for their visit was, predictably, less high-minded than that
of, say, William Hutton; rather, Tom and Bob are evidence that, as Benjamin
Silliman observed, some people did go to the museum 'merely-to be amused'.
Their presence in the museum also signified the expansion and diversification
of its audience after 1810: their 'rambles' are not planned far in advance and
would hardly be compatible with the bureaucratic process of advanced ticket
application that previously existed.

The atmosphere of their tour is certainly less oppressive than that experienced by Hutton and his companions: there is a good deal of chatter amongst the group and their conductor was so obliging that, at the end of the visit, Bob tried to give him a tip 'in return for his politeness'. However, this 'pecuniary compliment … was refused; the regulations of the institution strictly prohibiting the acceptance by any of its servants of fee or reward from a visitor, under the penalty of dismissal'.[56] The rule against gratuities was another way in which the British Museum asserted its separation from the sphere of commercialised spectacles where admission charges and tips would have been the norm: Bob fails to make this distinction, and the author takes the opportunity to inform the future visitor of the regulation.

In keeping with the comic tone of *Real Life in London*, the focus quickly alights on the young men's companions and the satirical opportunities that they afforded:

> Entering the spacious court, our two friends found a party in waiting for the Conductor. Of the individuals composing this party, the reconnoitering eye of Dashall observed a trio, from whence he anticipated considerable amusement. It was a family triumvirate, formed of an old Bachelor, whose cent per cent ideas predominated over every other, wheresoever situated or howsoever employed; his maiden Sister, prim, starch and antiquated; and their hopeful Nephew, a complete coxcomb, that is, in full possession of the requisite concomitants— ignorance and impudence, and arrayed in the first style of the most exquisite dandyism.[57]

According to the chronicler of Tom and Bob, this 'delectable triumviri' each had their own reasons for visiting the museum. The money-loving Mr Timothy Surety was primarily concerned to ascertain if the public investment in the museum was money well spent: that is, 'whether, independent of outlandish baubles, gimcracks and gewgaws, there was any thing of substantiality with which to enhance the per contra side in the Account Current between the British Museum and the Public!'. His sister, Tabitha, was curious to see the Egyptian collections and their hieroglyphics – or as she put it: '"He-gipsyian munhuments, kivered with kerry-glee-fix …".' Meanwhile, their dandyish nephew was primarily interested in the opportunity to display his own 'sweet person along with the other curiosities of the Museum'.[58]

Initially, Tom and Bob are attracted this trio for the amusement that they might afford during their tour together. But eventually their entertainment value begins to wane, and the young men extract themselves from the group and link up with another party for the remainder of their visit; another sign of the comparative informality of the visit in the 1820s. However, before Tom and Bob leave Mr Surety and his family, they find themselves together in the gallery of 'Etruscan antiquities' where, according to Alken's print, they encounter a miscellany of broken and somewhat alarming sculptures,

including a fragment of the Parthenon frieze. Alken locates the motley group of visitors amid an equally disparate collection of objects, and the close proximity of a number of nude statues gave rise to some odd and embarrassing adjacencies: 'Of the company present, there stood on the left a diminutive elderly gentleman in the act of contemplating the fragment of a statue in a posterior position, and which certainly exhibited somewhat of a ludicrous appearance'. Meanwhile:

> the exquisite Jasper pointed out, with the self-sufficiency of an amateur, the masculine symmetry of a Colossian statue to his Aunt of antiquated virginity, whose maiden purity recoiling from the view of nudation, seemed to say, "Jaz, wrap an apron round him!"

In the centre of the print, Tom and Bob are standing next to the 'rotunditive form of Timothy Surety' who took 'a cursory and contemptuous glance at the venerable representatives of mythology' and then declared that:

> there was not in the room an object worth looking at; and as for them there ancient statutes [...] I would not give twopence for the whole of this here collection, if it was never for nothing else than to set them up as scare-crows in the garden of my country house at Edmonton!

Such vulgar remarks may have offended the sensibilities of its curators, but the presence of both the young men about town and the Surety family were an important part of the process of the British Museum becoming an inclusive social body. In contrast to the constraint experienced by eighteenth-century visitors as they were hurried through the galleries in awed silence, everyone in Alken's print feels free to express themselves, both verbally and physically, through gesture as well as conversation. Of course, both the print and its accompanying text are caricatures, but they pinpoint an important shift in the social and corporeal relations accommodated within the museum, from the highly regulated management of movement and comment to a space in which new freedoms of movement and discussion were licensed – and enjoyed.

'Tom and Bob Amongst the Connoisseurs'

The metropolitan 'rambles' of Tom and Bob now take us across London to the Royal Academy exhibition at Somerset House. By the time they arrive at the exhibition, 'it was near three o'clock, and the Rooms exhibited a brilliant crowd of rank and fashion, which considerably enhanced the value of its other decorations'.[59] Tom knowledgeably observes that 'between the hours of two and five o'clock in the day' is the most popular time for seeing (and being seen within) the exhibition: this is when it is frequented by 'all the gaiety

and fashion of the Metropolis'.[60] Even allowing for the relatively relaxed sociability of their tour through the British Museum, the mobile, talkative crowd that filled the Great Room in Somerset House formed a striking contrast to the scholarly ambience of the museum. Here there was little constraint or regulation, and was instead a hectic atmosphere of chatter, flirtation and self-display. In the days when visitors to the British Museum were 'hackneyed' through its galleries by taciturn guides, visitors to Somerset House were free to stroll, sit and converse inside the exhibition as they wished. Inevitably, this degree of social license attracted both crowds and censure: typically, a comment from 1806 criticises male viewers for being more interested in the display of female beauty in the room than on the wall:

> The Exhibition Rooms were crowded during the whole of yesterday. About three o'clock the blaze of beauty was at its meridian, and admirable as are the exertions of our most esteemed Artists, the promenading groupes [sic] of Fair Originals seemed to afford certain Connoisseurs more pleasure in the examination, than all of the glowing effects of the pencil.[61]

Inevitably, the crush of people in the exhibition could be physically overwhelming. Another of our visitors to the British Museum, Frederick Wendeborn, recorded that the Great Room was:

> often so crowded with gentlemen and ladies, with pretended connoisseurs and supercilious critics, who all come to stare at the pictures that, in the middle of the day some ladies are ready to faint, on account of the heat in the rooms, and the powerful perfumes of the odiferous company with which they are filled.[62]

Bob Tallyho's first impression of the exhibition is predictably both confusing and captivating: like others, he finds the dense crowd of paintings and people equally diverting:

> the elegance of the company, the number and excellence of the paintings, were attractions so numerous and splendid, as to leave him no opportunity of decidedly fixing his attention. He was surrounded by all that could enchant the eye and enrapture the imagination.[63]

By contrast, his cousin Tom is both more worldly and cultured. He is full of admiration for the paintings on display, but even so, is not immune to the attractions of his fellow visitors and occasionally turns 'to the inspection of a set of well-formed features, or a delicately turned ancle [sic]'.[64] Meanwhile, Bob is captivated by the number of attractive women in the crowd and by their self-conscious performance of erudition: 'Moving groups of interesting females were parading the rooms with dashing partners at their elbows, pointing out the most beautiful paintings from the catalogues, giving the names of the artists, or describing the subjects.'[65]

This is the context in which Solkin argues that viewing practices in Somerset House should 'be understood as a social experience, mediated by one's place within a "company or party", as well as by individual subjectivities which have in turn been socially produced'.[66] Then, as now, there were many reasons for going to an exhibition: as well as looking at the pictures, to meet one's friends, and to see and be seen within the diverting, chattering crowd. The early Royal Academy was thus a critical venue for the development of exhibition going as a social, as much as an aesthetic, experience. Conversation was crucial to both to the conviviality of the occasion and also to show off one's art appreciation; the range of viewing positions produced by the dense picture display in the Great Room was calculated to stimulate equally diverse opinions regarding the respective merits of the artworks on display. According to Solkin the idea was that 'conversations in front of paintings should range freely over a spectrum of issues, exploiting the latitude that was implicit in the very nature of the hang'.[67]

Bob and Tom's visit to the Royal Academy was illustrated by Alken in a plate entitled *Exhibition Room, Somerset House. Tom and Bob Amongst the Connoisseurs* (Figure 5). Whereas Alken depicted Tom and Bob in the British Museum amid an ill-assorted group of spectators and amongst an equally inchoate display of objects, here they are shown within a tightly packed crowd that, in turn, mirrors the mosaic-like display of pictures covering the walls. Both

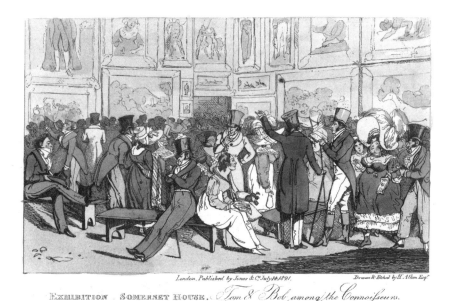

5 Henry Thomas Alken, *Exhibition Room, Somerset House.*
Tom and Bob Amongst the Connoisseurs, 1821. Peter Jackson Collection.

visitors and artworks are cut off at the margins of the plate: there is not just enough space to squeeze everyone and everything in. The plate's satirical title pokes fun at the aesthetic pretensions of the exhibition's participants, whilst simultaneously directing the reader's attention to the process of becoming part of an art public, rather than on the content and merits of the exhibition per se. In the accompanying text, the artworks similarly recede into the background, whilst the different types that constitute the social body of the exhibition are deftly caricatured. Both text and image delineate the diversity of art consumers at the exhibition: each becomes instantly recognisable in Alken's depiction of embodied viewing, distinguished by their gender, posture and dress. Thus, in the centre of the plate stands: 'The lounging Blood, who had left his horses at the door, was bustling amongst the company with his quizzing-glass in his hand, determined, if possible, to have a peep at every female he met, caring as much for the Exhibition itself, as the generality of the visitors cared for him.'[68]

Evidently, both men and women were prone to self-advertisement and also to fatigue. Sitting on the bench in the foreground of the plate we see (and hear):

> the tired Dandy, whose principal inducement to be present at this display of the Arts, was to exhibit his own pretty person, and attract a little of the public gaze by his preposterous habiliments and unmeaning countenance; to fasten upon the first person who came within the sound of his scarcely articulate voice with observing, "It is d——d hot, 'pon honour—can't stand it—very fatiguing—I wonder so many persons are let in at once—there's no such thing as seeing, I declare, where there is such a crowd: I must come again, that's the end of it."

Sitting next to him, but looking in the opposite direction, 'was the full-dressed Elegante, with her bonnet in one hand, and her catalogue in the other, apparently intent upon examining the pictures before her, whilst, in fact, her grand aim was to discover whether she herself was observed'.[69] Apparently oblivious to each other, the Elegante remains preoccupied with the impression that she is making on the crowd, whereas the Dandy appears to have relinquished the effort, and is now only concerned with his hot and uncomfortable body.

To the left of the plate, the brown-coated 'Connoisseur' is making a spectacle of viewing the pictures, demonstrating his skill in looking by 'placing his eye occasionally close to the paintings, or removing to short distances, right and left, to catch them in the most judicious lights, and making remarks on his catalogue with a pencil'.[70] Connoisseurship had developed during the eighteenth century as an embodied and performative practice, characterised by the close and pedantic scrutiny of the artwork, often with the aid of an eye-glass.[71] This Connoisseur is just as keen to display his superior technique of viewing, by adjusting his position to achieve a better 'point of sight' and by taking notes of his observations.

Entering from the right, a fat woman in an oversized bonnet and accompanied by a young man (who appears to have outgrown his trousers), is immediately recognisable as:

> Mrs. Roundabout, from Leadenhall, who had brought her son Dicky to see the show, as she called it, declared it was the "most finest sight" she ever seed, lifting up her hand and eyes at the same time as Dicky read over the list, and charmed her by reciting the various scraps of poetry inserted in the catalogue to elucidate the subjects.[72]

Notwithstanding her lack of fashion and sophistication, Mrs Roundabout does not strike a particularly incongruous figure in the Great Room: like others, she has come to enjoy herself for the price of the one shilling entrance charge, and she seems to be doing so rather more successfully than either the tired Dandy or the self-conscious Elegante. No doubt she would have concurred with Tom's conclusion that: 'The rooms are elegant and spacious; and I consider it at all times a place where a shilling may be well spent, and an hour or two well enjoyed.'[73]

This remark echoes a comment made by one of the prototypes of Tom Dashall in Pierce Egan's original novel, *Life in London*. In the Egan's tale, two cousins, Corinthian Tom and Jerry Hawthorn, provided the models for Tom Dashall and Bob Tallyho in the later pirate version. When Corinthian Tom announces to their friend Bob Logic that he and Jerry are planning a 'lounge' at Somerset House, it is Bob who makes a play on words by saying that the exhibition was always 'a *bob* well laid out'.[74] Accordingly, the print by George and Robert Cruikshank that accompanies this scene in Egan's work was entitled *A Shilling Well Laid Out. Tom and Jerry at the Exhibition of Pictures at the Royal Academy* (Figure 6). As in the Alken print of the exhibition, the emphasis is on those who have disposed of their shilling, rather than on the display of pictures that they have come to see.[75] There is no elevated perspective of the densely covered walls of Great Room: instead, once again, we meet the jostling, talkative, posing, flirting exhibition crowd at eye level.

At first, the naïve Jerry is taken in by the outspoken judgments of his fellow visitors, and says to Tom:

> It appears to me that we are surrounded by a host of critics; as I have heard no other remarks, but "What a shocking daub! – a most miserable likeness indeed! – it as coarse as sign-painting," accompanied by grimaces and shrugs of the shoulders; - contrasted with "The execution is fine! – full of character! It is positively life itself!"[76]

Tom puts him straight by saying that these are not critics, but rather 'flippant *soi-disant* judges'.[77] However, this stern view of his fellow visitors is quickly dispelled when he and Jerry are joined by the 'Misses Trifle' who enchant them both with 'their trite and elegant remarks on the paintings and various

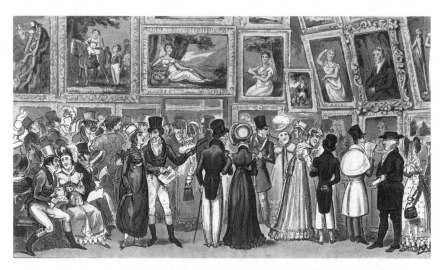

6 Robert and George Cruikshank, *A Shilling Well Laid Out. Tom and Jerry at the Exhibition of Pictures at the Royal Academy*, from *Life in London* by Pierce Egan, 1821. The Stapleton Collection. The Bridgeman Art Library.

characters they accidentally mixed with in their walk through the Exhibition'.[78] Cruikshank draws each young man arm in arm with an elegant Miss Trifle, amid the chattering throng whose diversity and affectations appear to be mirrored in the portraits hanging 'on the line'. On returning home, the pair declared themselves, '... more than usually pleased with their morning's excursion.'[79]

Looking and Reading

One of the frustrations of the eighteenth-century tour through the British Museum was the visitor's reliance on a (more or less helpful) guide for information about the exhibits. Not only were many of the objects unlabelled, there was no printed guide or catalogue available to enlighten the interested visitor, particularly on a question likely to be of limited interest to the rest of the party. Both Karl Philipp Moritz and Frederick Wendeborn lamented the absence of a catalogue that would provide information without, as the latter put it, 'giving unnecessary trouble to the gentlemen who attend the company'.[80] What he envisages is a hand-held guide that could direct visitors' eyes and bodies in a productive and personalised combination of reading and looking.

By contrast, catalogues feature prominently in both images and accounts of visiting the Royal Academy. For example, on entering the Great Room, Bob

Tallyho was immediately struck by: 'Moving groups of interesting females were parading the rooms with dashing partners at their elbows, pointing out the most beautiful paintings from the catalogues, giving the names of the artists, or describing the subjects.'[81] We have already noted how young Dicky Roundabout performed a similar service for his mother by reading aloud extracts of poetry included in the catalogue. Within the distracting and unregulated social body of the Great Room, the catalogue therefore provided an important conversational prop and medium. Specifically, it helped to direct the viewer's attention, not in isolation (as it might have done in the British Museum) but as part of a social activity that combined looking and talking. In this context, C.S. Matheson argues that the use of the exhibition catalogue functioned as 'a guarantee of good behaviour as spectators turn from the paintings and to each other, an assurance of their continuing participation in the event and of the regulation of their gaze'.[82] Specifically, commentators argued that the easily distracted gaze of female spectators should be regulated by their use of the catalogue or via a 'discoursing male companion'.[83] The problem of visitors' (in)attention is the subject of Chapter 2 and the gendered dimension of this debate is explored further in Chapter 6: for now, the provision (or not) of the exhibition catalogue puts into focus the different kinds of social bodies produced by the British Museum and the Royal Academy respectively in late Georgian London.

During the first 50 years of the British Museum, the bodies and eyes of visitors were regulated and directed by their tour conductor; at the Royal Academy, both were free to roam around the room and over the walls. What Dias calls the 'avid sociability' of the Royal Academy exhibition produced practices of spectatorship that were fluid and contradictory: both distracting and narcissistic, and *also* imaginative and permissive.[84] No such autonomous looking or walking was permitted in the early British Museum where visitors' failure to apprehend the scope and contents of the collection could be attributed to a lack of time, freedom and information available to them. However, as well shall see, once the system of guided tours was ended, visitors were forced to rely on their own capacity to structure and pace their path around the museum: inevitably, the intellectual and physical challenge was as great as when they were 'hackneyed' through the rooms with a group of uncomfortable strangers.

Notes

1 Sir Robert Peel, *Hansard*, XIV, 3 July – 14 August 1832, col. 664.

2 Lord Russell, quoting from a letter written by Sir Robert Peel. House of Commons, *Report from Select Committee on The National Gallery. Ordered by the House of Commons to be printed, 16th August 1853*, London, 1853, para. 8186.

3 Colin Trodd, 'Culture, Class, City: The National Gallery London and the Spaces of Education, 1822–57', in Marcia Pointon (ed.), *Art Apart: Art Institutions and Ideology across England and North America*, Manchester: Manchester University Press, 1994, pp. 33–49.

4 Charlotte Klonk, *Spaces of Experience: Art Gallery Interiors from 1800 to 2000*, New Haven and London: Yale University Press, 2009.

5 Bennett, 'The Exhibitionary Complex'.

6 Richard Altick, *The Shows of London*, Cambridge, MA: Belknap Press, 1978.

7 Ibid., p. 102.

8 Bennett, 'The Exhibitionary Complex', p. 86.

9 Ibid., p. 81.

10 Mary Poovey, *Making a Social Body. British Cultural Formation, 1830–1864*, Chicago: University of Chicago Press, 1995.

11 Ibid., p. 4.

12 Rosie Dias, '"A World of Pictures": Pall Mall and the Topography of Display, 1780–99', in Miles Ogborn and Charles J. Withers (eds), *Georgian Geographies: Essays on Space, Place and Landscape in the Eighteenth Century*, Manchester: Manchester University Press, 2004, pp. 92–113.

13 For respective histories of the two institutions, see: Sidney C. Hutchison, *The History of the Royal Academy: 1768–1968*, London: Chapman & Hall, 1968; Solkin, *Art on the Line*; Holger Hoock, *The King's Artists: The Royal Academy of Arts and the Politics of British Culture, 1760–1840*, Oxford: Oxford University Press, 2004; James Fenton, *School of Genius*, London: Salamander Press, 2006; Edward Edwards, *Lives of the Founders of the British Museum*, 2 vols, London: Trübner and Co., 1870; J. Mordaunt Crook, *The British Museum*, London: Allen Lane, 1972; Edward Miller, *That Noble Cabinet, A History of the British Museum*, London: Andre Deutsch, 1973; David Wilson, *The British Museum*, London: British Museum Press, 2002.

14 Anne Goldgar, 'The British Museum and the Virtual Representation of Culture in the Eighteenth Century', *Albion: A Quarterly Journal Concerned with British Studies*, 32.2, Summer 2000, pp. 195–231; Solkin, *Art on the Line*; De Bolla, *The Education of the Eye*.

15 Prior to its move to Somerset House on the Strand, the Royal Academy exhibitions were held in rooms on Pall Mall. Throughout the period discussed in this chapter, the British Museum occupied Montagu House in Bloomsbury.

16 Even though the Academy exhibition was only open for five weeks in the 1780s, it consistently attracted more visitors during that time than the British Museum did all year. For example, there were 61,381 visitors in 1780 (the first year in Somerset House), rising to 91,827 in 1822, and thereafter slightly declining.

17 Dias, 'A World of Pictures', p. 93.

18 L.M., 'Admission of the Lower Orders to Public Exhibitions', *The London Literary Gazette; and Journal of Belles Lettres, Arts, Sciences, &c.*, 15, 3 April 1819, p. 220.

19 Derek Cash, 'Access to Culture: The British Museum from 1753 to 1836', *British Museum Occasional Paper 133*, The Trustees of the British Museum, 2002, p. 27.

20 British Library, Department of Manuscripts, Thomas Birch, *A Collection of Papers Relating to the Establishment and Government of the British Museum*, Add. MS 4,449, fol. 115.

21 Cash, 'Access to Culture', p. 43.

22 Goldgar, 'The British Museum and the Virtual Representation of Culture', p. 211.

23 Quoted in ibid., p. 212.

24 Hoock, *The King's Artists*, p. 204.

25 Advertisement in the *Exhibition of the Royal Academy MDCCLXIX, THE FIRST*, London, 1769, n.p.

26 John Brewer, *The Pleasures of the Imagination*, London: HarperCollins, 1997, p. 246.

27 Hoock, *The King's Artists*, p. 207.

28 Brewer, *Pleasures of the Imagination*, p. 246.

29 Bennett, 'The Exhibitionary Complex', p. 82. See also Altick, *The Shows of London*, p. 27.

30 BL, Add. MS. 6179, ff. 61–62v. Amongst John Ward's papers on the museum; not in Ward's hand. Quoted in Goldgar, 'The British Museum and the Virtual Representation of Culture', p. 210.

31 Ibid.

32 Quoted in Cash, 'Access to Culture', p. 47.

33 Altick, *The Shows of London*, p. 26.

34 Carl Philipp Moritz, *Travels of Carl Philipp Moritz in England in 1782*, London: Cassell and Company, 10th edition, 1886.

35 Altick, *The Shows of London*, p. 26.

36 Moritz, *Travels in England*.

37 Ibid.

38 Ibid.

39 M. Grosley, *A Tour to London; or, New Observations on England and its Inhabitants*, 2 vols (trans. Thomas Nugent), London: Lockyer Davis, 1772, p. 28.

40 Ibid., pp. 24f.

41 Ibid., p. 25.

42 Ibid.

43 William Hutton, *A Journey from Birmingham to London*, Birmingham: Pearson and Rollason, 1785.

44 Ibid., pp. 186f.

45 Ibid., p. 189.

46 Ibid., pp. 189f.

47 Ibid., pp. 190f.

48 Ibid., pp. 192f.

49 Altick, *The Shows of London*, p. 439.

50 Ibid.

51 Benjamin Silliman, *A Journal of Travels in England, Holland and Scotland, and Two Passages over the Atlantic in the Years 1805 and 1806*, Vol. 1, Boston: Wait, 1812.

52 Ibid., p. 288.

53 Ibid.

54 House of Commons, *British Museum, Regulations and Returns respecting Admission to the Museum*, 1810–11 (168) XI. 159.

55 An Amateur, *Real Life In London, Volumes I. and II. Or, The Rambles And Adventures Of Bob Tallyho, Esq., And His Cousin, The Hon. Tom Dashall, Through The Metropolis; Exhibiting A Living Picture Of Fashionable Characters, Manners, And Amusements In High And Low Life*, London: Methuen and Co., 1821.

56 Ibid., p. 14.

57 Ibid., p. 9.

58 Ibid., p.9.

59 Ibid., p. 239.

60 Ibid.

61 'Royal Academy', *The Daily Advertiser, Oracle and True Briton*, 7 May 1806. Quoted in Hemingway, 'Art Exhibitions as Leisure-Class Rituals', p. 100.

62 Frederick Wendeborn, *A View of England Towards the Close of the Eighteenth Century*, Vol. 2, London, 1791, pp. 197–8.

63 An Amateur, *Real Life In London*, p. 240.

64 Ibid.

65 Ibid.

66 David Solkin, '"This Great Mart of Genius": The Royal Academy Exhibitions at Somerset House, 1780–1836', in Solkin, *Art on the Line*, p. 4.

67 Ibid.

68 An Amateur, *Real Life In London*, p. 240.

69 Ibid.

70 Ibid.

71 Harry Mount, 'The Monkey with the Magnifying Glass: Constructions of the Connoisseur in Eighteenth-Century Britain', *Oxford Art Journal*, 29.2, 2006, pp. 167–84.

72 An Amateur, *Real Life In London*, p. 240.

73 Ibid.

74 Pierce Egan, *Life in London or, the Day and Night Scenes of Jerry Hawthorn, esq., and his elegant friend, Corinthian Tom, accompanied by Bob Logic, the Oxonian, in their rambles and sprees through the Metropolis*, London: John Camden Hotten, 1821, p. 373.

75 Matheson, 'A Shilling Well Laid Out', p. 52.

76 Egan, *Life in London*, p. 373.

77 Ibid.

78 Ibid., pp. 373f.

79 Ibid., p. 374.

80 Wendeborn also advocated that labels should be 'affixed to [exhibits] in legible characters, in proportion to the height in which they are placed'. Wendeborn, *A View of England*, p. 226.

81 Ibid.

82 Matheson, 'A Shilling Well Laid Out', p. 48.

83 Ibid.

84 Dias, 'A World of Pictures', p. 100.

Not Just Looking

The question of how to look in the public art gallery is as old as the institution itself. The earliest art exhibitions in London produced a stream of advice to the untutored or hesitant visitor as to how he – and more often, she – should conduct himself in the presence of both art and his fellow visitors. Guides proliferated on how to look like an expert (in both senses): for example, 'when you view a painting, take particular care not to go, like ignorant people, excessively near; but rather beginning far off, approach gradually, till it appears rough; then recede a little, till it looks sweeter; it is what connoisseurs call finding the proper light of a painting'.[1]

In other words, seeing properly depends on knowing how and where to stand in relation to the displayed painting: finding the ideal viewing place within the gallery brings the work of art into perspective and enables the visitor to hold it in her static gaze. In the previous chapter, Tom and Bob observed the 'Connoisseur' in the Royal Academy following just such a rule-book by 'placing his eye occasionally close to the paintings, or removing to short distances, right and left, to catch them in the most judicious lights'.[2] The theory underpinning such practical advice was to 'place the Eye … exactly in the Point of Sight for which [the Picture] was drawn' otherwise it 'cannot appear strictly true'.[3] From this vantage point, looking is assumed to be sustained rather than fleeting, still rather than wandering, and serious rather than frivolous. The corollary is that 'the Picture ought always to be placed in such a Position, that it may be viewed from that Point'.[4]

From this perspective, the curator is responsible for ensuring that the spatial and visual relations between viewer and artwork are conducive to productive viewing and, by extension, that the practised visitor can ascertain where they should stand by virtue of their familiarity with these display conventions. It is a question of being physically attuned to the exhibition script: Brian O'Doherty observes that every picture hang feeds 'subliminal clues [that] indicate to the audience its deportment'.[5] Yet images of the Great Room at Somerset House show that it would have been impossible to see many of the pictures in the

Royal Academy annual exhibitions from the correct 'Point of Sight' because they were too high, too low or hung at an awkward angle (Figure 2). Added to which, Solkin notes, 'the physical process of moving through and within this interior necessarily created an endless and constantly shifting multiplicity of viewpoints'.[6] Within the milling crowd, the chance of aligning one's body with the perspectival illusion of any but the most prominently displayed pictures would have been remote.

The difficulty of seeing artworks clearly and correctly under such conditions regularly provoked criticism of the Royal Academy. An anonymous article tellingly entitled 'Our Royal-Academical Lounge' published in *Fraser's Magazine* in 1832 deplored the:

> dense crowd of frames and canvasses, wedged together as their forms and dimensions will best permit, without any regard to arrangement, except that certain places are provided for the privileged ... whilst the rest are looked upon as so many ciphers ... not only useless, but actually depreciating. Rather does the majority of inferior works tend to 'swamp' the entire assemblage.[7]

According to the author, a picture 'requires its own atmosphere—to be viewed apart from other subjects. This is quite out of the question in a place where it is almost impossible to look at any one piece from a proper distance, without taking in a glimpse of some half-dozen others'.[8] Far from promoting attentive and productive viewing, the distracting environment of the Great Room undermined the efforts of the most committed spectator:

> Even those ... who do possess discrimination do not always exercise it, their attention being distracted by such a multiplicity of objects; while those, likewise, who are really attached to art for its own sake, are apt to feel palled and sated by over-abundance, unless they check their curiosity, and examine only a few pieces at each visit.[9]

Solkin acknowledges that the physical process of moving around the Great Rom would have 'created an endless and constantly shifting multiplicity of viewpoints, from which the paintings could be discerned clearly, badly or not at all'.[10] However, far from inhibiting or diminishing spectatorship, he argues that the relations between the artwork and the viewer within Somerset House were potentially liberating and permissive: without external regulation or direction, visitors' eyes and bodies could wander where they pleased. These relations constituted the exhibition's 'scopic regime', which De Bolla defines as 'the envelope within which practices of looking play out their variations' and that, crucially, 'gives definition to the subject who looks'.[11] In contrast to the strict conditions imposed on eighteenth-century visitors to the British Museum, spectatorship in the Royal Academy became 'less an experience controlled entirely from without than a mental process orchestrated at least partially from within'.[12] In both spaces visitors acquired an awareness of

themselves as viewing subjects; but whereas the regulations enforced in the British Museum permitted only a limited, externally driven sense of oneself as a passive onlooker, the scopic regime of the Academy exhibition enabled the viewer to perceive herself as aesthete, crowd watcher and, in turn, as someone who was herself observed.

Then, as now, viewing pictures in an exhibition was a question of negotiating sightlines amidst other bodies; often glimpsing a picture out of the corner of one's eye rather than from a full-frontal Point of Sight or allowing the eye to be caught by a distant image, as well as looking close up. The challenge was, as Norman Bryson puts it, to 'bracket out the process of viewing' a particular picture from the many distractions that crowded in on it.[13] Bryson describes the duality of looking that is implied in the distinction between the 'gaze' and the 'glance': whereas the former is 'prolonged, contemplative' and connotes a 'certain aloofness and disengagement', the latter is 'a furtive or sideways look whose attention is always elsewhere'.[14] Within the art exhibition, there is almost always a tension between the gaze and the glance: it is the sustained attentiveness of the gaze that the artist seeks to attract and that the curator endeavours to manage. Yet, in practice, museum looking invariably oscillates between the two, and the second part of this chapter argues that the dynamic shift between gazing and the glancing (or between attention and distraction) is essential to the choreography of visitors' bodies inside an exhibition. Within the Great Room at Somerset House, the function of the glance was to apprehend the exhibition en masse and, in the process, to recognise, compare and discriminate. De Bolla describes how the spectator's eye would roam 'hurriedly across surfaces, delighting in variety' and, in so doing, would feel itself to be 'located' within the visual field.[15] The difference that he acutely observes is that 'the gaze imposes an orderliness in vision and on the seen, [whereas] the glance is ordered by and through its encounter with the visual field'.[16] The contrast is between surface and depth, reflection and penetration. Viewing within the Academy exhibition therefore oscillated between the glance and the gaze, and was alternately mobile and still, wandering and focused: De Bolla calls this 'catoptric' viewing, from the Greek word for mirror, *katoptron*.[17] In other words, different modes of looking may be imbricated (or may collide) and the viewer may occupy different subject positions simultaneously within a single scopic regime.

Equally, from a phenomenological perspective, there cannot be a universally 'correct' viewing position dictated by the perspectival illusion of the picture plane; rather, it is a question of each individual finding the best position in relation to the displayed artwork so as to achieve an optimum 'balance between the inner and outer horizon' within their perceptual field.[18] That is, between the artwork's 'inner horizon' in the viewer's consciousness and its 'outer horizon' in the external world. In other words, the practised gallery visitor knows how and where to position their body in relation to

the object so that 'it vouchsafes most of itself'.[19] The spectating body is alert to the requirements of the object on display; each exists in a relationship of dynamic symbiosis with each other, as well as with the space they occupy and everything within it, including other visitors.

Yet, as this chapter shows, the museum's scopic regime frequently neglects to take account of the capacities and instincts of visitors' bodies. The clearest instance of this disavowal of corporeality is the disembodied installation photograph, in which the work of art is displayed in pure, unpopulated gallery space. The absence of visitors' bodies from images of the modernist 'white cube' and its variants was, in its time, as normative and regulatory as the strategic representation of viewing subjects in the eighteenth-century exhibition print. Just as the latter provided exemplars of practised visitors for the inculcation of their less experienced counterparts, so, according to O'Doherty, the absence of people in the installation photograph 'offers the thought that, whilst eyes and minds are welcome, space occupying bodies are not'.[20] The contrast between the *Tom and Jerry* and *Tom and Bob* plates of the Royal Academy exhibition, discussed in the previous chapter, and an interior view of the 1936 exhibition *Cubism and Abstract Art* at the Museum of Modern, New York makes the point (Figure 7).

7 *Cubism and Abstract Art*, Museum of Modern Art, New York, 1936.
The Museum of Modern Art Archives, NY. Digital Image © 2011,
The Museum of Modern Art, New York/Scala, Florence.

O'Doherty argues that within the discursive formation of modernism, the art 'Spectator' became an uncertain and clumsy figure whose presence violated the immaculate tableau of the 'white cube' gallery as 'he staggers into place before every new work that requires his presence'.[21] The question of 'where to stand?' was repeatedly invoked by illegibility of modernist painting when viewed close-up: O'Doherty's 'dark-adapted wanderer' was often confused in the presence of the Impressionists and their successors, although usually eager to please and be pleased.[22] Moving between the artworks, the perceiving body of the Spectator functioned only to support the roving Eye: walking and looking, looking and walking. The modernist art gallery was not a convivial or flirtatious space where strangers caught each other's eyes across the room: to his fellow visitors, the Spectator was 'mostly a back' as he 'stoops and peers' at each successive work.[23]

In fact, O'Doherty's ironic critique of the twentieth-century 'white cube' exposes a museological conceit whose roots stretch back into much earlier institutional practices: namely, the disembodiment of perception and the associated production of display schemes that ignored the inconvenient presence (and comfort) of heterogeneous and unpredictable bodies. The ways in which some museum bodies have protested against their own negation is the subject of Chapter 5; for now, my focus is on the acquisition of those *embodied* techniques of looking that are involved in the process of 'becoming viewers in the culture of visuality'.[24] Once acquired, practised museum visitors draw on a repertoire of viewing habits that demonstrate, both to themselves and to others, their familiarity and ease with the institution's scopic regime. Recalling the description of Tom and Bob's 'Connoisseur' at Somerset House, De Bolla observes that moving through an exhibition 'we unthinkingly adopt the posture of the connoisseur as we thread our way through the textuality of visuality, stopping here to inspect a label, there a brushstroke, here a genre, there a school'.[25] To behave like this is consciously to align oneself with the curatorial intention of the display: the attuned visitor knows how to read the exhibitionary script, as well as the individual artwork. Specifically, they have mastered the art of comprehending the displayed object within the narrative into which it has been inserted. And yet for all the assurance of De Bolla's art lover, there is perhaps a sense that they are moving too quickly through the gallery: are they paying sufficient attention to the demands of each piece? Is their delight in the comparison between artworks, and their absorption of the nuggets of art historical information provided by the object labels, at odds with the possibility that they might stop and just look at a single painting for, say, an hour? Or would that be a slightly eccentric thing to do? The sense of sight is less temporal than, say, hearing or touch, so how long should the visitor look at the displayed object in order to ascertain its qualities and absorb its lessons?

Castigating the crowded display at the Royal Academy exhibition, *Fraser's Magazine* argued that, instead of being surrounded by diverse and competing images, a picture requires sufficient room 'to be viewed apart from other subjects'.[26] Yet, as Figure 7 shows, even within the spatial economy of the white cube, the curator lures the visitor through a linear sequence of artworks with a tantalising glimpse of what is to come. This dynamic between, on the one hand, stasis and attention (the gaze) and, on the other hand, mobility and distraction (the glance) is central to the way in which the museum works on the bodies (and eyes) of its visitors. In any display that contains more than one exhibit, there is an inherent tension between the static point of beholding the individual object and the relational visual field of the gallery as a whole. At the edge of one's field of view, there is always another painting, another room beckoning the visitor to move on. If sight is above all the 'sense of simultaneity', [27] capable of surveying a wide field at a time, how does the museum attach it to the surface of a single object? It would seem that the challenge for the curator is how to construct conditions of viewing that support the visitor's attentive and receptive gaze, whilst also choreographing their journey through the gallery, so as to apprehend fully the exhibition or collection as an entire ensemble.

This rest of this chapter explores how curators and museum administrators have sought to inculcate normative practices of spectatorship within the art gallery through a combination of display techniques, tacit corporeal training and observation of visitors' conduct. In turn, it asks how have institutionally prescribed modes of looking been experienced through the embodied eyes of actual visitors? How have members of the art museum's public ignored, adopted or adapted these prescriptions, wilfully or otherwise? An important part of this story, therefore, is how visitors become aware of themselves as viewing subjects. Both the Connoisseur in Somerset House and De Bolla's art lover are well aware of their own visibility within the play of looks and stares inside the gallery, as well as within the monitoring regime of the institution. Yet, this self-confidence in being, and been seen as, an art aficionado also has to be acquired. As we shall see, accounts of untutored visitors in the nineteenth-century art exhibition oscillated between cheerful ignorance of the coded messages of display and the dawning realisation that not all behaviours and responses were equally validated and valued by the institution.

Ways of Looking

The history of looking at art in public is inextricably linked to histories of display, and specifically to the aesthetic and/or pedagogic objectives of different exhibition schemata, as is evident from the contrasting representations of the early Royal Academy *vis-à-vis* the modernist white cube. However, it was not

8 Frederick Mackenzie, *The National Gallery*, c.1834.
Victoria & Albert Museum, London.

always so easy to discern the desired mode of viewing or the correct Point of Sight. For example, Charlotte Klonk has described how two principles of displaying art were fused together in the public rooms in the early National Gallery, when it was housed in the residence of the late John Julius Angerstein at 100 Pall Mall. Klonk argues that the cluttered, floor-to-ceiling display depicted in a painting by Frederick Mackenzie was a kind of hybrid that combined the 'picturesque' style of hanging paintings that was fashionable in private homes and galleries, and was primarily based on size and symmetry, with the visual density of the Somerset House exhibition (Figure 8). As a result, there was 'no single prescribed viewing position for the paintings, and visitors were invited to compare the parts of one with another as they wandered amongst them'.[28] In practice, it would have been difficult to locate the optimum Point of Sight for, say, a painting hung near to the ceiling in such a small room, let alone to appreciate the detail of any but the largest and most centrally-placed works.

By the middle of the nineteenth century, this kind of free-ranging looking was increasingly regarded as an inadequate response to the art museum's emerging pedagogic purpose. In 1847, John Ruskin called for the replacement of the crowded hang in the National Gallery by a serial display of pictures

at eye level: 'Every gallery should be long enough, to admit of its whole collection being hung in one line, side by side, and wide enough to allow of the spectators retiring to the distance at which the largest picture was intended to be seen.'[29] In other words, the roving eye should stop moving and pay attention. According to Ruskin, not only would a spacious, single line hang enable the full frontal appreciation of the individual artwork, it would also enable to viewer to absorb a linear account of the progression of art itself. Within Ruskin's art museum, what Tony Bennett describes as the 'distinctive relations between vision and pedagogy'[30] would be achieved via a display that combined both individuation and seriality, in which the historical and aesthetic affinities between pictures were rendered palpable on the gallery wall. A different kind of dialogue would thereby take place between the displayed artworks. Instead of the diverse and intersecting conversations – based variously on their subject, composition and creator[31] – between the pictures crowded together on the walls of Somerset House, this new logic of display transformed each piece into 'a moment in art history'.[32]

Although it would be some time before the National Gallery fully adhered to Ruskin's display prescription, within a decade his ideas into were put into practice in a singular curatorial experiment: the 1857 Manchester Art Treasures Exhibition was not only enormously ambitious in terms of its size and organisation, it was also a bold venture in art education aimed at a diverse and inclusive public.[33] Specifically, its objective was to mount an unprecedented three-dimensional object lesson in which interwoven narratives of national and art history would be presented for the edification of thousands of visitors each day. Rejecting the 'gaudy chaos'[34] of both the Somerset House exhibitions and the fledgling National Gallery, the organisers of the Art Treasures Exhibition were praised for the clarity and logic of the displays, although in practice, they seem to have failed in their attempt to engage either the eyes or bodies of a great many visitors. Manchester in 1857 therefore provides an illuminating case study in the management of visuality within the nineteenth-century art field. As such, it makes an eloquent contrast to the strategies and effects of visiting either Somerset House or the National Gallery in earlier years – yet, the museological tension between attention and distraction continues as a recurring theme. Central to the evaluation of the exhibition's success was the question of its effectiveness in directing visitors' walking and looking in a systematic and productive alliance that enabled the appreciation of the display en masse, as well as of the individual artwork.

Th' greight Hert Treasures Eggshibishun at Owd Traffort
(or The Manchester Art Treasures Exhibition)

The Manchester Art Treasures Exhibition ran from 5 May to 17 October 1857 and was housed in a vast iron and brick building covering three acres, erected on the grounds of Manchester Cricket Club at Old Trafford, two miles from the centre of the city (Figure 9).[35] The scale, ambition and, arguably, the art historical significance of the exhibition was unprecedented in Britain, and has not been equalled since. In all, over 16,000 works of art were gathered together in the Art Treasures Palace, including 1,173 works of the Ancient Masters, 689 productions of the Modern Masters and 386 British portraits. In addition, there were 969 watercolours and drawings, 260 old master drawings, 1,475 engravings, 597 photographs and some 10,000 objects that comprised the 'Ornamental Art Museum'.[36] The majority of exhibits were the property of private individuals and many were on public show for the first time.[37] A total of 1,300,000 visitors witnessed the vast spectacle and, inevitably, this massive assemblage of people and artworks produced a rich vein of commentary on both the constitution and the conduct of the exhibition's public. For many, the organisers' extraordinary achievement in amassing objects of such quantity and quality was central to the problem of actually seeing it: how could the

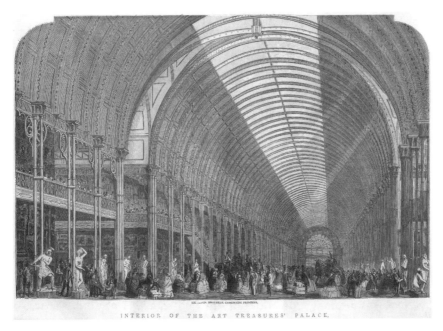

9 Interior of the Art Treasures Palace, *Art Treasures Examiner*, 1857.

attention of diverse and numerous visitors be marshalled in front of thousands of artworks in a single day to some valuable effect?

The sheer scale of the enterprise, and the practical impossibility of seeing even a fraction of the exhibition in a few hours, made it difficult for people to know how to structure and pace their visit, let alone identify those artworks works most worthy of close scrutiny. Inevitably, the challenge of apprehending such a vast spectacle was felt to be particularly acute amongst the numerous visitors who were unfamiliar with the conventions of the art gallery or the principles of art history, notwithstanding their familiarity with the technical exhibitions at their local Mechanics Institute or the panoramas in Manchester's pleasure gardens.[38] But even for metropolitan visitors, accustomed to viewing art at the Royal Academy and the National Gallery, the prospect of so many exhibits was daunting: after a long afternoon in the Art Treasures Palace, the future prime minister, William Gladstone, wrote in his diary that it was 'a wonderful sight materially, and not less remarkable morally, but bewildering to the mind and exhausting to the eye from vastness when viewed wholesale'.[39]

In order to be fully appreciated, important sections of the Art Treasures Exhibition were designed to be viewed in a particular sequence; in the absence of explanatory labels or access to a shilling catalogue, the 'lessons' of these parts of the exhibition could only be digested by mobilising one's feet and eyes in accordance with the curatorial script. For example, the vast central nave of the Art Treasures Palace was flanked on each side by the British Portrait Gallery, devised as a pantheon of British monarchs, heroes and worthies, from Richard II to Queen Victoria. The portraits were hung in a (roughly) chronological sequence, which, confusingly, started at the far end of the hall, furthest from the entrance.[40] The experience of walking through history would be lost on a visitor who started at the wrong end or in the middle. This was also the first public exhibition in Britain to display a progressive chronology of art along the walls of the corridor-like galleries devoted to the Ancient Masters, in which the works of the so-called Northern and Southern Schools faced each other on opposite walls, thereby enabling the visitor to 'read' the history of art both along and across each room. From the curators' perspective, the didactic capacity of the exhibition was palpable in its spatial organisation and in the serial presentation of art history, but how accessible was this to the general visitor?

The educational objectives of the exhibition had been officially sanctioned by Prince Albert in a letter to the organisers. The consort's approval of the venture was conditional on the basis that would provide more than the '... mere gratification of public curiosity' and should instead 'illustrate the history of Art in a chronological and systematic arrangement, [so as to] speak powerfully to the public mind, and enable, in a practical way the most

uneducated eye to gather the lessons which ages of thorough and scientific research have attempted to abstract'.[41]

Significantly, Albert insisted that this experiment in comparative art history should not be aimed primarily at the connoisseur, but rather should address the 'uneducated eye' to some productive, practical effect. In other words, a wide and inclusive public was being invoked via the metonymic substitution of the disembodied 'eye' for the corporeal spectator. In terms of evaluating the success of the exhibition, its direct impact on the eyes and minds of its visitors was impossible to ascertain, but their posture and movement could be monitored and evaluated as evidence of its scopic effect. Therefore, it was the conduct of visitors' walking, looking and consuming bodies that provoked a stream of commentary and debate on the exhibition's success (or otherwise) in 'speaking' to its public.

Throughout the exhibition, visitors' conduct was closely observed: deportment, posture, gesture and speech were scrutinised as a means of calibrating its success in educating the eyes of its audience. Behaviour such as 'lounging', 'parading' or 'wandering' was translated as a register of effects, and such outward signs of 'languor', 'vanity' or 'confusion' were deemed symptomatic of a failure adequately to interiorise the artistic and historical lessons of the exhibition. Images of the exhibition's public in the Art Treasures Palace contributed to an awareness of how one was supposed to look and behave: in the illustrated press, visitors could see their ideal selves interpellated in scenes of quiet conversation and diligent attention. However, in practice, the experience of many visitors was very different: the scale and novelty of the spectacle was both confusing and exhausting, making it difficult to pay attention to anything in particular. The American novelist and diarist, Nathaniel Hawthorne, who visited the exhibition about a dozen times, must have spoken for many when he described the 'depressing … sight of a great many pictures together'. It was, he said, 'like having innumerable books open before you at once, and being able to read only a sentence or two in each. They bedazzle one another with cross lights.'[42] Hawthorne found that he could not fix on any one object because he was constantly distracted by everything else that surrounded it. Reflecting on the impossibility of truly absorbing the exhibition's contents, he added that 'every great show is a kind of humbug' because other visitors were 'skimming the surface, as I did, and none of them so feeding on what was beautiful so as to digest it, and make it a part of themselves'.[43]

Hawthorne was atypical amongst the crowd inasmuch as he had both the inclination and the resources to see the exhibition a number of times during an extended stay in Manchester; but what of the majority who only could only visit once and for a few hours? The official catalogue offered limited help: its primary function was to provide a comprehensive list of the works on art on display rather than practical direction. Recognising its limitations,

enterprising publishers spotted an opportunity and soon a plethora of unofficial guidebooks were available for sale at the exhibition bookstand; each held the promise of an efficient, comprehensive and enjoyable tour through the vast building, without inadvertently missing any of the most important artworks. The author of *What to see and where to see it! Or the Operative's Guide to the Art Treasures Exhibition* wrote that his one-penny pamphlet was intended to meet the needs of those workers and their families who appeared 'somewhat bewildered and dazzled' by the size of the exhibition, and whose time for visiting was necessarily limited.[44] Whereas the majority of exhibition guides began with the gallery of Ancient Masters, this author advised his readers to start their tour in the Museum of Ornamental Art where they would find objects whose design and craftsmanship that they could appreciate more readily than 'the ideal productions of the painter'.[45]

Even so, the itineraries recommended in all of the guidebooks must have been exhausting, and we can only surmise how many of their readers adhered to their prescribed route for a whole day. Evidence suggests that many did not: at the end of the first month, one commentator wrote that: 'The novelty of the show as a whole, the distraction afforded by its magnitude and variety, leading people hither and thither without a fixed purpose, have held the educational and refining influences of the affair in suspense.'[46] Charles Dickens (who visited the exhibition on 1 August) believed that, on balance, the exhibition failed to capture the interest and imagination of working-class visitors who lacked the knowledge to decipher and appreciate any but the most naturalistic works of art: 'The plain fact is, that a collection of pictures of various "schools" excites no interest, and affords but little pleasure to the uninstructed eye.'[47] If so, it was hardly surprising that the exhibition failed 'to speak powerfully' to the minds of many of its visitors or that their eyes drifted and their legs grew weary.

Before long, the failure of some working-class visitors to grasp both the concept and the conventions of the exhibition became the butt of satirical anecdotes. For example, when a group of mill workers was asked what they thought of their visit, one of their number reputedly answered:

> "Aye, we be theer ... [but] there wur nought to see!"[48] Similarly, the *Art Journal* reported that another group of factory workers had spent a couple of hours wandering around the Art Treasures Palace "with puzzled anxiety. Then, eagerly and with a mixture of apprehension and weariness, they inquired, 'when the exhibition would begin?' Obtaining no such answer as they desired, they gradually dispersed, to seek consolation for themselves in the neighbouring places of 'good entertainment'".[49]

Dickens attributed such defections from the exhibition to indifference and boredom. He recounted a tale of a 1,200 factory workers from Sheffield, whose visit to Manchester was organised and paid for by their employer,

1,000 of whom had disappeared before their lunch was served in the second-class refreshment room, leaving just 200 of the original party to eat the meal provided for them.[50] The problem was that 'the care for the common people, in the provision made for their comfort, and refreshment, is ... admirable and worthy of all commendation' but, he argued, 'they want more amusement, and particularly something in motion, though it were only a twisting fountain. The thing is too still after their lives of machinery; the art flows over their heads in consequence'.[51] In other words, the exhibition's failure to spark their interest meant that many visitors lacked the capacity or the desire to muster the visual attention that the endeavour demanded. The systematic walking and looking prescribed by the layout in the Art Treasures Palace was unfamiliar, tiring and, frankly, uninviting – and all the more so, when compared with more exhilarating spectacles on offer in the city.

Setting aside these metropolitan commentaries on the conduct of its audience, there is (as ever) tantalisingly little evidence of how it was physically and practically experienced by the majority of those who actually visited the exhibition. However, a number of contemporary stories in a variety of local Lancashire and Yorkshire dialects do suggest how the spectacle was viewed, both metaphorically and materially, within working-class culture. Within weeks of the exhibition opening, humorous accounts appeared recounting the tribulations and triumphs of a day at the 'Hert Treasures Eggshibishun' by popular fictive characters such as Tom Treddlehoyle, Tim Gamwattle, a Rachde Felley, Owd John and Bobby Shuttle and his doubtable wife, Sayroh.[52] Such tales provide a rare contemporary glimpse of the brief encounter with the display of official culture that the exhibition offered, although most devote rather more space to the journey from home and arrangements for having a snack in Manchester than to their protagonists' adventures inside the exhibition itself.

Two of the pseudonymic stories by 'Bobby Shuttle' (written by the editor of the *Bolton Luminary*, James T. Staton) and 'Tom Treddlehoyle' (written by the Barnsley writer and artist, Charles Rodgers) respectively, address the challenge of viewing the pictures in the British Portrait Gallery. In the opinion of Bobby Shuttle, some of kings and queens represented in the gallery were 'rum-looking jockies' who were 'dressed so quare' and 'so stiff and stilted' that they 'imitated humanity so abominably'. He is not, however, a naïve observer and he understands that, in the words of Shakespeare, portraits were 'a keawnterfeit presentment o'th illustrious original'.[53] Victoria Whitfield observes that this sophisticated understanding of the fictive nature of portraiture contrasted with the way that Shuttle and his wife 'Sayroh' viewed the modern English works. Joining the crowd in front of Henry Wallis's celebrated painting *The Death of Chatterton*, Sayroh was so absorbed by the pathetic realism of the image, that she forgot that it was only a picture and reached out to straighten the quilt on Chatterton's bed (Figure 10).[54] By

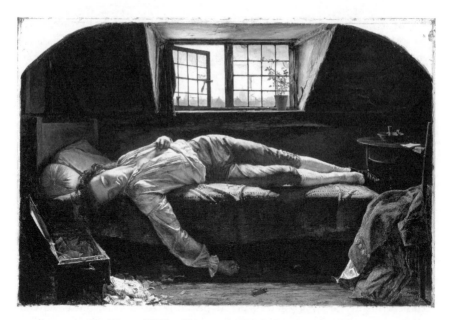

10 Henry Wallis, *Chatterton*, 1856. © Tate, London 2012.

contrast, Tom Treddlehoyle's initial amusement 'at seein wot time an fashan hed dun' as he inspected 't'renks' of British worthies in the Portrait Gallery was swiftly deflected by the more interesting appearance in the hall of a living celebrity, the former Whig prime minister, Lord John Russell.[55]

One of the characters in Tim Gamwattle's story, Ben-o-Dyers, is perhaps most appreciative of the exhibition overall and of the Portrait Gallery in particular, which as far as he is concerned, seems to have fulfilled Prince Albert's intention that the displays should speak to the 'uneducated eye' of a man like him. For Ben, the gallery was better than a fine sermon 'preycht bi deawmb pikturs' which, he thinks, are 'mooar konvinsin ur words'. The pictures prompted him to reflect more deeply than do the preacher's words: 'fur whot is it ut konvinsus o mon but iz hown innurt thowts'.[56] But despite his enjoyment, Ben is also conscious of his ignorance about the historical events and characters represented in the gallery, and feels that greater knowledge would have increased his appreciation: 'iv awd knoan istrey better aw shud ov ad mooar pleshur nur aw av ad'.[57] By contrast, another of Tim's friends reports that he has seen the entire exhibition in half an hour: 'Awve sin welly evvuri mon jack on um e tuthri minnits'. Disconcertingly, he asks, 'Didtah think aw shud moider myself wi stayrin at um one ut o toime?'[58]

This final comment, questioning the very idea of looking at the pictures one at a time, coupled with the anecdote about the group of workers who asked when the exhibition would 'begin', indicates the gulf of understanding

between the intentions of its organisers and the interests and capacities of at least some of its consumers. The visual lessons of the Art Treasures Exhibition were not only undermined by its scale and complexity, but also by its failure to acknowledge that exhibition spectatorship is an acquired technique. Within such a vast and exhausting arena, opportunities for distraction inevitably outweighed many visitors' capacity for paying attention. Put another way, for many people the tension between the gaze and the glance remained unresolved: the scale and complexity of the exhibition undermined the value of the glance as a strategy of apprehending its visual field and of locating oneself within it; whilst prolonged and contemplative gazing was practically impossible if one wanted to see more than fraction of the artworks in a single visit.

Fixing Attention

The growing interest in the educational potential of the art museum became evident in the (re)organisation of many museums on systematic and pedagogical principles from the 1850s onwards.[59] As the Art Treasures Exhibition had demonstrated only too clearly, the challenge to such reforms arose from the propensity of visitors to ignore or misconstrue the visual lessons that had been carefully arranged for them by the museum's curators. How could people possibly learn the lessons of, say, the progress of the history of art if they walked through the displays in the wrong direction or missed out crucial exhibits altogether? Or if they could not see the point of looking at the pictures 'one ut o toime'? In short, how could the museum do its work if its visitors failed to *pay attention*?

To paraphrase Jonathan Crary, it was increasingly through the 'frame of attentiveness ... that the seeing body was deployed and made productive' within the late nineteenth-century museum.[60] Scanning a wider horizon of visual practices, he argues that:

> The problem of attention is interwoven, although not coincident, with the history of visuality in the late nineteenth century. In a wide range of institutional discourses and practices within the arts and human sciences, attention became part of a dense network of texts and techniques around which the truth of vision was organized and structured.[61]

Crary and others have fruitfully addressed the wider issues of opticality, psychology and operation of attention within the history of visuality.[62] Within the art museum in particular, the practice and effect of attention critically 'implied some process of perceptual or mental organisation in which a limited number of objects or stimuli [were] isolated from a larger background of possible attractions'.[63] This is akin to Bryson's notion of 'bracketing out' other

visual distractions in order to fix one's gaze on a single artwork. And yet, the museum also depends on its capacity to distract its visitors (in order to lure them to the next showcase, to the next room and so on) whilst simultaneously requiring them to screen competing attractions from their contemplation of an individual object. How then can the museum manage visuality so as to bring visitors' reciprocal practices of attention and distraction (or gazing and glancing) into a productive alliance?

Moving into the early twentieth century, the majority of museum commentators continued to express a dim view of the inattentive visitor. In 1928, the psychologist, Edward S. Robinson, posed this rhetorical question: 'What does the average man do in a museum? He wanders aimlessly, but not blindly. His attention is drawn to this and distracted from that.'[64] According to Robinson, central to the task of museum reform was the management and direction of 'that casual, self-conscious crowd which, on Saturday and Sunday afternoons, moves like some inanimate current from picture to picture and from glass case to glass case'.[65] If the aim was to orientate visuality in accordance with institutional objectives, a different choreography of moving and looking was required. As we shall see, the first systematic attempts to study visitors and, in turn, recommend how their attention could be marshalled more effectively, focused on the effects of the museum's material apparatus (including the layout, design and content of galleries) and its discursive systems (such as its architectural syntax and taxonomies of display). However, in addressing a perceived deficit of attention amongst visitors, the positive possibilities of distraction were firmly ignored.

Despite the continuous interest in the constitution and conduct of the museum's public from the mid-eighteenth century onwards, it was not until the 1910s and 1920s that the first systematic studies of visitors' behaviour were undertaken. One pioneer was Benjamin Ives Gilman, Secretary of the Boston Museum of Fine Arts, whose interest in visitors focused on what he called the 'evil' of 'museum fatigue', which he diagnosed on the evidence of a discernible loss of interest in the museum's displays towards the end of a visit.[66] He wrote that:

> museum visiting is one of the most fatiguing of occupations. To see a work of art thoroughly is not only an effort of the eyes but in general of the body, in standing, bending or other muscular tension; to understand it taxes memory and intelligence alike. In proportion as appreciation is more complete, the need of occasional relaxation increases.[67]

Although Gilman had trained as a psychologist, he believed that the primary cause of 'museum fatigue' was muscular. He hypothesised that the effort of peering at awkwardly positioned and badly arranged displays involved uncomfortable and unnecessary exertions that were either exhausting or simply off-putting. Either way, the result was the same because the visitor

was either too tired, or could not be bothered, to look properly. Gilman demonstrated his theory by staging a series of photographs which were 'taken with the object of determining by actual observation just what kinds and amount of muscular effort are demanded of the visitor who endeavours to see exhibits as museum authorities plan to have them seen'.[68] To make his point, he co-opted his ideal museum visitor: an able-bodied, Caucasian male, 'intelligent … with good eye-sight, and well accustomed to museums and their contents'.[69] The resulting photographs showed the absurd contortions that this fine specimen was obliged to undergo in order to study objects and their labels on different sized plinths and in large and crowded showcases (Figure 11).

Gilman's aim was to reform museum practice by illustrating the need to improve the ergonomics and communicative efficiency of display design. His photographs were intended to demonstrate the 'muscular effort of *good seeing*'[70] (my italics), thereby minimising what he believed were the causes of museum fatigue. Gilman's taken-for-granted notion of 'good seeing' warrants further scrutiny. As a museum professional, he automatically aligned the eye of the ideal visitor with the intention of the curator: looking properly amounted to no more or less than viewing exhibits 'as museum authorities plan to have them seen'. From this perspective, the amelioration of museum fatigue was desirable because it undermined the visitor's capacity and desire to absorb the messages of the museum. Gilman was, however, obliged to admit a significant omission in what his photographs revealed: namely, the 'effort of the eye muscles' which 'cannot be directly shown in pictures, but is evidently considerable and may be hopeless'.[71]

Clearly, the normative practice of 'good seeing' advocated by Gilman involved the full-frontal, binocular vision of the lone individual, effectively screening out distractions, both social and material. In order to assist in the production of such lucid and productive looking, Gilman even invented a hand-held 'skiascope' for the gallery visitor. Designed to reduce visual interference from glare and from other objects, it enabled the visitor to achieve a kind of tunnel vision (Figure 12). The idea was that: 'At a distance of six or eight feet from a wall [the visitor] sees only a patch of it perhaps four feet high and three feet broad.'[72] As a result of its practical efficacy, Gilman believed that the skiascope user would immediately perceive the value of controlling glare and other visual pollutants in promoting 'good seeing'.

Gilman's physiological approach to the problem of museum fatigue was revised in the 1920s and 1930s by two psychologists at Yale University: Edward S. Robinson and Arthur W. Melton. Working under the auspices of the American Association of Museums and funded by the Carnegie Institute, Robinson and Melton instigated a series of observational studies to identify the intersection of physical and psychological factors that influenced how people looked in the museum, and what they looked at.[73] Like Gilman, they

II. MUCH BENT

Fig. 10. *Object.* — A Renaissance crucifix lying on the bottom of a floor case, and bearing an incised design. The observer was asked to describe the design. *A.* — The figure of Christ.

Fig. 11. *Object.* — A fragment of ornament lying on the bottom of a floor case. *Q.* — What does the pattern on this fragment represent? *A.* — A group of five persons dancing.

Fig. 12. *Object.* — A cast of the Venus of Melos. The observer was asked to read the label on the pedestal.

258

11 Photographs illustrating postures 'Much Bent', Benjamin Ives Gilman, *Museum Ideals of Purpose and Method*, 1918.

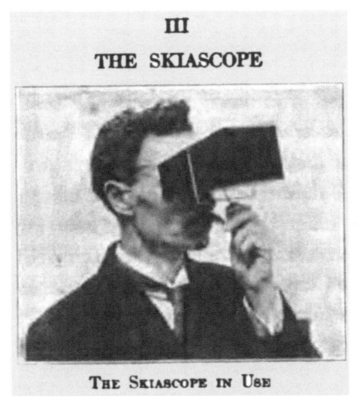

12 'The Skiascope in Use', Benjamin Ives Gilman,
Museum Ideals of Purpose and Method, 1918.

had clear ideas about what constituted 'good looking', which Robinson regarded as being 'more intelligent, more interested' than the behaviour of the drifting, distracted crowd.[74] His overall aim was nothing less than to establish 'empirical norms of museum behaviour'.[75] However, unlike Gilman, Robinson and Melton believed that 'museum fatigue' was as much psychological as physical: for them, it was both the cause and a symptom of the visitor's distraction and aimlessness. Their objective was to reform the museum so as to optimise its operation on the visitor's body, eye and brain. At the heart of their project was the problem of attention: specifically, the management of visitors' attention, which they viewed as a kind of resource that could be distributed productively, rather than dispersed and dissipated, in the course of a museum visit. For Robinson and Melton, attention was self-generating: the attentive visitor was less susceptible to museum fatigue because their interest was happily engaged.

Robinson and Melton were committed behaviourists who regarded museum visitors as unreliable witnesses to their own experiences: 'The casual

visitor to a museum has not usually had psychological training and there are few reports so untrustworthy as those of an unpracticed observer regarding what he thinks he thinks and what he feels he feels.'[76] Untroubled by visitors' own descriptions of their experiences, Robinson and Melton believed that attention could be calibrated via the covert, systematic observation of people as they moved through the museum. Their initial studies addressed a range of questions: how long did a visitor spend in the museum? How many rooms did they visit? What percentage of exhibits did they look at in each room and for how long? Although Robinson and Melton acknowledged that some exhibits were likely to attract visitors' attention per se (such as particularly large or colourful paintings) they rejected the idea that 'the character of the art object' was the primary determinant in 'the amount of the attention it receives'.[77] Instead, they identified a range of 'conditioning factors' that influenced where and for how long visitors' attention was directed.[78] Echoing nineteenth-century critics of the Royal Academy exhibitions, they regarded the museum as a kind of arena in which 'every object in the museum gallery acts as a rival of every other object in the competition for the attention of visitors'.[79] So what were the conditioning factors that made some objects winners and others losers?

The first factor was the isolation of the object: that is, the extent to which it was susceptible to the 'distraction effects' of other objects competing for attention within a single space. Isolation could be calibrated according to two further sub-factors: the degree of crowding or distance between objects, and the overall number of objects in the space.[80] In general, Robinson and Melton found that the greater the number of objects in the room, the more competition there was to catch the visitor's eye, but once caught, the factor of crowding had little marginal effect. The object had to compete with others for its initial 'drawing power' but, once the spectator's attention was caught, the surrounding competition made little difference to its 'holding power'.[81]

The second factor concerned the debate over homogeneous (single medium) versus mixed (or 'period style') displays. At a time when 'period' or 'style' rooms (comprising furniture, decorative arts, sculpture and paintings) were fashionable amongst American curators, Robinson and Melton found that displays of mixed media produced the same distraction effects as, say, the competition between works in a gallery solely devoted to paintings. They concluded that 'the spatial configuration, the *gestalt*, of the period-room ... is not in itself sufficiently potent to overcome the normal distraction effects due to the competition between objects housed in the same gallery'.[82]

Thirdly, they considered position of the object in the gallery as a 'determinant of interest' and concluded that the position of a particular object (for example, in terms of height and centrality) on the wall was less significant than the variation in 'display values of different regions of the gallery'.[83] These variations can be explained in relation to the position of the museum's

entrance and exit. Robinson's observations showed that over 75 per cent of visitors turned right when entering a room and over 50 per cent only looked at objects along the wall to which they first turned: therefore, objects placed along a wall to the right of the entrance are more likely to capture the attention of visitors than those on the opposite wall. Melton also considered that the position of the exit should be accorded 'a first rank amongst the significant variables' in any gallery.[84] The sight of a doorway not only draws visitors through a space, it 'also acts as extremely interesting object and competes with the art objects for attention'.[85] To illustrate the point, after a second exit was opened in a gallery, the average time that visitors stayed there dropped from 73 seconds to 23 seconds.

Believing 'museum fatigue' to be both a cause and effect of aimless distraction, Melton characterised it as 'a lowered responsiveness' to the museum's displays.[86] He thought that some loss of concentration was inevitable towards the end of a visit, but rejected the supposition that this was largely due to physical tiredness, as opposed to the effects of 'object satiation' or boredom. A study conducted by Robinson in a small branch of the Pennsylvania Museum of Art also undermined the idea that 'museum fatigue' was primarily physical: a decline in attentiveness was observed, despite the fact that, on average, visitors only spent four minutes in the museum.[87] As Melton noted, this was 'truly an exceedingly short time for the production of pronounced physical fatigue'.[88] He therefore rejected ergonomic measures to ameliorate museum fatigue, such as more resilient flooring, smaller displays and more seating, arguing that 'object satiation' could only be combated by greater variety in the style of displays and the types of exhibits, so as to sustain the visitor's purposive attention for longer. Overall, Melton and Robinson believed that their findings should feed into a new branch of study wholly concerned with the psychological problems of museum architecture. More effective museums could, in turn, be developed based on the knowledge that, for example, most people turn right on entering a room, exits exert a considerable 'distraction effect' and homogeneity of displays induces museum fatigue.

Reviewing these early visitor studies in light of contemporary practice, certain continuities are striking. Although Robinson and Melton's unwavering faith in behaviourism as a means of elucidating visitors' experiences has been widely discredited, tracking studies are still conducted in many museums, albeit alongside interviews and other methods that can be triangulated with data based on observation. Similarly, the symptoms of museum fatigue and the problem of attention still persist; both within and beyond the museum, attempts to explain attention empirically and to render it manageable were ultimately unsuccessful.[89] Meanwhile, inside the museum, attention is still promoted as a positive and extendable resource, at the expense of recognising its inherent volatility. Looking too closely and for too long at a single object

may be to miss the point of the exhibition as a whole: the rhythm of the museum visit requires movement, as well as stasis. Again, Crary's broader argument applies: 'Attention always contained within itself the conditions for its own disintegration; it was haunted by the possibility of its own excess – which we all know so well whenever we try to look at any one thing for too long.'[90]

In the final part of this chapter, we turn to see what happens when attention disintegrates not via its own excess, but through the distracting allure of other visitors.

The Pleasures of Distraction

Tom Treddlehoyle's pleasure in coming face to face with a 'living portrait' in the form of Lord John Russell was one of many stories of visitors following diverse luminaries around the Art Treasures Exhibition. In fact, a culture of celebrity watching in the exhibition was fostered by the publication of the names of famous visitors, including lists of British and foreign royalty, in the weekly *Art Treasures Examiner*.[91] Typically, Hawthorne's reflections on the exhibition were frequently peppered with lively comments on the behaviour of other visitors. He was always ready to be distracted from looking at a picture by the competing spectacle of the crowd and admitted that he had often visited the second-class refreshment room in order to see 'John Bull and his wife ... in full gulp and guzzle'.[92] It was not only the presence of workers and their families in the Art Treasures Palace that captured Hawthorne's imagination. One day a fellow visitor informed him that Alfred, Lord Tennyson, the Poet Laureate, was in the exhibition and Hawthorne was delighted when he tracked him down: 'Gazing at him with all my eyes, I liked him well, and rejoiced more in him than all the other wonders of the Exhibition.'[93] Hawthorne lacked the courage to introduce himself to the great man, but discreetly continued to observe him as if Tennyson were a walking exhibit.

Beyond the Art Treasures Exhibition, the fascinating spectacle of other people has always been an integral aspect of looking in an exhibition. Seeing and being seen was central to the optical conviviality of Somerset House, and in 1811 Jane Austen wrote to her sister that her greatest pleasure in museum visiting was looking at her fellow visitors: 'Mary and I, after disposing of her Father and Mother, went to the Liverpool Museum, and the British Gallery, and I had some amusement at each, tho' my preference for Men and Women, always inclines me to attend more to the company than the sight.'[94] Perhaps it is not surprising that novelists seem to have been particularly susceptible to this form of pleasurable distraction. A decade after Hawthorne spent his summer in Manchester, his fellow countryman and author, Mark Twain, visited the 1867 International Exposition in Paris. It was a similarly gigantic

display, but for all its attractions, Twain found that 'the moving masses of people of all nations we saw there were a still more wonderful show'.[95] Like Hawthorne, he was repeatedly distracted by the sight of his fellow visitors, until, that is, he abruptly left the exhibition after just a couple of hours, having heard that the Emperor of France and the Sultan of Turkey were about to review 20,000 troops at the Arc de l'Etoile.[96]

Moving to the present, Irit Rogoff has analysed a distracting encounter that she and a friend experienced when they were visiting an exhibition of paintings by Jackson Pollock at the Tate Gallery.[97] As a professor of art history and visual culture, Rogoff felt something of a professional duty to visit the Pollock show, despite having some misgivings about both the artist and the premise of the exhibition itself. In the event, the visit of Rogoff and her companion was considerably enlivened when they spotted amongst the other spectators the actress Julianna Margulies who, at the time, was starring in the television series, *ER*. Like Treddlehoyle in pursuit of Russell and Hawthorne in pursuit of Tennyson, Rogoff and her friend found themselves tracking the actress around the gallery, happily discussing the latest plotlines and characters in the television programme whilst simultaneously 'viewing' the exhibition. This welcome distraction from the reverential attention prescribed by the installation of Pollock's work enabled Rogoff and her friend to re-orientate their visit by playing the part of television fans whilst simultaneously viewing the exhibition from a rather more oblique perspective than the curators had intended. Rogoff uses this anecdote to explore what happens when we 'avert our gaze': that is, when we deliberately do not look at the work of art that demands our contemplative attention. She argues that by resisting and disentangling ourselves from the institutional script we demonstrate a flexible capacity to view (and be viewed) within the exhibition in more ways than one.

Rogoff recounts her visit in a paper entitled 'Looking Away' which, in turn, alludes to Slavoj Žižek's work 'Looking Awry' in which he explores the Lacanian anamorphic gaze through the lens of popular culture.[98] Much of Žižek's discussion falls outside the concerns of this chapter, but the concept of anamorphosis does bear on the norm of attentive looking within the museum. Daniel Collins describes anamorphic projection as a denial of 'the usual conventions of "looking" in which an observer views an image frontally from a limited range of viewing angles. It is a technique of disruption and distortion'.[99] Instead of the perpendicular viewing position prescribed in Gilman's museum photographs, the successful observer of the anamorphic image must position herself off-centre and be 'willing to sacrifice a centric vantage point for the possibility of catching a glimpse of the uncanny from a position off-axis'.[100] It is a mode of viewing that is self-aware, skewed and playful. As Rogoff found during her visit to the Pollock exhibition, different modes of spectatorship are not mutually exclusive: they can be simultaneously folded into the experience of what she calls 'the *lived* cultural moment'.[101]

The look of the spectator can be fragmented and imbricated with alternative viewing positions: it is possible to be both art viewer *and* celebrity watcher.

Rogoff's experience in the Tate Gallery takes us back to the Royal Academy exhibitions at Somerset House, where different modes of viewing were similarly staged within a single space.[102] Within its 'catoptric' regime of glancing and gazing, and of stasis and mobility, it was possible to see oneself (and others) as both connoisseur and people watcher, and in turn, to enjoy both seeing and being seen. As soon as we insist on the re-embodiment of museum looking that takes account of the both the viewer's *and* the institutional metaphorical point of sight, it is clear that the models of one-way looking propounded by Gilman, Robinson and Melton are inadequate to the task of either understanding or managing this experience. The scopic regime of the museum is neither necessarily hegemonic nor panoptical, but has frequently been experienced as part of what Chris Otter calls an expanded 'oligoptica' of mutable, interconnected and partial looking, in which distraction can be as rewarding as attention.[103] Conversely, as we shall see in subsequent chapters, being both attentive and distracted in the museum can be exhausting and uncomfortable.

Notes

1 *The Polite Arts, Dedicated to the Ladies*, 1796. Cited in Brewer, *The Pleasures of the Imagination*, p. 276.

2 An Amateur, *Real Life In London*, p. 240.

3 John Hamilton, *Stereography, or, a Complete Body of Perspective*, London, 1738, quoted in Solkin, 'This Great Mart of Genius', p. 3.

4 Ibid.

5 Brian O'Doherty, *Inside the White Cube, the Ideology of Gallery Space*, Berkeley: University of California Press, 1976, p. x.

6 Solkin, 'This Great Mart of Genius', p. 3.

7 'Our Royal-Academical Lounge', *Fraser's Magazine*, 5, July 1832, pp. 710–11.

8 Ibid., p. 710.

9 Ibid., p. 711.

10 Solkin, 'This Great Mart of Genius', pp. 3f.

11 De Bolla, *The Education of the Eye*, p. 16.

12 Ibid., p. 4.

13 Bryson, *Vision and Painting*, p. 94.

14 Ibid.

15 De Bolla, *The Education of the Eye*, p. 73.

16 Ibid.

17 Ibid., p. 74.

18 Maurice Merleau-Ponty, *Phenomenology of Perception*, London: Routledge (first published 1945), 1962, p. 302.

19 Ibid.

20 O'Doherty, *Inside the White Cube*, p. 15.

21 O'Doherty insists the Spectator is more male than female. Ibid., p. 39.

22 Ibid., p. 41.

23 Ibid., p. 39.

24 De Bolla, *The Education of the Eye*, p. 7.

25 Ibid., p. 17.

26 'Our Royal-Academical Lounge', p. 710.

27 Hans Jonas quoted in Jay, *Downcast Eyes*, p. 24.

28 Klonk, *Spaces of Experience*, p. 24.

29 John Ruskin, *The Times*, 7 January 1847, p. 5.

30 Bennett, 'Pedagogic Objects', p. 347.

31 Mark Hallett, 'Reading the Walls: Pictorial Dialogue at the British Royal Academy', *Eighteenth-Century Studies*, 37.4, Summer 2004, pp. 581–604.

32 Carol Duncan and Alan Wallach, 'The Universal Survey Museum', *Art History*, 3.4, 1980, pp. 455f.

33 The literature on the Art Treasures Exhibition is not extensive compared with, say, the critical and historical attention devoted to the Great Exhibition of 1851. See: C.P. Darcy, *The Encouragement of the Fine Arts in Lancashire 1760–1860*, Manchester: Manchester University Press, 1976; Francis Haskell, *Rediscoveries in Art*, London: Phaidon, 1976; Ulrich Finke, 'The Art Treasures Exhibition', in John Archer (ed.), *Art and Architecture in Victorian Manchester*, Manchester: Manchester University Press, 1985, pp. 102–26; Giles Waterfield (ed.), *Palaces of Art. Art Galleries in Britain 1790–1990*, London: Dulwich Picture Gallery, 1991; Francis Haskell, *The Ephemeral Museum: Old Master Paintings and the Rise of the Art Exhibition*, New Haven and London, 2000; Helen Rees Leahy, 'Walking for Pleasure? Bodies of Display at the Manchester Art Treasures Exhibition', *Art History*, 30.4, 2007, pp. 543–63; Helen Rees Leahy (ed.), *Art, City Spectacle*, Special Issue of the Bulletin of the John Rylands University Library, Manchester, 2009; Elizabeth Pergam, *The Manchester Art Treasures Exhibition of 1857*, Farnham: Ashgate, 2011.

34 Solkin, 'This Great Mart of Genius', p. 4.

35 Old Trafford is to the west of Manchester and was chosen as the site for the Art Treasures Exhibition because, due to the prevailing 'aerial currents', the western suburbs were generally less smoky than the rest of the city. Thomas Morris, *An Historical, Descriptive and Biographical Handbook to the Exhibition of the UK's Art Treasures at Manchester*, Manchester, 1857, p. 9.

36 *Catalogue of the Art Treasures of the UK. Collected in Manchester in 1857*, London, 1857.

37 Gustav Waagen, whose catalogues of British private collections had provided both the intellectual stimulus and a practical tool for the exhibition organisers, calculated that approximately one-third of all the pictures in English collections were assembled in Manchester. Gustav Waagen, *Treasures of art in Great Britain: being an account of the chief collections of paintings, drawings &c, Volumes 1 – IV* (trans. Lady Eastlake), London: John Murray, 1854.

38 Rees Leahy, 'Walking for Pleasure?', pp. 543–63.

39 William Gladstone, *The Gladstone Diaries, Volume V, 1855–1860*, edited by H.C.G. Matthew, Oxford: Oxford University Press, 1978, p. 234.

40 Victoria Whitfield, '"The Illustrious or Infamous Dead": The Portrait Gallery of the Manchester Art Treasures Exhibition', in Helen Rees Leahy (ed.), *Art, City, Spectacle: The Manchester Art Treasures Exhibition Revisited. Special Issue of the John Rylands Bulletin*, 87.2, 2007, pp. 39–54.

41 Letter from H.R.H. Prince Albert to the President of the General Council of the Exhibition. Quoted in *Exhibition of Art Treasures of the UK held in Manchester in 1857. Report of the Executive Committee*, London and Manchester, 1859.

42 Nathaniel Hawthorne, *Passages from the English Note-books*, Cambridge, MA: Harvard University Press, 1898, p. 521.

43 Ibid.

44 E.T.B., *What to see and where to see it! Or the Operative's Guide to the Art Treasurs Exhibition*, Manchester, 1857, p. 4.

45 Ibid.

46 P.I., 'The Exhibition Undressed', *The Art Treasures Examiner*, Manchester and London, 1857, p. 60.

47 Charles Dickens, 'The Manchester School of Art', *Household Words*, Vol. XVI, London, 1857, p. 349.

48 'The Functions of Art by R.M', *Art Treasures Examiner*, Manchester and London, 1857, p. 176.

49 'Lectures at the Crystal Palace', *The Art-Journal*, III, 1 October 1857, p. 325.

50 Dickens, 'The Manchester School of Art', p. 350.

51 Charles Dickens, *The Letters of Charles Dickens, Volume 2 (1857–1870)*, edited by Mamie Dickens and Georgina Hogarth, London: Chapman & Hall, 1880, p. 23.

52 Charles Rodgers, *Tom Treddlehoyle's Peep at t'Manchester Art Treasures Exhebishan, e 1857; an uther wonderful things beside, at cum in hiz way i t'city at Manchister*, London, 1857; *Tim Gamwattle's Jawnt E Ab-O'-Dick's Oth' Doldrums Waggin, Wi O Whul Waggin full O' Foak, Fro Smobridge to Manchester O Seein't Queene, Wi Just a Wap ut th'Eggsibishun*, Manchester: John Heywood, 1857; *Rachde Felley's Visit to th' Great Eggshibishun*, Manchester, 1857; *A Yewud Chap's Trip to Manchester to see th' Queen, Prince Halbert an' th' Art Treasures Eggshibishun by Oudjohn*, Manchester: John Heywood, 1857; James T. Staton, *Bobby Shuttle un his woife Sayroh's visit to Manchester: un to th' greight Hert Treasures Eggshibishun at Owd Traffort: written for Bobby Hissel, by th' editor oth "Bowton Luminary*, Manchester: John Heywood, 1857.

53 Staton, *Bobby Shuttle*, pp. 66–7.

54 Whitfield, 'The Illustrious or Infamous Dead'.

55 Rodgers, *Tom Treddlehoyle*, p. 25.

56 *Tim Gamwattle*, p. 57.

57 Ibid., p. 58.

58 Ibid.

59 See for example: Charlotte Klonk, 'Mounting Vision: Charles Eastlake and the National Gallery of London', *Art Bulletin*, 82.2, June 2000, pp. 331–47; Tony Bennett, *Pasts Beyond Memory*, London and New York: Routledge, 2004.

60 Jonathan Crary, 'Unbinding Vision', *October*, 68, Spring 1994, p. 23.

61 Ibid.

62 See also: Jonathan Crary, 'Spectacle, Attention, Counter-Memory', *October*, 50, Autumn 1989, pp. 96–107; Jonathan Crary, *Suspensions of Perception. Attention, Spectacle and Modern Culture*, Cambridge, MA and London: MIT Press, 2001; Michael Hagner, 'Towards a History of Attention in Culture and Science', *MLN*, 118.3, April 2003, pp. 670–87.

63 Crary, 'Unbinding Vision', p. 25.

64 Edward S. Robinson, *The Behaviour of the Museum Visitor*, Washington, DC: American Association of Museums, 1928, p. 7.

65 Ibid.

66 Gilman, 'Museum Fatigue', pp. 62–74.

67 Benjamin Ives Gilman, *Museum Ideals of Purpose and Method*, Cambridge, MA: Riverside Press, 1918, p. 400.

68 Gilman, 'Museum Fatigue', p. 62.

69 Ibid.

70 Ibid., p. 70.

71 Ibid., p. 63.

72 Gilman, *Museum Ideals of Purpose and Method*, p. 239.

73 Robinson, *The Behaviour of the Museum Visitor*; Edward S. Robinson, 'The Pyschology of Public Education', *American Journal of Public Health*, 23, 1933, pp. 123–8; Andrew W. Melton, *Problems of Installation in Museums of Art*, Washington, DC: American Association of Museums, 1935; Andrew Melton, 'Visitor Behaviour in Museums: Some Early Research in Environmental Design', *Human Factors*, 1972, pp. 393–403.

74 Robinson, *Behaviour of the Museum Visitor*, p. 7.

75 Ibid., p. 15.

76 Ibid., p. 12.

77 Melton, 'Visitor Behaviour in Museums', p. 394.

78 Ibid., p. 394.

79 Ibid., p. 396.

80 Ibid.

81 Ibid., p. 396.

82 Ibid., p. 397.

83 Ibid., p. 399.

84 Ibid., p. 400.

85 Ibid.

86 Ibid., p. 398.

87 Measured by the frequency with which visitors stopped to examine objects during the last fifth of their total visit.

88 Melton, 'Visitor Behaviour in Museums', p. 398.

89 Crary, *Suspensions of Perception*, p. 5.

90 Ibid., p. 26.

91 Rees Leahy, 'Walking for Pleasure?', pp. 543–63.

92 Hawthorne, *English Note-books*, p. 543.

93 Ibid., pp. 530f.

94 Jane Austen, *Selected Letters 1796–1817*, edited by R.W. Chapman, Oxford: Oxford University Press, 1985, p.109. Also quoted in Barbara J. Black, *On Exhibit. Victorians and their Museums*, Charlottesville and London: University Press of Virginia, 2000, p. 109.

95 Mark Twain, *The Innocents Abroad*, London: Penguin Books (first published 1869), 2002, p. 86.

96 'We immediately departed. I had a greater anxiety to see these men than I could have had to see 20 Expositions.' Ibid., p. 87.

97 Irit Rogoff, 'Looking Away', in Gavin Butt (ed.), *After Criticism. New Responses to Art and Performance*, Oxford: Blackwell Publishing, 2005, pp. 117–34.

98 Slavoj Žižek, 'Looking Awry', *October*, 50, Autumn 1989, pp. 30–55.

99 Daniel L. Collins, 'Anamorphosis and the Eccentric Observer: Inverted Perspective and Construction of the Gaze', *Leonardo*, 25.1, 1992, pp. 73–82.

100 Ibid., p. 73.

101 Rogoff, 'Looking Away', p. 133.

102 De Bolla, *The Education of the Eye*, p. 16.

103 Otter, *The Victorian Eye*. For discussion on the museum as panopticon see: Crimp, *On the Museum's Ruins*; Bennett, 'The Exhibitionary Complex'.

Walking the Museum

On a brilliant day in May, in the year 1868, a gentleman was reclining at his ease on the great circular divan which at that period occupied the centre of the Salon Carré, in the Museum of the Louvre. This commodious ottoman has since been removed, to the extreme regret of all weak-kneed lovers of the fine arts; but the gentleman in question had taken serene possession of its softest spot, and, with his head thrown back and his legs outstretched, was staring at Murillo's beautiful moon-borne Madonna in profound enjoyment of his posture.[1]

So begins *The American*, a novel by Henry James published in 1876–7. Its theme is characteristically Jamesian: the unfolding tale recounts the collision of social and cultural mores when the 'new world' represented by the eponymous 'American', Christopher Newman, meets the 'old Europe' embodied in the Bellegardes, a repressive French aristocratic family. At first sight, Newman appears to be the archetypal museum 'lounger'. We find him (literally and metaphorically) laid back on the oval-shaped ottoman installed at one end of the Salon Carré in the Louvre; even James's description of this 'great circular divan' suggests a sensation of distinctly oriental luxury and ease, at odds with the ambulatory effort of viewing pictures in the museum. Having found his couch, Newman takes as much pleasure in 'his posture' as in the famous painting of *The Immaculate Conception* by Murillo that hangs on the wall in front of him. Surely every weary wanderer in the Louvre can relate to Newman's relief at being able to rest both his legs and eyes for a few minutes, but for a precise visual reference we can turn to Joseph Castiglione's painting *The Salon Carré in 1865* (Figure 13). Painted three years before the opening scene of *The American*, Castiglione shows us the very divan that James describes occupied by visitors, one of whom leans back, like Newman, to enjoy Murillo's picture in comfort.

Caught in this position, Newman appears 'listless as he lounges there', although his 'serene possession' of the couch simultaneously denotes the physical confidence of a healthy young man.[2] James describes him as 'long, lean, and muscular' and 'evidently not a man to whom fatigue was familiar'.[3]

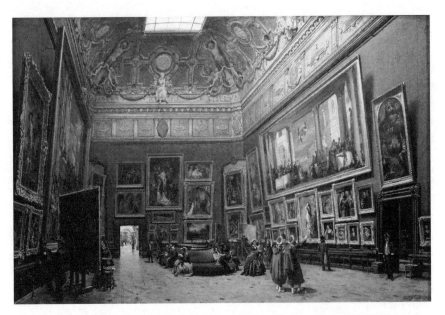

13 Joseph Castiglione, *The Salon Carré au Musée du Louvre*, 1861. © Erich Lessing.

And yet, like many thousands before and since, he has been brought to a state of exhaustion by 'a tranquil stroll through the Louvre'.[4] In any other environment, a walk of such a distance would have barely registered: tellingly, it is the combination of strolling and looking diligently at all the pictures 'marked as being worthy of note in his Beadeker' that has produced this effect. As a result, 'his attention had been strained and his eyes dazzled, and he had sat down with an aesthetic headache'.[5] Put another way, Newman is suffering from what, in 1916, Benjamin Ives Gilman would identify as 'museum fatigue': in this case, caused by a combination of visual concentration and regulated walking.[6] The *mise-en-scène* with which James opens his novel can be read as metaphor for the wider cultural encounter that is to come. Just as his impending encounter with the beautiful and elusive daughter of the Bellegarde dynasty will defeat Newman's quest for romantic love during his stay in Paris, so this vigorous and energetic young man has been reduced by an afternoon in its greatest picture gallery.

It is also a provocative starting point for an exploration of the experience of walking (conjoined with looking) in the museum. As Kirshenblatt-Gimblett points out 'mobility is a defining feature of the museum' and yet little attention has been paid, either by museum historians or theorists, to what she calls 'the museum's psychogeography, that is … the *felt* quality of its navigated space' (my italics).[7] Perhaps it is not surprising that the sensation of walking in the museum has been largely ignored by the people who work in it, albeit, as

we shall see, with some notable exceptions. From a curatorial perspective, it is the thing that makes the visitor stop still which is important – that is, the displayed artwork – rather than the process of moving from one object to the next. And yet, as we discovered in the previous chapter, museum looking cannot be extricated from museum walking. Even though institutions may pay little heed to 'the felt quality' of visitors' movement through museum space, the imperative to manage their viewing is inseparable from the need to direct their walking. In short, walking choreographs visuality within the museum. And, consequently, the museum's template for looking is continually at risk of being undermined by visitors who walk too fast, too slowly, aimlessly or in the wrong direction.

What kind of walking is therefore required by, and in, the museum, and how has this particular 'bodily technique'[8] been both institutionalised and inculcated? For a start, strictures against running recur in official rules and regulations: for example, the authorities at the Ashmolean Museum, Oxford, request that visitors 'walk and move carefully through the Museum. This protects you, other people and the objects!'[9] Here the potential danger of running is cited as justification for its prohibition; but moving too fast – and also too slowly – has been deemed problematic for different reasons within a range of museological contexts. As we saw in Chapter 1, in the early British Museum, it was the institution that set the pace: visitors consistently complained of being hurried through the rooms without being able to look at anything for more than a fleeting moment. By contrast, the aimless drifting of the distracted visitor whom Robinson and Melton had in their reforming sights, implies a mode of walking that is too slow and listless.[10] Historically, observations of 'lounging', 'parading' or 'wandering' visitors have connoted a lexicon of disapproval. For example, in his 1883 essay entitled 'The Use and Abuse of Museums', W. Stanley Jevons commented severely that 'The delectation of loungers and youngsters is no more the purpose of a great national Museum than the raison d'être of the Royal Mint is to instruct visitors in mechanical processes'.[11] However, 60 years earlier Corinthian Tom and Jerry Hawthorne had been content to describe their visit to the Royal Academy exhibition as a 'lounge'; certainly the Great Room at Somerset House required a great deal less walking, and afforded more opportunities for sitting, than, say, the Manchester Art Treasures Palace, to cite an extreme example of exhibition gigantism.

The key tenet of museum walking, established in a variety of eighteenth- and nineteenth-century contexts, was to proceed at a pace and to stop in pattern, that was 'rhythmically resonant' with the exhibition script, as well as with the movement of other visitors.[12] Walking either too slowly or too fast was therefore regarded as symptomatic of a deficit of cultural competence and, specifically, a failure to choreograph one's body with the pulse of the museum. Of course, this was a considerable challenge in a vast building such

as the Art Treasures Palace, let alone one the size of the Louvre. In the 1850s, the *Daily Telegraph* correspondent in Paris wrote that he had never met anyone who felt satisfied after a single visit to the Louvre because it was so vast that it took a day just to find your way around the building.[13] However, the same writer was also critical of those English families who marched through the galleries too fast to absorb any of their contents, and yet loudly passed opinions on what they had not properly looked at. Such comments are a reminder that the social and spatial modalities of walking and looking at art in public have been acquired via a history of practice and its associated critique.

Once more, Kirshenblatt-Gimblett usefully reminds us that 'the sensory experience of a mobile observer' within the museum 'calls for spatial and kinetic intelligence, for an ability to think with and within a materialized space of a very special kind'.[14] This chapter aims to explore what walking in the museum looks and feels like, and how it frames the experience of spectatorship.

The Art of Walking and Looking

In David Teniers's painting of Archduke Leopold Wilhelm's seventeenth-century picture gallery in Brussels, the pictures are either stacked on the walls from floor to ceiling or presented for closer inspection by a handful of cultivated viewers (Figure 14). Unlike the wandering visitors in a public museum, the Archduke's guests do not need to pace around the gallery: the paintings are all within eye contact and can be placed on a table or on the floor for detailed examination. Nor do these connoisseurs need to sit down: they are not tired from walking, and their morning in the gallery is punctuated by serious conversation rather than the need to rest.

Similarly, it was possible to stand or sit in the centre of the Great Room at Somerset House and see a very large part of the Royal Academy exhibition without moving a great deal. The angle of the walls and the use of opera glasses aided looking, albeit at an oblique angle rather than from a perspectively correct 'Point of Sight' directly in front of the picture at eye-level (Figure 2). The exhibition room was also filled with conversation, albeit of a more gossipy and flirtatious variety than the discussion amongst the exclusively male company in Archduke Leopold Wilhelm's gallery. Images of both galleries remind us that, although separated by time, space and conditions of access, they were united in providing an experience of art which was not, primarily, ambulatory. Both contrast with a different architectural precursor of the public art museum: the corridor-like 'Long Gallery' of the English country house in which walking and looking were explicitly conjoined.

Rosalys Coope has described how the long gallery evolved during the sixteenth century within the context of ecclesiastical and royal palaces, and

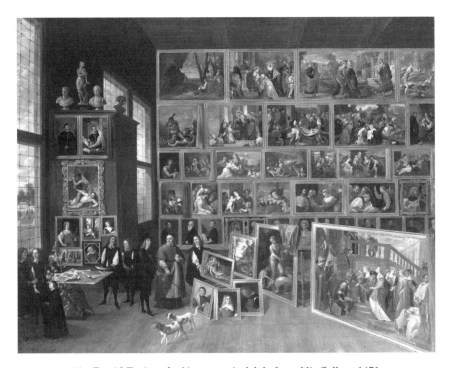

14 David Teniers the Younger, *Archduke Leopold's Gallery*, 1651.
Petworth House, The Egremont Collection. © NTPL/Matthew Hollow.

country houses: often, they combined practicality (for example, by linking two parts of a building with an enclosed corridor-like structure) with pleasure by providing a space in which to receive visitors, walk, talk and from which admire the garden.[15] By 1700, the practice of hanging family and royal portraits in the gallery was well established, sometimes against a backdrop of tapestries used as wall coverings, as, for example at Hardwick Hall, Derbyshire (Figure 15). This watercolour of Hardwick by the Birmingham artist David Cox probably dates from 1838; the artist has included figures in seventeenth-century dress to suggest what the Long Gallery might have looked like in its heyday. Pictures, including Tudor and Stuart portraits demonstrating the family's social prestige and political affiliation, are hung floor-to-ceiling against the tapestries: these were visual messages to be 'read' off the walls as visitors strolled up and down the gallery.[16] However, it was walking, rather than looking, which took precedence in the Long Gallery. Designed primarily for recreational exercise (especially during bad weather), pictures were added in order to give people something at which to look as they walked, and to function as backdrop for, and as focus of, conversation.[17]

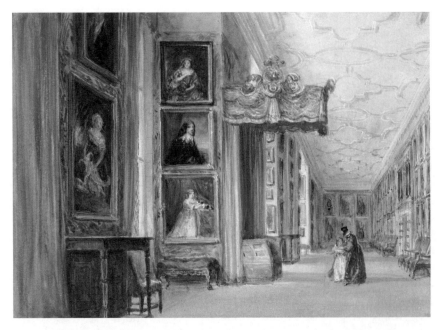

15 David Cox, *Interior of the Long Gallery, Hardwick Hall, Derbyshire*, 1838.
© Birmingham Museums and Art Gallery. The Bridgeman Art Library.

Whilst modern gallery-goers often decry the amount of walking involved in seeing a museum, the first galleries in private houses were employed precisely for walking. Paintings were added to these galleries in order to give people something at which to look as they walked.

Two important themes emerge from these brief reflections on the Long Gallery as a promenade. The first is the presence of other walking and looking bodies. The Long Gallery was primarily a social space, not unlike a modern museum, and people would have walked in company and at a pace that was rhythmically aligned with the movement of others around them. Tim Ingold and Jo Lee Vergunst argue that 'walking is a profoundly social activity: that in their timings, rhythms and inflections, the feet respond as much as the voice to the presence and activity of others'.[18] Imagine therefore a host and his guests pacing up and down a Long Gallery, discussing business or personal matters, whilst looking directly or indirectly at the pictures: their feet, voices and eyes would have been linked rhythmically to each other as well as to the dimensions of the room. Ingold and Vergunst remind us that we habitually calibrate our stride and pace in response to the presence of our fellow pedestrians: this is what makes walking social and, they argue, it is because we are social that we walk. This is why the practice of walking is central to the social life of the museum: whether or not we talk to, or even

meet the eye of, our fellow visitors, we keep pace with each other, overtake, then fall back, and take turns to stand in front of successive exhibits.

The second idea that derives from the Long Gallery as promenade is the link between walking and thinking. In an essay entitled 'The Art of Walking in Late-Nineteenth-Century Paris', Nancy Forgione describes walking as 'a coherent intertwining of body, mind, vision' and 'the exploitation of [this] triad of faculties'.[19] She notes that the history of walking makes a connection between walking and thinking, extending back in the Western tradition at least to the Peripatetic philosophers who, according to legend, practiced a method of teaching whilst strolling about. In the so-called Peripatetic school, Aristotle is said to have lectured to his pupils whilst walking up and down under a covered colonnade (peripatos).[20] Bypassing the Long Gallery promenade, Rebecca Solnit traces the modern origins of walking as a conscious cultural act (as opposed to a means of getting from A to B) to Jean Jacques Rousseau who espoused the value of walking as a mental stimulus: 'I can only meditate when I am walking. When I stop, I cease to think, my mind works only with my legs.'[21] Solnit observes that walking seems to give rise to 'kind of unstructured, associative thinking' as opposed to deep concentration: it is an improvisational relationship between mind and body, whereby the process and rhythms of walking seem to promote the process and rhythms of thinking.[22] Unlike, say, running, the speed of walking enables the walker to perceive their environment and to react to external stimuli. When you walk 'everything is moving, yet nothing is out of control'.[23]

A recurring theme in writing about walking is its capacity to integrate the inner and outer worlds of the pedestrian. Forgione's nineteenth-century walkers discovered that the activity of walking energises the senses, including vision, thereby cultivating a more heightened sense of oneself within the world. By the middle of the century, this combination of walking, introspection and self-awareness had migrated from the countryside to the bustling streets of the city. Of all the city walkers, this intense feeling of self-presence was most clearly identified with the *flâneur*, who self-consciously made use of strolling as a means to encounter urban modernity and who has become the prototypical spectator of modern life. But although the (masculine) *flâneur* dominates the literature on urban pedestrianism, in reality, he shared the pavement with men and women of different classes, some also walking for pleasure, and others for work or some other purpose.[24] According to Paul Fournel, the rapid development and commercialisation of a city like Paris exerted its own pressure on the visual capacities of those who walked its streets. In the face of such unrelenting stimulus, the detachment of the *flâneur* was replaced by the gaping, awe-struck *badaud*. Whereas the *flâneur* is always self-possessed, 'the individuality of the *badaud* disappears' under the intoxication of an urban spectacle that he can neither absorb nor resist.[25]

The next part of this chapter asks what kind of pressures did the nineteenth-century museum place on these everyday practices of urban walking? Did walking in the museum increase or diminish an individual's self-assurance and capacity to interiorise sensory experiences? Two accounts – one fictive and one a reported event – provide contrasting narratives of museum (or exhibition) walking; one of which was unexpectedly 'rhythmically resonant' with the exhibition script, whilst the other was painfully out of step.

Losing and Finding Your Way in the Museum

L'Assommoir, Emile Zola's great novel of alcoholism and poverty in nineteenth-century Paris, is also a story about walking – walking the city and also walking in the museum.[26] As Forgione observes, Zola's working-class pedestrians are quite unlike the leisurely *flâneurs* of the city, but neither are they gullible *badauds*.[27] Rather, they are 'the ordinary practitioners of the city' described by Michel de Certeau, whose moving bodies inscribe the shape of the walk and who are, in turn, shaped by and attuned to the rhythms of the street.[28] Their walking is not directed by either the voyeuristic gaze of *flâneur* or the credulous impressions of the *badaud*, but by their 'blind eye' – that is to say, a corporeal and visceral knowledge of the city.[29] In a famous passage, Zola describes how a group of friends decide to celebrate the wedding of two of the novel's characters, Gervaise and Coupeau, by visiting the Louvre. It is a wonderful account of how, as Chris Otter puts it, visuality 'captures the simultaneously physiological, practical, discursive and technospatial' dimensions of seeing. Initially, the party is delighted and amazed by the highly-polished wooden floor of the gallery which is like 'walking through water', as much as by the old master paintings on the walls.[30] Self-consciously, the group navigates the physical demands of the gallery: they enjoy stepping on the polished floor, but are also fearful that they might slip and fall. They quickly give up trying to look at the ceiling paintings because this makes their necks ache. Although certain pictures take their fancy, they are more interested in the copyists working at their easels: the performance of these amateur artists is more compelling than the 'centuries of art' that passes before 'their dazed eyes' on the gallery wall.[31] However, it is not long before the party itself forms a conspicuous presence in the gallery:

> people sat down on the benches to watch the procession at their ease, while the attendants shut their mouths tight so as not to make rude jokes. And the wedding party, already weary and feeling far less awestruck, dragged their hobnailed boots and clattered their heels on the noisy floors, like the trampling of a herd running amok in the bare and solemn grandeur of the galleries.[32]

The spectators have now become the spectacle, caught in a web of glances and stares exchanged between visitors, staff, copyists and artworks. After a while, the visit begins to descend into chaos when the group loses its way in the maze of galleries and they find themselves going round in circles, unable to locate the exit. As the group becomes increasingly lost, weary and despondent, they continue to attract the attention of other visitors and of the gallery attendants who 'watched them go past and marvelled'.[33] Within this play of appearances, viewers are also viewed and their conduct is calibrated as a register of cultural competence by other visitors and the museum staff. As Rogoff reminds us 'the performance of exclusion has nothing to do with entrance or access and far more to do with perceptions of the possible'.[34] She argues that 'entering a space inscribed with so many caveats and qualifications ... leads to the active production of questions concerning the very rights of entry and belonging'.[35] Lost inside the Louvre, Zola's wedding party was trapped in a performance of their own cultural exclusion. According to Bourdieu and Darbel, the passage in the novel evokes the 'reverential distancing exerted by the museum' that manifests itself in 'the respectful confusion of all chance visitors ... [who are] destined in the course of their visit to prompt malicious remarks from the regulars, laughter from the sketchers and calls to order from the warders'.[36]

As we saw in the previous chapter, similar experiences of unease and confusion were encountered by many visitors to the 1857 Art Treasures Exhibition. To many commentators, Manchester was, to say the least, an incongruous setting for such an exhibition. During the previous decade, authors such as Benjamin Disraeli, Elizabeth Gaskell and Charles Dickens had fixed the city within the national imaginary via its literary aliases: 'Mowbray', 'Coketown' and 'Milton'.[37] Each denoted a city whose skyline was delineated by chimney stacks, and whose daily rhythms were regulated by the exigencies of the cotton mill. Within its heart, 'the ceaseless roar and mighty beat, and dizzying whirl of machinery, struggled and strove perpetually'.[38] Gaskell's Manchester novels repeatedly evoke a city of 'haste, bustle and speed' where both masters and men were equally and continually 'busy and restless'.[39] In her 'Milton', 'there were few loiterers – none walking for mere pleasure'.[40] Yet the constant weekday motion of men and machines meant that, like Zola's walkers, its inhabitants relished the chance to stroll whenever they could. Gaskell describes how, on a Sunday morning, 'there was a pleasure, an absolute refreshment in the dawdling gait they, one and all of them, had'.[41] Just walking, rather than hurrying, was a means of physical and mental recuperation.

The invitation to participate in the Art Treasures Exhibition invoked a choreography of walking and looking that involved neither rushing nor strolling. Within the vast complex of the Art Treasures Palace (as in the Louvre) the challenge was to find a pace of walking that combined both economy of motion and aesthetic receptivity. Evidence suggests that many

did not. Defeated by the sheer size of the Art Treasures Palace, it was virtually impossible to establish a mode of walking that was 'rhythmically resonant' with the spatial relations between artworks as well as with the movement of other bodies inside the crowded galleries. Diverse guidebooks encouraged a mode of purposive strolling along a pre-determined route in order to apprehend the exhibition in an unhurried, yet efficient, manner in the course of a single visit. In practice, the disaggregated bodies of individual visitors within the social body of the exhibition were more or less willing and competent to conform to the prescription of walking both for pleasure and for edification.

Yet the Art Treasures Palace was also an inclusive space in which a wide repertoire of recreational practices was authorised, even if the presence and behaviour of certain categories of visitors aroused a degree of censure or anxiety. By the end of the summer of 1857, innovative practices of walking in the exhibition had developed amongst parties of working-class visitors. Nowadays an organised outing to an exhibition usually comprises an aggregate of private individuals; in 1857, it provided an opportunity to perform the communal identity of a school, club or association through processional walking, carrying banners and wearing uniforms. By the mid-nineteenth century, rituals of processional walking were well established in Manchester and across the north of England. The custom of local 'Walking Days' or 'Whit Walks' had first emerged within the Sunday school movement in recognition of the need of child workers, literally, to stretch their legs out of doors after a week confined to the factory or workshop. Now, similar processions of schools, temperance societies and boys' clubs entered the Art Treasures Palace, walking behind their flags and banners, and sometimes accompanied by their own bands. Their attendance was recorded in the weekly *Art Treasures Examiner*, next to the names of visiting dignitaries, thereby conferring both publicity and approval on their collective presence in the exhibition.[42]

Many factory owners followed suit by arranging and financing outings for their workers and their families, confident in the expectation that the assembly of their workforce would enhance the reputation of the company. Perhaps the largest and most spectacular single visit took place on Saturday 19 September, when 2,500 workers from the 'monster manufactory of Messrs Titus Salt and Co, of Saltaire', near Bradford, came to Old Trafford 'all attired in their Sunday best'.[43] They travelled to Manchester in three special trains, accompanied by a brass band and a drum and fife band. Marching behind their banners and the two bands, the workers processed into the Palace 'in an orderly manner, with the bands playing "The Fine Old English Gentlemen"'.[44] The bands continued to play during the workers' visit, entertaining their colleagues and their families during lunch (served in two sittings of 1,250 in the large dining room next to the second-class refreshment room) and

then, taking up 'a commanding position in the Clock Gallery', the drum and fife band played a selection of their most popular pieces to the 'evident gratification of many of the visitors'. Some apparently regarded the music as hardly 'fit' for an art gallery, 'but even these cheerfully acquiesced on the principle that some licence should be conceded' to such an extraordinary event.[45] The evident sense of occasion and the display of the workers' *esprit de corps* contrasted with the confusion and fatigue felt by other visitors; the purpose of the Saltaire outing was to participate in the exhibition as an end in itself, not to look at 16,000 works of art in one day. The music that they brought with them no doubt engendered a holiday spirit; it also enabled the workers to overlay a rhythm of walking that was entirely familiar on to the daunting spatial logic of the Art Treasures Palace.

Turning Corners

Michel de Certeau argues that the elevated posture of the pedestrian transforms the world into a 'text that lies before one's eyes'.[46] But as the guests at Gervaise and Coupeau's wedding discovered, the spatialised text of the museum is not equally legible to every visitor; unlike Henry James's *American*, they lacked both Christopher Newman's self-confidence and his Beadeker to prevent them from walking round in circles. In practice, the curator's elevated view of the exhibition plan is always susceptible to being ignored or misunderstood by visitors who walk against the grain of the museum's master narrative, whether intentionally or not. Allowing uncertainty and chance to steer a different course may reveal unexpected and enriching connections, actualising an alternative exhibition narrative, but simply getting lost can be tiring and alienating. Walking pleasurably in the museum is an acquired technique.

From an institutional perspective, the challenge is to minimise the risk of visitors failing to walk in the right direction and at the right pace. Gilman believed that the logic of the exhibition must be evident at all times: 'They must know where they are at any time, what remains before them and whither to turn to reach it.'[47] And, given that the goal of most museum visitors was to see its 'chief treasures' in the course of a couple of hours, 'an easily comprehensible circuit through the whole space' would enable them to achieve this 'without bewilderment, difficulty and waste of time'.[48] Precisely how to produce this effect was, of course, a matter of debate. Early twentieth-century opinion was divided over the relative merits of what 'space syntax' theorists call either 'probabilistic' or 'deterministic' museum layouts.[49] The question was, how much choice should a visitor have en route through the museum? A 'probabilistic' layout is one in which the visitor can opt to walk in one direction, or another: it is not determined by a single linear script, but is improvisational and encourages exploration. For example, the German

museum reformer, Alfred Lichtwark, who was director of the Hamburg Kunsthalle from 1886 to 1914, devised a circuit in which individual galleries were accessible from broad corridors, allowing visitors to choose which to enter, without having to go through every room. By contrast, a 'deterministic' layout follows a fixed, unidirectional route, so as to relieve the visitor of any possibility of confusion or uncertainty. However, proponents of both approaches agreed on the elimination of certain architectural features that had been popular in the nineteenth century. For example, the alignment of doorways to form a long vista down an *enfilade* of rooms, was deemed both distracting (because the visitor's eye was liable to be caught by the sight of a distant exhibit) and fatiguing (because the vista also suggested a lengthy walk was required to reach that tantalising object).[50]

So far so good, at least in principle: but many museum buildings are a palimpsest of past adaptations and accretions, whose logic is still discernible in odd architectural disjunctions and remnants of outdated display conventions. Writing about the Victoria & Albert Museum in the early 1970s, the architectural theorist, Robert Harbison, described the collision between a complex building and a display regime which was still divided into so-called 'primary' and 'secondary' galleries:

> The floor plan of the Victoria and Albert Museum caters remarkably to the divided mind ... The four floors are not 1,2,3,4 but 1,A,2,B – as it were two systems present in the same place. Floors adjacent do not communicate, giving a feeling of not being able to get hold of what is nearby ... The two-things-in-the-same-place scheme is echoed by a bifurcation of the displays into galleries which show all kinds of objects of a certain period and galleries containing a certain class of object in all periods.[51]

Added to this, the biases of collecting and curatorial expertise sometimes produced a mystifying version of history, without, of course, any public explanation: 'In the Renaissance Italian is separated from the others whilst after the Renaissance English is separated and Italian goes back. Continental art ends in the eighteenth century and English continues to the early twentieth.'[52]

The result, according to Harbison, was that even experienced visitors got lost and, crucially, for the museum pedestrian, 'For some reason, turning corners in the Victoria and Albert is more pointedly an arbitrary act than in other museums, as if the straight line of history were suddenly bent'.[53] He also felt that the difficulty was compounded by the fact that the museum visitor thinks that they *should* look at the exhibits in the 'right' order: by deviating from the prescribed route, 'the spectator feels he is violating history, that it would be more serious to look at things in the order they are displayed'.[54] In fact, as Harbison points out, it is easier to make historical connections by starting in the present and working backwards: in effect, to reverse the chronology of most museum displays that start with their oldest artefacts

and end with the most recent. Walking backwards in the museum can be productive, but only if you do not lose your physical and intellectual bearings each time you turn a corner.

Walking in Rhythm

Once we re-attach the disembodied eye of the museum visitor to their peripatetic body strolling, striding or drifting through the gallery, it is obvious that the question of pace is critical to the 'felt experience' of the museum. By pace, I mean both the duration of a single visit, and also the spatio-temporal rhythm of the museum's display measured out in human steps. As people move through a gallery, their bodies articulate the shape of their museum visit, whether or not they conform to its script or walk in the 'right' direction. Their movements calibrate the space of the gallery as a quantity of both distance and time. They also respond to the pulse of display, in terms of both the quantity and the spatial arrangement of exhibits. However, knowing how to walk in the museum is not straightforward: Harbison observes that, 'Nothing tells [the spectator that] he is not supposed to look at everything; he must learn that it is not feasible. Instructions for using ... a museum have not been written because they would be instructions for using the mind, and these skills are much harder than they look'.[55]

They would also need to be kinaesthetic instructions on how to move at a pace that is 'rhythmically resonant' not only with the curatorial script, but also with the visitor's judicious editing of that script. In the absence of such useful guidance, we can adduce an approved mode of walking from its associated prohibitions (for example, against running) and criticisms (for example, of people walking too fast or too slowly). The ideal mode of walking appears therefore to be purposive, but also improvisational, and slow enough to be attentive, but not listless. It also needs to take account of the scope of the exhibition as a whole: as Harbison says, you cannot look at everything.

This intersection of space, time and energy is what Henri Lefebvre called 'rhythm', which he argued was fundamentally corporeal.[56] That is to say, we first experience and know rhythm through the beats, measures and cycles of our own bodies. Similarly, the rhythm of a museum visit is somatic and is set by the punctuation of our walking as we stop to look ... before moving on again, as well as by our pace of walking, and the overall duration of the visit. In turn, each of these factors reflects the structure of the display, the density of the exhibits and the size of the exhibition or building. Applying Lefebvre's concept of 'rhythmanalysis', the reciprocal operation of space and time in the museum becomes clear: each functions as both the experience and the measure of the other. When the rhythm of a visit is either too compressed (as in the eighteenth-century tours of the British Museum) or too prolonged (as

in the visit of Zola's wedding party to the Louvre), the effect is both alienating and exhausting. Of all the museum's bodily techniques, setting the pace may be one of the most difficult.

In July 2009, the performance artist Marina Abramović created a project for the Whitworth Art Gallery, Manchester, in which she re-calibrated the conventional relationship between time and space in an exhibition through a radical restructuring of the museum visit. Entitled *Marina Abramović Presents* …, at the heart of the project was Abramović's interest in re-choreographing the rhythm of the museum, by both deconstructing and reconstructing its narrative in space and time, primarily through the agency of the human body. First, she curated the bodies of a dozen other performance artists, installing each of them in his or her own room or space within the Whitworth. Then, she curated the bodies of the audience via an hour-long induction process that she called 'The Public Drill'. In effect, this was what Lefebvre calls 'dressage': an intensive re-training of the bodies of the exhibition audience so as to overturn their acquired habits and expectations, and to re-orientate them within an alternative spatio-temporal framework (Figure 16). Put another way, the purpose of The Public Drill was to re-set the rhythm of the museum by re-setting the rhythms of its visitors – and vice versa.

16 The Public Drill, *Marina Abramović Presents* …,
Whitworth Art Gallery, Manchester, 2009.

The exhibition was open at fixed times each day, and required prior booking. At the time of booking, visitors were required to sign up to Abramović's 'Rules of Engagement', which included staying in the museum for the four hours of the durational exhibition. On arrival at the Whitworth they were asked to leave their bags, coats and phones in the cloakroom and to put on a uniform white lab coat before being mustered into a large gymnasium-like gallery. Lining up along a grid of crosses marked out on the floor, visitors then took part in the hour-long Public Drill under Abramović's direction. In order to prepare the audience for the experience of time-based performance, Abramović led them through a series of mental and physical exercises, ritualising basic actions to slow down participants' breathing, drinking, looking and, finally, walking. At the end of the hour, Abramović slowly led everyone in a procession out of the room and into the rest of the building. The remaining three hours were undirected: visitors could walk, stand and sit to watch any or all of the performances for a long or as little as they liked, except that they were asked not to do any of the usual things associated with a gallery visit, such as making a phone call, buying a coffee, going to the shop – or leaving the building. Water, dry fruit and biscuits were available in the now empty room where the Public Drill had taken place. At the end of the four hours, a gong sounded signalling the end of the exhibition: as they left, visitors were given a 'certificate of endurance' authorised by Abramović, before taking off their white coats, gathering their belongings and walking back out on to the street.

Abramović's project deliberately disrupted the quotidian rhythms and navigation of the museum in order to bring the conventions and habits of looking and walking back into focus. Critics who argued that the process of 'dressage' (the Public Drill) over-determined the audience's subsequent experience of the performance works located throughout the building missed the point: the Public Drill was an end in itself, and the rest of the 'show' served primarily as kind of laboratory in which the effects of Abramović's re-calibration of visitors' bodies could be experienced.

The previous year, the conventions of museum mobility had been disrupted in a contrasting project staged at Tate Britain: whereas *Marina Abramović Presents …* was concerned with slowing down the rhythm of the museum, Martin Creed's exhibition called *Work No. 850* explored the idea of dramatically speeding it up. *Work No. 850* comprised a succession of people running as fast as they could, at 30-second intervals, through the Duveen Gallery, the grand neo-classical hall (86 metres long) that forms the architectural axis of the building (Figure 17). The work reflected Creed's fascination with running as an everyday experience that is both commonplace and disconcerting: if you see someone running in the street, how do you know if they are running to something – or running away from something? Are they being chased, or are they chasing? The idea of the work was simple: to re-evaluate our cultural

17 Martin Creed, *Work No. 850*, Tate Britain, London, 2008.
Photograph: Shaun Curry © Getty Images.

expectations of museum movement and to see what happens when someone violates the unwritten code of comportment:

> Indoor public spaces ... are still exempt from the cult of running. If you break into a sprint in a library or a church or an art gallery, somebody will probably try to stop you. So coming across Martin Creed's *Work No. 850* at Tate Britain, your first response is, naturally, surprise, with a slight added frisson of danger. You're in a museum. This means a social rule is being broken.[57]

The impact of Creed's installation derived from being simultaneously unexpected and predictable: the appearance of successive runners at regular intervals and sprinting in a straight line imposed its own rhythm and order on the museum, in contrast to the slow and meandering paths of 'ordinary' visitors. It was not only the unexpected velocity of someone running at full pelt through the neo-classical gallery, the simultaneous pounding of the runners' feet was a reminder that the sound of the museum is invariably muted and that the footfall of the strolling visitors is soft, rather than loud. Walking noisily in the museum invariably strikes a dissonant note, as Zola's heavily booted visitors discovered. The sound of clattering steps in the Louvre also provided the soundtrack the famous Louvre scene in Jean-Luc Godard's film *Bande à Part* (1964) that Creed's work, in turn, echoed (Figure 18).

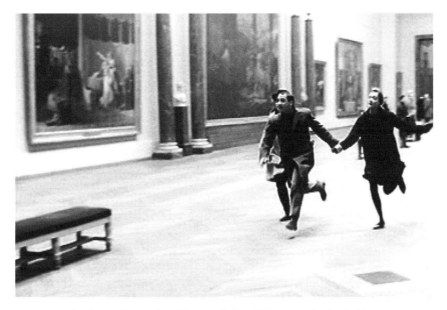

18 Anna Karina, Sami Frey and Claude Brasseur in *Bande à Part*,
directed Jean-Luc Godard, 1964. Copyright British Film Institute (BFI).

In the scene, a group of three friends attempt to beat the world record for
running through the Louvre in nine minutes and 43 seconds, which, according
to the film's narrator, had been set by Jimmy Johnson of San Francisco.
Godard's so-called *sprint du Louvre* was directly quoted by Bernardo Bertolucci
in his film *The Dreamers* (2003) when another trio of two young men and a
woman consciously re-enact the scene from Godard's film. The friends are
cinephiles, and their stunt is intended both as an homage to Godard and as
an act of identification with the trio of friends in *Bande à Part*. Having decided
that they are going to do it, the scene immediately cuts to the three running
through the museum, and a shot of Anna Karina as Odile in *Bande à Part* is
intercut with Eva Green playing Isabelle in *The Dreamers*.

The projects by Abramović and Creed provocatively re-imagined the
experience of speed and time in the museum drawing on conventional, but
not static, coordinates. Over the past century, museums themselves have also
modified their ambulatory expectations of visitors and have adapted their
rhythms in order to increase accessibility and comfort. For example, vertical
movement has been, and remains, a critical aspect of museum pedestrianism,
but the installation of lifts and escalators has supplemented or replaced stairs
and, in turn, has recalibrated the time and effort of moving between floors.

A common survival of the museum's ideological past is an imposing flight
of steps from the ground to its elevated entrance.[58] The nineteenth-century

museum used these steps both to project its separation from the mundanity of the street and also to work on the bodies of its visitors by ritualising their passage into the sphere of culture.[59] Perhaps the most extreme proponent of the benefits of physical effort as preparation for both the mind and body prior to entering the museum was John Ruskin. In 1875, when Ruskin founded the St George's Museum in Walkley, near Sheffield, he deliberately chose a site at the top of a steep hill on the principle that its audience would find the climb 'symbolically instructive'. He explained that, 'The mountain home of the Museum at Walkley was originally chosen, not to keep the collection out of smoke, but expressly to beguile the artisan out of it'.[60] More generally, and certainly in larger museums, the expectation that visitors would be willing and able to climb a great many stairs was gradually perceived as being incompatible with the principles of inclusive access and the practical amelioration of museum fatigue. In 1905, the *Museums Journal* noted with approval plans to install a lift in the Louvre, which it declared 'shows such thoughtful consideration for visitors as ought to excite emulation in other places, for all concerned with museums well know how the upper floors are neglected by visitors owing to the toil involved in reaching them'.[61] However, one aspect of the innovation would surprise today's visitor: the cost of the lift was estimated at £1,200, which was intended to be defrayed by the levy of a small charge from those who used it.

The contemporary imperative to extend museum access has produced an architectural typology that is designed to remove every barrier to admission, be it physical, social or cultural. The substitution of stairs (and hills) with escalators and lifts not only eases the visitor's journey into and through the building it also replaces an arduous climb with the exhilaration of moving effortlessly through vertical space. Today, the exertion of climbing has been replaced by physical stasis inside a lift or on an escalator, from which the visitor can see the interior of the building unfold as they effortlessly ascend and descend. Travelling on an escalator is as prescriptive as walking through a closed sequence of rooms: you cannot get off until you reach the top and, in this sense, it is the vertical equivalent of a 'deterministic' floorplan. The social body of the museum is disclosed during the ascent through the building: seen from above, the exhibition is revealed as a spectacular ensemble of objects and people.

However, the obvious imperative for the presence of lifts and escalators in the museum in terms of accessibility and inclusivity has rarely been extended to the installation of horizontal moving walkways (or moving sideways). The 'travelator', or moving walkway, has only made a rare appearance in museum space, despite its first appearance at the 1893 World's Columbian Exposition in Chicago, where it efficiently shuttled 31,680 passengers around the site every hour. A French version, the *trottoir roulant*, was one of a number of technological innovations on show at the 1900 Exposition Universelle in Paris,

including the diesel engine and film projection. The Parisian *trottoir roulant* comprised walkways travelling at three different speeds, which, according to Philippe Jullian, 'caused many an incident worthy of the vaudeville, separating families, sending old men sprawling, delighting the children and reducing their nannies to despair'.[62] Apparently, it was also a popular spot for pickpockets who took full advantage of the moment of hesitation in stepping from one walkway to another. Nonetheless, it formed a speedy and practical way of navigating the vast exhibition site, and was itself regarded as a technological marvel.[63]

The travelator has subsequently been used in a number of museums, primarily as a means of moving people across a large site, such as the moving walkway that connects the West and East Buildings of the National Gallery of Art, Washington, DC. Within the exhibition itself, however, it has the obvious disadvantage of controlling the time spent in front of each exhibit: a mechanical equivalent of an eighteenth-century conductor in the British Museum. A notable exception to the museum's general aversion to the travelator is the short moving walkway installed by Historic Royal Palaces in front of the crown jewels in the Tower of London in 1994. Described by the *Museums Journal* as 'an inspired way of rationing access' to an exhibition that can attract 20,000 people a day (or 2,700 an hour), a similar desire or need for 'rationing' spectatorship has not been felt elsewhere.[64]

Taking a Seat

Finally, let us conclude this chapter where we began, by taking a well-earned rest – or rather, by looking for a seat where we can interrupt our walk. Christopher Newman was lucky to find a spot on the 'great circular divan' in the Salon Carré: not all visitors have been as fortunate. In 1841, Sir Henry Ellis, Principal Librarian at the British Museum, acknowledged visitors' complaints about the lack of seating in the museum, despite the provision of 'benches in some parts, and chairs in others' and reported that 'two dozen chairs' had been ordered to address the problem.[65] The question of museum seating is therefore closely related to the practice of museum walking, as well as to the pace and duration of the gallery visit. How many and what kinds of seats should be provided for weary visitors without encouraging indolence or cluttering the gallery? In the terminology of the nineteenth century, how could the museum ensure the comfort, as well as the edification, of its audience without turning itself into a 'lounge'?

Ironically, benches seem to be most prevalent in exhibitions where the least walking is required. In Rowlandson's print of the 1808 Royal Academy exhibition, benches upholstered in green fabric fill the centre of the room and whilst the majority of spectators stand to gain a clearer view of the

exhibits, others sit down to talk, rest or read the catalogue (Figure 2). As well as enabling sociability, the provision of seating could also be intended (and used) to support the sustained contemplation of a work of art. For example, when the new wing of the Gemäldegalerie Alte Meister in Dresden designed by Gottfried Semper opened in 1855, an entire room was devoted to the museum's most famous masterpiece: Raphael's *Sistine Madonna*.[66] Hans Belting describes this installation as 'a new kind of chapel – where visitors sat in silence on velvet-upholstered chairs in front of the masterpiece that loomed over them intimidatingly in a golden frame on a veritable altar of art'.[67] Having removed the Raphael from what Nicholas Serota has described as 'the conveyor belt of art history' presented by the museum, viewers could also stand – or sit – still in order to admire it.[68]

The design of museum seating has always been viewed as both an aesthetic problem and, sometimes, an architectural opportunity in the gallery. For example, a large freestanding radiator in the centre of the room was often enclosed, and thus disguised, by a purpose-built seating unit. Klonk illustrates a particularly elaborate example of this common practice. In 1905, the artist and designer, Bernhard Pankok, was commissioned to design a new scheme for the Königlichen Gemäldegalerie in Stuttgart: as part of his scheme to integrate contemporary art and design, he created elaborate furniture to conceal the gallery radiators, including a row of writing desks running down each side of one long radiator, with a set of shelves for books and journals at each end.[69] However, the presence of gallery furniture has also encountered curatorial resistance: for example, when it is deemed to interfere with an intended display effect. Seating for the galleries in Tate Modern was designed by the project architects, Herzog and De Meuron. However, their curved wooden benches were apparently deemed too 'artistic' by the curatorial team and were reputedly removed from some of the rooms so as to ensure that the seating did not compete with the art on display.[70]

The stop-start promenade of the large museum (like Tate Modern) is, as we have seen, singularly tiring, irrespective of whether or not the visitor pays attention to all or many of the artworks en route. Given that Gilman believed that museum fatigue was caused by the physical, rather than the mental, effort of spectatorship, it is not surprising that he addressed the issue of seating in a discussion of 'ideal restful inspection'. He believed that the key was prevention, rather than cure: 'We are at sea on the question of the best way to provide seats in a museum until we catch sight of the truth that their foremost office is not to restore from fatigue, but to prevent its advent.'[71] Working on this principle, Gilman argued that seats are 'most useful not when they afford the greatest ease and when they most exempt the visitor from the temptation to go on examining things, but when they afford just enough ease to make it comfortable to go on looking and are conveniently distributed amongst the exhibits for this purpose'.[72] Echoing the anxieties of

earlier museum administrators and curators, his point was that seats should be 'supports rather than lounging places'.[73] As if he has the image of Christopher Newman relaxing on the comfortable divan in the Louvre in his mind's eye, Gilman deplores the customary provision of 'cushioned ottomans inviting to repose; and to be so placed in the centre of galleries or along the walls that nothing but a general view of the exhibits can be obtained from them'.[74] As a result, the viewer ceases to be a viewing subject and becomes the object of attention: 'sitting down one becomes a cynosure; when one wants and ought to remain a neighbouring eye'.[75]

Gilman's solution was what he called a 'tabouret', or a lightweight stool, which visitors could pick up and move to their preferred position in front of an exhibit. As the idea was to prevent, rather than relieve, fatigue, the fact that the stool would not be very comfortable was beside the point: his aim was to enable people to spend longer in front of objects that particularly interested them, which would be more likely if they were not standing up, and for this purpose, a rudimentary design would suffice. The simplicity of the tabouret design was also intended to avoid filling the gallery with furniture, thereby impeding the passage of other visitors. Gilman called his solution 'the unit of *exhibit plus seat*' and although he is rarely credited with its formulation, the provision of portable (usually folding) stools for visitors is now a familiar alternative to the cushioned ottoman in many exhibitions.

Meanwhile, Gilman's provocative comment about the visitor becoming a 'cynosure' within the museum provides a neat link to the next chapter on the interaction between spectatorship and performance.

Notes

1 James, *The American*, p. 33.

2 Ibid., pp. 36 and 33.

3 Ibid., p. 33.

4 Ibid., p. 36.

5 Ibid., p. 33.

6 Gilman, 'Museum Fatigue', pp. 62–74.

7 Barbara Kirshenblatt-Gimblett, 'The Museum – A Refuge for Utopian Thought', 2004, p. 4. Online at: www.nyu.edu/classes/bkg/web/museutopia.pdf.

8 Mauss, 'Techniques of the Body'.

9 Ashmolean Museum Rules. Online at: www.ashmolean.org/documents/LAOmuseumrules.pdf.

10 Robinson, *Behavior of the Museum Visitor*; Melton, 'Visitor Behavior in Museums'.

11 W. Stanley Jevons, 'The Use and Abuse of Museums', in *Methods of Social Reform and Other Papers*, London: Macmillan, 1883, p. 61.

12 Tim Ingold and Jo Lee Vergunst (eds), *Ways of Walking. Ethnography and Practice on Foot*, Farnham: Ashgate, 2008.

13 S.-J. Bayle, *The Louvre, or Biography of a Museum*, London: Chapman & Hall, 1855, p. 7.

14 Ibid., p. 3.

15 Rosalys Coope, 'The "Long Gallery": Its Origins, Development, Use and Decoration', *Architectural History*, 29, 1986, pp. 43–72 and 74–84.

16 Mark Girouard, *Life in the English Country House*, New Haven and London: Yale University Press, 1978, pp. 100–01.

17 Classen, 'Museum Manners', p. 897.

18 Ingold and Vergunst, *Ways of Walking*, p. 1.

19 Nancy Forgione, 'Everyday Life in Motion: The Art of Walking in Late-Nineteenth-Century Paris', *The Art Bulletin*, 87.4, December 2005, p. 664.

20 Rebecca Solnit, *Wanderlust. A History of Walking*, London: Verso, 2001, p. 15.

21 Quoted in ibid., p. 14.

22 Ibid., p. 21.

23 Mirjam Schaub (ed.), *Janet Cardiff. The Walk Book*, Koln: Walther Konig, 2005, p. 74.

24 Janet Wolff, 'The Invisible Flâneuse: Women and the Literature of Modernity', *Feminine Sentences. Essays on Women and Culture*, Cambridge: Polity Press, 1990, pp. 34–50.

25 Quoted in Jay, *Downcast Eyes*, p. 119.

26 Zola, *L'Assommoir*.

27 Forgione, 'Everyday Life in Motion', p. 665.

28 Michel de Certeau, *The Practice of Everyday Life* (trans. Steve Rendall), Berkeley: University of California Press, 1984, p. 93.

29 Daniela Zyman, 'At the Edge of the Event Horizon', in Schaub, *Janet Cardiff. The Walk Book*, p. 11.

30 Zola, *L'Assommoir*, p. 89.

31 Ibid., p. 90.

32 Ibid.

33 Ibid.

34 Rogoff, 'Looking Away', pp. 120f.

35 Ibid.

36 Pierre Bourdieu and Alain Darbel, *The Love of Art. European Art Museums and the Public* (trans. Caroline Beattie and Nick Merriman), Oxford: Polity Press, p. 49.

37 Benjamin Disraeli, *Sybil: Or the Two Nations*, London: Henry Colburn, 1845; Charles Dickens, *Hard Times*, London: Bradbury & Evans, 1854; Elizabeth Gaskell, *North and South*, London: Penguin Books (first published 1855), 2003.

38 Gaskell, *North and South*, p. 407.

39 Ibid., p. 296.

40 Ibid.

41 Elizabeth Gaskell, *Mary Barton*, Oxford: Oxford University Press (first published 1848), 2008, p. 269.

42 For example, on Saturday 7 September 'There were several excursion trains to Manchester. Mr [Thomas] Cook had another "moonlight trip" from Newcastle, by which about 1,000 passengers reached Manchester about seven o'clock in the morning … About 450 of the work people in the employment of Messrs.Winkworth, Proctor, & Co., of Macclesfield; about 800 in the employment of Messrs.Cooke, of Oxford Road; about 400 in the employment of Messrs.Houldsworth and Co., of Manchester; and about 520 connected with temperance societies in Bradford and Halifax were also amongst the throngs who, by special train or otherwise, visited the Palace'. *Art Treasures Examiner*, Manchester and London, 1857, p. 240.

43 Ibid., p. 252.

44 Ibid.

45 Ibid.

46 De Certeau, *The Practice of Everyday Life*, p. 92.

47 Gilman, *Museum Ideals of Purpose and Method*, pp. 227f.

48 Ibid.

49 Yoon Kyung Choi, 'The Morphology of Exploration and Encounter in Museum Layouts', *Proceedings of the Space Syntax First International Symposium*, Vol. 1, London, 1997, p. 16.1.

50 Noordegraaf, *Strategies of Display*, pp. 97f.

51 Robert Harbison, *Eccentric Spaces*, Cambridge, MA: MIT Press, 2000, p. 144.

52 Ibid.

53 Ibid.

54 Ibid., p. 145.

55 Ibid.

56 Henri Lefebvre, *Rhythmanalysis: Space, Time and Everyday Life*, London: Continuum, 2004.

57 Tom Lubbock, 'Is Art Running Out of Ideas? Artists Forced to Explain Modern Art', *Independent*, 14 July 2008. Online at: http://uk.mc867.mail.yahoo.com/mc/welcome?.partner=bt-1&.gx=1&.tm=1267205172&.rand=951ld5vfje3f6.

58 Nikolaus Pevsner, *A History of Building Types*, London: Thames and Hudson, 1976.

59 Carol Duncan, *Civilizing Rituals: Inside Public Art Museums*, London: Routledge, 1995.

60 E.T. Cook and Alexander Wedderburn (eds), *The Library Edition of the Works of John Ruskin*, 39 vols, London: George Allen, 1903–12, Vol. 30, p. 317.

61 'For the Convenience of Visitors', *Museums Journal*, 4, April 1905, p. 363.

62 Philippe Jullian, *The Triumph of Art Nouveau: Paris Exhibition 1900*, London: Phaidon, 1974, p. 184.

63 'At one time, it was man who moved over the ground; but such is our mastery of matter that it is now the ground which moves under man.' *Journal of a Negro* quoted in ibid., p. 185.

64 Maurice Davies, 'Three-Minute Heritage', *Museums Journal*, May 1994, p. 23.

65 Quoted in Jonah Siegel (ed.), *The Emergence of the Modern Museum. An Anthology of Nineteenth-century Sources*, Oxford: Oxford University Press, 2008, p. 97.

66 Semper's building, known as the Neues Königliches Museum, formed a wing of the Zwinger Palace.

67 Hans Belting, *The Invisible Masterpiece*, London: Reaktion, 2002, p. 61.

68 Serota, *Experience or Interpretation*.

69 Klonk, *Spaces of Experience*, p. 65.

70 Karl Sabbagh, *Power into Art*, London: Allen Lane, 2000, p. 320.

71 Gilman, *Museum Ideals of Purpose and Method*, p. 270.

72 Ibid.

73 Ibid., p. 271.

74 Ibid.

75 Ibid.

4

Performing the Museum

In the centre of a grand exhibition hall, a man wearing a top hat, neat tie and light coloured trousers stands apart from his fellow spectators and surveys the scene (Figure 19). His detachment from the clusters of chattering friends and families that surround him is marked not only by his solitude, but also by his self-assurance and equipoise. By contrast, few other visitors are alone: most stand or sit in pairs or groups, walking arm in arm, and a number are consulting catalogues or guidebooks. It is not a famous painting or sculpture that has caught his attention: he is looking up at the balcony galleries ranged around the hall, from which his fellow spectators can, in turn, look down at the scene below. For this visitor at least, the mobile transience of the assembled bodies appears more captivating than the collection of the art treasures that he has, ostensibly, come to see. Like Baudelaire's *flâneur*, he appears at ease in the 'heart of the multitude, amid the ebb and flow of movement, in the midst of the fugitive and the infinite'.[1] And being both part of and distinct from the crowd, he seems to the embody the 'metropolitan individuality' that was described by Georg Simmel as prone to self-distanciation, reserve and fastidiousness as strategies of both self-preservation and self-assertion within the modern city.[2] But this is not the Paris of Baudelaire, nor Simmel's Berlin; it is Manchester in May 1857. Once again, the scene is the Art Treasures Exhibition.

As we saw in Chapter 1, prints of exhibitions and their visitors have a regulatory function: reading the print, actual visitors may see themselves reflected, flattered and sometimes satirised as archetypes within a broad art public, whilst others may imaginatively project themselves into the exhibition crowd through their identification with certain figures and their rejection of others.[3] As Matheson puts it, the 'first duty of the exhibition print is to record (and thus ratify) the constitution of the … show through convincing graphic accounts of individual performances, the relation between them, and the cumulative visual impact of the ensemble'. And related to this, 'the second duty … is to testify to the efficacy and power of the spectacle by representing a strategic cross-section of viewer responses'.[4] In other words, such prints

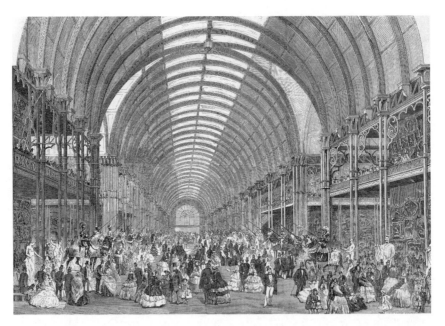

19 Art Treasures Exhibition: The Grand Hall, *Illustrated London News*, 9 May 1857.

interpellate the reader as a viewing subject, delineated by appearance and comportment. Tellingly, few members of the well-dressed crowd in depicted in Figure 19 are actually looking at the displays: most appear to be talking to their companions whilst simultaneously absorbing the noise and spectacle of the great hall in the centre of the Art Treasures Palace. It was not only the extraordinary mass of artworks that impeded focused concentration within the exhibition: we have already seen that celebrity watching was a frequent occurrence in the exhibition, and the spectacle of one's fellow visitors en masse was equally, if not more, distracting. Critics of the exhibition frequently complained that many visitors were more interested in the social performance of participation, than in the works of art:

> If ladies and gentlemen had to go to Old Trafford in deal cases, and see each for himself the several pictures so shrouded, only the light above and the Art Treasures before them; in other words, if they had to go solely for the pictures – to look at the pictures and not at their neighbours – how many season tickets would have been sold, how many crinolines would have choked the turnstiles?[5]

The daily musical programme, under the management of Charles Hallé, which took place in the Art Treasures Palace was both an acknowledgement of the physical and mental challenge of viewing art on such a vast scale and also a licence to combine strolling and listening. Even if many visitors

continued looking at the displays during the recital, for a couple of hours each day the collective activity of listening overlay the atomised viewing of art. Dickens suggested that, for many, the afternoon concert provided a welcome respite from the serious business of the exhibition: 'The experience of the regular frequenter of the Manchester galleries was that, the majority of the well-dressed crowd gossiped and grouped around the music, promenaded and looked and admired each other – did everything, in short, except examine the pictures.'[6]

Every visit to an exhibition or museum is populated with a series of transient encounters with other visitors: strangers in public with whom we share the private experience of looking at art. Beyond the frame of the print of the great hall were other visitors for whom the Art Treasures Exhibition could sometimes be an uncomfortable social space and who lacked the self-assurance of Dickens's 'well-dressed crowd'. Just as the wedding party in *L'Assommoir* was subject to the silent condescension of visitors and staff in the Louvre, so too the unfamiliar company and conventions of the exhibition could catch out an unwary novice, such as Tom Treddlehoyle or Bobby Shuttle. All of the fictive characters who were brought to life in local dialect accounts of an outing to the Art Treasures Palace, committed trivial social solecisms or were occasionally rebuked for not understanding the etiquette of the exhibition. When Sayroh Shuttle grew tired of walking around the galleries, her husband Bobby appropriated a bath chair that was conveniently to hand – until the person who had hired it for the day reappeared and they were obliged to relinquish it.[7] Even the relatively worldly Tom Treddlehoyle suffered various mishaps inside the crowded galleries, including tripping up over a lady's flounced hem and falling into another's skirt: 'forrads ah flew; and if it heddant been at me noaze cum e contact we another laidiz' bussal, at wort stickin aght like a truss a hay, likely enif ah sud a goan reight flat upon t'floor.'[8] However, Tom's embarrassment is swiftly tempered by his characteristically practical reflection that such vast skirts turned women into 'dreizen machines' whose long trains served just one useful purpose: to keep the floor clean. This thought enables him to recover from his 'bit ov a disaster' and cheerfully carry on looking around the exhibition.

This chapter is about the range of performances, both scripted and improvised, that visitors enact inside the museum. Does a successful performance necessarily depend on the 'correct' reading of the institutional script, and if not, what other factors contribute to a requisite display of competence when we adopt the role of exhibition viewer? Tony Bennett quotes some important advice offered in a 'Short Sermon to Sightseers' at the 1901 Pan-American Exposition: 'Please remember when you get inside the gates you are part of the show.'[9] The duality of looking and being looked at inside the gallery means that the museum audience is, according to Gaynor Bagnall, always 'performatively attuned to the spectacle of the performance of

others'.[10] If so, are the cues for such performances generated by the institution or by other visitors – or both?

The museum's script enunciates what Judith Butler terms a series of 'performatives' that make the body both legible and manageable. Performatives are, she says, 'forms of authoritative speech: most performatives, for instance, are statements that, in the utterance, also perform a certain action and exercise a binding power'.[11] As Elizabeth Gray Buck puts it: 'The "hey you, don't touch" or "silence please" produces a museum body that is never unwieldy, noisy, smelly, or dirty ... This body, described and conditioned by nineteenth century museum guidebooks, is only an eye that roams demurely'.[12] As we have seen in previous chapters, the museum's script is also encoded in the rhythm of its displays that regulates the direction and pace of walking and in the organisation of pictures on the gallery wall that engenders a specific modality of looking.[13] Kirshenblatt-Gimblett describes the technique through which museums 'stage knowledge' as 'object performance': that is, a means both of arranging objects in space and also of installing the visitor in relation to them.[14]

Yet we have already encountered numerous examples of recalcitrant bodies that have rebuked the museum's performatives. Intentionally or not, these visitors resist the official script and, as Butler says, they do not comply with the norms that would compel them to act according to its strictures. Sometimes visitors' responses to the exhibition's lessons are half-hearted, tiring or mentally and physically confusing; they improvise, or reject the institutional script altogether. In other words, the empirical *performances* of individual visitors may conform to, ignore or resist the prescriptive institutional *performative*. Each of these incorporated responses reveal a degree of 'habit acquisition' – in this context, familiarity with the operation of the museum – that provides the visitor with a repertoire of potential, appropriate and situated actions.[15] But what happens when the museum deliberately changes the script and disrupts the repertoire, the familiar choreography of viewing? The next section explores visitors' performances produced by strategies of showing that are devised to unsettle their awareness of themselves as viewing subjects.

Unsettling Spectatorship

From surrealism to conceptualism and relational aesthetics, radical artists have disrupted visitors' habits and expectations of museum comportment by distorting their experience of gallery space. Famously, in 1938 at the *Exposition Internationale du Surréalisme* at the Galerie Beaux-Arts, Paris, Marcel Duchamp transformed the gallery into a kind of cave by covering the gallery ceiling with (he claimed) '1,200' coal sacks, so that a shower of coal dust fell on to

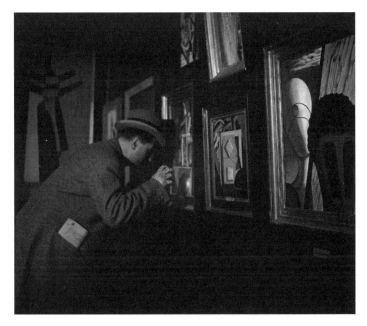

20 Josef Breitenbach, *Exposition Internationale du Surréalisme*, Galerie des Beaux-Arts, Paris, 1938. © The Josef and Yaye Breitenbach Charitable Foundation, New York, courtesy the Josef Breitenbach Archive, Center for Creative Photography, Tucson.

visitors' clothes, and by lighting the space with a single bulb (Figure 20).[16] The floor was covered with dead leaves, ferns and grasses, and an iron brazier was installed in the centre of the main room. Artworks were hung on makeshift panels made from the revolving doors taken from a department store. Just as significant in terms of bodily relations in the exhibition was an element of its 'object performance' that was not realised.[17] Originally, Duchamp had wanted to install 'magic eyes' that would have automatically illuminated an artwork whenever a viewer crossed an invisible ray in front it. The idea proved impractical, but Man Ray adapted the idea for the opening night by turning out the lights and distributing hand-held torches to visitors. Elena Filipovic points out that the solution retained much of Duchamp's original intention: viewers were obliged to lean forwards so as to focus their flashlight on the picture surface – in other words, to abandon the conventions of 'proper distance', disembodied viewing and the 'enlightening' clarity of the typical art gallery. In contrast to the conventions of the modernist art space, where 'the spectator was choreographed to keep a safe distance … and to forget his or her body', Duchamp reasserted the corporeality of seeing by demonstrating that the possibility of vision depends on the approach of the body.[18]

In 1941, Duchamp was responsible for a installing a show in New York in aid of French Relief Societies entitled the *First Papers of Surrealism* (Figure 21).

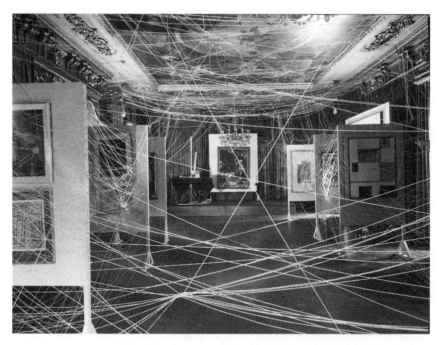

21 John Schiff, *First Papers of Surrealism*, New York, 1942.
Philadelphia Museum of Art: Gift of Jacqueline, Paul and Peter
Matisse in memory of their mother Alexina Duchamp.

The exhibition was held in the drawing rooms at the Whitelaw Reid mansion, New York, whose Italianate opulence Duchamp subverted by weaving a three-dimensional web of twine across the walls and ceilings, simultaneously framing and obstructing the display of artworks. The tangled mesh did not cut off vision entirely: Duchamp's objective was to frustrate, not eliminate, sight. Guests at the opening party were doubly confounded, both by the entangled conditions of viewing with which they were confronted and also by the presence of a group of boys and girls running around and playing games in the exhibition. These children had been invited by Duchamp and instructed simply to continue skipping, playing ball and larking around, and to ignore the comments of the adult guests.

Duchamp's tactics were devised to tease and exasperate the spectators, and also to make them aware of themselves in the act of deciphering, and thereby completing, the creative act that he had initiated. Here art is experienced not as a discreet 'acting out' of perception,[19] but through a heightened consciousness of one's body installed in relation to the object in space. Tony Jackson and Jenny Kidd have described the experience of 'unsettlement' within the museum as potentially 'stimulating, surprising, generating a sense of dissonance that requires further thought', but it can also be uncomfortable when visitors find

'themselves trapped inside an event that they find exasperating, irritating, demanding more of them than they wish to give, but from which there is no escape'.[20] At times, it can also be physically strenuous – and even dangerous.

In 1971, the sculptor Robert Morris was invited to create a retrospective exhibition of his work at the Tate Gallery. During the course of developing the exhibition concept, Morris described his intentions to the curator in charge of the project, Michael Compton, in phenomenological terms:

> Time to press up against things, to squeeze around, crawl over – not so much out of a childish naïvete to return to the playground, but more to acknowledge that the world begins to exist at the limits of our skin and what goes on at that interface between the physical self and external conditions doesn't detach us like the detached glance.[21]

The ensuing exhibition consisted of lumps of metal or stone, balls that could be propelled along tracks, ramps, climbing frames, balancing beam, ramps and unstable platforms. The gallery was divided into three zones, each of which required slightly different physical interactions between spectators and objects: in the first area, objects were acted upon by the spectator (for example, by heaving lumps of metal); in the second part, the spectator set the object in motion (for example, by rolling or propelling balls or cylinders); and in the third section, spectators were enjoined to climb, squeeze, crawl, balance their bodies into and on fixed structures. Explaining the kind of performative field that he envisaged for the exhibition, Morris wrote: 'I want to provide a situation where people can become more aware of themselves and their own experience rather than more aware of some version of my experience.'[22] A number of 'demonstration' photographs (featuring Tate Gallery staff) were installed in the exhibition, as a visual prompt to direct visitors' interaction with the exhibits (Figure 22).

In the event, the exhibition attracted 2,500 visitors in just five days, at which point it was closed due to a number of injuries sustained by members of the public, as well as damage to some of the exhibits, resulting from the 'exuberant and excited' response of some visitors to the radical possibilities of the museum as a space of play.[23] Described variously in the press as 'an assault course' and a 'fun fair', the early closure of the exhibition seemed to signal a failure both of the institution to anticipate the public's response and of the public to interact playfully, but not chaotically, with Morris's installation. Catherine Wood tries to locate more precisely the reasons for the exhibition's 'failure' by contrasting the self-reflexive practice of the artist in his studio with the position of the spectator in the public museum. Whereas Morris and his peers used photography continually to view and to review their practice, visitors to the exhibition simply could not see themselves 'acting out' in the same way: 'Without the self-consciousness that is literally provided as feedback by the image, the ideal of the body-object relationship

22 Demonstration photograph displayed at the exhibition,
Robert Morris, Tate Gallery, London, 1971.

becomes threateningly unsteady.'[24] In other words, the exhibition's radical premise exceeded the familiar coordinates of the self-image, as well as the past experience, of the viewing subject within the art museum: visitors to Morris's show could not see themselves within the exhibition, but others could. This doubling of the 'beholder's role' is, Wood argues, inherent in how the art museum frames participation: the spectator is not only part of the spectacle, but also perceives herself as such.

Nearly 30 years after *Robert Morris* closed at the Tate Gallery, it was restaged in May 2009 at Tate Modern, entitled *Bodyspacemotionthings*, as part of an emerging trend in exhibition revivals or 're-dos' (Figure 23).[25] Once again, Morris's black and white photographs from 1971 of the Tate staff demonstrating the exhibits were displayed: their function on this occasion was not to provide visitor instruction, but to provide referents to, and quotations from, the original installation. In the event, *Bodyspacemotionthings* showed

23 *Bodyspacemotionthings*, Tate Modern, London, 2009.
Photograph: Shaun Curry © Getty Images.

how the reinstallation of an exhibition 28 years later could not recapture the radical impact of its original incarnation. This was partly due to the effects of health and safety policies on the methods of construction used in 2009, as well as the regulation of visitor access to Morris's interactive sculptures. To avoid a repeat of the chaos of the original show, the exhibits were modified and made from less hazardous materials in order to reduce the risk of injury, and visitors were carefully supervised by gallery staff who watched over every piece and guided visitors in their use.

Far from creating the 'bedlam in which all rules of decorum had been abandoned'[26] the show now resembled an unusually well mannered playground. Had the exhibition been reinstalled in the neo-classical Duveen Gallery at Tate Britain, some measure of the disjunction between Morris's invitation to roll, climb and wobble and the etiquette of the traditional art gallery might have been preserved. Transposed into the art playground of the Turbine Hall at Tate Modern, *Bodyspacemotionthings* was re-staged as family entertainment: the risk of the original was erased, not only with deference to current practices of health and safety, but because interactive art has become commonplace, and visitors have become aware of themselves as public performers in the field of relational aesthetics.[27]

'Watch your Step' at Tate Modern

Since 2000, the Turbine Hall at Tate Modern has been the site of a series of annual commissions in which the triangular relationship between body–artwork–space has been interrogated and re-staged by successive artists.[28] The launch of each project is a major public relations event for the Tate: in short, the spectacle of sculpture keyed to the massive dimensions of the Turbine Hall fills newspapers and draws a crowd. Mieke Bal has observed that scale has become the common denominator of the series: 'In an exhibition space so monumental as to require works especially made for it, one expects something huge. The Turbine Hall of Tate Modern is so enormous that one needs the spatial reassurance of an artwork that fills it.'[29] Perhaps not surprisingly, the projects that have been most successful in 'filling' the Turbine Hall, both conceptually and actually, have each dramatised visitors' corporeal interaction with the artwork, by extending and challenging their repertoire of cultural consumption. Kirshenblatt-Gimblett argues that all museums activate propriocepsis (that is, 'how the body knows its own boundaries and orientation in space'[30]), but in the Turbine Hall, propriocepsis is deliberately sensational, in both meanings of the word. To adapt Merleau-Ponty's formulation that our bodies are things that are 'caught in the fabric of the world', in the Turbine Hall they are (sometimes literally) caught in the fabric of the work.[31] In phenomenological terms, the visitor's performance is an ontological process that occurs at the intertwining of the body and the world or, more specifically, at the intersection of their embodied subjectivity and the materiality of the museum.

The opening commission in 2000 at Tate Modern was by Louise Bourgeois and was entitled *I Do, I Undo and I Redo*. The installation comprised a massive metal spider (*Maman*) and three tall steel towers, at the top of which was a platform reached by a flight of stairs. Limited numbers of people were allowed on to the platforms at any time and queues formed at the base of each tower, as visitors waited for their turn to climb the stairs and then, having reached the platform, to sit, stand, talk and look around, before making their descent – all the whilst being watched by other visitors, looking down from the surrounding balconies and up from the floor. The visual and physical encounters between climbers and onlookers, architecture and artwork were, in turn, captured and reflected in the large mirrors suspended above the platforms. Within the context of the newly opened Tate Modern, this interplay of mutual self-regard, reflexive panopticism and self-display was a novel experience. With hindsight, Bourgeois's project signalled the start of a sustained intersection between the Turbine Hall and the practice of relational aesthetics, described by Nicolas Bourriaud as artwork that takes 'as its theoretical horizon the realm of human interactions and its social context'.[32] According to Bourriaud's formulation, an installation like *I Do, I Undo and I*

Redo functions as 'a machine provoking and managing individual and group encounters'.[33] By the time that Bourgeois's work was dismantled, an agenda was set for the Turbine Hall as a site in which an expanded art public would henceforth be constituted via managed and improvisational practices of embodied sociality, self-conscious performance and mutual self-regard.

The brooding presence of Bourgeois's giant spider and steel towers contrasted with subsequent projects by Olafur Elliasson and Carsten Höller that licensed a more relaxed and playful occupation of the Turbine Hall. Perhaps the most vivid display of stranger sociability was produced by the fourth commission, *The Weather Project* by Olafur Elliasson (Figure 24). Here Elliasson used the ubiquity of the ostensible subject (the weather) to trigger the visitor's awareness of the mediation of the museum in their perception of

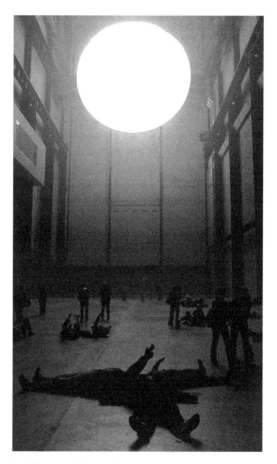

24 Olafur Elliasson, *The Weather Project*, Tate Modern, London, 2004.
Photograph: Chris Young © Press Association Images.

the artwork via the transformation of the Turbine Hall into a gallery of special effects. Each day, the space was filled with a fine mist that accumulated as faint, cloud-like formations, before dissipating across the hall. The ceiling itself 'disappeared' behind mirrored panels, so that an image of everything and everyone in the hall below was caught in their vast reflection, and the mass of visitors became the object of its own fascination. At the east end of the Turbine Hall, a giant semi-circular form made up of hundreds of mono-frequency lamps was similarly captured in the ceiling's reflection, forming the illusion of a dazzling sphere.

For Elliasson, the interplay of reflection and reflexivity were central to the project: in his words, 'our ability to see ourselves seeing allows us to evaluate and criticise ourselves'.[34] Its phenomenological ambition (to render the visitor conscious of his perception) was therefore entwined with its critical ambition (to render the visitor conscious of the conditions of seeing and thus of the institutional frame). Accordingly the Tate exposed the mist-making machines attached to the walls of the Turbine Hall and the lamps that illuminated it, so as deliberately to dispel the installation's illusory effects and reveal its mechanisms of production. Whether or not the tactics of institutional critique were evident to the mass audience that revelled in the novelty of the installation is another matter. James Meyer argued that the magnitude of the installation was itself overwhelming and as a result, 'the museum is not so much "revealed" as transformed into a destination, an event', whilst the most compelling aspect of *The Weather Project* was 'the work's social effects'. In response to Elliasson's manipulation of effect, visitors sat and lay down on the floor of the Turbine Hall, the better to see their own reflection in the huge overhead mirrors. Individually and collectively, people arranged their bodies to form shapes like stars and snowflakes, watching themselves as they opened and closed their limbs in rotational symmetry. Other visitors, looking down from the internal balconies and viewing platforms, formed an auxiliary audience for this collective performance. The journalist Andrew Marr described the play of sociality produced by *The Weather Project* as a moment when 'contemporary art folded into mass experience, if not an act of collective worship then perhaps a silent, optical rave'.[35] It was also the moment when, with the blessing of the institution, visitors abandoned the decorum of the white cube gallery and occupied the Turbine Hall with their lying, sitting, touching, talking, embracing, eating, drinking, dozing, self-absorbed, consuming bodies.

Two years later, Carsten Höller's project called *Test Site* provided an even more ludic experience of contemporary art when he installed three, tubular slides that spiralled down the height of the Turbine Hall (Figure 25). The idea of the 'test site' was to experiment with the sensation and the spectacle of sliding within the incongruous setting of an art museum. As well as the 'inner spectacle' (the state of simultaneous delight and anxiety of the descent)

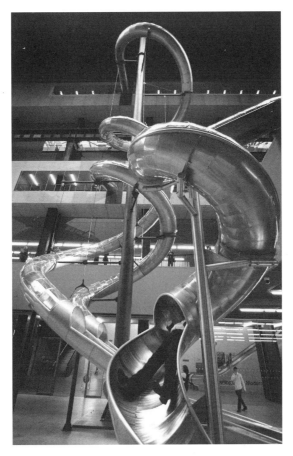

25 Carsten Höller, *Test Site*, Tate Modern, London, 2006.
Photograph: Peter Macdiarmid © Getty Images.

experienced by the sliders themselves, onlookers (within the museum and online via a webcam) were drawn into the extraordinary spectacle of people propelled through transparent tubes suspended mid-air inside an art museum. The embodied experiences and casual conviviality stimulated by both *The Weather Project* and *Test Site*, contrived by the artists in collaboration with Tate itself, were (at least, ostensibly) permissive and inclusive; both Elliasson and Höller resisted a single or correct reading of their respective projects. On the contrary, each installation was contrived as if everyone involved was conducting some kind of investigation into open-ended questions that visitors would actually be able to answer: how often do you talk about the weather each day? What does it feel like to hurtle down a slide?

By contrast, Doris Salcedo articulated a very specific reading of her site-specific commission for the Turbine Hall in 2007, entitled *Shibboleth* (Figure

26 Doris Salcedo, *Shibboleth*, Tate Modern, London, 2007.
Photograph: Edmond Terakopian © Getty Images.

26). Salcedo's work was jagged fissure that ran across the floor of the Turbine Hall, beginning as a hairline crack and gradually growing wider and deeper. At its furthest extent, it was some six inches wide and about two feet deep. Shortly after the public opening of the installation, a sign was posted at the entrance to Tate Modern alerting visitors to 'watch your step' in a response to the number of people who lost their balance or caught their feet by stepping too close to, or into, the crack, and thus formed a new category of visitors known to the Tate staff as 'trippers'. As soon as the piece was revealed to the press and public, the tantalising notion that it posed a trivial physical risk only increased its popularity amongst amused visitors who explored the boundaries of the crack as if to test the limits of their balance. Following the installations by Elliasson and Höller, *Shibboleth* soon became another site of physical play and mutual self-regard, although this time, at odds with the meaning of the work intended by both the artist and Tate.

According to Salcedo, the work represented the fault-line in society between rich and poor, included and excluded. This, she says, is the dark legacy of racism and empire that underlies the modern world: '*Shibboleth* is a negative space: it addresses the w(hole) in history that marks the bottomless difference that separates whites from non-whites ... which runs parallel to the history of modernity, and is its untold dark side'.[36] However, despite the efforts of both the artist and the museum to fix the meaning of *Shibboleth* as a fracture in modernity, the institutional account of the work was at odds with how it was perceived and performed by many of its many visitors. Even the name, *Shibboleth*, was displaced in the media by its popular pseudonym, 'The Crack', thereby signalling both a loss of official meaning and also the project's success as a publicity coup, talking point and visitor attraction. Meanwhile, the mystery of how 'The Crack' was made became a source of fascination and the Tate's refusal to be drawn on this question inevitably fuelled speculation amongst visitors and in the media.

The curator Achim Borchardt-Hume prescribed how the work should be experienced: 'visitors have to commit the time it takes to walk its 150-metre length ... Akin to a procession, this walk invites us to look at what we have been conditioned to look away from'.[37] In fact, very few visitors walked up and down its entire length compared with those who followed it for a whilst, and then when the crack became wide enough, stepped into it, strode across it, lay down next to it, and peered into it. Borchardt-Hume also asserted that 'whilst the Turbine Hall's monumentality feeds the hunger of a profane culture for sublime experiences, *Shibboleth* quietly refuses to be comfortably consumed'.[38] In fact, the opposite was the case. *Shibboleth* may have been intended as a more unsettling work than either *The Weather Project* or *Test Site*, but as Lisa Jardine commented after visiting the Tate on a Saturday evening, 'those roaming up and down the Turbine Hall last weekend seemed to be making their own meaning, rather than following an itinerary mapped out by the artist'.[39] For many, this process of 'making meaning' was a physical and social performance: 'hands were held across the crack at its widest points. Children stood arms akimbo over it, peering downwards. Groups clustered as if in consultation at the points where it deepened, or changed direction'.[40] Performatively attuned to artworks such as *Test Site* and *The Weather Project*, the audience at Tate Modern had become used to consuming the Turbine Hall as playground and photo opportunity: it was impossible for *Shibboleth* to project its more sombre message on to the flow of leisured, entertainment-seeking and self-conscious bodies. The issue was not so much whether certain corporeal responses were more or less appropriate to the work, but rather the recognition that the bodies of visitors were interpretative agents that were generating new meanings of *Shibboleth* through their actions and reactions. These were improvisational bodies acting against the grain of institutional and artistic intention by encountering the work on their own terms. The moment

of dissent was, however, fleeting as the museum swiftly reincorporated these 'transgressive' bodies into a strategy of audience development that embraced both the contrasting corporeal regimes of the modernist white cube gallery and the permissive 'street' of the Turbine Hall. Tate's response to the public's simultaneous misreading of and fascination with 'The Crack' revealed what Nick Prior calls its 'allotropic' capacity to 'cater for a more fickle audience hankering after spectacle' whilst maintaining its authority as a national museum.[41]

The Turbine Hall has never been a space of quiet reflection and visitors' response to *Shibboleth* showed that the work was too ambiguous to resist its own transformation by the body-space relations enacted within it. Meyer has pointed out that there is no possibility of retreat from the throng of spectacle in the Turbine Hall; instead it functions to instrumentalise 'the phenomenological encounter of the work of art, within a scenario of unrelenting global museological competition'.[42] Finally, why did visitors fall into 'The Crack'? Despite the massive publicity surrounding the work, were they somehow unprepared for their embodied encounter with it, thereby failing to achieve an appropriate 'balance between the inner and outer horizon', between perceiving subject and object? Some people seemed unaware that it was an actual break in the fabric of the gallery (one visitor is reported to have stumbled into the crack because she had thought it was painted on to the floor) and some tried their luck by walking along its edge, only to catch their shoe at its jagged rim. Others simply stumbled because they were talking to their companions and forgot to look down. But accidents aside, a fissure was an unsettling presence: *Shibboleth* was designed to de-stabilise, and like Robert Morris's 1971 exhibition, it did – literally.

Incorporating the Period Eye

In recent years, projects designed to raise awareness of oneself not only as viewing subject, but also as an embodied participant, within the art exhibition have been developed by academic curators, as well as by artists. The most interesting of these have focused on the historical conditions and institutional conventions of spectatorship, with the objective of alerting the contemporary viewer to differences in the performativity of spectatorship, past and present. These have attempted to evoke the ways in which today's museum objects would have been viewed and handled in the past, sometimes via the reconstruction of historical exhibitions (further examples of exhibition 're-dos'). Such techniques have a long museological history: Alexandre Lenoir explicitly manipulated the use of light and colour to effect specific visual and corporeal responses to the display of medieval artefacts at the Musée Royale des Monuments Français in 1795.[43] Over 200 years later, similar visual

(and also aural) strategies were used to evoke an atmosphere of medieval piety and courtly culture in the redisplay of the Medieval & Renaissance Galleries at the Victoria & Albert Museum, London, which opened in 2009. A more innovative, albeit modest, attempt to enable contemporary viewers to experience historical object-body relations was staged in the 1999 exhibition *A Sense of Heaven* at the Henry Moore Institute, Leeds (Figure 27). This was a small exhibition of early sixteenth-century boxwood sculptures, such as rosary beads, that were designed for personal devotion. To see each one, the viewer had to kneel down, as if on a *pre dieu*, and then open two wooden panels to reveal the 'sculpture' beneath. The obvious limitation of the display was that the visitor could see, but not touch, the tiny objects that had been made to fit into a person's hand; even so, the installation successfully focused the eyes and the body of the visitor in an un-museum-like posture of solitude, intimacy and concentration.

27 *A Sense of Heaven. Boxwood Sculptures for Personal Devotion 1500–1560*, Henry Moore Institute, Leeds, 1999. Photograph: Jerry Hardman-Jones © Henry Moore Institute.

Reconstructions of historical exhibitions may have similar objectives: for example, to reproduce past modalities of display and spectatorship, and thus build an archive of the immaterial through retrospective and performance practices. Recent 'exhibitions of exhibitions' have included allusions to, and quotations from, past installations to full-scale re-enactments and reconstructions.[44] For example, *Art Treasures in Manchester: 150 Years On* at Manchester Art Gallery celebrated the 150th anniversary of the Manchester Art Treasures Exhibition in 2007. As a re-presentation of the original exhibition it was avowedly partial and fragmentary; the fragility of the surviving artworks effectively precluded the reassembly of the famous 'Ancient Masters' section, which had consisted almost entirely of paintings on unstable wooden panels that are rarely, if ever, lent nowadays. Similarly insurmountable was the issue of scale. The Art Treasures Palace was large enough to accommodate some 16,000 exhibits and, thankfully, Manchester Art Gallery is not. The spectatorship invoked by *Art Treasures in Manchester* was therefore located firmly in the present: it barely departed from a horizontal axis of display whereby pictures are viewed serially along a wall, each accompanied by a small text label and separated from their neighbours by a respectful gap.

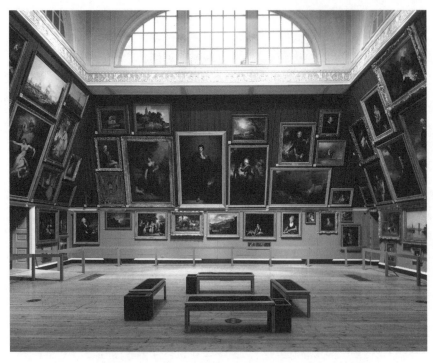

28 *Art on the Line*, Courtauld Institute of Art, London, 2002.
By courtesy of The Samuel Courtauld Trust, The Courtauld Gallery.

By contrast, *Art on the Line* curated by David Solkin at the Courtauld Institute in 2002 was a more ambitious reconstruction in terms both of presentation and also conditions of reception (Figure 28). The 2002 exhibition was, in effect, a composite recreation based on Royal Academy exhibitions staged between 1780 and 1836; critical to both its rationale and impact was the opportunity to mount the exhibition in the Great Room at Somerset House, complete with the reconstruction of angled walls to increase the visibility of 'skied' pictures. Contemporary prints of the Academy exhibition provided the curators with rich visual accounts of its scopic regime of pictures and viewers; as a result, *Art on the Line* not only replicated a typical Academy hang of the early nineteenth century, but also recreated its visual performatives for a contemporary audience. The walls of the gallery were hung with densely packed, historically precise displays: there was not an inch to spare between the paintings' frames, let alone space for the customary museum label.

Art on the Line deliberately re-positioned contemporary viewers in the same physical and visual relation to the paintings on display as their nineteenth-century predecessors at the Royal Academy. Instead of walking around a line of paintings each hung at the same (accessible) height, visitors stood or sat in the middle of the room and looked up and down: horizontal looking gave way to vertical looking, aided by opera glasses needed to see the very highest pictures. A different (and for many, surprisingly pleasurable) technique of looking was invoked by the display of pictures from wall to wall, and floor to ceiling. Viewing paintings in these conditions also enabled an appreciation of the visual tricks deployed by artists to ensure that their works stood out from the crowd. Reflecting on the unexpected 'lessons' of *Art on the Line*, Solkin noted how it had revealed the skill of artists in 'working' the space of the Great Room, anticipating the relative positions of picture and spectator, and calculating how to maximise their painting's impact. For example, the curators discovered that a surprising number of artworks had been designed to be seen from below and, far from being shown to disadvantage when viewed at an angle, they looked much better when they were hung tilted forwards, above the Academy's famous 'line'.[45] Solkin concluded that, for the first time in living memory, the Great Room itself was revealed 'as a gallery space ... supremely well designed for the spectacular display of historic British art'.[46]

Accustomed to viewing works placed sequentially along a wall, with the optimal viewing position squarely in front of the individuated work of art, the 'gaudy chaos'[47] that greeted visitors to *Art on the Line* required a process of visual and physical re-tuning. Instead of being guided along a sequence of paintings as if reading a text, the viewer's eye was once more free to roam the crowded wall, making one's own connections and following one's fancy. Freed from the need to stand in the 'proper place', everyone in the exhibition could see the pictures from a slightly different vantage point, both physically and metaphorically. It was this social aspect of early nineteenth-century

viewing the exhibition that Solkin wanted both to emphasise and recreate, recalling the principle that 'instead of being just one, there are many equally proper "points of sight", that these will necessarily give rise to a variety of opinions, and that pleasure will arise from their expression and exchange'.[48] Put another way, the installation required an activation of what Michael Baxandall termed the 'period eye' in order both to decode the visual effects of the exhibition and also to re-locate oneself in the position of historical spectators at the Royal Academy.[49]

Baxandall's concept of the 'period eye' is based on the premise that the skills involved in apprehending works of art are historically and culturally acquired and that, in turn, the artist responds to the en-skilled (or attuned) viewer. As Adrian Randolph observes, the period eye emphasises the cultural-constructedness of vision, characterises a set of viewing norms, and charts the manner in which artists responded to those norms in their works.[50] Taking the example of Piero della Francesco's *Annunciation*, Baxandall suggests that a fifteenth-century Chinese man, entirely unfamiliar with the conventions of perspectival painting and the biblical story depicted, might suppose that the figures whom we recognise as the Virgin Mary and the Archangel Gabriel were paying homage to the column in the centre of the picture. Can we extend this idea to the operation of visuality within an exhibition? David Carrier suggests that we can: 'Because we are accustomed to the ways in which visual artworks are displayed in modern galleries and museums, it is easy to forget how recently these ways of presenting art have been created and how they influence our judgment of artworks.'[51] In this context, *Art on the Line* functioned as a practical experiment for both audience and curator. For Solkin it prompted a deeper understanding of how visuality was experienced in the early nineteenth-century Great Room, as well as a reappraisal of a number of artworks shown for the first time for 200 years, in the space and conditions for which they were designed.

Bourdieu further developed Baxandall's thesis of the 'period eye' in an essay entitled 'The Social Genesis of the Eye' in which he addressed the problem of comprehending historical works and practices in the present.[52] The paradox identified by Bourdieu arises from the fact that whereas a historical spectator would have immediately grasped the artist's (or curator's) intention, the modern viewer must reconstruct the code within which the work was embedded, whilst simultaneously understanding that no such effort of construction and translation was required in the original context of reception. According to Bourdieu, what is called for is not an act of mimicry, but rather a willingness to comprehend in a 'somewhat vicarious mode'.[53] In the case of exhibition reconstructions, this means putting ourselves in the position of past viewers. The experience of viewing that was mounted by *Art on the Line* was a reminder that the eye of the spectator is also attached to a physical body: within the exhibition, visuality is structured through comportment and

movement and in this sense, the period eye cannot be separated from the 'museum body' that responds to its spatio-visual coordinates.

Art on the Line succeeded in revealing its structuration through its invocation of the period eye; Solkin's hang insisted on the displacement of modernist conditions of viewing with the visual modalities of the early nineteenth-century Academy exhibition. However, the project included a further element that stood outside of the narrative space of the Great Room. In an adjoining gallery, a small screen showed continuous closed circuit television footage of the audience next door in the main exhibition. Visitors could thus watch each other as they looked, talked, walked and sat. It was a device that closed the performative loop, as viewers were revealed to themselves and others as spectators in the act of spectating. Butler reminds us that 'performativity is … not a singular "act," for it is always a reiteration of a norm or a set of norms, and to the extent that it acquires an act-like status in the present, it conceals or dissimulates the conventions of which it is a repetition'.[54]

The video screen also constituted a disruptive, non-diagetic element within the exhibition: standing outside of, and looking into, its internal world. Watching other people performing the double-act of twenty-first century visitors experiencing an early nineteenth-century exhibition, the invisible hand of the curator became doubly apparent. The visual equivalent of a voiceover narration in a film, the video provided a silent commentary on the action within the exhibition. By simultaneously staging and showing their performances, viewers became aware not only of their own embodied practice, but of the relations between themselves and others within the shared space of the museum, past and present. A distant echo of Duchamp's surrealist tactics, the exhibition deliberately fragmented the act of viewing by enjoining visitors both to look and also to watch themselves looking.

Dressing the Part

The 'Short Sermon to Sightseers' at the 1901 Pan-American Exposition reminded its audience that, within the exhibition, spectators are also an important part of the spectacle. The sociality of the art gallery or exhibition hall is invariably marked by the silent (and not so silent) scrutiny of one's fellow visitors, yet museum historians have rarely discussed an important aspect of self-representation and people-watching within the exhibition: namely, how people dressed for the occasion.[55] On the one hand, contemporary commentators were often critical of displays of vanity and self-regard: to cite just one example, Dickens's wry observation that members of the 'well-dressed crowd' in the Art Treasures Palace were too busy gossiping, promenading and admiring each other to look at the pictures, clearly implied a reprimand to those visitors who were more interested in self-display than in

the art display.[56] On the other hand, strictures concerning dress were applied to ensure a minimum standard of respectability and cleanliness amongst the museum's public: for example, from 1810, 'all Persons, of decent appearance' could be admitted to the British Museum on specified 'public days'.[57] However, the definition of what constituted 'decent' in this context remained ambiguous and contested, as we shall see in the following chapter.

Sumptuary regulations appear to have been less controversial in France during the reign of Louis XIV: Germain Bazin reports that any man could visit Versailles to see the paintings and the gardens provided that he was carrying a sword and wearing a plumed hat, and that these necessary accoutrements of cultural access could be rented from the palace concierge.[58] In the absence of such clear guidance, the question remains: what to wear for one's role as a museum visitor? Is the museum a destination for which you dress up, or down?

The museum's oscillation between high-minded pedagogy and modish spectacle was evident in its ambivalence towards the clothing of its nineteenth-century public: respectability was required, but evidence of vanity deplored. This may be one explanation for the paucity of fashion plates that employ the museum or exhibition as an attractive *mise-en-scène* for showing off the latest styles compared with, say, pleasure gardens, shops or balls. A rare example is this 1815 plate from Rudolph Ackermann's illustrated monthly magazine *The Repository of arts, literature, commerce, manufactures, fashions and politics*, which shows a fashionable young woman at the annual exhibition of the British Institution and which clearly proposes that this is an appropriate setting for a combined display of female fashion and connoisseurship (Figure 29).[59] Ackermann's *Repository* was published from 1809 to 1829 and combined a popular mixture of news, reviews and information on a wide range of subjects, including the latest designs in clothing and also furniture. Each issue included two fashion plates for 'ladies' that could be copied and adapted by skilful dressmakers. Each depicted a single female in a pose or setting appropriate to the ensemble that she was wearing: walking, reading indoors, reading outdoors, drinking tea, preparing for a ball, and so on. Here a visit to the British Institution provides the pretext for putting on a 'carriage dress' described as comprising:

> A white satin pelisse, richly ornamented at the feet with clusters of leaves made in white twilled sarsnet, beaded with tull; open fronts, trimmed to the bottom of the waist with a superb shell trimming of white satin ribbon and tull; loose open sleeve ... Hat composed of white satin and tull, with a plume of feathers of the pomona green. Half-boots of a similar colour.[60]

Although a 'carriage dress' was generally made of slightly heavier fabric than a 'walking dress' and was designed to withstand the inevitable creasing of a carriage ride, this outfit would have been wholly impractical for anyone

29 'Fashions for Ladies – Plate 29 Carriage Dress', *Ackermann's*
Repository of arts, literature, commerce, manufactures, fashions and politics,
June 1815. Reproduced by courtesy of the University Librarian and
Director, The John Rylands Library, The University of Manchester.

obliged to walk any distance at all on a dirty city street or even to travel very
far in an open carriage. The plate therefore combines a display of feminine
luxury and modishness with a performance of concentrated spectatorship,
complete with the exhibition catalogue as an assurance of the woman's
seriousness as an art aficionado, now put to one side as her attention is caught
by a painting's detail.[61]

A different style of fashion illustration was marketed in the 1830s by the
London tailor, B. Read, who issued a set of fashion plates twice a year, showing

men's 'summer' and 'winter' fashions modelled within a specific urban locale. The backgrounds against which Read's groups of figures preen themselves were selected with great care, so as to enhance the currency of his designs by association. For example, they included the most fashionable shops in London (the Bazaar at the Pantheon and the Queen's Bazaar), places of entertainment (the Diorama in Park Square East, the Colosseum and Madame Tussaud's Wax Works) and the royal parks (Hyde Park, Kensington Gardens, St James's Park and Green Park). Read's formula was shortly taken up by others including J. Wyatt, a tailor at 36 Frith Street, Soho Square. Wyatt employed the illustrator J. Findlay to design similar scenes of 'The Present Fashions' shown against topographical backgrounds, including the newly opened Elgin Room in the British Museum (Figure 30). Both Read's and Wyatt's plates (together with templates for pattern cutting) could be purchased on subscription by provincial tailors whose clients might aspire to such levels of metropolitan elegance. The opening of the Elgin Room in 1832 was evidently a sufficiently 'fashionable' event to warrant its depiction as one of the new season's plates and to provide a recognisable setting for this highly stylised congregation of well-dressed visitors.

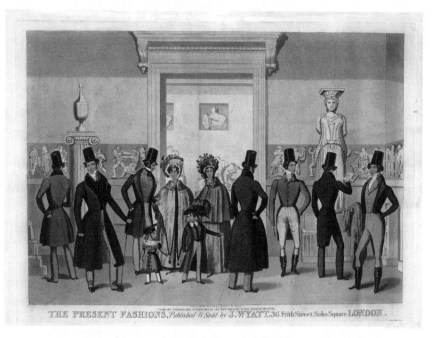

THE PRESENT FASHIONS, *Published & Sold by* J. WYATT. 36 Frith Street, Soho Square. LONDON.

30 Drawn and etched by J. Findlay, acquainted by S.G. Hughes,
The Present Fashions. The Company viewing the sculptures in the New Gallery at the British Museum, 1832. © The Trustees of the British Museum.

Although the possibilities of a similarly performative or strategic use of dress would have been more limited at the opposite end of the social spectrum, they should not be entirely discounted. Sayroh Shuttle deliberately wore her finest dress and carried a prized umbrella when she visited the Manchester Art Treasures Exhibition, and it would be surprising if she was unusual in wanting to appear at her best for the trip.[62] The symbolic language of clothing would have been as familiar to the poor as to the rich, even if their practical choices were more constrained. For example, the adoption of 'fustian' (a coarse twilled cloth usually of cotton or linen) as a working-class signifier during the 1840s shows how conforming to the 'decent appearance' required by the museum authorities could be double-coded. At this time, it was not uncommon for fustian to serve as a kind of shorthand for working-class dress: thus one writer described the breadth of the museum's audience with the words: 'whether [he] moves in the ranks of the rich and influential or wears a humble fustian jacket, he finds this ingress equally afforded'.[63] However, Paul Pickering has argued that, by the 1840s, wearing fustian was more than a neutral indicator of class: it signified one's allegiance to the working-class movement.[64] By deliberately donning suits made of fustian, the leaders of the Chartist movement expressed their solidarity with the working people of Britain: henceforth, their demands for political and economic reform on behalf of 'the people' meant, in effect, on behalf of the working classes. A new vein of exclusively working-class radicalism had found its symbol in fustian. In Pickering's words: 'Into the cloth was woven the shared experiences and identity of working-class life.'[65] Henceforth, wearing fustian in inappropriate settings, such as Anglican Church services, became a symbol of class confrontation: 'a statement of class without words'.[66] And if the working-class museum visitor of 'decent appearance' wore fustian too, the coat on his back may well have carried a message of working-class rights to cultural access without discrimination or limitation.

To conclude this chapter, let us turn to a well-known image of strategic self-staging within the exhibition, in which dress is codified in terms of artistic, rather than political, affiliation. *Private View at the Royal Academy, 1881* by William Powell Frith uses the dress worn by art spectators not as a signifier of class, but of taste (Figure 31). Here Frith has painted the scene of his greatest artistic success: a regular exhibitor and popular favourite at the Royal Academy, this was the last of his paintings that had to be protected from the enthusiasm of the crowd with the erection of an iron rail.[67] In the work, he elides his famous antipathy to Aestheticism and its adherents with the slavish love of fashion, irrespective of its intrinsic merits:

> Beyond the desire of recording for posterity the aesthetic craze as regards dress, I wished to hit the folly of listening to self-elected critics in matters of taste, whether in dress or art. I therefore planned a group, consisting of a well-known apostle of the beautiful, with a herd of eager worshippers surrounding him.[68]

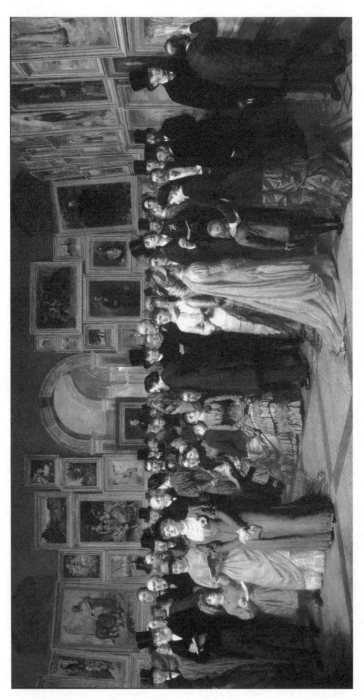

31 William Powell Frith, *Private View at the Royal Academy, 1881*, 1883. © Pope Family Trust. The Bridgeman Art Library.

The setting is Gallery III, the grandest room in the Royal Academy galleries at Burlington House, Piccadilly (where the Academy had moved in 1868). The subject of the painting the contrast between what Frith regards as lasting historical achievements as opposed to ephemeral fads: the former is represented by the portrait by Millais of the recently deceased former prime minister, Benjamin Disraeli, which hangs prominently on the back wall of the gallery; and the latter by the effects of the Aesthetic movement on men's and women's dress. Frith's 'well-known apostle of the beautiful' is Oscar Wilde, who stands to the right of the picture, surrounded by female admirers. One of the main proponents of Aestheticism, Wilde is distinguished from the other men in the picture by his long hair, velvet waistcoat and characteristic lily in his buttonhole. Meanwhile, the green, pink and orange gowns worn by three women in the foreground mark them out as advocates of dress reform and the associated cult of Aestheticism.[69] Most of the people in Frith's scene are identifiable historical figures: it is an accurate depiction of the constituency of the wealthy, powerful and famous who would have been invited to the Academy private view, one of the set-piece events of the London social season. In effect, he has painted a performance of the British cultural and political elite: on this stage, the performers are both spectators and spectacle, and Frick has ensured that each of his characters is very deliberately dressed for the part.

Notes

1 Charles Baudelaire, 'The Painter of Modern Life' (trans. Jonathan Mayne), *The Painter of Modern Life and Other Essays*, London and New York: Phaidon, 1995, p. 5.

2 Georg Simmel, 'The Metropolis and Mental Life', in Donald N. Levine (ed.), *On Individuality and Social Forms*, Chicago: University of Chicago Press, 1971, pp. 324–39.

3 Dias, 'A World of Pictures', p. 97.

4 Matheson, 'A Shilling Well Laid Out', p. 39.

5 P.I., 'The Exhibition Undressed', p. 60.

6 Dickens, 'The Manchester School of Art', p. 350.

7 Staton, *Bobby Shuttle*.

8 Rodgers, *Tom Treddlehoyle*, p. 9.

9 Bennett, 'The Exhibitionary Complex', p. 81.

10 Gaynor Bagnall, 'Performance and Performativity at Heritage Sites', *Museum and Society*, 1.2, 2003, p. 95.

11 Judith Butler, *Bodies that Matter*, London and New York: Routledge, 1993, p. 225.

12 Elizabeth Gray Buck, 'Museum Bodies: The Performance of the Musée Gustave Moreau', *Museum Anthropology*, 20.2, 1996, p. 16.

13 Noordegraaf, *Strategies of Display*.

14 Barbara Kirshenblatt-Gimblett, *Destination Culture: Tourism, Museums, and Heritage*, Berkeley: University of California Press, 1998, p. 190.

15 Merleau-Ponty, *Phenomenology of Perception*, p. 142.

16 Lewis Kachur, *Displaying the Marvelous: Marcel Duchamp, Salvador Dali and Surrealist Exhibition Installations*, Cambridge, MA and London: MIT Press, 2001.

17 Elena Filipovic, 'A Museum That is Not', *e-flux*, 2011. Online at: www.e-flux.com/journal/view/50.

18 Ibid.

19 Charles R. Garoian, 'Performing the Museum', *Studies in Art Education*, 42.3, 2001, pp. 234–48.

20 Anthony Jackson and Jenny Kidd, *Performance, Learning & Heritage Report*, Manchester: Centre for Applied Theatre Research, University of Manchester, 2008, p. 70. See also Helen Rees Leahy, 'Watching Me, Watching You: Performance and Performativity in the Museum', in Tony Jackson and Jenny Kidd (eds), *Performing Heritage*, Manchester: Manchester University Press, 2010, pp. 39–52.

21 Quoted in Jon Bird, 'Minding the Body: Robert Morris's 1971 Tate Gallery Retrospective', in Michael Newman and Jon Bird (eds), *Rewriting Conceptual Art*, London: Reaktion Books, 1999, p. 96.

22 Robert Morris quoted in Bird, 'Minding the Body', p. 97.

23 Ibid.

24 Catherine Wood, 'The Rules of Engagement: Displaced Figuration in Robert Morris's mise-en-scène', in Anna Dezeuze (ed.), *The 'Do-it-Yourself' Artwork: Participation from Fluxus to New Media*, Manchester: Manchester University Press, 2010, p. 127.

25 R. Greenberg, '"Remembering Exhibitions": From Point to Line to Web', *Tate Papers*, 12, 2009. Online at: www.tate.org.uk/research/tateresearch/tatepapers/09autumn/greenberg.shtm.

26 Reyner Banham quoted in Bird, 'Minding the Body', p. 104.

27 Nicolas Bourriaud, *Relational Aesthetics*, Paris: Les Presse du Reel, 2002.

28 Helen Rees Leahy, 'Watch Your Step: Embodiment and Encounter at Tate Modern', in Sandra Dudley (ed.), *Museum Materialities*, London: Routledge, 2010, pp. 162–74.

29 Mieke Bal, 'Earth Aches: The Aesthetics of the Cut', in Achim Borchardt-Hume (ed.), *Doris Salcedo, Shibboleth*, London: Tate, 2007, p. 40.

30 Barbara Kirshenblatt-Gimblett, 'Performance Studies', Rockefeller Foundation, Culture and Creativity, September 1999. Online at: www.nyu.edu/classes/bkg/issues/rock2.htm.

31 Maurice Merleau-Ponty, *The Primacy of Perception* (trans. J.M. Edie), Evanston: Northwestern University Press, 1964, p. 163.

32 Bourriaud, *Relational Aesthetics*, p. 14.

33 Ibid., p. 30.

34 Quoted in James Meyer, 'No More Scale. The Experience of Size in Contemporary Sculpture', *Artforum*, Summer 2004. Online at: http://artforum.com/inprint/id=6960&pagenum=0.

35 Andrew Marr, 'The Magic Box', in Francis Morris (ed.), *Tate Modern: The Handbook*, London: Tate, 2006, p. 14.

36 Quoted in Borchardt-Hume, *Doris Salcedo, Shibboleth*. Frontispiece.

37 Achim Borchardt-Hume, 'Sculpting Critical Space', in Borchardt-Hume, *Doris Salcedo, Shibboleth*, p. 20.

38 Ibid.

39 Lisa Jardine, 'Making Contact', BBC Radio 4, 2007. Online at: http://news.bbc.co.uk/go/pr/fr/-/1/hi/magazine/7075030.stm.

40 Ibid.

41 Nick Prior, 'Having One's Tate and Eating It', in Andrew McClellan (ed.), *Art and its Publics*, Oxford: Blackwell, 2003, p. 53.

42 Meyer, 'No More Scale'.

43 Stephen Bann, *The Clothing of Clio: A Study of the Representation of History in Nineteenth-Century Britain and France*, Cambridge: Cambridge University Press, 1984; Stephen Bann, *The Inventions of History: Essays on the Representation of the Past*, Manchester: Manchester University Press, 1990;

Francis Haskell, *History and Its Images: Art and the Interpretation of the Past*, New Haven and London: Yale University Press, 1993; Andrew McClellan, *Inventing the Louvre: Art, Politics and the Origins of the Modern Museum in Eighteenth-Century Paris*, Cambridge: Cambridge University Press, 1994.

44 Greenberg, 'Remembering Exhibitions'.

45 David Solkin, 'Art on the Line – Reflections and Surprises', *Courtauld Institute Newsletter*, Spring 2002. Online at: www.courtauld.ac.uk/newsletter/spring_2002/08artonlineSP02.shtml.

46 Ibid.

47 Solkin, 'This Great Mart of Genius', p. 4.

48 Ibid.

49 Michael Baxandall, *Painting and Experience in Fifteenth-Century Italy*, Oxford: Oxford University Press, 1972.

50 Adrian W.B. Randolph, 'Gendering the Period Eye: Deschi da Parto and Renaissance Visual Culture', *Art History*, 27.4, 2004, pp. 538–62.

51 Carrier, 'The Display of Art', p. 83.

52 Pierre Bourdieu, 'The Social Genesis of the Eye', *The Rules of Art: Genesis and Structure of the Literary Field*, Stanford: Stanford University Press, 1996, pp. 313–21.

53 Ibid., p. 315.

54 Butler, *Bodies that Matter*, p. 12.

55 See a notable exception: Irit Rogoff, 'How to Dress for an Exhibition', in Mika Hannula (ed.), *Stopping the Process? Contemporary Views on Art and Exhibitions*, Helsinki: NIFCA (The Nordic Institute for Contemporary Art), 1998, pp. 130–52.

56 Dickens, 'The Manchester School of Art', p. 350.

57 House of Commons, *British Museum, Regulations and Returns respecting Admission to the Museum*, 1810–11 (168) XI. 159.

58 Germain Bazin, *The Museum Age* (trans. Jane van Nuis Cahill), New York: Universe Books Inc., 1967, p. 150.

59 The catalogue held by the woman identifies the British Institution as the setting for the exhibition.

60 'Fashions for Ladies – Plate 29 Carriage Dress', *The Repository of arts, literature, commerce, manufactures, fashions and politics*, London: Ackermann, Vol. 13, June 1815, p. 366.

61 Ann Pullan, '"Conversations on the Arts": Writing a Space for the Female Viewer in the *Repository of Arts* 1809–15', *Oxford Art Journal*, 15.2, 1992, pp. 15–26.

62 Staton, *Bobby Shuttle*.

63 Charles Knight, James Thorne, George Dodd, Andrew Winter, Hariet Martineau, William Harvey and William Michael Wylie, *The Land We Live In: Pictorial and Literary Sketch Book of the British Empire*, 4 vols, London: Charles Knight, 1847, Vol. 1, p. 34. Quoted in Candlin, *Art Museums and Touch*, p. 85.

64 Paul A. Pickering, 'Class without Words: Symbolic Communication in the Chartist Movement', *Past & Present*, 112, August 1986, p. 158.

65 Ibid., p. 159.

66 Ibid., p. 162.

67 See Chapter 5 for discussion of rails at the Royal Academy.

68 William Powell Frith, *My Autobiography and Reminiscences*, London: R. Bentley and Son, 1887–8.

69 Edwina Ehrman, 'Frith and Fashion', in Mark Bills and Vivien Knight (eds), *William Powell Frith: Painting the Victorian Age*, London and New Haven: Yale University Press, 2006.

Bodies of Protest

Some 50 years after Henry James's eponymous American, Christopher Newman, was afflicted by 'an aesthetic headache' at the end of a stroll through the Louvre, the poet and philosopher, Paul Valéry, followed in his footsteps – and suffered accordingly. In his 1923 essay *Le problème des musées*, Valéry described the familiar sensations of mental and physical exhaustion produced by a morning in the art gallery; a self-confessed museum sceptic, he believed that these were the inevitable consequences of the institution's voracious urge to accumulate and display. His argument was that the museum's processes of fragmentation, decontextualisation and re-organisation of diverse artworks so as to create an account of 'art history' necessarily have a detrimental effect not only on the objects on display, but also on the minds and bodies of its visitors.[1] In order to illustrate the point, Valéry takes the reader on a corporeal tour of the museum, beginning with the sense of unease that he feels on entering the building and culminating in the 'splitting head' with which he departs. Deprived of his customary stick at the very threshold of the building, the visitor is disarmed to withstand the cultural assault that he is about to encounter:

> At the first step that I take toward things of beauty, a hand relieves me of my stick, and a notice forbids me to smoke. Chilled at once by this act of authority and by the sense of constraint, I make my way into a room of sculpture where cold confusion reigns ... I am lost in a turmoil of frozen beings, each of which demands, all in vain, the abolition of all others – not to speak of the chaos of sizes without any common scale of measurement, the inexplicable mixture of dwarfs and giants, nor even of the foreshortening of evolution presented to us by such an assemblage of the complete and the unfinished.[2]

Moving on from the apparently indiscriminate juxtapositions of the sculpture gallery, Valéry enters a paintings gallery where he is 'smitten with a sacred horror' at both the density and the diversity of display: here are works of art that were never intended to be neighbours on the same wall which 'destroy

each other' by virtue of their adjacency.[3] Valéry points out that the 'ear could not tolerate the sound of 10 orchestras at once', so how could a museum visitor be expected to apprehend with 'one instantaneous glance … a *portrait* and a *seascape*, a study of *food*, and a *triumph*'?[4] Faced with such a bewildering array of secular and sacred art, Valéry notices involuntary changes in his gait and speech: his 'pace grows reverent' and his vocal cords tense so that his 'voice alters, to pitch slightly higher than in church, to a tone less strong that that of every day'.[5] It is the unsettling hybridity of the museum – part temple, part drawing room – that provokes this somatic response to its combination of solemnity and excess, and compels him 'to walk like a drunk man between counters'.[6]

No man, claims Valéry, can truly withstand this combined onslaught on his senses and his sensibility: as a result, the museum effect is invariably oppressive. As he puts it: 'However vast the palace, however suitable and well-arranged, we always feel a little lost, a little desolate in its galleries, all alone against so much art.'[7] At the end of his visit, he 'stagger(s) out of this temple of the loftiest pleasures with a splitting head – an extreme fatigue, accompanied sometimes by an almost painful activity of mind'.[8] Valéry is, he says, gripped by 'an obsessive feeling of confusion' brought about by the chaos and excess of the museum.[9]

Like Christopher Newman, his fictive precursor in the Louvre, Valéry suffered from a museum headache whose cause was as much psychological as physiological. Both were exhausted, not by the distance they had walked, but by the visual and cognitive demands made by the museum; their respective experiences prompt the questions whether and how museums make people physically ill? At a time when there is much discussion about the contribution that visiting museums can make to an individual's sense of well-being, the suggestion that adverse pathological effects can be attributed to museums may seem perverse.[10] Yet as this chapter shows, descriptions of symptoms ranging from the almost ubiquitous experience of fatigue to cases of dizziness, nausea and fainting form a persistent theme in museum literature. The majority of visitors are 'cured' either, like Newman, by taking a rest or, like Valéry, by leaving the museum: their external symptoms are barely palpable, and they suffer only briefly and in (either respectful or resentful) silence. Other cases are more acute, even resulting in hospitalisation until the visitor-patient's palpitations, breathlessness and nausea have passed.[11]

As Valéry's account suggests, the causes and effects of museum sickness are often (although not always) described in terms that are fundamentally hostile to the museum on the grounds of its scale, acquisitiveness, principles of display and, above all, its claim to cultural authority. Usually, it is the museum that assaults the body of the visitor, not vice versa. But at the other end of the spectrum of protesting bodies are those who inflict violence on the museum, its contents or even on other visitors. These are the most overt and

dramatic effects of what Dario Gamboni calls 'museum pathology': namely, acts of damage and destruction, as well as the theft of works of art, that are motivated not by financial gain, but devised to harm the institution and its symbolic position within the nation state.[12] Such actions are sometimes motivated by (or at least, justified on the basis of) the political grievances of an individual or a group, as in the case of campaigners for female suffrage in Britain in the years preceding 1914. Collective acts of civil disobedience or protest within the museum raise the question of what, if anything, inspires demonstrators to choose this as the target or the location of their actions.

Linking these interconnected themes, this chapter explores accounts of non-compliance in the museum: visitors' behaviour that, wilfully or not, transgresses the implicit codes of comportment and the explicit rules of the institution. Authors as diverse as Valéry and Gamboni agree that it is because of, rather than despite, the museum's best efforts to produce attentive, purposive and restrained bodies, that many visitors go astray. As we know from the accounts of exhibition viewers in Manchester, the pages of Zola's novel L'Assommoir and the visitor studies of Robinson and Melton in the 1920s, weary and confused bodies fail to obey the museum's strictures and rebuke its curatorial scripts through indifference, exhaustion or frustration – or a combination of all three. Resistance to the museum manifests itself in fatigue, nausea, frustration and anger, whose symptoms are revealed on the bodies of visitors and in their trivial and serious acts of disobedience.

Making and Breaking the Rules

Anxiety about potentially rowdy and violent behaviour haunts both the exhibition and the museum from the mid-eighteenth century onwards. In practice, deliberate damage inflicted by visitors seems to have been relatively rare, albeit with some notable exceptions. For example, Richard Altick describes outbreaks of vandalism at the first exhibition mounted by the Society of Arts, London, in the spring of 1760. Window glass to the value of 13s.6d. was broken, and artists complained of 'the intrusion of great numbers whose stations and education made them no proper judges of statuary or painting and who were made idle and tumultuous by the opportunity of a show'.[13] Evidently the strict rules drawn up by the Society to prevent such trouble were either ignored or deliberately flouted. The exhibition attendants had been instructed 'to exclude all persons whom they shall think improper to be admitted, such as livery servants, foot soldiers, porters, women with children, etc., and to prevent all disorders in the Room, such as smoking, drinking etc., by turning the disorderly persons out'.[14] But, it seems, to no avail.

However, the failure of the Society's precautions on this occasion does not appear to have set a precedent for future exhibitions. From 1779 onwards, the

Royal Academy regularly hired the services of Bow Street constables to 'Keep the Peace' during its summer exhibition, and few incidents of rowdy, let alone violent, behaviour subsequently occurred.[15] Despite the alarmist predictions of the British Museum trustee, Dr John Ward, that 'any rules or directions' issued to visitors would ' be treated only with contempt and set at nought' people were reported to have been generally well-behaved – even when they were eventually allowed to walk through the museum unaccompanied, some 50 years after Ward's gloomy prognosis.[16] He believed that if public were freely admitted, the museum would need to retain two magistrates and the local constabulary in order to protect the building and its contents from the risk of theft and what he termed 'Accidents'. As it happened, the opposite was the case: the 1841 Report of the Select Committee on National Monuments and Works of Art &c, reported that 'the great experiment' of general admission on public holidays had been very successful:

> From 16,000 upwards to 32,000 persons have passed through the doors of [the British Museum] on one day, without any accident or mischief; and, it is gratifying to report, that in the course of the three or four years that this liberal system has continued, not a single case has required the interference of the police.[17]

In fact, admission was not entirely unrestricted: children under eight were excluded from entry to the British Museum, thereby preventing a great many families from visiting with their offspring. However, a more liberal policy prevailed at the National Gallery where the 1841 Select Committee noted that:

> The greatest propriety has been observed in the demeanour of visitors, and no instance of misconduct, requiring the interference of the police authority, has occurred. Children of every age have been admitted, with, or without their parents; and not one accident has occurred, or any inconvenience been experienced.[18]

An attendant at the National Gallery, John Peter Wildsmith, concurred with this satisfactory report, saying that 'nothing could be more orderly' than the conduct of the visitors whom he supervised everyday.[19] Interestingly, the Assistant Keeper at the National Gallery, Lieutenant-Colonel Thwaites, also observed in his evidence to the committee that, although the conduct of the public 'as far as it relates to the pictures' had been 'unexceptionable', only a minority actually bothered to look at them. According to Thwaites, the mass of the holiday crowd 'come and go without paying very much attention to the pictures'.[20]

Similarly, throughout the 1857 Manchester Art Treasures Exhibition there was very little unruly, mischievous or criminal behaviour. The fear of misconduct prior to the event echoed the anxieties that had been voiced in advance of its precursors: notably, the Great Exhibition of 1851 and the Dublin

Exhibition of 1853. As on those occasions, initial concerns were succeeded by relief and self-congratulation when fears of criminality proved unfounded. Dickens was amongst those who applauded the good behaviour of 'the provincial public', noting that worries about the 'destructive properties of the English mob' were shown to be misplaced when, at the end of the exhibition, over one million visitors of all classes had not 'misbehave[d] themselves whilst partaking of a tempting Art-banquet'.[21]

Alcohol was served in the refreshment rooms (both first- and second-class) at the Art Treasures Exhibition and also, from 1857 onwards, at the South Kensington Museum, London, in the first museum cafeteria in the world. Critics of this innovation at South Kensington asserted that drunkenness and its related problems amongst visitors would, inevitably, ensue. Once again, their predictions were unrealised. In 1860, the museum director, Henry Cole, reported to a House of Commons committee that during the month of February, the museum had received 45,354 visitors and had sold 20 bottles of wine, five bottles of brandy, six quarts of bottled ale and stout, 80 gallons of draught ale and 20 gallons of porter. This, he calculated, averaged two and a half drops of wine, 14 fifteenths of a drop of brandy, and 10 and a half drops of ale per capita.[22] Given such abstemious consumption, it was not surprising that drunkenness was rarely encountered in the museum.

The Reverend Charles Kingsley, an eloquent champion of free and unrestricted admission to the British Museum and the National Gallery in the mid-nineteenth century, wrote in 1848 that he believed that working people especially respected the contents of both museums because they were 'national property' and therefore visitors understood that they had a 'share in the treasure' and behaved accordingly. Kingsley advised those who doubted his word to observe visitors' conduct at the British Museum during Easter Week, when one could watch:

> hundreds of thousands, of every rank and age, wandering past sculptures and paintings, which would be ruined by a blow – past jewels and curiosities, any one of which would buy many a poor soul there a month's food and lodging – only protected by a pane of glass, if by that; and then see not a thing disfigured – much less stolen.[23]

If Kingsley was correct, then the good behaviour of visitors had at least as much to do with their sense of symbolic ownership of the museum's collections, than with self-conscious obedience to its rules and regulations. This dimension of his argument received support from perhaps an unlikely voice from within the museum itself. Giving evidence in 1841 on the comparative regimes of British and foreign museums, John Edward Gray, Keeper of Zoology, said that, in his opinion, visitors to the British Museum 'are better behaved than persons who visit the foreign museums, because the people here are not

under any fear; but in foreign museums they seem to be under the idea that they are closely watched and guarded'.[24] He continued:

> For example, in Paris I have seen a man reprimanded for putting his finger on a glass, in order to point out a bird: I was myself arrested, in company with my wife, because I had a small piece of paper in my hand, and I was conducted through the rooms by three soldiers; I had been making notes, and had carried the paper in my hand on which I had made my notes, and this was against the regulation; they would allow nothing to be carried by visitors to the collection.[25]

Luckily for Dr Gray, he was recognised by a Parisian colleague and, thanks to his friend's invention, was 'set free' at once.

The general picture that emerges from English museums and exhibitions from the late eighteenth century onwards is that of a growing number of visitors taking advantage of the gradual expansion of the public art field and conducting themselves peaceably, if not necessarily attentively, inside the museum or exhibition gallery. Violent or scandalous incidents were uncommon, and were therefore all the more noteworthy when they did occur. During this period, there were two remarkable events that disturbed the body politics of the Royal Academy exhibition and the British Museum respectively: each was, in its way, an unprecedented act of defiance of the boundaries of institutional etiquette and of the criminal law.

The visit of the Hon. Edward Onslow, second son of George, Lord Onslow, to the Royal Academy exhibition at midday on 2 May 1781 seemed unexceptional at the outset. Apparently he spent time chatting with some young ladies of his acquaintance, the Misses Keppel, before he turned his attention to a stranger, a young man named Felix McCarthy.[26] At this point in his visit, Onslow seems to have made repeated sexual advances to McCarthy: the details of what passed between the two men are unclear, but the newspapers described the incident as 'the attempt of an infamous familiarity with a gentleman'.[27] What might have passed off as a private matter became public scandal for Onslow (and the Academy) when McCarthy's 'indignation was so roused that the honourable aggressor was obliged to run out of the house'.[28] Apparently, McCarthy struck Onslow and challenged him to a duel; in response, the latter's flight from the exhibition room did little to enhance his 'innocence' in the eyes of his many onlookers, of both sexes. In the resulting scandal, Onslow's father threatened to charge McCarthy with libel, on the grounds that he (McCarthy) had accused Edward of 'infamous advances' with the intention of committing sodomy. At the time, sodomy itself was a capital offence, and even the 'meditation' of it could be punished by confinement in the public stocks.[29] Although Onslow's many aristocratic supporters expressed their incredulity that he could have been guilty of a 'sodomitical advance', the social pressure on him increased until he was obliged to leave for France, where he lived in self-imposed exile for the remainder of his life: itself, perhaps, the strongest indication of his 'guilt'.

There was no lasting damage to reputation of the Royal Academy as a result of the incident although, at the time, it undermined the Academicians' high-minded claim that the exhibition was primarily an artistic, rather than social, event. The episode also demonstrated how easily the flirtatious sociality of the Great Room could be destabilised by a display of 'deviant' sexuality that was deemed to subvert the rational social order, although one wonders how many similar interactions went unrecorded because neither party caused a fuss. The Academy's justification of charging one shilling for admission in order to prevent the rooms being filled by 'improper persons' was also exposed as ineffective in preventing improper conduct, particularly when it was attributed to the son of a peer.

Many years later, an event with much greater material consequences occurred in the British Museum. A Roman cameo-glass vessel, famously known as the 'Portland Vase', had been presented to the museum on long-term loan by the 4th Duke of Portland in 1810. For the next 35 years, it was displayed in a glass case, and was particularly admired as the famous archetype of numerous copies made and sold by the industrialist, Josiah Wedgwood. Then, at 3.45 p.m. on 7 February 1845, a young Irishman named William Mulcahy entered the gallery, grabbed a nearby sculpture and smashed both the case and the vase.[30] Mulcahy, who falsely gave his name as William Lloyd, said he had been drinking for days before the attack, but gave no explanation for his actions. Ironically, because of a faulty clause in the Wilful Damage Act, Mulcahy could be charged only with breaking the showcase, for which he was convicted and imprisoned, although he was soon released on payment of a £3 fine by an anonymous donor (rumoured to have been the Duke of Portland himself). One hundred years after Mulcahy smashed the vase, the British Museum finally bought the heavily repaired piece from the Portland family.

These were exceptional incidents inasmuch each was an (apparently) inexplicable act of a single individual that contravened not only the rules of the museum, but also the criminal law, although no charge was brought against Edward Onslow. Accordingly, both perpetrators suffered the consequences of their actions, one by a life of self-exile and the other by a short term in prison. The specific actions of Onslow and Mulcahy were unpredictable, but each dramatised the potential for transgressive or violent behaviour that always lurked within the public exhibition and museum. The case of Onslow is also a salutary reminder that the temptations of the museum not only relate to the material value of its collections, but also as an arena for the congregation of strangers. His case stands out amongst the innumerable encounters, both licensed and illicit, within the 'transsocial'[31] space of the museum only because it erupted into a public row. In time, the scandal of Edward Onslow faded from public memory, and the Portland Vase was mended and put back on display; meanwhile the majority of visitors continued to behave themselves, even if their weary or confused bodies silently protested against the museum's strictures.

'Please to Leave Your Umbrella'

Some years after the event, *Blackwoods Edinburgh Magazine* reported that an important aspect of museum–body relations that directly affected a great many visitors was a direct result of Mulcahy's attack on the Portland Vase: 'The initiation of the rule which forbids visitors to carry sticks or umbrellas in the Museum, dates from this piece of Vandalism, which also gives birth to a law making such acts for the future punishable by flogging as well as imprisonment.'[32] From an institutional perspective, the prohibition on walking sticks and umbrellas inside the galleries was deemed a vital security measure. In his evidence to the 1841 Select Committee, Thwaites insisted that the rule on leaving such items at the front desk provided the National Gallery with 'one of the greatest safeguards of the pictures' and on busy days both a porter and a police constable were employed in collecting and returning visitors' property.[33]

However, just as Dr Gray of the British Museum believed that the imposition of an overly strict security regime could be counterproductive in terms of encouraging good behaviour, so others have noted how the particular regulation against sticks and umbrellas could erode one's equipoise and self-assurance. Accordingly, the visitor is put on to the metaphorical back foot at the very threshold of the institution – by having to relinquish their belongings to the museum porter. Thus Valéry observed that the requirement to give up his stick at the doorway of the Louvre produced a 'sense of constraint' from the moment he stepped in from the street: deprived of a prop that he used to mediate his encounters with the world of people and objects, he sensed both a social and a physical disequilibrium.

The problem was compounded by the arcane procedure for depositing and then retrieving one's property in many institutions, which seemed calculated to embarrass the first-time visitor. An American clergyman, Nathaniel Sheldon Wheaton, was exasperated by an encounter with the porter at the British Museum in 1823:

> My umbrella was taken from me by the porter, as I entered, who gave me a slip of paper marked with a number, but without signifying what use I was to make of it. I ought to have hung it on my umbrella, and then called for the number when I came out. When I asked for it, the wily rogue affected great surprise at my negligence—said that it would take him a long time to find it among so many; and was spinning a long string of rigmarole, which I cut short by picking it out myself.[34]

Worse was to follow:

> His next attack was on my pride. He began to talk so loud about "gentlemens' refusing to pay for the trouble they gave," that, feeling the awkwardness of my situation among a number of auditors, I threw him a sixpence, with about the

same feeling of kindness that one would throw a bone at a snarling dog: and repented of it the next moment.[35]

Bobby and Sayroh Shuttle were similarly discomforted by an unhelpful porter on duty at the Manchester Art Treasures Palace: as exhibition novices, they were surprised (and a little dismayed) to discover that they were obliged not only to deposit Sayroh's umbrella in the cloakroom, but also to pay sixpence for the privilege. Each of these experiences, trivial in themselves, point to the shift in social relations that occurs when visitors cross the museum threshold: relinquishing one's personal items is the first act of submission to the authority of the institution. Dickens pinpointed what was really surrendered during this transaction in a satirical piece for *Household Words* entitled 'Please to Leave Your Umbrella'. Prompted by the experience of having to deposit his umbrella with a duty policeman at the entrance to Hampton Court Palace, he reflected that this simple act signified giving up a great deal more:

> Please to leave your umbrella. Of all the Powers that get your umbrella from you, Taste is the most encroaching and insatiate. Please to put into your umbrella, to be deposited in the hall until you come out again, all your powers of comparison, all your experience, all your individual opinions. Please to accept with this ticket for your umbrella the individual opinions of some other personage whose name is Somebody, or Nobody, or Anybody, and to swallow the same without a word of demur. Be so good as to leave your eyes with your umbrellas, gentlemen, and to deliver up your private judgement with your walking sticks.[36]

Thus taste, judgment and opinion are yielded to the superior knowledge of the museum, along with one's umbrella. In effect, the visitor must leave at the front desk, not only their umbrella, but also their independent critical faculties – not to mention their freedom to touch, run and shout. The effect of leaving one's property behind is both disconcerting and infantilising: the visitor is thereby acknowledging their compliance with the museum's pedagogic and corporeal regime. Dickens might well have sympathised with a comment by an eighteenth-century connoisseur who expressed his distaste for the museum's didacticism in the following terms: 'One who desires an art history can enter [the museum], but the sensitive man is kept away.'[37]

From the moment of entry, visitors have complained about feelings of dizziness, nausea and fatigue induced by the museum. The French philosopher, Maurice Blanchot, describes the initial experience of 'shock, the physical certainty of an imperious, singular presence' produced by the realisation that one is in the presence of great art: 'Painting is truly there in person.'[38] However, like Dickens, Blanchot immediately feels oppressed by the museum's assertion of its own authority, via its simultaneous manipulation of art into a spectacle of cultural superiority, and of the public into mere spectators. The museum, he says, turns painting into a 'person' who is 'so

sure of herself, so pleased with her prestige and so imposing, exposing herself with such a desire for spectacle that, transformed into a queen of theatre, she transforms us in turn to spectators who are impressed'.[39]

After a while, the initial awe fades and the visitor becomes 'a little uncomfortable, then a little bored'.[40] In order to diagnose the problem Blanchot returns to a familiar refrain: namely, the impossibility of fixing attention on any individual artwork when the museum presents such a 'noisy' profusion of images that the visitor can only muster 'a gaze so general, so confused and so loose' that it is impossible to see anything properly.[41] Thus, the visitor succumbs to the museum's assertion of encyclopedic authority, first with a sense of confusion and then with a sense of fatigue. Unlike Benjamin Ives Gilman and his fellow museum reformers in America, both Valéry and Blanchot realised that the symptoms of 'museum fatigue' are primed at the very start of the visit, rather than a manifestation of exhaustion at its end. The disconcerting sense of oppression that greets the visitor at the museum's threshold subverts the possibility of sustained and attentive looking: from the outset, the visitor is distracted and, deprived of their umbrella or stick, is doubly destabilised. From this perspective, efforts to fix the problem of fatigue by redesigning displays to promote visitors' attention or by providing more seating are futile: it is endemic in the institutionalisation and spatialisation of art within the museum.

In response, the protests mustered by weary museum bodies include aimless wandering, exhaustion, headaches and dizziness; few rebuke the museum directly, only complaining in their subsequent letters, diaries and memoirs. To cite just a couple more examples, the artist, Martin Archer Shee, visited the Louvre during the Peace of Amiens (1802–3) and found it 'quite embarrassing. All is confusion and astonishment: the eye is dazzled and bewildered, wandering from side to side–from picture to picture'.[42] Half a century later during a visit to Paris, the American clergyman and social reformer, Henry Ward Beecher, succumbed to acute fatigue and feelings of oppression in the Luxembourg Gallery. He noted that, 'I am only half through the gallery, and am utterly exhausted. I can neither feel, think, nor look. There are Murillos, Titians, Carraccis, and others of equal note; but I see only a vast wilderness of colour, and the sense of beauty, jaded and sated, sinks under the burden'.[43]

In fact, Altick suggests that museum fatigue was already recognisable as 'a novel affliction of urban life' by the beginning of the nineteenth century.[44] Its symptoms – 'the head turns round and cannot right itself' and 'an aching and barren sense of gay confusion' – were employed by William Wordsworth in an extended poetic metaphor for his own unsystematic intellectual development during his childhood in Cambridge:

Carelessly,
I gazed, as through a cabinet
Or wide museum (thronged with fishes, gems,
Birds, crocodiles, shells) where little can be seen
Well understood, or naturally endeared,
Yet still does every step bring something forth
That quickens, pleases, stings; and here and there
A casual rarity is singled out,
And has its brief perusal, then gives way
To others, all supplanted in their turn.
Meanwhile, amid this gaudy congress framed
Of things by nature most unneighbourly,
The head turns round, and cannot right itself;
And, though an aching and barren sense
Of gay confusion still be uppermost,
With few wise longings and but little love,
Yet something to the memory sticks at last
Whence profit may be drawn in times to come.[45]

The passage from Wordsworth's *Prelude* is discussed by Eric Gidal as evidence of the wider problem of spectatorship in the early museum: that is, the constant visual and corporeal 'oscillation between a contemplation of the particulars and an apprehension of the museum as a whole'.[46] Identification with the public exhibition is, in the end, impossible for Wordsworth: the 'aching' and 'confusion' engendered by the museum obstruct the 'wise longings' and 'love' that the poet needed in order to align himself successfully with the museum's imaginary and to internalise its prospect of the unity of creation. Gidal links Wordsworth's response to the British Museum to that of Karl Philipp Moritz, the young Prussian clergyman whom we met being hurried through the museum rooms in Chapter 1. Moritz's guided tour took just one hour, during which he could only 'cast one poor longing look of astonishment on all these stupendous treasures': the effect, he wrote, 'quite confuses, stuns, and overpowers one'.[47] As Gidal observes: 'For both Wordsworth and Moritz, museum fatigue registers a dialectical relation between fragment and totality, between insufficiency and anticipation'.[48] Each also foreshadowed a more extreme physical reaction to this 'dialectical relation' that was famously experienced by the French writer Marie-Henri Beyle, known as 'Stendhal'.

Museum Sickness: Stendhal and Others

It was during a visit to Florence in 1817 that Stendhal first experienced palpitations of the heart and dizziness, apparently stimulated by an over-

whelming exposure to an abundance of great art.[49] Leaving the Basilica of Saint Croce, he was overcome not only by the beauty of what he had seen, but also by his self-consciousness of being in Florence. The anticipation of its cultural treasures heightened – and then destabilised – his eventual experience of seeing them. In a famous passage, he wrote:

> My soul, affected by the very notion of being in Florence, and by the proximity of those great men whose tombs I had just beheld, was already in a state of trance. Absorbed in the presence of sublime beauty, I could perceive its very essence close at hand: I could, as it were, feel the stuff of it beneath my fingertips. I had attained to that supreme degree of sensibility where the divine intimations of art merge with the impassioned sensuality of emotion. As I emerged from the porch of Santa Croce, I was seized with a fierce palpitation of the heart (that same symptom which, in Berlin, is referred to as an attack of the nerves); the well-spring of life was dried up within me, and I walked in constant fear of falling to the ground.[50]

Stendhal's metaphor of 'feel[ing] the stuff of it beneath my fingertips' expresses the somatic intensity of his encounter. In contrast to Wordsworth's inability to reconcile his 'longing' for absorption and self-realisation within the museum's 'gaudy confusion', Stendhal believed that he had 'attained to that supreme degree of sensibility' where a kind of aesthetic rapture combined with 'the impassioned sensuality of emotion'. Hannu Salmi suggests that it was precisely this kind of intensity of experience that fuelled European travellers' quest for sensation, combined with a longing to encounter a past that seemed increasingly remote from the modern world.[51] However, although Stendhal's account of his travels in Italy was widely read during the nineteenth century, it was not until 1989 that an Italian psychiatrist, Graziella Magherini, named the phenomenon of psychiatric disorder stimulated by exposure to art the 'Stendhal Syndrome' (also known as 'hyperkulturemia' or the 'Florence Syndrome').[52]

Over a period of 10 years, from 1977 to 1986, Magherini had observed a correlation between certain psychiatric conditions, travelling and an exposure to artworks in some 106 patients at the Santa Maria Nuova hospital in Florence. She describes the aesthetic encounter in these terms: in seeking to 'understand' each artwork, the receptive tourist triggers a kind of internal crisis – a moment of uncertainty and of doubt – which is then resolved into an aesthetic and conscious pleasure. For a weary tourist in an unfamiliar city, this can be an exhausting and disorientating experience, especially if the 'crisis' is not always or fully resolved. Italians themselves seem to be immune from the condition, presumably because they do not visit their museums and churches with the same frequency and intense expectation as tourists. Similarly, highly regimented, so-called 'hit-and-run' sightseeing protects members of tour groups who hardly have the time to register the effects of any individual

work of art: apparently, Europeans are more vulnerable to the syndrome than either Americans or Japanese.[53] Those most susceptible are already mentally and physically tired from travelling, have prepared extensively for their trip and arrive with high levels of anticipation. Two-thirds of Magherini's patients experienced paranoid psychoses, whilst the remainder developed a range of affective or anxiety states.

A recent article in the *British Medical Journal* put the 'Stendhal Syndrome' into context: why is it that ostensibly positive life events can lead to relatively severe mental health problems?[54] The authors presented the case of a 72-year-old fine-arts graduate and creative artist who had been suffering from insomnia and concerns about being followed and monitored. His symptoms first appeared eight years previously during a longed-for trip to Florence. Standing on the Ponte Vecchio, he experienced a panic attack and became disorientated, 'followed by florid persecutory ideation'. The symptoms resolved gradually over the following three weeks. Four years later, a trip to the South of France recalled vividly the earlier visit to Florence, and triggered another panic attack followed by persecutory beliefs. Again, the symptoms subsided and, since then, there have been no further occurrences of a similar kind. The authors concluded that 'pilgrimages' (whether religious or artistic) rather than ordinary holidays, where the 'pilgrims' have a high levels of emotional investment in the object of the trip, are most likely to induce such psychological reactions, irrespective of the pleasure that they derive from the fulfilment of a long-held ambition.

Elkins contrasts the 'Stendhal Syndrome' with what he calls the 'Mark Twain Malaise': a self-consciously pragmatic and down-to-earth response to European culture.[55] The tone of this 'malaise' is taken from Twain's memoir of a five-month cruise through Europe and the Middle East undertaken in 1867, entitled *The Innocents Abroad or The New Pilgrims' Progress*. The account is peppered with sardonic comments about his fellow travellers, the places they visited and their intransigent and comedic inhabitants. Throughout, Twain remains immune to the temptations of European culture. Visiting the Louvre more from a sense of duty than desire, he and his companions:

> looked at its miles of paintings by the old masters. Some of them were beautiful, but at the same time they carried such evidences about them of the cringing spirit of those great men that we found small pleasure in examining them. Their nauseous adulation of princely patrons was more prominent to me ... more surely than the charms of colour and expression which are claimed to be in the pictures.[56]

Here there is none of the personal investment that triggers Magherini's moment of inner crisis: the pictures' subjects only offend Twain's democratic sensibilities and he rejects their aesthetic qualities because of the 'cringing spirit' that artistic patronage produces. Far from feeling emotionally drained

after looking at the 'miles' of paintings in the Louvre, Twain dismisses the experience by saying: 'I will drop the subject, lest I say something about the old masters that might as well be left unsaid.'[57]

By contrast, Blanchot described 'museum sickness' as 'analogous to mountain sickness which is made up of a feeling of suffocation and vertigo': following in Stendhal's footsteps, he attributed its cause to the impossible aesthetic demands of the art museum.[58] But there have always been other, more prosaic reasons why people do not feel well in museums – perhaps ones that even Mark Twain would recognise. If the mass of objects within the encyclopaedic museum can give you a headache, then the crowd of one's fellow visitors can also make you faint. We have already noted (in Chapter 1) Frederick Wendeborn's comment that the crush of people combined with the heat 'and the powerful perfumes of the odiferous company' in the Great Room at Somerset House made some ladies feel weak and nauseous.[59] Similarly, rooms that were either too hot or too cold were a constant problem for both museum staff and visitors. An attendant at the National Gallery commented in 1841 that the rooms were 'wretchedly ventilated' with the result that they were either oppressively hot in the summer or, if the windows were pulled down, so draughty 'that many people leave in consequence'.[60] He also believed that his colleagues frequently caught colds as a result of the draughts. Meanwhile, at the British Museum, the absence of lavatories for female visitors caused some women to collapse or feel unwell. Thus Dr Gray reported that:

> I have been called upon, as having been a medical man, to wait upon women fainting in the institution; and I have found that the real cause of illness was the want of accommodation, and the best mode of cure to send them to an out-of-door's closet, the only one accessible, and very inconveniently placed.[61]

The provision of museum lavatories may not (yet) have provided a particularly rich seam of historical enquiry, but Gray's comment provides an important empirical counterpoint to philosophical, poetic and even psychiatric enquiries into the causes of 'museum sickness'.

Touching, Falling, Slashing

Finally, in this chapter, I turn to the question of damage caused by visitors to the fabric – or more, often – the contents of the museum. This damage ranges from petty acts of anti-social (or anti-museum) behaviour – from the fingerprint of an illicit touch, a piece of chewing gum stuck to an object, minor scratches, smudges and smears – to deliberate, and sometimes very dramatic acts of violence – slashing, smashing, cutting and even shooting works of art. According to Gamboni, the 'petty' damage caused by gum, lipstick or

ink is akin to similar incidents of 'low-grade' abuse of any public space or property.[62] It is like dropping litter: people do it because they can, are lazy and do not regard the consequences for themselves or others as significant. Within the museum, this kind of damage is usually surreptitious and anonymous: offenders are rarely caught, and are simply admonished by the museum when they are. It is also nothing new: in 1841, Edward Hawkins, the Keeper of Antiquities and Coins at the British Museum, reported that the only misbehaviour he had observed on the part of the public was 'that constant habit that young people have of touching everything, which dirties some of the objects'.[63]

Fiona Candlin has traced the shift from what she calls 'tactuality' to visuality within the museum from the second half of the eighteenth-century museum onwards. She describes how touching was no longer sanctioned as an appropriate means of apprehending the museum object and how its prohibition was increasingly regulated via rules and conventions of behaviour.[64] The art critic Anna Jameson's often quoted comment made in 1844 that everyone could remember the days when visitors to art galleries walked around 'touching the ornaments – and even the pictures!' suggests that touching was no longer a casually accepted practice.[65] Broadly, this is the change in conventions and expectations that Candlin interrogates, although there is very little evidence of touching in, for example, the eighteenth-century British Museum or Royal Academy, not least because of the presence of the conductor in the former and the fact that many of the exhibits were out of reach in the latter. Candlin's argument is that touching by curators and invited scholars was (and is) still sanctioned as an elite connoisseurial practice, and that the general application of the museum's 'do not touch' rule was a corollary of the admission of an inclusive public. The paradox is that a sign that says 'do not touch' may have the opposite effect, and not only on deliberate vandals. Ruth Hoberman acutely observes that, 'From its earliest incarnation, the museum has seemed inseparable from the imagination of disorder: its evocation of extreme order brings with it an impish vision of havoc'.[66] The 'trippers' whom we encountered in Chapter 4 as they fell into 'The Crack' at Tate Modern lost their balance on the smooth gallery floor, despite signs warning visitors to 'Watch your step': is this evidence that the museum's efforts to organise the bodies of its visitors are liable to produce the opposite effect to the one intended?

Despite measures to keep visitors at a distance from valuable objects, accidents do occur a result of their unstable or disobedient bodies. In 2006, a visitor to the Fitzwilliam Museum, Cambridge, trod on a loose shoelace and fell on a marble staircase thereby knocking over a Qing dynasty vase on open display on a nearby windowsill, which, in turn, fell on to two adjacent vases.[67] The value of the broken items was said to be £100,000 in total.[68] As a result of this expensive accident, the repaired vases have acquired celebrity

status, not in terms of their original design and craftsmanship, but because of the accident and the skill of the restorers in their reconstruction. Four years later, a hapless art student lost her balance during a class in the Metropolitan Museum of Art, New York, and fell against a large canvas by Picasso entitled *The Actor*, leaving a six-inch tear in its bottom right-hand corner.[69] When the repaired painting was put back on public display it was covered with non-reflective acrylic glazing. In general, museums resist glazing oil paintings because of the resulting difficulty of controlling lighting glare and the loss of visibility of the artist's brushwork. The question of how best to protect their most famous works from an admiring or curious public has always been problem for museums: in 2005, the *Mona Lisa* was reinstalled in the Salle des États in the Louvre within a self-contained, climate-controlled case made of bulletproof glass. It is no longer easy to see the world's most famous painting, not least due to the crowds that gather around it, but its protective case meant that the picture was undamaged when a Russian woman hurled a ceramic mug at it in 2009.[70]

The measures taken to protect particular artworks from visitors inevitably, and sometimes deliberately, draw attention to their artistic or financial currency – often both. In the nineteenth century, the metal rail that was installed in front of the most popular paintings in the Royal Academy functioned both as a security precaution and as a material symbol of a picture's celebrity (Figure 32). The rail also had the effect of arranging the body of the viewer in a specific spatial relation to the celebrated exhibit, although, realistically, the close proximity of a police constable was a more effective deterrent to the potential vandal. Fashions in gallery furniture change, and the visual intrusion of a high iron rail or fence that had made the human presence tangible in the nineteenth-century gallery, had no place in its modernist successor (Figure 7).[71] Noordegraaf argues that the absence of rails was a sign that, by the twentieth century, visitors no longer needed to be restrained from touching the paintings, on the grounds that 'that they had internalized the proper reading of the museum script: they knew how to behave in front of works of art'.[72] Another possibility is that, as O'Doherty puts it, whilst minds and eyes were welcome in the white cube gallery 'space occupying bodies' were not.[73] From this perspective, the absence of gallery furniture (such as rails and benches) connotes the museum's disavowal of the unwelcome corporeality of its spectators, rather than an endorsement of their good behaviour. The history of museum vandalism in the twentieth century certainly makes the case for continuing precautions against visitors' capacity to inflict damage, even if they are sometimes ineffectual. When Josef Nikolaus Kleer attacked Barnett Newman's *Who's Afraid of Red, Yellow and Blue IV* in the Nationalgalerie in (then) West Berlin in 1982, he used one of the plastic bars that were inserted in the gallery floor in order to demarcate the viewing

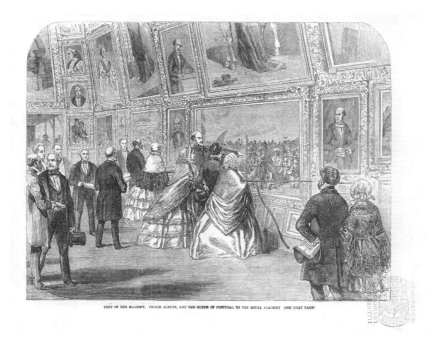

VISIT OF HER MAJESTY, PRINCE ALBERT, AND THE QUEEN OF PORTUGAL TO THE ROYAL ACADEMY (SEE NEXT PAGE)

32 Prince Albert and the Queen of Portugal at the Royal
Academy of Arts, *Illustrated London News*, 22 May 1858.

position of the visitor: on this occasion, the apparatus of protection provided a convenient weapon of assault.[74]

Gamboni argues that museums exert a kind of 'threshold effect' on their potential aggressors. Crossing from the street into the symbolically charged space of the museum, the stakes are raised: in general, museum vandals seem to be highly invested in their acts, showing evidence both of premeditation and public identification with the damage that they cause.[75] In this context, David Freedberg argues that all iconoclasts 'know of the financial and cultural and symbolic value of the work they assault. The work has been adored and fetishized: the fact that it hangs in a museum is sufficient testimony to that'.[76] In many cases, assailants do not seek to evade apprehension by the museum or the police: on the contrary they appear to cultivate the publicity that attends their actions.

According to Gamboni's study, those who deliberately damage museum artworks 'often provide warning, accompanying and subsequent statements, since they tend to desire and enjoy publicity'.[77] The majority of cases of museum vandalism seem to follow a pattern: they are overt, rather than surreptitious, and they target renowned and famous objects. In 1993, Christopher Cordess and Maja Turcan published a study of the prevalence of art vandalism, based

primarily on a survey of incidents in British museums and galleries.[78] Ninety-two questionnaires were distributed and 60 were returned, including five left blank out of a fear of publicity and 'copycat' incidents. Of those that were completed, 37 museums reported the occurrence of vandalism, and only five reported none. The majority of incidents (over 200) were 'minor' acts of vandalism: for example, scratching, scribbling or sticking chewing gum on to a display. The perpetrators were rarely caught, and even more rarely prosecuted even if their offence was tantamount to criminal damage, usually in order to avoid publicity on the part of the museum.[79] Just nine museums reported 'major' acts such as slashing, stabbing, shooting, smashing and arson: forms of violence that corroborate Steven Goss's 'A Partial Guide to the Tools of Art Vandalism' which lists the most commonly used implements of destruction as hammers, glass cutters, ink, knives, guns, stones, scissors and sulphuric acid.[80] These major acts were, according to Cordess and Turcan, often devised in order to attract publicity and their perpetrators were rarely drunk.[81] In the survey, at least half of the offenders prosecuted were detained under the Mental Health Act (1983).

The museum directors surveyed by Cordess and Turcan identified certain categories of art that appear to be particularly susceptible to vandalism: specifically, works with religious or political content, depictions of nudity and sexually explicit subjects, and kinetic art and mechanical sculptures.[82] Amongst the most vulnerable artworks were those depicting naked or idealised women, such as the Virgin Mary or the goddess Venus. Freedberg adds that assailants can be very deliberate in the target of their attack: for example, removing the eyes or slashing the belly of a nude portrait. The eyes are, he says, 'those organs which give us most sense of [the] liveliness' of the image, whereas attacks on erotic pictures demonstrate a failure to grasp the distinction between the signifier and the signified: as Freedburg puts it, between 'the image and the prototype'.[83]

A similar elision between the museum (and its contents) and the nation state is cited as justification for attacks carried out on political grounds. For example, when the Russian woman who threw a mug at the Mona Lisa in 2009 was arrested, she said that she was angry that her application for French citizenship had been refused. She underwent psychiatric testing and was released.[84] A more serious attack on Rembrandt's Danaë involved a man cutting the painting 'in the region of Danaë's lower belly' and then pouring a litre of sulphuric acid on to the canvas.[85] The perpetrator was reported to be a Lithuanian who had 'launched his knife-and-acid barrage' to protest against the Soviet occupation of his native land.[86] Restoration of the picture took 12 years: it was finally back on display in 1997. Just as a grudge against the nation state is violently expressed via an assault on one of its most precious objects, so too the power of the museum to reproduce its official culture is simultaneously dramatised through such acts of destruction.

Prior to the assault on the *Mona Lisa* in 2009, the painting had been attacked in 1956 and again in 1974. First in 1956, the lower part of the panel was badly damaged when a vandal doused it with acid; then in December the same year, a young Bolivian threw a rock at it, resulting in the loss of a speck of pigment near the left elbow. The man was homeless and was reported to have confessed to committing the crime in the hope of being arrested and put in jail, as he had no money and nowhere to go.[87] Then in April 1974, a disabled woman sprayed red paint at the *Mona Lisa* whilst it was on display at the Tokyo National Museum in protest against the museum's access policy.

Repeated attacks on Rembrandt's masterpiece *The Night Watch* indicate that it occupies a comparable position to the *Mona Lisa* within the national pantheon of Dutch museum culture. On 13 January 1911, an unemployed navy cook tried to cut the canvas with a knife, but made little impact due to the thick varnish that covered the painting. At the time, it was reported that the attack was intended as vengeance against the state, following his discharge from the Navy.[88] In 1975, William de Rijk, an unemployed school teacher, was turned away from the Rijksmuseum because he had arrived after closing time: the next day he returned and cut dozens of zigzag lines in *The Night Watch*. The painting was restored, but traces of the cuts still remain. The most recent attack took place in 1990, when a man threw acid on the work: it was quickly diluted and once again the varnish protected the paint layers beneath.

Bennett speculates that, 'It seems unlikely, come the revolution, that it will occur to anyone to storm the British Museum. Perhaps it always was.'[89] Yet even these isolated examples of calculated violence on artworks such as the *Mona Lisa* and *The Night Watch* demonstrate how closely the art museum is associated with the cultural and, by extension, the political authority of the nation state. Bennett is correct to point out that fears of a concerted assault on the British Museum during periods of political unrest in the eighteenth and nineteenth centuries were not realised, although as we shall see, museums have not been immune to organised symbolic violence.[90] On a number of occasions, troops were installed to protect the British Museum from the prospect of attack by the mob. In 1780, during the height of the anti-Catholic Gordon Riots, a regiment of 600 soldiers was dispatched to defend the museum; in the event, it was not attacked, but the violence came close.[91] The rioters destroyed churches, carriages and private homes, including some in nearby Bloomsbury Square. Again, after the third reading of the Corn Bill in March 1815, crowds attacked the houses of known supporters of the Bill including a number of British Museum trustees. Once more, troops were stationed at the museum to safeguard the building and its contents.[92] Even more elaborate precautions were taken in 1848 when the Chartists marched to present the People's Charter to Parliament: museum staff were sworn in as special constables and a garrison of museum staff, regular troops and Chelsea pensioners occupied the buildings. Fortifications were constructed around

the perimeter and stones were carried to the roof to be hurled down on the demonstrators if they managed to break through the outer defences.

The same fear of mob violence is evident in a precautionary clause included in the revised constitution of the National Gallery, dated 27 March 1855: 'On occasion when crowds are likely to assemble in the streets, during any extraordinary ceremony or during periods of excitement, the Keeper, with the sanction of the Trustees or, when there is not time to consult the Trustees, with the sanction of the Director, will close the Gallery.'[93] However, it would be another 50 years before the National Gallery became the target, not of a riotous crowd, but of a single assailant in the form of the suffragist, Mary Richardson. Richardson's action was not an isolated incident, but part of a concerted wave of politically motivated assaults on museum (and other) property in the years prior to the outbreak of the First World War.[94] The leading suffragist, Sylvia Pankhurst, later recalled that:

> The destruction wrought in the seven months of 1914 before the War excelled that of the previous year ... The *Rokeby Venus*, falsely, as I consider, attributed to Velazquez, and purchased for the National Gallery at a cost of £45,000, was mutilated by Mary Richardson. Romney's *Master Thornhill*, in the Birmingham Art Gallery, was slashed by Bertha Ryland, daughter of an early Suffragist. Carlyle's portrait of Millais in the National Gallery, and numbers of other pictures were attacked, a Bartolozzi drawing in the Dore Gallery being completely ruined.[95]

The suffragists did not restrict themselves to attacks on museums: other forms of property also destroyed. 'Many large empty houses in all parts of the country were set on fire ... Railway stations, piers, sports pavilions, haystacks were set on fire. Attempts were made to blow up reservoirs.'[96] In all, Pankhurst notes that an extraordinary 4,141 acts of destruction were reported in the press between January and August 1914. Of these, perhaps the most notorious of all was Richardson's assault on Velazquez's *The Toilet of Venus*, popularly called the *Rokeby Venus*.

The purchase of the *Rokeby Venus* in 1906 had not been without controversy. The sum of £40,000 for the picture was raised by public subscription organised by the National Art Collections Fund, with little support or enthusiasm from the National Gallery itself. Questions were raised regarding the propriety of its acquisition for a public museum: Lord Ronald Sutherland Gower and the London Council for the Promotion of Public Morality objected that such a painting was perfectly 'suited for the sanctum of some multi-millionaire, but not for an English public art gallery'.[97] Nonetheless, by the time it was attacked by Richardson with a small axe on 10 March 1914, the painting was, in the words of Lynda Nead, 'no longer ... in any material sense the *Rokeby Venus*, it was now the nation's Venus'.[98] The idea that the picture now symbolically belonged to every man and woman in the country was, of course, precisely the

point: to attack the *Rokeby Venus* was to attack the nation state itself. It was also a symbol of the reproduction of femininity within Edwardian society. Within this context, Suzanne Macleod argues that an assault on the *Rokeby Venus* was a blow against the dominant patriarchal culture and against the position allocated to women in that culture: namely, a position of subordination and objectification that was represented and reproduced in the collecting and display practices of the National Gallery.[99] As Richardson was led from the scene of the attack towards the constable's office, she was reported to have said: 'Yes, I am a suffragette. You can get another picture, but you cannot get a life, as they are killing Mrs Pankhurst.'[100] Her message was clear: to shame both the government and the public alike for valuing an inert painting over a human life (Figure 33).

The following day *The Times* published an account of Richardson's attack, which reveals a great deal about the body politics of the National Gallery in 1914:

> Miss Richardson … visited the National Gallery about 11 o'clock yesterday morning. She is a small woman, and was attired in a tight-fitting grey coat and skirt. She stood in front of the Rokeby Venus for some moments, apparently in contemplation of it. There was nothing in her appearance or demeanour to arouse the suspicions of the uniformed attendant and a police constable who were on duty in the room and were standing within seven or eight yards of her. The first thought of the attendant, when he heard the smashing of glass, was that the skylight had been broken; but a moment later he saw the woman hacking furiously at the picture with a chopper which, it is assumed, she had concealed under her jacket. He ran towards her, but he was retarded somewhat by the polished and slippery floor. The constable reached the woman first and seizing her by the right arm prevented her from doing further mischief. She allowed herself to be led quietly away to the inspectors' office.[101]

Richardson did not attract attention in the heavily guarded room (in which both a gallery warder and a police officer were present) because both her clothes and her behaviour appeared 'normal': she *looked* like an ordinary visitor and the idea of an incident of vandalism seemed so unlikely that the gallery attendant initially assumed a window had broken when he heard the sound of breaking glass. At that point, the norms of gallery comportment were shattered too: the respectable attire worn by Richardson was revealed as a hiding place for a weapon, and the polished floor impeded the movement of the guards as they tried to run towards her. In the wake of Richardson's attack, women were no longer admitted to the National Gallery wearing muffs; a visitor's outward appearance of respectability could no longer be trusted as a reliable indicator of their rectitude inside the museum.

By 1914, when Richardson attacked the *Rokeby Venus*, Macleod argues that the museum had become 'one amongst a series of potential sites of protest in the spatial networks of the city'.[102] Instead of viewing museum

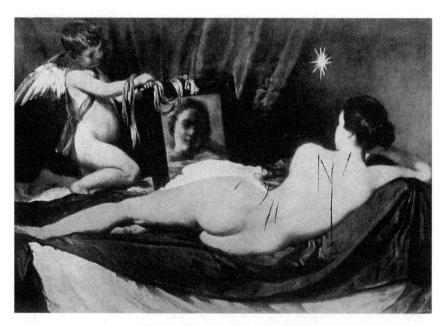

33 Velazquez's *The Toilet of Venus* (the *Rokeby Venus*),
photographed 1914. © Press Association Images.

violence in terms of a 'pathology of destruction' she seeks to shift the focus
to the museum 'as a site and a recognition of architectural space, interior and
exterior, as productive of social relations'.[103] Specifically, the museum is a
space where questions about the extension (and the restriction) of cultural
enfranchisement and inclusion are continually renegotiated: the rhetoric and
practice of the institution is, inevitably, a marker of political, as well as artistic,
ideology. Following Macleod's assertion of the potential of museum as a site
of civil disobedience, my final example in this chapter suggests that museum
violence has sometimes contributed towards the production of a new image
of the state. During the July Revolution of 1830, which marked the end of the
Bourbon monarchy of Charles X, the centre of Paris, including the Tuileries
Gardens and the Louvre, fell to the revolutionaries on 29 July 1830. That
stout defender of the universal right to cultural access in Britain, *The Penny
Magazine of the Society for the Diffusion of Useful Knowledge*, took up the story:

> When the people entered the Louvre, a portion of them immediately made
> a rush into the great picture gallery. An armed and tumultuous multitude,
> heated by the intoxication of sudden victory, thus let loose amid so rich a store
> of the most precious and most fragile creations of art, might well strike a thrall
> of apprehension to the stoutest heart.[104]

However, the revolutionaries showed considerable restraint as well as political, if not artistic, discrimination:

> But to the eternal honour of these brave men, most of them belonging to the very humblest class of the population, they felt more nobly than to stain their triumph over despotism by so terrible an outrage as they now had it in their power to perpetrate on the glories of civilization. One or two pictures only … they destroyed with the same weapons and the same energy with which they had wreaked their vengeance on their living enemies. A splendid representation of the coronation of Charles X, by Gerard, and also a full-length portrait of that monarch … were in few minutes reduced to tatters, pierced by countless bullets.[105]

The portraits of Charles X were targeted as proxies for the monarch himself: their destruction sent an unambiguous message to the king, who left Paris the following day. In Freedberg's terms, the crowd elided 'the image and the prototype', but in doing so, they targeted their museum violence strategically as a process of an act of symbolic, rather than actual, regicide.[106] The events of July 1830 are also a salutary reminder, that come the revolution, the museum was indeed stormed.

Notes

1 On the 'museum effect' see: André Malraux, *The Voices of Silence* (trans. Stuart Gilbert), London: Secker and Warburg, 1954; Duncan and Wallach, 'The Universal Survey Museum'.

2 Valéry, *The Collected Works*, p. 202.

3 Ibid., pp. 203 and 204.

4 Ibid., p. 204.

5 Ibid., p. 203.

6 Ibid.

7 Ibid., p. 204.

8 Ibid., p. 205.

9 Ibid.

10 See for example the Happy Museum Project at: www.happymuseumproject.org.

11 Magherini, *La Sindrome di Stendhal*.

12 Gamboni, *The Destruction of Art*.

13 Altick, *The Shows of London*, p. 101.

14 Ibid.

15 Hemingway, 'Art Exhibitions as Leisure-Class Rituals', p. 99.

16 BL, Add. MS. 6179, ff. 61–62v. Amongst John Ward's papers on the museum; not in Ward's hand. Quoted in Goldgar, 'The British Museum and the Virtual Representation of Culture', p. 210.

17 Quoted in Siegel, *The Emergence of the Modern Museum*, p. 90.

18 Ibid., p. 91.

19 House of Commons, *Report of the Select Committee appointed to inquire into the present state of the National Monuments and Works of Art in Westminster Abbey, in St Paul's Cathedral, and in other Public Edifices; to consider the best means for their Protection, and for afford Facilities to the Public for their Inspection as means of moral and intellectual Improvement for the People*, 1841, para. 2640.

20 Ibid.

21 Dickens, 'The Manchester School of Art', p. 348.

22 Altick, *The Shows of London*, p. 500.

23 Charles Kingsley writing as 'Parson Lot', 'The British Museum', *Politics for the People*, London: John W. Parker, 1848, p. 184.

24 Quoted in Siegel, *The Emergence of the Modern Museum*, p. 114.

25 Ibid.

26 Karen Stanworth, 'Picturing a Personal History: The Case of Edward Onslow', *Art History*, 16.3, September 1993, pp. 408–23.

27 Royal Academy Archives, *Royal Academy Critiques &c.*, Vol. 1: 1769–1793. Leaf 101.

28 Ibid.

29 Stanworth, 'Picturing a Personal History', p. 412.

30 Nigel Williams, *The Breaking and Remaking of the Portland Vase*, London: British Museum Publications, 1989.

31 Black, *On Exhibit*, p. 120.

32 'The British Museum and the People who go there', *Blackwoods Edinburgh Magazine*, 144.874, August 1888, p. 208.

33 Quoted in Siegel, *The Emergence of the Modern Museum*, p. 92.

34 Nathaniel Sheldon Wheaton, *A Journal of a Residence during Several Months in London: Including excursions through Various Parts of England and a Short Tour in France and Scotland in the Years 1823 and 1824*, Hartford: Huntington, 1830.

35 Ibid.

36 First published in *Household Words*, 1 May 1848. Reprinted Charles Dickens, 'Please to Leave your Umbrella', in David Pascoe (ed.), *Charles Dickens: Selected Journalism 1850–1870*, Harmondsworth: Penguin, 1997, pp. 587f.

37 Quoted in Duncan and Wallach, 'The Universal Survey Museum', p. 455.

38 Maurice Blanchot, *Friendship* (trans. Elizabeth Rottenberg), Stanford: Stanford University Press (first published in French 1971), 1977, p. 45.

39 Ibid.

40 Ibid.

41 Ibid.

42 Quoted in Cecil Gould, *Trophy of Conquest: The Musée Napoléon and the Creation of the Louvre*, London: Faber, 1965, p. 84.

43 Henry Ward Beecher, *Star Papers, or, Experiences of Art and Nature*, New York: J.C. Derby, 1855, p. 75.

44 Altick, *The Shows of London*, p. 33.

45 William Wordsworth, *The Prelude*, edited by Jonathan Wordsworth, M.H. Abrams and Stephen Gill, New York: Norton (first published 1850), 1979.

46 Eric Gidal, *Poetic Exhibitions. Romantic Aesthetics and the Pleasures of the British Museum*, Lewisburg: Bucknell University Press, 2001, p. 77.

47 Moritz, *Travels of Carl Philipp Moritz in England in 1782*.

48 Gidal, *Poetic Exhibitions*, p. 81.

49 Stendhal, *Rome, Naples and Florence*, p. 302.

50 Ibid.

51 Hannu Salmi, *Nineteenth-Century Europe. A Cultural History*, Cambridge: Polity Press, 2008, pp. 55f.

52 Magherini, *La Sindrome di Stendhal*, 1989.

53 Melinda Guy, 'The Shock of the Old', *Frieze Magazine*, 72, January–February 2003. Online at: www.frieze.com/issue/article/the_shock_of_the_old.

54 Timothy Richard Joseph Nicholson, Carmine Pariante and Declan McLoughlin, 'Stendhal Syndrome: A Case of Cultural Overload', *BMJ Case Report*, 20 February 2009. Online at: www.ncbi.nlm.nih.gov/pmc/articles/PMC3027955/.

55 Elkins, *Pictures & Tears*.

56 Twain, *The Innocents Abroad*, p. 96.

57 Ibid.

58 Blanchot, *Friendship*, p. 45.

59 Wendeborn, *A View of England Towards the Close of the Eighteenth Century*, pp. 197f.

60 Quoted in Siegel, *The Emergence of the Modern Museum*, p. 96.

61 Ibid., p. 123.

62 Gamboni, *The Destruction of Art*, p. 192.

63 Quoted in Siegel, *The Emergence of the Modern Museum*, p. 113.

64 Candlin, *Art Museums and Touch*.

65 Anna Jameson, *Companion to the Most Celebrated Private Galleries of Art in London*, London: Saunders and Otley, 1844, pp. 34f.

66 Hoberman, *Museum Trouble*, p. 3.

67 For the Fitzwilliam Museum's account of the accident and its aftermath, see: www.fitzmuseum.cam.ac.uk/gallery/chinesevases/disaster.html.

68 Sam Jones, 'Museum Visitor who Broke Historic Vases Laments his "Norman Wisdom Moment"', *Guardian*, 6 February 2006. Online at: www.guardian.co.uk/uk/2006/feb/06/arts.artsnews1.

69 David Usborne, 'Oops, that's Torn it – Clumsy Art Student Rips £80m Picasso Canvas', *Independent*, 26 January 2010. Online at: www.independent.co.uk/news/world/americas/oops-thats-torn-it-n dash-clumsy-art-student-rips-16380m-picasso-canvas-1878809.html.

70 Angelique Chrisafis, 'Woman Hurls Mug at Mona Lisa after being Refused French Citizenship', *Guardian*, 11 August 2009. Online at: www.guardian.co.uk/world/2009/aug/11/mug-attack-mona-lisa.

71 Noordegraaf, *Strategies of Display*, p. 162.

72 Ibid., p. 162. Also, Dirk Hannema, Director of the Boymans Museum, Rotterdam, observed during a trip to France in the 1920s, that the erection of an iron fence in front of the pictures in the Palais des Arts, Lille, 'looks very unpleasant and cannot protect the paintings from malevolence anyway'. Quoted in ibid., pp. 123f.

73 O'Doherty, *Inside the White Cube*, p. 15.

74 Gamboni, *The Destruction of Art*, p. 207.

75 Ibid., p. 191.

76 David Freedberg, *The Power of Images*, Chicago and London: University of Chicago Press, 1989, p. 409.

77 Gamboni, *The Destruction of Art*, p. 197.

78 Christopher Cordess and Maja Turcan, 'Art Vandalism', *British Journal of Criminology*, 33.I, 1993, pp. 95–102.

79 Ibid., p. 97.

80 Steven Goss, 'A Partial Guide to the Tools of Art Vandalism', *Cabinet*, 3, Summer 2001. Online at: www.cabinetmagazine.org/issues/3/toolsofartvandalism.php.

81 Cordess and Turcan, 'Art Vandalism', p. 97.

82 Ibid., p. 98.

83 Freedberg, *The Power of Images*, p. 409.

84 Chrisafis, 'Woman Hurls Mug at Mona Lisa'.

85 John Russell, 'Healing a Disfigured Rembrandt's Wounds', *New York Times*, 31 August 1997. Online at: www.nytimes.com/1997/08/31/arts/healing-a-disfigured-rembrandt-s-wounds.html?scp=1&sq=Healing%20a%20Disfigured%20Rembrandt's%20Wounds&st=cse.

86 Gridley McKim-Smith, 'The Rhetoric of Rape, The Language of Vandalism', *Woman's Art Journal*, 23.1, 2002, p. 29.

87 Goss, 'A Partial Guide to the Tools of Art Vandalism'.

88 Freedberg, *The Power of Images*, p. 407.

89 Bennett, 'The Exhibitionary Complex', pp. 82f.

90 As this chapter is not concerned with violence in or theft from museums for monetary gain, I do not discuss here the issue of looting during times of political upheaval, such as occurred during the Napoleonic wars, the Second World War, and more recently at the National Museum of Iraq, Baghdad in 2003 and at the Museum of Egyptian Antiquities, Cairo in 2011.

91 Altick, *The Shows of London*, p. 27; Bennett, 'The Exhibitionary Complex', p. 82.

92 Cash, 'Access to Culture', p. 39.

93 National Gallery Archive. Treasury Minute, *Reconstituting the Establishment of the National Gallery*, 27 March 1855 (file NG5/134/1857).

94 Suzanne MacLeod, 'Civil Disobedience and Political Agitation: The Art Museum as a Site of Protest in the Early Twentieth Century', *Museum and Society*, 5.1, 2007. Online at: www.le.ac.uk/ms/m&s/Issue%2013/macleod.pdf.

95 Sylvia Pankhurst, *The Suffragette Movement: An Intimate Account of Persons and Ideals*, London: Longmans, 1931, p. 544.

96 Ibid.

97 Letter from Sutherland Gower to Lord Balcarres, 29 November 1905. Quoted in Mary Lago, *Christiana Herringham and the Edwardian Art Scene*, London: Lund Humphries, 1996, p. 133.

98 Lynda Nead, *The Female Nude Art, Obscenity and Sexuality*, London and New York, 1992, p. 36.

99 MacLeod, 'Civil Disobedience and Political Agitation'.

100 *The Times*, 11 March 1914, p. 9.

101 Ibid.

102 MacLeod, 'Civil Disobedience and Political Agitation', p. 46.

103 Ibid.

104 'The National Gallery', *The Penny Magazine of the Society for the Diffusion of Useful Knowledge*, 31 October to 30 November 1836, p. 468.

105 Ibid.

106 Freedberg, *The Power of Images*, p. 409.

Disquieting Bodies

Throughout this book I have explored the capacity of both empirical and archetypal bodies to apprehend the socio-cultural script of the art museum through accounts of actual and fictive visitors, and through their visual representations. Historically, anxieties about certain kinds of visitors coalesced around categories of gender, age and class, each of which were deemed to correlate to an innate or acquired deficit of cultural receptivity. According to the exclusionary model of cultural access, neither women, nor children nor the working classes were qualified to obtain full admission to the sphere of art appreciation, although in practice, practical barriers to their entry into the museum were contested and difficult to enforce. Certainly, middle-class women were never barred from physical admission, although their children, as well as their poorer sisters, occasionally were. Even so, once inside the institution, women's deportment, conversation and clothes frequently prompted a commentary of disapproval, often peppered with the charge that their very presence amid the art crowd was a distraction to other visitors and risked the de-stabilisation of social relations within the exhibition. Meanwhile, working-class adults and all children were deemed capable of ignorant, mischievous or transgressive behaviour, and thus liable to undermine the civilising effects of the display of art.

On the other hand, it was precisely because these categories of visitors were apparently so unattuned to the museum's spatio-visual programme that they were, at times, also courted and prized as evidence of its inclusivity and social efficacy. Only the participation of the demographically diverse 'social body' could attest to the museum's symbolic status within the nation state or city, as well as to its universalising artistic schema.[1] It is useful to recall Poovey's argument that nineteenth-century mass participation in museums and exhibitions was the kind of empirical event that underpinned the abstraction and formation of the 'social' as a category that comprised the entire population. Having amassed the whole population, it could be stratified and classified according to economic and social circumstances. Thus

the presence within the exhibition of the well-behaved child, the attentive woman and the intelligent labourer was a cause for celebration. Less welcome to the museum authorities were the smells, noises and dirt produced by the bodies of their incontinent, chattering and ill-shod peers. On the one hand, here was evidence of the socially unifying effects of cultural consumption: in the words of Robert Peel, a demonstration of the art museum's potential to cement 'the bonds between the richer and poorer orders of the state'.[2] On the other hand, proponents of an exclusionary model of cultural access could cite numerous examples of the museum's failure to educate the ignorant and to refine the vulgar. Official attitudes to these disquieting bodies within the eighteenth- and nineteenth-century museum therefore oscillated between a desire to restrict admission in order to preserve both the museum's holdings and its decorum, and a desire to demonstrate the efficacy of the museum on the corpus of the whole population.

This chapter recounts some of the narratives of exclusion, ambivalence and uncertainty that were provoked by the actual and the idealised participation of these entrants into the field of art spectatorship. We have, of course, already encountered aspects of this theme. Chapter 1 compared the different mechanisms and debates concerning access to the early British Museum and Royal Academy respectively, whilst subsequent chapters on different bodily techniques, such as looking and walking, identified some of the challenges facing the museum novice in the acquisition of appropriate comportment and a requisite display of cultural competence inside the institution. The focus of this chapter is therefore intended to complement these perspectives. By looking in turn at three different groups of visitors and the arguments that surrounded their presence in the museum, my aim is to show how specific expectations and requirements were attached to each and how, in turn, the nineteenth-century museum calibrated its response to the challenge of audience diversity. As ever in this book, my aim is also to re-attach abstract debates about categories of visitors and behaviour to the empirical bodies of those concerned: how did these arguments relate to the lived experiences and actions of embodied spectators?

In addition to historical accounts and comments that reveal how class, gender and age were viewed as markers of aesthetic capacity and training, this chapter deploys a number of contemporary visual representations that reveal the ways in which diverse visitors were idealised, satirised and observed by artists within the museum. These range from the depiction of social stereotypes designed to amuse or instruct (or both) to portraits of individuals that intimate their capacity (or its absence) for aesthetic reception. How artists represent museum looking comes into focus via their depiction of posture, expression and dress as outward markers of an interior process, as well as how they position certain visitors within the social and object relations

of the museum – for example, as instructors or pupils, as viewing subjects or the object of the gaze of others.

Before turning to each of these categories of museum visitors in more detail, let us begin by looking at a famous painting in museum history and what it tells us about the museum's ambition to produce an idealised and inclusive public. *The Artist in His Museum* was painted by Charles Willson Peale in 1822, both to commemorate the museum that he had founded in Philadelphia in 1786 and to record its diverse audience (Figure 34). The artist has depicted himself in the foreground lifting back a crimson curtain to reveal the distinctive display schema that he had devised. Ranks of portraits of American worthies from the recent past were hung above showcases containing natural history specimens, chief amongst which was the massive mastodon skeleton, whose jaw and tibia sit on the floor next to Peale himself. Here, then, was an object

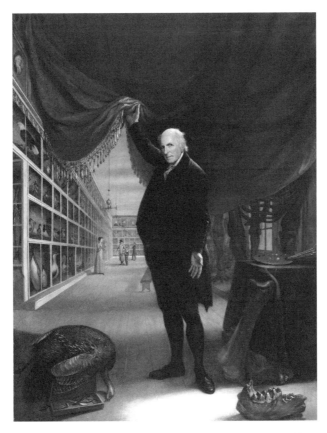

34 Charles Willson Peale, *The Artist in His Museum*, 1822.
Courtesy of the Pennsylvania Academy of the Fine Arts, Philadelphia.
Gift of Mrs. Sarah Harrison (The Joseph Harrison, Jr. Collection).

lesson in the unfolding of divine providence, rendered palpable via the direct visual connection between the natural order of the animal kingdom and the heroes of the American Revolution.

Four visitors occupy the museum space into which Peale invites the viewer to enter: one female and three males of varying ages. The woman who stands by herself, with her arms lifted in amazement at the mounted mastodon skeleton, is identifiable by her bonnet as a member of Philadelphia's substantial Quaker community. Behind her and to the right of the picture, a father instructs his son in the lessons of the museum: their pedagogic agenda is reinforced by their reference to a book, probably Peale's *Guide to the Collections*, which is held by the boy. To the rear of the picture, another man stands by himself: his arms are folded and he leans back on one leg in a posture of self-confident appraisal. He is both more composed than the woman who expresses astonishment and curiosity, and less intense than the self-absorbed father and son. Each of the three males differs in age, from the young boy to the solitary young man and the slightly older father. In effect, Peale has constructed an inclusive and exemplary public for his museum from just four small figures, whose collective presence instantiates his desire that the museum would serve the needs of 'the unwise as well as the learned'.[3] Research by David R. Brigham into the admission practices of Peale's museum, shows that he was particularly concerned to ensure that women were invited to participate in its activities, either alone or accompanied by their husbands.[4]

However, the plurality of people and responses within the painting also reveals a hierarchy of understanding and of cultural competence inside the museum; each figure represents a stereotypical response that reinforces, rather than challenges, a correlation between age, gender and intellectual receptivity. Evidently, the roles of teacher and pupil are performed by father and son respectively. But for now, it is only the boy's youth that prevents him from fully grasping the messages of the museum; in time, he will mature in understanding, and thus acquire the knowledgeable assurance of the young man who stands nearby. By contrast, the women's response is expressive rather than reflective: she seems to lack the capacity to interiorise what she sees and can only stand in amazement. There is no one on hand to direct her reactions and so, welcome as she is to enter the museum, once inside she cannot penetrate an invisible inner circle of superior male knowledge and comprehension. Within the microcosm of Peale's painting, an ostensibly inclusive public is thus demarcated in terms of education and gender.[5]

Even so, the visitors in Peale's scene appear at ease with one another: although standing apart from each other, they occupy a single space and there is no sign of tension between them. The potential social embarrassment arising from the close proximity of different sexes and classes was, however, a recurring refrain in commentaries on, and depictions of, museum visitors in England at this time. For example, the British Museum system of escorting

small groups on a conducted tour of the collections meant that strangers were obliged to share their visit in close companionship with each other: ironically, therefore, a system of strict control, devised to regulate visitors' access and movement, also had the potential to produce unwelcome contiguities within a single group. We have already noted the observation made in 1774 by the Principal Librarian, Matthew Maty, that 'the joining of Companies is often disagreeable, from Persons of different Ranks and Inclinations being admitted at the same Time, and obstructing one another'.[6] In fact, as we saw in Chapter 1, the primary cause of dissatisfaction about the pre-1810 system of conducted tours was the haste and unhelpfulness of the museum guides, rather than the conduct, appearance or manners of other visitors. Equally, the process for procuring a ticket to the eighteenth-century British Museum was so complicated that very small numbers were admitted overall and amongst them would have been even fewer members of the working classes: in practice, the risk of social embarrassment amongst visitors would have been slight and it is not surprising that we hear little about it. Nevertheless, Maty's unease about the mixing of 'Persons of different Ranks and Inclinations' did not dissipate with the subsequent relaxation of admission procedures. In 1835, one of his successors, Sir Henry Ellis, observed that, 'People of a higher grade would hardly wish to come to the Museum at the same time with sailors from the dock-yards and girls whom they might bring with them'.[7] Predictably, Ellis's solution was to exclude the sailors and their 'girls' from the museum, adding: 'I do not think that such people would gain any improvement from the sight of our collections.'[8]

'Four-fifths Care Nothing for the Pictures'

The cessation of the system of admission by pre-booked ticket and compulsory guided tours again raised the question of whether 'undesirable' people should be prevented or deterred from entering the British Museum and, if so, how. The revised regulations issued in 1810 stipulated that 'all Persons, of decent appearance, without limitation of numbers' could be admitted during opening hours on 'public days' when they were allowed to view the collections unescorted.[9] Thus, two decades later, the editor of *The Penny Magazine* assured his working class reader that he had the right to visit the museum no matter that his 'garb' was 'homely': the important thing was that he and his wife were clean, if not smart.[10] In fact, such confidence in the right of admission was not always justified: evidently some working people were refused entry, even though their clothes were neat and tidy. Only the previous month, *The Times* had reported that a livery servant had been denied access by the museum porter, presumably on the grounds of his dress, even though soldiers and sailors in uniform were allowed in.[11] The inference was that the

possible meeting of servants and masters on equal terms within the museum would have been an unwelcome and uncomfortable encounter, in contrast to the strict spatial divisions between family and staff that certainly adhered at home. Reflecting on the servant's complaint, the editor of *The Times* surmised that the refusal of admission was not based aristocratic prejudice on the part of the trustees, but on a 'fastidious feeling' which presumably objected to the visible presence of a servant amongst the museum's spectators.

The ill-defined interpretation of what constituted 'decent dress' in the context of the British Museum was raised in the House of Commons the following year by the radical MP William Cobbett. Cobbett objected to the fact that those who did not have the requisite attire for entrance – such as, the 'chopstick in the country, as well as the poor man who mended the pavement in town' – were obliged to pay for the upkeep of the British Museum, even though they derived no benefit from it.[12] Goldgar recounts how William Cobbett used the signifier of dress to mount an attack on an exclusionary model of 'cultural transmission' that promulgated the view that the whole nation benefited from having a national museum, whether or not every citizen had an equal right of access to it.[13]

The novelist Anthony Trollope was amongst those who refused to believe that uneducated visitors could appreciate, and therefore benefit from, access to museums. To support this, he reiterated the view that universal admission to the National Gallery had resulted in very little interest in the collections amongst the majority of its visitors: 'The National Gallery now is a place of assignation, of shelter from rain, a spot in which to lounge away an idle 10 minutes, a nursery for mothers who are abroad with their infants, a retirement place for urban picnics ... it is always clear that of those who are there four-fifths care nothing for the pictures.'[14] His argument was not that the presence of working people discomforted their social superiors, but that their use of the gallery for recreational purposes spoiled the enjoyment of the true art aficionado:

> Such uses of a picture gallery do rob those who really love pictures of much of their pleasure. That the poorer classes, that is, those who are comparatively uneducated and who are doomed to lives of manual toil, should really care for pictures, we believe to be impossible.[15]

Trollope's solution was the introduction of an admission charge on two days a week. He did, however, acknowledge that an economic barrier was not the same as a social filter. A charge would not necessarily exclude *all* working people, only the great majority who, he believed, were indifferent to art and for whom the National Gallery had become a convenient drop-in space, rather than a cultural venue: 'There would be no invidious class admission. The sixpence of the mechanic would be as operative as that of the peer.'[16] Trollope's position was opposed by the Liberal MP and art collector, William

Coningham, who provided evidence to the 1853 Select Committee of Enquiry into the National Gallery: when asked whether he thought that the enjoyment of 'upper class' visitor was impeded 'if large masses of the lower orders crowd in, many of them perhaps only from idle curiosity', Coningham said that he did not.[17] For example, during the Great Exhibition of 1851, he 'used to see ladies frequenting the building on the cheap days just as much as on the dear days'.[18] Despite evidence of this kind, the deleterious presence of working-class visitors continued to concern museum administrators, commentators and politicians.

A number of intersecting objections to working-class admission to the nineteenth-century museum emerge from these commentaries: the first was the question as to whether the uneducated person could derive any benefit from visiting a museum and, related to this, whether they were actually interested in its contents. Linked to these arguments, was the assertion that the admission of working people into the museum was detrimental to the enjoyment of their educated betters: how could the middle and upper classes appreciate the museum's contents if the norms of social stratification and exclusion did not apply there? Specifically, objections to the presence of the 'lower orders' within the museum focused on their unregulated, unpredictable and unwelcome bodies, although, as discussed in the previous chapter, fears of widespread damage and vandalism arising from unrestricted admission to the museum proved unfounded. On the contrary, a National Gallery attendant observed in 1841 that 'nothing could be more orderly' than the conduct of visitors of all classes who mixed together in the gallery each day.[19] However, even if they did not harm its contents by touching or breaking them, the presence of the poor carried a more insidious threat to the museum: dirt.

Mid-nineteenth century debates about the management of museum collections (and their visitors) invariably coalesced around the problems of dirt and dust: what caused it, and how to deal with it. In practical terms, the presence of dust in the urban museum was undeniable. On one occasion when the artist Joseph Farington visited the British Museum, it was so crowded 'that it appeared to smoke with dust, which caused us to go to the interior part of the Gallery which is not yet open to the general view'.[20] In fact, Farington's need to retreat into some private area of the museum may well have been prompted by the presence of dust from renovation works to the building, although he seems to have attributed the problem to the number of visitors. When there was dust in the building, visitors do appear to have made the problem worse: during the 1840s, the general public was excluded from the King's Library (part of the British Museum) due to the amount of dust 'shuffled up' by visitors which, it was said, damaged the books.[21]

However, it was in the National Gallery that the issue of dirt was considered to be most acute. According to *The Times*, the small size of the rooms at the

National Gallery (compared with the British Museum) exacerbated the situation: 'if the repositories of such works are not of ample atmospheric space, and if the numbers of visitors are legion, of course human respiration, dust, and dirt will encrust canvas, and require occasionally cleaning and fresh varnish.'[22]

Notwithstanding the close proximity to the National Gallery of chimney, barracks and a public wash house, all of which produced noxious and dirty fumes, the greatest danger was deemed to emanate from visitors themselves. Specifically, the presence of human effluvia, generated by breathing and sweating bodies, was regarded as a real pollutant that could damage the surface of an oil painting.[23] The idea of effluvia – that is, invisible, vaporous emissions given off by human bodies – was closely related to the persistence of the miasmatic theory of disease, which held that illnesses were caused by a miasma, or poisonous mist, filled with particles from decomposed matter. The metaphorical miasma that hung over the pictures in the National Gallery was therefore attributable to the presence of the dirtiest and smelliest bodies within its unfiltered and (largely) unwashed audience. In practical terms, the grease and dust that clung to the pictures was directly correlated to the presence of working-class bodies: concerns about pollution became a proxy for objections to unrestricted access to the gallery.

The 1853 Select Committee on the National Gallery was particularly exercised on the question: was the damage caused to the pictures by dirt sufficiently injurious to justify the removal of the collection to a more salubrious location, or should there be some control over the admission of working-class visitors? The Committee concluded that there were serious objections to the current site 'chiefly on account of its exposure to smoke, dust and idle crowds, and other influences unfavourable to the preservation of pictures'.[24] The former Keeper (and future Director) of the gallery, Charles Eastlake, had advocated practical measures such as 'the door-keeper being required to make visitors to the gallery dust their feet' on mats at the entrance to the building, and was 'very reluctant to put any restriction as to the admission on the numbers visiting the gallery'.[25] He did, however, add that 'at the same time I think the crowds visiting the gallery are the chief cause of the state to which the pictures are reduced'.[26] The same view of the polluting effects of visitors was expressed rather more forcibly by an assistant in the Department of Antiquities at the British Museum who described 'the animal heat and moisture arising from great crowds' that was palpable in the museum after public holidays.[27] And according to another witness, the 'greasy deposit' that coated the pictures in the National Gallery was directly attributable to the 'class and the number of persons' who visited it. Furthermore, the problem was exacerbated by the 'much more copious emanations and exhalations' that arose from the clothing of those who entered the building merely to shelter from the rain than from the garments of those 'who went decently dressed, and for the real purpose

of seeing the pictures'.[28] The idea of the working-class visitor as a noxious presence thus entangled issues of dress, cultural motivation and spectatorial competence.

'Lads of the Loom' and 'Thoughtless Blocks of Millinery'

Given its educational objectives and policy of social inclusivity, the level of working-class participation in the Manchester Art Treasures Exhibition was bound to attract considerable attention. The presence of 'operatives' and 'artisans' in the Art Treasures Palace provided commentators with an unprecedented opportunity to observe the character and conduct of the urban poor within the sphere of visual culture, not least as a means of assessing the efficacy of the exhibition as an educative and refining medium. Already, the scrutiny and analysis of working-class bodies and lives was well established in the city as a means of measuring and managing social issues. Notably, the Manchester Statistical Society had been formed in 1834 with the purpose of gathering facts on subjects such as housing conditions, access to clean water, the consumption of fresh meat and the circulation of books and pamphlets, thereby rendering the lives of working people both visible and, to an extent, explicable to middle-class investigators.[29]

Opinions as to the extent and effect of workers' participation in the exhibition were divided between those who argued that their absence was more noticeable than their presence and that they were largely 'untouched' by the experience – and vice versa. Dickens believed that the organisers were disappointed at the level of working-class participation in the exhibition, asserting that 'the working man has not come forwards eagerly, neither with his shilling, nor with that glow of enthusiasm for the thing of beauty, which, it was promised him, would be a joy forever'.[30] For all of Dickens's irony, 'the glow of enthusiasm' is a telling phrase because it was precisely such evident, but controlled, eagerness amongst 'lads of the loom' that attracted the approbation of many commentators. The *Art Treasures Examiner* conjured up an idealised artisan in the art gallery who was characterised by his 'quick glance, flushing cheek, the healthy, hearty admiration that expresses itself curtly, coarsely it may be, but earnestly and forcibly'. Such spontaneous expressions of appreciation were considered preferable to 'the cold eye of languid inspection' and the 'vapid common-places of conventional rule-criticism' uttered by the seasoned visitor who has seen it all before.[31] During the course of the exhibition, certain pictures acquired a kind of celebrity status arising from and, simultaneously contributing to, their popularity amongst working-class visitors in particular. According to the *Art Treasures Examiner*, the first Saturday afternoon of 6d admission attracted a large number of 'young factory operatives who crowded round the most showy pictures with

evident delight'.[32] The word 'showy' indicates that these were not paintings that elicited the admiration of art experts; instead, their public appeal was attributed to their drama, emotionalism and pathos. Most celebrated of all were *The Death of Chatterton* by Henry Wallis (Figure 10) in the Gallery of Modern Masters and *The Three Maries* by Annibale Carraci in the Gallery of Ancient Masters, the latter being frequently cited as the most visited picture in the entire exhibition.[33] The disjunction between the more measured scholarly view of these works and their public popularity also marks the shift from decorum to enthusiasm: the latter is to be encouraged, but also checked it if becomes excessive.

In contrast with the attention paid to working-class men at the exhibition, working-class women went almost entirely unnoticed, yet they undoubtedly took part in both family and works outings. For example, we have seen how Sayroh Shuttle accompanied her husband Bobby on their day out in the Art Treasures Palace, including the intensity of her own response to *The Death of Chatterton* when she was so moved by the tragic scene in front of her that reached out to straighten the quilt on Chatterton's bed.[34] In general, however, the responses of working-class women were deemed to be of little interest. One writer assumed that wives and daughters would be influenced by their men folk whose newly acquired 'taste for the fine arts' had the potential to 'throw an additional charm over the felicities of family life, and add a silken cord to the ties that unite the family circle'.[35] By comparison, the appearance and behaviour of middle-class women in the exhibition attracted considerable attention, much of it disapproving.

Amongst the pleasures of the Art Treasures Exhibition, Dickens described 'the moving spectacle of well-dressed, ever-changing company, always delightfully sprinkled with Lancashire witchcraft, which spreads its incantations (and its ample drapery) broadcast over the scene'.[36] He was not alone in his ambivalence about the performance of specifically female sociality staged in the Art Treasures Palace. The *Illustrated London News* reported that 'forms of witching beauty and female loveliness moved gracefully amid the treasures of art' at the opening of the exhibition.[37] But once the glitter and majesty of the opening ceremony had dimmed, critics increasingly condemned the behaviour of 'the frivolous and the idle' for 'making that temple a parade ground, insulting the shades of the mighty men of genius with the silly vanities of fashion'.[38] The display of women's clothes and the belief that they had occupied the exhibition for the purpose of a fashion parade was a recurring theme amongst (male) commentators, and many used expressions such 'a crinoline' or 'the most thoughtless block of millinery' to signify metonymically the woman who wore it.[39]

The organisation of the Art Treasures Exhibition had been an entirely male affair; once it opened, middle-class women were enjoined to participate as cultural consumers whose presence and conduct would add to its refining

effects.[40] In practice, their participation provoked rather more complex responses that, in turn, echoed anxieties prompted by the presence of fashionable and flirtatious women at the Royal Academy exhibitions during the previous century. The display of women's dress at in the Great Room at Somerset House had been censured as a frivolous distraction from the serious contemplation that good art demanded, and whilst the participation of respectable women was welcomed, in the belief the mixing of the sexes was essential to the modern civilising process, there was always the danger that they could stimulate improper sexual desires.[41]

Like the department store, which would make its entrance into the lives of urban women in the 1850s and 1860s, the art exhibition provided an important arena for the legitimate public appearance of middle-class women. However, the privatisation of the lives of leisured women within the domestic sphere also ensured that their visibility within the Art Treasure Palace attracted attention and disquiet. Although their fine clothes signalled their (and their husbands') social status, evidence of their failure to master the choreography of walking, talking and looking at art destabilised the 'play of appearances' within the exhibition.[42] On the one hand, women's participation in the exhibition was an important expression of their husband's wealth: as Thorstein Veblen contends, at a time when 'women were in the full sense the property of the men, the performance of conspicuous leisure and consumption came to be part of the services required of them'.[43] On the other hand, their sociability and interest in the appearance of fellow visitors indicated their inability fully to absorb the lessons of the exhibition.

At the same time as women were criticised for showing off their fine clothes within the exhibition, they were also directly targeted by the enterprising merchants of Manchester who placed advertisements for hats, shawls, gloves, linen and shoes in the various publications and guidebooks that were on sale at the exhibition bookstall. One firm of bootmakers, Lulham Steadman & Co, even produced a special line in ladies' 'Promenade Boots' which were 'expressly made in their Brighton Establishment for those visiting the Art Treasures Exhibition at 7s 6d a pair'.[44] Stepping into a pair of these boots and entering the Art Treasures Palace, a woman might look and feel the part of an equally accomplished consumer of art and fashion; if so, she was likely to attract both approbation and censure.

Academy Belles, Flâneuses and Mothers

The response to women's participation in the Art Treasures Exhibition emerged from, and contributed to, an established discourse about the deficiencies of bourgeois female viewing. The eighteenth-century Swiss physiognomist, Johann Kaspar Lavater, had declared that 'man surveys and

observes – woman glances and feels', and evidently this was a view that still prevailed despite (or because of) her presence in public exhibition and museum.[45] Women's perceived inability to generalise or abstract from the particular, and their attraction to sentimental or domestic genre painting, were deemed symptomatic of their failure to appreciate serious artistic genres, such as history painting. A report on female responses to paintings displayed in the Royal Academy exhibition of 1781 had described how easily 'ladies' could be overwhelmed by sentimental subjects and even by chance resemblances:

> Last Friday in the Royal Academy, a young lady of fortune was so affected with a portrait that resembled her sister lately deceased, that she was obliged to withdraw from the rooms, and has since continued extremely ill. As there is nothing which captivates the senses, heightens the affectations, or elevates the ideas, more than painting, it is no wonder that a striking likeness of a deceased friend or relation, suddenly appearing, should excite the most painful emotions.[46]

Similarly, another lady 'beholding the Infant Saviour of the world sleeping in his mother's arms, was so affected with the piece, that she fell into hysterics'.[47] The writer attributed the cause of such incontinent responses to an excessive degree of sensibility, due 'solely to fine imaginations, disturbed by events in life analogous to the object which thus so fatally strikes them'.[48]

Nancy Rose Marshall observes that the same dim view of women's aesthetic capacities endured nearly a century later, when it was echoed in a satirical verse entitled 'Academy Belles' published in an 1867 edition of *London Society*:

> In pictures of children they revel –
> Call Haylar a duck and a dear,
> And Millais (when down to their level)
> The pet of all painters this year ...
> Of harmony, colour, and keeping
> They're ignorant – joking apart;
> And a picture of Baby sleeping
> They think is the highest of art.[49]

Ann Pullan links women's perceived superficiality and their intellectual inability to appreciate serious art to their subordinate position in the field of art practice. Excluded from professional artists' societies and networks, the majority of female artists were consigned to the status of hobbyists and amateurs and, she argues, their 'viewing and patronage was framed and controlled by this amateur status'.[50] Moreover, as amateurs 'they were taught to admire and respect, but not equal, the "greater" powers of professional artists'.[51] In practice, this meant that women artists occupied a distinctive position within the practices of the museum, where they formed a conspicuous presence working as copyists, as demonstrated in nineteenth-century interiors of both the National Gallery and the Louvre (Figures 8 and 13).

At the beginning of Chapter 4, I invoked the familiar figure of the *flâneur* to characterise a solitary male exhibition visitor, apparently content to observe, and to be observed, within the gallery crowd. Detached and self-contained, he appeared at ease with the techniques of spectatorship required by the exhibition and comfortably aware of his own participation in the event. Was such a viewing position available to his female counterpart: in other words, was it possible to be a museum *flâneuse*?[52] Certainly she is difficult to detect in prints of either the Royal Academy or the Art Treasures exhibitions, where women are rarely depicted as solitary spectators, or even as serious ones, unless they are reading from the catalogue or receiving guidance from a male companion. Perhaps we can, however, catch a glimpse of her in a number of studies of women looking at pictures in the Louvre made by Edgar Degas, probably in the late 1870s.[53] Amongst this group of related works are two oil paintings: *Woman Viewed from Behind* (National Gallery of Art, Washington, DC) *A Visit to the Museum* (Boston Museum of Fine Arts) and (Figures 35 and 36).

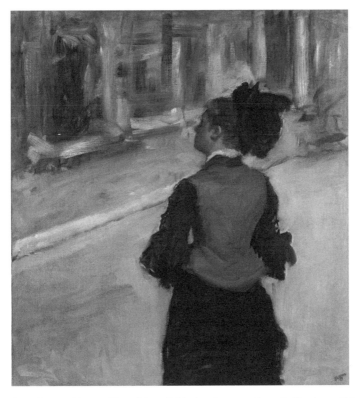

35 Edgar Degas, *Woman Viewed from Behind*, unknown date. Collection of Mr and Mrs Paul Mellon. Image courtesy of the National Gallery of Art, Washington.

Visit to a Museum shows two women, one standing and the other seated, whilst *Woman Viewed from Behind* depicts just one woman standing by herself. Although the identities of neither of the two females can be firmly established, it has been suggested that the standing figure in both pictures is the artist, Mary Cassatt, who was the subject of a number of the works in the related group.[54] The two artists were friends, and Degas may well have sketched Cassatt during their shared visits to the Louvre. The figure in *Woman Viewed from Behind* is elegantly, but not showily, dressed in tones of black and grey. She stands at a precise distance and angle in relation to the wall of paintings: her stillness implies a steady gaze although we cannot see her face, and the tilt of her head suggests that a particular work or detail has caught her attention and interest.

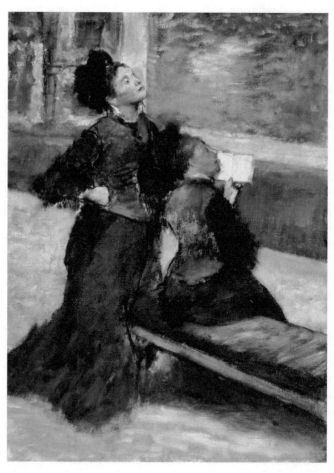

36 Edgar Degas, *Visit to a Museum*, c.1879–90. Museum of Fine Arts, Boston. Gift of Mr and Mrs John McAndrew. The Bridgeman Art Library.

In *A Visit to the Museum*, the nonchalant pose of a standing figure is contrasted with a seated companion who is perhaps Cassatt's sister, Lydia. The face of the seated woman is partly obscured because she is engrossed in the catalogue that she holds in her hands. Similarly dressed in subdued but well-cut clothes, she too is absorbed, but in a close reading of the catalogue on which she seems to rely for information about the artworks on display. There is a contrast between the bodily techniques of the two women and, as Lucretia Giese suggests, their different personalities 'are conveyed through the position and gesture of their bodies: in one case, a hand placed resolutely on the hip, a strong-willed, upward turn of the head, a critical glance; in the other, a quietly held catalogue, a timid look towards the paintings'.[55] In both of Degas's images, the depiction of the paintings on the gallery walls is impressionistic and imprecise: the focus is on the viewers, not the exhibition. Their figures are close to the picture plane and we feel ourselves standing next to them. Degas's composition invites us to identify with the women and to join in their activity, rather than observe them at a distance.[56]

The artist, Walter Sickert, recorded a visit to Degas's studio in 1883, where watched his friend as he varnished a painting of 'a lady drifting in a picture-gallery'.[57] According to Sickert, Degas said that 'he wanted to give a impression of that bored, and respectively crushed and impressed absence of all sensation that women experience in front of paintings'.[58] However, the standing woman in each of these paintings appears neither crushed nor impressed; rather she is self-assured, attentive and alert. The absence of male companions or onlookers in the paintings is notable: the women can devote themselves to the pleasures of art viewing, relieved of the pressures and expectations of themselves becoming the objects of male scrutiny. Taking up Pullan's association between the status of women's art practice and their spectatorship, could it be that Cassatt's success as an artist, whom Degas himself admired and promoted, enables her to incorporate the same techniques of aesthetic appreciation as her male counterparts?

Around the same time that Degas was sketching Mary Cassatt in the Louvre, his contemporary James Tissot also made a number of paintings of visitors there. In contrast to the two paintings by Degas, men are never absent from Tissot's images of museum life. However, the focus of our attention is invariably drawn to the woman who stands or sits within a complex web of stares and glances within and beyond the picture frame. Unlike Degas's interested and invested female viewers, Tissot's women seem incapable of looking at the artworks on display; they stare past the treasures of the Louvre, alternately coquettish or bored. In a painting entitled *Visiting the Louvre* (c.1879), the woman in the centre of the picture holds a lorgnette that perhaps signifies an earlier plan, now abandoned, to be a serious spectator. Instead of looking at the objects that surround her, she stares directly at the (presumably, male) viewer of the painting itself. The outline and folds of her

dress echo the marble column in the background: she too is depicted as an object to be viewed, and yet she holds little interest for the men who stand nearby. Their own techniques of looking (pointing, leaning back with their legs astride, reading) embody an energetically masculine appraisal of the museum; by contrast, the woman's body is entirely contained and bounded within her tightly cut dress. Whilst the men are wholly absorbed in the practice of viewing, the woman looks outside of the picture to catch the eye of the admirer whom she seeks.

Tissot's work *L'Esthetique* is located in a different part of the Louvre: a corner of the Rotonde de Mars (where the *Borghese Mars* was displayed) within the Salle des Antiques (Figure 37).[59] The picture is dominated by a large vase decorated with bacchic heads, which is placed on top of a massive triangular

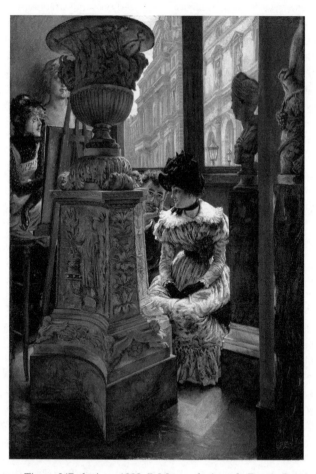

37 James Tissot, *L'Esthetique*, 1883–5. Museo de Arte de Ponce, Puerto Rico. Photograog © Whitford & Hughes, London. The Bridgeman Art Library.

pedestal (both from the Borghese collections). Sitting in this monumental corner of the museum are three figures of modern life: a young man looks directly at the viewer from around the side of the vase, whilst a fashionably dressed young woman next to him gazes listlessly into space. Wedged into the other side of the composition is another woman, perched on a high stool and sketching the artworks. The massive vase and its pedestal press up against the picture plane, so that the viewer has a disconcerting sense of being squeezed into the cramped corner with this strange trio. The copyist appears engrossed in her work, but the other woman stares past the vase into the middle distance. Both female figures were modelled by Tisssot's lover, Kathleen Newton, and each represents a contrasting mode of female spectatorship, neither of which is wholly satisfying: the artist is industrious in her study of the great art of the past, which she can copy but never emulate; whilst the young woman who

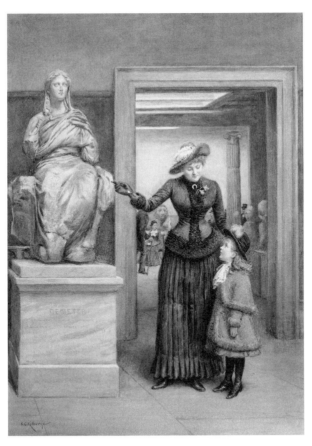

38 George Goodwin Kilburne, *At the British Museum*, 1869–84. Private Collection. © Christopher Wood Gallery, London. The Bridgeman Art Library.

has dressed up for an afternoon promenade finds that she is tired and bored, and does not know where or how to look.

In both paintings by Tissot, it is notable that none of the male spectators attempts to instruct or guide the attention of their female companions. As we have seen, prints of the Great Room at Somerset House frequently depicted women's viewing being guided by a male associate or via their reading of the exhibition catalogue. By contrast, Tissot's men and women stare across each other, rather then look together.

In other pictures, women are shown teaching object lessons to their own children; not perhaps with regard to the finer details of aesthetic theory, but with a characteristic focus on the narrative or moral dimensions of an artwork. For example, Thomas Davidson's picture entitled *England's Pride and Glory* (1894) shows a young mother and her son, a navel cadet, looking at the portrait of Lord Nelson by Lemuel Abbott in the Naval Gallery of Greenwich Hospital. The image of Nelson is viewed not as a work of art per se, but as a spur and inspiration to the lad. The moral import of a painting (between 1869 and 1884) by George Goodwin Kilburne showing a mother and her daughter looking a statue of Demeter in the British Museum may be less historically specific, but the theme is the same (Figure 38). The museum is a space where parents can (and should) instruct their children, and the presence of recently excavated sculpture of the earth goddess Demeter from the site of ancient Halicarnassus reinforces the painting's theme of exemplary motherhood. The well-dressed little girl looks simultaneously to her own elegant parent and to the ancient goddess of the harvest and fertility for representations of the maternal female that she will, in time, become.

Children in the Museum: Seen, but not Heard?

Not all children and their mothers have been as welcome in the museum as this well-behaved little girl in her fur-trimmed coat and her caring parent. Amongst those deemed 'improper to be admitted' to the 1760 exhibition organised by the Society of Arts Exhibition were women with children.[60] Although children had been allowed into the National Gallery since its creation in 1824, they were excluded from the British Museum for many years. Even after the British Museum had embarked in 1837 on 'the great experiment of admitting the public on annual holidays' – when it regularly received between 16,000 and 32,000 visitors each day 'without any accident or mischief' – children under eight years of age were still denied entry.[61] The Select Committee of 1841 concluded that this restriction had 'caused considerable inconvenience and disappointment' to families wishing to visit the museum on 'public days'. The rule appeared all the more arbitrary as children were allowed into Hampton Court as well as the National Gallery, where youngsters 'of every age had

been admitted, with, or without their parents [since its foundation]; and not one accident has occurred, or any inconvenience experienced'.[62]

Inevitably, opinion was divided on the question of children's admission to the British Museum. In 1832, the cautious *Penny Magazine* endorsed their exclusion: 'By the way … very young children (those under eight years old) are not admitted; and that for a very sufficient reason: in most cases they would disturb the other visitors.'[63] Giving evidence to the 1841 Select Committee, an attendant at the National Gallery, suggested that the prohibition on children at the British Museum could be justified on the grounds that many more exhibits there were within reach of the visitor and therefore more vulnerable to being touched, than in the art gallery.[64] However, few of the senior staff in the British Museum appear to have been in favour of their exclusion. The Principal Librarian, Henry Ellis, believed that 'a child of 14 is as likely to be mischievous as a child of eight' and therefore could not see the point of excluding any except for the 'very young' who were 'apt to commit little indiscretions'.[65] In Ellis's view, a child aged 14 was 'undoubtedly' more likely to benefit from the museum than a child of eight, but he had seen younger children drawing there on 'private days' and felt that there was no material reason to exclude them on 'public days' either. Similarly, Edward Hawkins, Keeper of Antiquities and Coins, thought that children should be allowed in on 'public days', as they caused no bother of any kind when they came in as part of an escorted group on 'private days'.

Gray, the pragmatic Keeper of Zoology, regretted that the prohibition on the admission of children prevented their mothers from visiting the museum as well.[66] In fact, he said, their exclusion was inconvenient to their families, the museum staff and its neighbours. Unaware of the rule, parents frequently arrived at the museum with their children only to be turned away by the porter. A number of families therefore asked Mr Caldecot, the upholsterer who lived over the road, if they could leave their children with him whilst they visited the museum. Those who applied to Ellis himself were advised to come back the following day when children were allowed in as members of an accompanied party, although for many working parents this would not have been a practical option.

Meanwhile, the staff at the National Gallery held divergent views on the admission of children, and more particularly, on the efficacy of the supervision provided by their parents. Wildman reported that very young children were often brought into the gallery: 'Infants in arms, and as soon as they can walk.'[67] Any 'inconvenience' arising from their presence was, he said, 'very trifling: nothing worth remarking'.[68] However, a few years later, the Keeper, Thomas Uwins, observed that the liberal admission of families with young children sometimes produced rather different pedagogical practices than those intended by the institution:

> One another occasion, I witnessed what appeared to me to evidence of anything but a desire to see the pictures: a man and woman had got their child, teaching it its first steps; they were making it run from one place to another, backwards and forwards; on receiving it on one side, they made it run to the other side; it seemed to be just the place that was sought for such an amusement.[69]

According to Uwins, it was not only families who sometimes used the gallery for unsanctioned purposes, but school parties too:

> I saw a school of boys, imagine 20, taking their satchels from their backs with their bread and cheese, sitting down and making themselves very comfortable, and eating their luncheon … I asked whether they had any superintendent or master; they pointed out a person to me, to whom I addressed myself; and I must say that, with great civility and attention, he immediately ordered the ceremony to be put an end to, and it was stopped accordingly.[70]

Nonetheless, the National Gallery continued to function, at least in part, as a children's playground throughout the nineteenth century. One witness to the 1853 Select Committee of Enquiry observed that on most days there was enough space inside the building 'for children to be at play'.[71] Given the lack of educational resources provided either by the institution or by many parents, the issue was whether children's games inconvenienced other visitors, rather than whether or how their energies could be redirected towards the study of the collection.

Whenever they had access to them, both working-class children and adults used museums as social and recreational spaces throughout the nineteenth century. As restrictions on access to the British Museum were eased further during the second half of the century, admission numbers increased, including children of all classes.[72] In a story by Andrew Lang published in 1902, a character comments that: 'The British Museum is mainly used by children of the poor, as a place where they play a kind of subdued hide-and-seek' to which another replies: 'That's because they are not interested in tinned Egyptian corpses and broken Greek statuary ware.'[73] Presumably the same was true of the old master paintings housed in the National Gallery.

Instances of disregard for museum etiquette, as well as violations of its regulations, attracted disapproval, but also, perhaps surprising, levels of tolerance from museum staff. Another report by Uwins included the following account of familiar misdemeanours:

> One another occasion, I saw some people, who seemed to be country people, who had a basket of provisions, and who drew their chairs round and sat down, and seemed to make themselves very comfortable; they had meat and drink; and when I suggested to them the impropriety of such a proceeding in such a place, they were very good-humoured, and a lady offered me a glass of gin, and wished me to partake of what they had provided; I represented to them that those things could not be tolerated.[74]

In fact, Uwins said: 'Scarcely a day passes that I do not visit the Gallery myself, and I have observed a great many things which show that many persons who come, do not come really to see the pictures.'[75] Parallel processes of regulation and refinement are discernible in these comments: first, the museum itself was developing and implementing increasingly systematic practices of managing the bodies of its diverse audience; and second, visitors were being trained in techniques of self-restraint as a prelude to the acquisition of techniques of spectatorship. By contrast, images such as *A Sunday Afternoon in a Picture Gallery* published in *The Graphic* magazine in 1879 suggested that working-class participation in the museum was already predicated on practices of 'prestigious imitation', self-directed learning and the friendly interaction between strangers (Figure 39). The evidence of less idealistic witnesses suggests that the nineteenth-century museum staged a more complex repertoire of viewing (and non-viewing) practices.

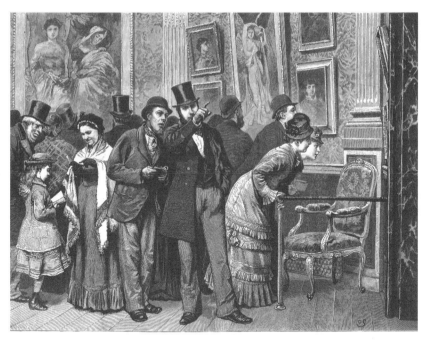

A SUNDAY AFTERNOON IN A PICTURE GALLERY
DRAWN FROM LIFE

39 Charles Green, *A Sunday Afternoon in a Picture Gallery*, published in *The Graphic*, 8 February 1879. Department of Image Collections, National Gallery of Art Library, Washington, DC.

The same rhetoric of inclusivity was idealised by Charles Kingsley writing under the pseudonym 'Parson Lot' in 1848:

> The British Museum is my glory and joy; because it almost the only place which is free to English Citizens as such – where the poor and the rich may meet together ... In the British Museum and the National Gallery alone the Englishman may say – "Whatever my coat or my purse, I am an Englishman, and therefore I have a right to be here. I can glory in these noble halls, as if they were my own house."[76]

Kingsley's depiction of the museum as a meeting place for the poor and the rich was true inasmuch as diverse visitors occupied the same material space. However, as this chapter shows, visitors of different classes were also socially separated by their divergent practices of visiting and by as much mutual suspicion as cooperation. The fact was that the museum was not like one's 'own house' and ultimately it required a different code of restraint than was understood by the woman who had hysterics in the Royal Academy, the picnickers in the National Gallery or the children playing hide-and-seek in the British Museum. Meanwhile, the presence of these disquieting bodies continued to be alternately censured, tolerated and welcomed.

Notes

1 Poovey, *Making a Social Body*; Duncan and Wallach,'The Universal Survey Museum'.

2 Peel, *Hansard*, col. 664.

3 Quoted in David R. Brigham, *Public Culture in the Early Republic. Peale's Museum and its Audience*, Washington, DC and London: Smithsonian Institution Press, 1995, p. 5.

4 Ibid.

5 Ibid.

6 Quoted in Goldgar, 'The British Museum and the Virtual Representation of Culture', p. 212.

7 House of Commons, *Report from the Select Committee on the Condition &c. of the British Museum with the Minutes of Evidence and Appendix*, London, 1835, para. 1329.

8 Ibid.

9 House of Commons, *British Museum, Regulations and Returns respecting Admission to the Museum* (168) XI. 159, 1810–11.

10 Anon., 'The British Museum', pp. 13f.

11 *The Times*, 1 March 1832, p. 5.

12 Hansard, Parliamentary Debates third series 16, 25 March 1833, pp. 1003–1004.

13 Goldgar, 'The British Museum and the Virtual Representation of Culture'.

14 Anthony Trollope, *The New Zealander*, edited by N. John Hall, Oxford: Oxford University Press, 1972, pp. 203f.

15 Ibid.

16 Ibid., p. 206.

17 House of Commons, *Report from Select Committee on The National Gallery. Ordered by the House of Commons to be printed, 16th August 1853*, London, 1853, para. 6924.

18 Ibid.

19 *Report of the Select Committee on National Monuments and Works of Art &c. 1841*, para. 2640.

20 Joseph Farington, *The Diary of Joseph Farington*, edited by Kenneth Garlick and Angus MacIntyre, Vol. V, August 1801–March 1803, New Haven: Yale University Press, 1979, p. 1863.

21 Quoted in Siegel, *The Emergence of the Modern Museum*, pp. 99f.

22 'The National Gallery', *The Times*, 25 November 1856.

23 Quoted in Siegel, *The Emergence of the Modern Museum*, p. 78.

24 *Select Committee on The National Gallery, 1853*, p. xli.

25 Ibid., paras 6430 and 6422.

26 Ibid., para. 6422.

27 Ibid., para. 8348.

28 Ibid., para. 8187.

29 Gary Messinger, *Manchester in the Victorian Age. The Half-Known City*, Manchester: Manchester University Press, 1985.

30 Dickens, 'The Manchester School of Art', p. 350.

31 *Art Treasures Examiner*, p. x.

32 *Art Treasures Examiner*, p. 180.

33 Hawthorne was surprised to discover the fame of *The Three Maries*, as he had 'hardly looked at it'. Hawthorne, *English Note-books*, p. 554.

34 Victoria Whitfield, 'The Illustrious or Infamous Dead'.

35 'Working Men and the Art Treasures Exhibition', *Art Treasures Examiner*, p. 40.

36 Dickens, 'The Manchester School of Art', p. 351

37 'The Art Treasures Exhibition at Manchester', *Illustrated London News*, 9 May 1857, p. 432.

38 P.I., 'The Exhibition Undressed', p. 60.

39 Ibid.

40 D. Sachko Macleod, 'Homosociality and Middle-Class Identity', in A. Kidd and D. Nicholls (eds), *Gender, Civic Culture and Consumerism. Middle-Class Identity in Britain, 1800–1940*, Manchester: Manchester University Press, 1999, pp. 65–80.

41 Hemingway, 'Art Exhibitions as Leisure-Class Rituals', p. 101; Solkin, 'This Great Mart of Genius', p. 6.

42 Simon Gunn, 'The Middle Class,Modernity and the Provincial City: Manchester c.1840–80', in Kidd and Nicholls, *Gender, Civic Culture and Consumerism*, pp. 112–27.

43 Thorstein Veblen, *The Theory of the Leisure Class*, London: Unwin, 1899, p. 126.

44 Morris, *Handbook to the Exhibition*, unpaginated advertisement.

45 Marshall notes that this view was reinforced by discoveries in the field ophthalmology which showed that women's eyesight was weaker than men's. Quoted in Nancy Rose Marshall, 'Image or Identity: Kathleen Newton and the London Pictures of James Tissot', in Katharine Lochnan (ed.), *Seductive Surfaces: The Art of Tissot, Studies in British Art 6*, New Haven and London: Yale University Press, 1999, p. 28.

46 Royal Academy Archives, *Royal Academy Critiques &c. Volume 1: 1769–1793*. Leaf 101: 1781.

47 Ibid.

48 Ibid.

49 Quoted in Marshall, 'Image or Identity', p. 28.

50 Pullan, 'Conversations on the Arts', p. 20.

51 Ibid.

52 Wolff, 'The Invisible Flâneuse'.

53 Lucretia H. Giese, 'A Visit to the Museum', *MFA Bulletin*, 76, 1978, pp. 42–53.

54 These are two etchings (*Mary Cassatt in the Louvre, Museum of Antiquities*, Clark Art Institute, Williamstown, Massachusetts and *Mary Cassatt in the Louvre, Looking at Paintings*, Boston Public Library), plus three pastels and five drawings.

55 Giese, 'A Visit to the Museum', p. 46.

56 Ibid., p. 46.

57 Quoted in ibid., p. 51.

58 Ibid.

59 The painting was part of a projected, but not completed, series to be called *L'Etrangère*, showing the pursuits of foreign women in Paris, painted between 1779 and 1885. The window behind the couple looks out on the façade of the *Pavillon Sully*, one of the wings of the Louvre.

60 Ibid.

61 *Report of the Select Committee on National Monuments and Works of Art &c., 1841*, para. 133.

62 Ibid., p. 133.

63 Anon., 'The British Museum', p. 14.

64 *Report of the Select Committee on National Monuments and Works of Art &c., 1841*, para. 2648.

65 Quoted in Siegel, *The Emergence of the Modern Museum*, p. 101.

66 *Report of the Select Committee on National Monuments and Works of Art &c., 1841*, para. 3186.

67 Ibid., para. 2648.

68 Ibid., para. 2650.

69 House of Commons, *Report of the Select Committee to Consider the Present Accommodation Afforded by the National Gallery; and the Best Mode of Preserving and Exhibiting to the Public the Works of Art Given to the Nation or Purchased by Parliamentary Grants Commissioners on the Fine Arts*, London, 1850, para. 82.

70 Ibid.

71 Ibid., para. 7387.

72 Black, *On Exhibit*, p. 101.

73 Andrew Lang, 'Adventure of the Fair American', in *The Disentanglers*, London: Longmans, Green, 1902.

74 *Report of the Select Committee on the National Gallery &c., 1850*, para. 82.

75 Ibid.

76 'Parson Lot', 'The British Museum', p. 183.

Epilogue

Some 5.8 million people visited the British Museum in 2011, making it the most popular visitor attraction in the UK for the fourth successive year.[1] Today, tourists from overseas make up more than half of its annual audience.[2]

The majority of visitors to the British Museum still enter via the monumental South Entrance designed by the architect Robert Smirke, as they have for the past 160 years. Having ascended Smirke's grand flight of steps, they enter the building beneath a neo-classical pediment decorated with sculptures showing *The Progress of Civilisation* designed by Richard Westmacott and finished in 1851. Once inside the museum, the exhibition galleries continue to invoke the familiar choreography of walking, looking, reading, talking, listening and occasionally sitting that we have seen being enacted and imitated by museum bodies since the eighteenth century. But unlike (at least some of) their historical predecessors, today's visitors can walk where they like, wear what they choose and are always welcome to bring their children to the museum. These continuities and contrasts between bodily practices at the British Museum past and present show how the techniques of the museum spectator are both durable *and* flexible – and, given the size and mix of the museum's audience, that their acculturation is widespread and international.

The British Museum remains open to everyone, free of charge. It also continues to calibrate its audience in terms of age and class, as well as ethnicity and health (defined in terms of long-term illness, disability or infirmity). The museum's annual reports include attendance figures for each of these categories of visitors, in accordance with demographic targets agreed with the UK government Department for Culture, Media and Sport (DCMS).[3] Far from attempting to filter its audience, the museum's objective nowadays is to include those whom it previously discouraged from attending in an effort to ameliorate its legacy of past exclusions. Visitors are no longer classified as 'undesirable' by virtue of their class, appearance or youth, but only on the evidence of potential or actual misbehaviour in the museum. Thus the current Visitor Regulations state that the authorities can refuse admission to or expel

anyone whose 'conduct or presence is considered by a responsible officer of the Museum to be causing or liable to cause annoyance to the public, or to endanger or be liable to endanger the exhibits, the fabric of the building, or to be otherwise undesirable'.[4]

Visitors today are certainly allowed a good deal more license than the hapless subject of H.M. Bateman's famous Punch cartoon called *The Boy who breathed on the Glass in the British Museum* (Figure 40). Bateman recounts the cautionary tale of a young boy who breathes on the glass showcase housing

THE BOY WHO BREATHED ON THE GLASS IN THE BRITISH MUSEUM.
An ante-bellum tragedy.

40 Henry Mayo Bateman, *The Boy who breathed on the Glass in the British Museum*, published in *Punch*, 1916. Reproduced with permission of Punch Limited. Courtesy of H.M. Bateman Designs.

an Egyptian mummy: he is about to write with his finger in the condensation when he is apprehended by a museum guard, and then turned over to the police, charged and imprisoned for his offence. After serving his time, he finally returns to the museum as an old man, breathes on the case once more, and expires on the floor, to the astonishment of the ever-present guard. As Classen says, Bateman's tale 'highlights the popular notion of the museum as inviolable and untouchable, a site of pristine preservation where even a breath might have damaging effects'.[5]

Times have changed: it was reported in 2011 that visitors to a temporary exhibition of Christian reliquaries entitled *Treasures of Heaven* were kissing the museum showcases in which the containers of saintly remains were displayed. It is not clear whether these devotees had deliberately evaded the surveillance of the gallery attendants, but evidence of their religious ardour was discovered by the cleaners who had to remove the kiss marks from the glass each morning. The director of the British Museum, Neil MacGregor, commented that: 'It's a new form of audience participation, one we've never experienced before.'[6] It is also an interesting coda to Hegel's observation that no one kneels in front of a Madonna in a museum; perhaps they do nowadays.

The current British Museum Visitor Regulations forbid touching exhibits (but not showcases), smoking, picnicking, playing music and, other than in the Great Court, using mobile phones. The distinction between the Great Court and the rest of the museum in this context is a significant demarcation between the activities sanctioned in the former, and their prohibition in the exhibition galleries. Designed by the architectural firm of Foster and Partners and opened in 2000, the Great Court is a covered courtyard in the centre of the British Museum that occupies two acres of space that was reclaimed by the museum following the departure of the British Library in 1997 (Figure 41). This vast concourse, enclosed under Foster's toroidal glazed roof, houses information desks, two cafés, a restaurant, three shops, an educational centre and an exhibition space inside the round drum of the former Reading Room. It also feeds visitors into and through the exhibition galleries via the ground floor exits and upper level walkways on three sides of the Great Court.

The Great Court is, as Richard J. Williams observes, a space of flows and consumption: everyone here is either in transit, shopping or eating.[7] Both aesthetically and functionally, it resembles an airport departure lounge where people have a snack, use the lavatories, check the latest information and then move off (in this context, into the exhibition halls). In fact, Williams suggests, the ritual of arrival at the museum is not dissimilar to the process of checking into an airport: first you deposit your bag and answer a number of related security questions. There may be a further security check before you move into the Great Court, and thence into the museum itself. The palpable sense of surveillance that this entails is the twentieth-first century equivalence of

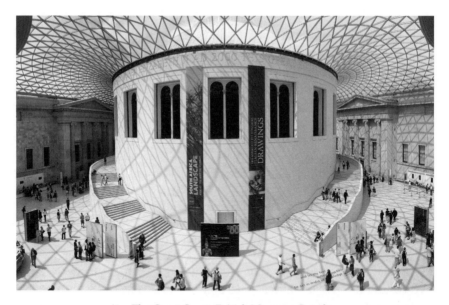

41 The Great Court, British Museum, London.
© The Trustees of the British Museum.

Valéry's and Dickens's feeling of unease at having to relinquish their walking stick or umbrella at the museum entrance.

The Great Court has attracted criticism for its emptiness and anonymity: that is, for its un-museum-like characteristics. But that is precisely the point: it accommodates visitors' physical and practical needs, and on a scale required by nearly six million visitors a year. Contrast this with the fact that, in the 1840s, there were no public lavatories inside the museum, but just 'one or two privies on the outside of the house, in the garden' to which people were directed 'if they make inquiry for them'.[8] Ellis, the Librarian, considered these amenities quite sufficient, although his colleague, Grey, disagreed, attributing cases of women fainting to the lack of conveniences inside the museum.[9]

The idea of the Great Court is also to provide visitors with information and interpretation to direct their route through, and to assist their looking in, the museum. No doubt many people still get lost, confused and bored amid its maze of galleries, but perhaps fewer today than in the 1880s when *Blackwoods Edinburgh Magazine* argued that the majority of visitors were ill-prepared for their visit, did not have a plan of what they wanted to see, and so ended up wandering aimlessly amongst a bewildering array of disparate and unintelligible objects. The writer observed that: 'In these circumstances the inevitable result is easily foreshadowed. They grow weary of looking at they know not what, and they leave the building voting it dreary, uninteresting and very tiring.'[10] Even allowing for rhetorical emphasis, it was a prescient

description of what Benjamin Ives Gilman would diagnose as 'museum fatigue' 18 years later.

In many respects, the British Museum now provides a multi-sensory environment, at least for those who participate in certain activities. For example, although looking is still privileged and, in general, touching is prohibited, object handling sessions are provided at 'hands on desks' in specified galleries, and background music is used to convey cultural or historic contexts in certain exhibitions. Still, effectively managing the pace, rhythm and direction of visitors' walking persists as one of the most intractable issues in this, and every other, enormous museum. Institutions are aware that visitors' time is limited and, like others, the British Museum offers 'highlight' itineraries, currently for one- and three-hour visits respectively. Visitors can also hire hand-held, multi-media guides that provide a choice of guided tours or a menu of information about particular exhibits, allowing the individual to select either a narrated or a personalised path around the building. Increasingly, museums offer downloadable programmes and apps to mobile phones, so that visitors have the information to hand and on a device with which they are familiar when they arrive. But the question remains: how can museums effectively guide their participants' speed of walking and looking, especially when there is so much to see and so many people want to see it?

One solution was proposed on 17 April 2010 when art lovers in cities around the world took part in the first 'Slow Art Day'. Recruited via online viral marketing, participants spent two hours very deliberately looking at between three and five designated works of art in their local gallery, before meeting fellow participants to discuss their responses to the experience over lunch. The global Slow Art Day was designed as a rebuke to the cultural velocity of contemporary museums in which the possibility of quiet and still contemplation is crowded out by a throng of pictures and people. Although supported by a number of institutions, the idea of the Slow Art Day exposes a tension between the duration of spectators' looking and the management of increasing numbers of people in the museum. It goes without saying that, more than ever before, museums rely on income from temporary exhibitions and high visitor figures as a measure of 'success'. As a result, many are caught between an ambition to attract growing audiences through a continuous cycle of exhibitions and events, and the desire to create the requisite conditions of visuality to encourage attentive spectatorship. The phrase 'gallery rage' was coined in response to the crush of visitors at the Tate Modern exhibition *Gauguin: Maker of Myth* in the winter of 2010.[11] Both critics and visitors complained about the difficulty and frustration of trying to see Gauguin's artworks in the overcrowded galleries, and also about the attempts of the exhibition attendants to move people on before they had been able to see specific pieces.

The unsatisfactory experience of spectators at this (and other) shows and the associated negative publicity prompted the National Gallery to limit the number of tickets available for admission to its exhibition *Leonardo Da Vinci: Painter at the Court of Milan* in the autumn of 2011: although the legal maximum number of people allowed in the exhibition gallery is 230 each half hour, the museum announced that it would restrict admission to 180 in order to reduce the risk of visitors' sight being blocked by the bodies of other viewers.[12] In the event, all pre-booked tickets for exhibition were sold out in the first week after it opened, and a consensus emerged amongst visitors that, to see the exhibits, there was little option but to move through the rooms at the slow pace of the majority of viewers. By contrast, in Milan itself, Michael Kimmelman of the *New York Times* reflected on the experience of seeing Leonardo da Vinci's *Last Supper in situ* in the refectory of Santa Maria delle Grazie.[13] Kimmelman compared the admission procedure as akin to entering an isolation ward, rather than an airport: 'The entrance, through several holding pens and sets of automatic doors, leads to an enormous, vaulted, semiprivate room, the patient stretched out to the right. A bedside crowd coos appropriately.' Once inside, each visitor is allotted 15 minutes in front of the artwork, and Kimmelman reflects that, far from feeling disappointed at not being able to stay longer, most visitors are actually grateful for the time limit:

> I notice that visitors to Santa Maria delle Grazie tend to peer a few times at the Leonardo, in between scanning the labels fastened to the railing beneath the painting, then, after a few minutes, they amble toward the other fresco in the room, near the exit, stealing glimpses at their watches, as if calculating the moment it might be acceptable to slip out of the room.[14]

After all, he asks, how often these days do we pause for even a full minute before any work of art? In recent years, the increasing instrumentalisation of visitors' participation, in order to demonstrate the social and economic efficacy of museum, has been accompanied by the institutionalisation of informal and even illicit visitor practices. For example, the fashion for holding 'singles' nights' and 'Valentine's nights' in museums is a marketing exercise that acknowledges the erotic potential of their collections and the museum's traditional role as a venue for amorous assignations. According to a report published by the Roman Institute of Psychology, from a survey of 2,000 museum visitors, one-fifth said that they had begun 'an erotic adventure' in a museum.[15] The Institute even named the phenomenon the 'Rubens Syndrome' on the basis that old master paintings depicting erotic scenes were most likely to stimulate encounters with strangers. Surely there are also more pragmatic explanations for the popularity of, say, the British Museum as a romantic rendezvous: it is free, and the indifference of the crowd may provide useful camouflage for covert meetings. As a character in Dodie Smith's novel, *I Capture the Castle*, remarked: 'People do nothing *but* use it for assignations'.[16]

Still, the museum remains freighted with the social, as well as cultural, distinctions that were exquisitely delineated by E.M. Forster in the setting for the climactic meeting between the estranged lovers, Maurice Hall and Alec Sudder, in his novel *Maurice*. Maurice arranges the meeting with Alec at 'Tuesday 5.30pm. entrance of British Museum. B.M a large building. Anyone will tell you which'.[17] Ostensibly, Maurice's choice of rendezvous is based on the neutrality and anonymity of the museum as the location where he will meet Alec's threat of blackmail over their affair, but it is also a site where his middle-class upbringing and education puts him at an advantage over the under-gamekeeper Alec.[18] During the course of the afternoon, the museum's spaces and objects intervene in the initial confrontation, followed by reconciliation, between the two men. Their mutual pleasure and astonishment at coming across a pair of Assyrian winged-man-bulls momentarily breaks the tension that still exists between them: 'Standing each by his monster, they looked at each other, and smiled.'[19] Later, it is their own bodies' walking and looking rhythmically together that suggests the rapprochement that will soon follow: 'They would peer at a goddess or a vase, then move at a single impulse, and their unison was the stranger because they were at war.'[20]

Finally, as the tension breaks and Maurice and Alec affirm their feelings for each other, 'the rows of old statues tottered' and they leave 'the enormous and overheated building ... seeking darkness and rain'.[21] In the end, the echoing halls of the museum can only reflect their alienation from official culture and their shared rejection of societal norms. As a closing vignette in a book about museum bodies, the British Museum scene in *Maurice* reminds us that the institution can never predict or manage the diverse and private social and physical encounters that it accommodates. Like thousands of other visitors before and since, Maurice and Alec walked around the museum 'as if in search of something', even if what they sought could only exist elsewhere.[22]

Notes

1 Maeve Kennedy, 'British Museum Remains UK's Top Attraction for Fourth Year Running', *Guardian*, 28 June 2011. Online at: www.guardian.co.uk/culture/2011/jun/28/british-museum-top-attraction.

2 *The British Museum Report and Accounts for the Year ended 31 March 2010. Ordered by The House of Commons to be printed 12 July 2010*, London, 2010, p. 21.

3 Ibid.

4 British Museum, *Visitor Regulations Policy Document*, 2003. Online at: www.britishmuseum.org/pdf/ Visitor_Regulations_Mar03.pdf (accessed August 2011).

5 Classen, 'Museum Manners', p. 895. See also, Hoberman, *Museum Trouble*, p. 5.

6 Kennedy, 'British Museum'.

7 Richard J. Williams, *The Anxious City*, London and New York: Routledge, 2004.

8 Quoted in Siegel, *The Emergence of the Modern Museum*, p. 97.

9 Quoted in ibid., p. 123.

10 Anon., 'The British Museum and the People who go there', p. 196.

11 Vanessa Thorpe, '"Gallery Rage" Mars the Tate's Record-breaking Gauguin Show', *The Observer*, 16 January 2011. Online at: www.guardian.co.uk/artanddesign/2011/jan/16/gauguin-tate-modern-crowds.

12 Mark Brown, 'Leonardo da Vinci Show at National Gallery to Limit Visitor Numbers', *Guardian*, 9 May 2011. Online at: www.guardian.co.uk/artanddesign/2011/may/09/leonardo-da-vinci-national-gallery.

13 Michael Kimmelman, '15 (Long) Minutes With "The Last Supper"', *New York Times*, 13 July 2011. Online at: www.nytimes.com/interactive/2011/07/13/arts/design/kimmelman-postcards-da-vinci-last-supper.html.

14 Ibid.

15 Guy, 'The Shock of the Old'.

16 Dodie Smith, *I Capture the Castle*, Boston: Little, Brown, 1948.

17 E.M. Forster, *Maurice*, London: Penguin Books (first published 1971), 2005, p. 193.

18 Black, *On Exhibit*, pp. 119f.

19 Forster, *Maurice*, 2005, p. 198.

20 Ibid.

21 Ibid., p. 196.

22 Ibid., p. 198.

Bibliography

Parliamentary and Institutional Sources

Advertisement, *Exhibition of the Royal Academy MDCCLXIX, THE FIRST*, London, 1769, n.p.

Ashmolean Museum Rules. Online at: www.ashmolean.org/documents/LAOmuseum rules.pdf.

British Library, Add. MS. 6179, ff. 61–62v.

British Library, Department of Manuscripts, Thomas Birch, *A Collection of Papers Relating to the Establishment and Government of the British Museum*, Add. MS 4,449, fol. 115.

British Museum, Visitor Regulations Policy Document, 2003. Online at: www.british museum.org/pdf/Visitor_Regulations_Mar03.pdf.

The British Museum Report and Accounts for the Year ended 31 March 2010. Ordered by The House of Commons to be printed 12 July 2010, London, 2010.

Hansard, Parliamentary Debates third series 14, 3 July – 14 August 1832.

Hansard, Parliamentary Debates third series 16, 25 March 1833.

House of Commons, *British Museum, Regulations and Returns respecting Admission to the Museum* (168) XI. 159, 1810–11.

House of Commons, *Report from the Select Committee on the Condition &c. of the British Museum with the Minutes of Evidence and Appendix*, London, 1835.

House of Commons, *Report of the Select Committee appointed to inquire into the present state of the National Monuments and Works of Art in Westminster Abbey, in St Paul's Cathedral, and in other Public Edifices; to consider the best means for their Protection, and for afford Facilities to the Public for their Inspection as means of moral and intellectual Improvement for the People*, London, 1841.

House of Commons, *Report of the Select Committee to Consider the Present Accommodation Afforded by the National Gallery; and the Best Mode of Preserving and Exhibiting to the Public the Works of Art Given to the Nation or Purchased by Parliamentary Grants Commissioners on the Fine Arts*, London, 1850.

House of Commons, *Report from Select Committee on The National Gallery. Ordered by the House of Commons to be printed, 16th August 1853*, London, 1853.

National Gallery Archive. Treasury Minute, *Reconstituting the Establishment of the National Gallery*, 27 March 1855 (file NG5/134/1857).

Royal Academy Archives, *Royal Academy Critiques &c.*, Vol. 1: 1769–1793.

References

A Yewud Chap's Trip to Manchester to see th' Queen, Prince Halbert an' th' Art Treasures Eggshibishun by Oudjohn, Manchester: John Heywood, 1857.

Altick, Richard, *The Shows of London*, Cambridge, MA: Belknap Press, 1978.

An Amateur, *Real Life In London, Volumes I. and II. Or, The Rambles And Adventures Of Bob Tallyho, Esq., And His Cousin, The Hon. Tom Dashall, Through The Metropolis; Exhibiting A Living Picture Of Fashionable Characters, Manners, And Amusements In High And Low Life*, London: Methuen and Co., 1821.

The Art Treasures Examiner, Manchester and London, 1857.

'The Art Treasures Exhibition at Manchester', *Illustrated London News*, 9 May 1857, p. 432.

Austen, Jane, *Selected Letters 1796–1817*, edited by R.W. Chapman, Oxford: Oxford University Press, 1985.

Bagnall, Gaynor, 'Performance and Performativity at Heritage Sites', *Museum and Society*, 1.2, 2003, pp. 87–103.

Bal, Mieke, 'Earth Aches: The Aesthetics of the Cut', in Achim Borchardt-Hume (ed.), *Doris Salcedo, Shibboleth*, London: Tate, 2007, pp. 40–63.

Bann, Stephen, *The Clothing of Clio: A Study of the Representation of History in Nineteenth-Century Britain and France*, Cambridge: Cambridge University Press, 1984.

Bann, Stephen, *The Inventions of History: Essays on the Representation of the Past*, Manchester: Manchester University Press, 1990.

Baudelaire, Charles, *The Painter of Modern Life and Other Essays* (trans. Jonathan Mayne), London and New York: Phaidon, 1995.

Bayle, S.-J., *The Louvre, or Biography of a Museum*, London: Chapman & Hall, 1855.

Baxandall, Michael, *Painting and Experience in Fifteenth-Century Italy*, Oxford: Oxford University Press, 1972.

Bazin, Germain, *The Museum Age* (trans. Jane van Nuis Cahill), New York: Universe Books Inc., 1967.

Beecher, Henry Ward, *Star Papers, or, Experiences of Art and Nature*, New York: J.C. Derby, 1855.

Belting, Hans, *The Invisible Masterpiece*, London: Reaktion Books, 2002.

Bennett, Tony, 'The Exhibitionary Complex', *New Formations*, 4, Spring 1988, pp. 73–102.

Bennett, Tony, 'Pedagogic Objects, Clean Eyes, and Popular Instruction: On Sensory Regimes and Museum Didactics', *Configurations*, 6.3, 1998, pp. 345–71.

Bennett, Tony, *Pasts Beyond Memory*, London and New York: Routledge, 2004.

Bird, Jon, 'Minding the Body: Robert Morris's 1971 Tate Gallery Retrospective', in Michael Newman and Jon Bird (eds), *Rewriting Conceptual Art*, London: Reaktion Books, 1999, pp. 88–106.

Black, Barbara J., *On Exhibit. Victorians and their Museums*, Charlottesville and London: University Press of Virginia, 2000.

Blanchot, Maurice, *Friendship* (trans. Elizabeth Rottenberg), Stanford: Stanford University Press (first published 1971), 1977.

Borchardt-Hume, Achim (ed.), *Doris Salcedo, Shibboleth*, London: Tate, 2007.

Bourdieu, Pierre, *The Logic of Practice*, Stanford: Stanford University Press, 1990.

Bourdieu, Pierre, *The Field of Cultural Production*, edited by Randal Johnson, Cambridge: Polity Press, 1993.

Bourdieu, Pierre, *The Rules of Art: Genesis and Structure of the Literary Field*, Stanford: Stanford University Press, 1996.

Bourdieu, Pierre and Darbel, Alain, *The Love of Art. European Art Museums and the Public* (trans. Caroline Beattie and Nick Merriman), Oxford: Polity Press, 1991.

Bourriaud, Nicolas, *Relational Aesthetics*, Paris: Les Presse du Reel, 2002.

Brewer, John, *The Pleasures of the Imagination*, London: HarperCollins, 1997.

Brigham, David R., *Public Culture in the Early Republic. Peale's Museum and its Audience*, Washington, DC and London: Smithsonian Institution Press, 1995.

'The British Museum', *The Penny Magazine of The Society for the Diffusion of Useful Knowledge*, 7 April 1832, pp. 13–15.

'The British Museum and the People who go there', *Blackwoods Edinburgh Magazine*, 144.874, August 1888, pp. 196–217.

Brown, Mark, 'Leonardo da Vinci Show at National Gallery to Limit Visitor Numbers', *Guardian*, 9 May 2011. Online at: www.guardian.co.uk/artanddesign/2011/may/09/leonardo-da-vinci-national-gallery.

Bryson, Norman, *Vision and Painting: The Logic of the Gaze*, London and Basingstoke: Macmillan Press, 1983.

Buck, Elizabeth Gray, 'Museum Bodies: The Performance of the Musée Gustave Moreau', *Museum Anthropology*, 20.2, 1996, pp. 15–24.

Butler, Judith, *Bodies that Matter*, London and New York: Routledge, 1993.

Butsch, Raymond, *The Citizen Audience: Crowds, Publics and Individuals*, London and New York: Routledge, 2008.

Candlin, Fiona, 'Touch, and the Limits of the Rational Museum or Can Matter Think?', *Senses & Society*, 3.3, 2008, pp. 277–92.

Candlin, Fiona, *Art Museums and Touch*, Manchester: Manchester University Press, 2010.

Carrier, David, 'The Display of Art: An Historical Perspective', *Leonardo*, 20.1, 1987, pp. 83–6.

Cash, Derek, 'Access to Culture: The British Museum from 1753 to 1836', *British Museum Occasional Paper 133*, The Trustees of the British Museum, 2002.

Catalogue of the Art Treasures of the United Kingdom. Collected in Manchester in 1857, London, 1857.

Certeau, Michel de, *The Practice of Everyday Life* (trans. Steve Rendall), Berkeley: University of California Press, 1984.

Choi, Yoon Kyung, 'The Morphology of Exploration and Encounter in Museum Layouts', *Proceedings of the Space Syntax First International Symposium*, 1, London, 1997, pp. 241–50.

Chrisafis, Angelique, 'Woman Hurls Mug at Mona Lisa after being Refused French Citizenship', *Guardian*, 11 August 2009. Online at: www.guardian.co.uk/world/2009/aug/11/mug-attack-mona-lisa.

Classen, Constance, 'Museum Manners: The Sensory Life of the Early Museum', *Journal of Social History*, 40, 2007, pp. 895–914.

Classen, Constance and Howes, David, 'The Museum as Sensescape: Western Sensibilities and Indigenous Artifacts', in Chris Gosden, Elizabeth Edwards and Ruth Phillips (eds), *Sensible Objects: Colonialism, Museums and Material Culture*, Oxford: Berg Publishers, 2006, pp. 199–222.

Collins, Daniel L., 'Anamorphosis and the Eccentric Observer: Inverted Perspective and Construction of the Gaze', *Leonardo*, 25.1, 1992, pp. 73–82.

Cook, E.T. and Wedderburn, Alexander (eds), *The Library Edition of the Works of John Ruskin*, 39 vols, London: George Allen, 1903–12.

Coope, Rosalys, 'The "Long Gallery": Its Origins, Development, Use and Decoration', *Architectural History*, 29, 1986, pp. 43–72 and 74–84.

Cordess, Christopher and Turcan, Maja, 'Art Vandalism', *British Journal of Criminology*, 33.I, 1993, pp. 95–102.

Cotter, H., 'In the Naked Museum: Talking, Thinking, Encountering', *New York Times*, 1 February 2010. Online at: www.nytimes.com/2010/02/01/arts/design/01tino.html? pagewanted=all.

Crary, Jonathan, 'Spectacle, Attention, Counter-Memory', *October*, 50, Autumn 1989, pp. 96–107.

Crary, Jonathan, 'Unbinding Vision', *October*, 68, Spring 1994, pp. 21–44.

Crary, Jonathan, *Suspensions of Perception. Attention, Spectacle and Modern Culture*, Cambridge, MA and London: MIT Press, 2001.

Crimp, Douglas, *On the Museum's Ruins*, Cambridge, MA: MIT Press, 1993.

Crook, J. Mordaunt, *The British Museum*, London: Allen Lane, 1972.

Darcy, C.P., *The Encouragement of the Fine Arts in Lancashire 1760–1860*, Manchester: Manchester University Press, 1976.

Davies, Maurice, 'Three-Minute Heritage', *Museums Journal*, May 1994, p. 23.

De Bolla, Peter, *The Education of the Eye*, Stanford: Stanford University Press, 2003.

Dias, Rosie, '"A World of Pictures": Pall Mall and the Topography of Display, 1780–99', in Miles Ogborn and Charles J. Withers (eds), *Georgian Geographies: Essays on Space, Place and Landscape in the Eighteenth Century*, Manchester: Manchester University Press, 2004, pp. 92–113.

Dickens, Charles, *Hard Times*, London: Bradbury & Evans, 1854.

Dickens, Charles, 'The Manchester School of Art', *Household Words*, Vol. XVI, London, 1857, pp. 349–52.

Dickens, Charles, *The Letters of Charles Dickens, Volume 2 (1857–1870)*, edited by Mamie Dickens and Georgina Hogarth, London: Chapman & Hall, 1880.

Disraeli, Benjamin, *Sybil: Or the Two Nations*, London: Henry Colburn, 1845.

Duncan, Carol, *Civilizing Rituals: Inside Public Art Museums*, London: Routledge, 1995.

Duncan, Carol and Wallach, Allan, 'The Universal Survey Museum', *Art History*, 3.4, 1980, pp. 448–69.

Editor, 'Introduction', *Representations (The Making of the Modern Body: Sexuality and Society in the Nineteenth Century)*, 14, 1986, p. vii.

Editorial, 'Introducing Sensory Studies', *Senses & Society*, 1.1, 2006, pp. 5–8.

Edwards, Edward, *Lives of the Founders of the British Museum*, 2 vols, London: Trübner and Co., 1870.

Egan, Pierce, *Life in London or, the Day and Night Scenes of Jerry Hawthorn, esq., and his elegant friend, Corinthian Tom, accompanied by Bob Logic, the Oxonian, in their rambles and sprees through the Metropolis*, London: John Camden Hotten, 1821.

Ehrman, Edwina, 'Frith and Fashion', in Mark Bills and Vivien Knight (eds), *William Powell Frith: Painting the Victorian Age*, London and New Haven: Yale University Press, 2006, pp. 111–29.

Elkins, James, *Pictures & Tears*, New York and London: Routledge, 2004.

E.T.B., *What to see and where to see it! Or the Operative's Guide to the Art Treasures Exhibition*, Manchester, 1857.

Exhibition of Art Treasures of the United Kingdom held in Manchester in 1857 Report of the Executive Committee, London and Manchester, 1859.

Farington, Joseph, *The Diary of Joseph Farington*, edited by Kenneth Garlick and Angus MacIntyre, Vol. V, August 1801–March 1803, New Haven: Yale University Press, 1979.

Fenton, James, *School of Genius*, London: Salamander Press, 2006.

Filipovic, Elena, 'A Museum That is Not', *e-flux*, 2011. Online at: www.e-flux.com/journal/view/50.

Finke, Ulrich, 'The Art Treasures Exhibition', in John Archer (ed.), *Art and Architecture in Victorian Manchester*, Manchester: Manchester University Press, 1985, pp. 102–26.

'For the Convenience of Visitors', *Museums Journal*, 4, April 1905, p. 363.

Forgione, Nancy, 'Everyday Life in Motion: The Art of Walking in Late-Nineteenth-Century Paris', *The Art Bulletin*, 87.4, December 2005, pp. 664–87.

Forster, E.M., *Maurice*, London: Penguin Books (first published 1971), 2005.

Foucault, Michel, *The Order of Things*, London and New York: Routledge, 2003.

Freedberg, David, *The Power of Images*, Chicago and London: University of Chicago Press, 1989.

Frith, William Powell, *My Autobiography and Reminiscences*, London: R. Bentley and Son, 1887–8.

Galard, Jean and Charrier, Anne-Laure, *Visiteurs du Louvre*, Paris: Réunion des musées nationaux, 1993.

Gamboni, Dario, *The Destruction of Art, Iconoclasm and Vandalism since the French Revolution*, London: Reaktion Books, 1997.

Garoian, Charles R., 'Performing the Museum', *Studies in Art Education*, 42.3, 2001, pp. 234–48.

Gaskell, Elizabeth, *North and South*, London: Penguin Books (first published 1855), 2003.

Gaskell, Elizabeth, *Mary Barton*, Oxford: Oxford University Press (first published 1855), 2008.

Gidal, Eric, *Poetic Exhibitions. Romantic Aesthetics and the Pleasures of the British Museum*, Lewisburg: Bucknell University Press, 2001.

Giese, Lucretia H., 'A Visit to the Museum', *MFA Bulletin*, 76, 1978, pp. 42–53.

Gilman, Benjamin Ives, 'Museum Fatigue', *The Scientific Monthly*, 2.1, January 1916, pp. 62–74.

Gilman, Benjamin Ives, *Museum Ideals of Purpose and Method*, Cambridge, MA: Riverside Press, 1918.

Girouard, Mark, *Life in the English Country House*, New Haven and London: Yale University Press, 1978.

Gladstone, William, *The Gladstone Diaries, Volume V*, 1855–1860, edited by H.C.G. Matthew, Oxford: Oxford University Press, 1978.

Goldgar, Anne, 'The British Museum and the Virtual Representation of Culture in the Eighteenth Century', *Albion: A Quarterly Journal Concerned with British Studies*, 32.2, Summer 2000, pp. 195–231.

Goss, Steven, 'A Partial Guide to the Tools of Art Vandalism', *Cabinet*, 3, Summer 2001. Online at: www.cabinetmagazine.org/issues/3/toolsofartvandalism.php.

Gould, Cecil, *Trophy of Conquest: The Musée Napoléon and the Creation of the Louvre*, London: Faber, 1965.

Greenberg, Reesa, '"Remembering Exhibitions": From Point to Line to Web', *Tate Papers*, 12, 2009. Online at: www.tate.org.uk/research/tateresearch/tatepapers/09autumn/greenberg.shtm.

Grosley, M., *A Tour to London; or, New Observations on England and its Inhabitants*, 2 vols (trans. Thomas Nugent), London: Lockyer Davis, 1772.

Grosz, Elizabeth, *Volatile Bodies: Toward a Corporeal Feminism*, Bloomington: Indiana University Press, 1994.

Gunn, Simon, 'The Middle Class, Modernity and the Provincial City: Manchester c.1840–80', in A. Kidd and D. Nicholls (eds), *Gender, Civic Culture and Consumerism. Middle-Class Identity in Britain, 1800–1940*, Manchester: Manchester University Press, 1999, pp. 112–27.

Guy, Melinda, 'The Shock of the Old', *Frieze Magazine* (72), January–February 2003. Online at: www.frieze.com/issue/article/the_shock_of_the_old.

Hagner, Michael, 'Toward a History of Attention in Culture and Science', *MLN*, 118.3, April 2003, pp. 670–87.

Hallett, Mark, 'Reading the Walls: Pictorial Dialogue at the British Royal Academy', *Eighteenth-Century Studies*, 37.4, Summer 2004, pp. 581–604.

Harbison, Robert, *Eccentric Spaces*, Cambridge, MA: MIT Press, 2000.

Haskell, Francis, *Rediscoveries in Art: Some Aspects of Taste, Fashion and Collecting in England and France*, London: Phaidon, 1976.

Haskell, Francis, 'Museums and their Enemies', *Journal of Aesthetic Education*, University of Illinois 19.2, 1985, pp. 13–22.

Haskell, Francis, *History and Its Images: Art and the Interpretation of the Past*, New Haven and London: Yale University Press, 1993.

Haskell, Francis, *The Ephemeral Museum: Old Master Paintings and the Rise of the Art Exhibition*, New Haven and London: Yale University Press, 2000.

Hawthorne, Nathaniel, *Passages from the English Note-books*, Cambridge, MA: Harvard University Press, 1898.

Hegel, Georg Wilhelm Friedrich, *Hegel's Aesthetics. Lectures on Fine Art*, Vol. 1 (trans. T.M. Knox), Oxford: Clarendon Press, 1975.

Hemingway, Andrew, 'Art Exhibitions as Leisure-Class Rituals in Early Nineteenth-Century London', in Brian Allen (ed.), *Towards a Modern Art World*, New Haven and London: Yale University Press, 1995, pp. 95–108.

Hoberman, Ruth, *Museum Trouble. Edwardian Fiction and the Emergence of Modernism*, Charlottesville and London: University of Virginia Press, 2011.

Hoock, Holger, *The King's Artists: The Royal Academy of Arts and the Politics of British Culture, 1760–1840*, Oxford: Oxford University Press, 2004.

Hutchison, Sidney C., *The History of the Royal Academy: 1768–1968*, London: Chapman & Hall, 1968.

Hutton, William, *A Journey from Birmingham to London*, Birmingham: Pearson and Rollason, 1785.

Ingold, Tim and Vergunst, Jo Lee (eds), *Ways of Walking. Ethnography and Practice on Foot*, Farnham: Ashgate, 2008.

Jackson, Anthony and Kidd, Jenny, *Performance, Learning & Heritage Report*, Manchester: Centre for Applied Theatre Research, University of Manchester, 2008.

James, Henry, *The American*, London: Penguin Classics (first published 1876–7), 1986.

Jameson, Anna, *Companion to the Most Celebrated Private Galleries of Art in London*, London: Saunders and Otley, 1844.

Jardine, Lisa, 'Making Contact', BBC Radio 4, 11 May 2007. Online at: http://news.bbc.co.uk/go/pr/fr/-/1/hi/magazine/7075030.stm.

Jay, Martin, *Downcast Eyes. The Denigration of Vision in French Twentieth-Century Thought*, Berkeley, Los Angeles and London: University of California Press, 1993.

Jevons, W. Stanley, 'The Use and Abuse of Museums', in *Methods of Social Reform and Other Papers*, London: Macmillan, 1883, pp. 53–81.

Jones, Sam, 'Museum Visitor who Broke Historic Vases Laments his "Norman Wisdom Moment"', *Guardian*, 6 February 2006. Online at: www.guardian.co.uk/uk/2006/feb/06/arts.artsnews1.

Jullian, Philippe, *The Triumph of Art Nouveau: Paris Exhibition 1900*, London: Phaidon, 1974.

Kachur, Lewis, *Displaying the Marvelous: Marcel Duchamp, Salvador Dali and Surrealist Exhibition Installations*, Cambridge, MA and London: MIT Press, 2001.

Kennedy, Maeve, 'British Museum Remains UK's Top Attraction for Fourth Year Running', *Guardian*, 28 June 2011. Online at: www.guardian.co.uk/culture/2011/jun/28/british-museum-top-attraction.

Kidd, Alan J. and Nicholls, David (eds), *Gender, Civic Culture and Consumerism. Middle-Class Identity in Britain, 1800–1940*, Manchester: Manchester University Press, 1999.

Kimmelman, Michael, '15 (Long) Minutes With "The Last Supper"', *New York Times*, 13 July 2011. Online at: www.nytimes.com/interactive/2011/07/13/arts/design/kim melman-postcards-da-vinci-last-supper.html.

Kirshenblatt-Gimblett, Barbara, *Destination Culture: Tourism, Museums, and Heritage*, Berkeley: University of California Press, 1998.

Kirshenblatt-Gimblett, Barbara, 'Performance Studies', Rockefeller Foundation, Culture and Creativity, September 1999. Online at: www.nyu.edu/classes/bkg/issues /rock2.htm.

Kirshenblatt-Gimblett, Barbara, 'The Museum as Catalyst', *Museum 2000: Confirmation or Challenge?*, Vadstena, 2000. Online at: www.nyu.edu/classes/bkg/web/vadstena. pdf.

Kirshenblatt-Gimblett, Barbara, 'The Museum – A Refuge for Utopian Thought', 2004. Online at: www.nyu.edu/classes/bkg/web/museutopia.pdf.

Klonk, Charlotte, 'Mounting Vision: Charles Eastlake and the National Gallery of London', *Art Bulletin*, 82.2, June 2000, pp. 331–47.

Klonk, Charlotte, *Spaces of Experience: Art Gallery Interiors from 1800 to 2000*, New Haven and London: Yale University Press, 2009.

Knight, Charles, Thorne, James, Dodd, George, Winter, Andrew, Martineau, Hariet, Harvey, William and William Michael Wylie, *The Land We Live In: Pictorial and Literary Sketch Book of the British Empire*, 4 vols, London: Charles Knight, 1847.

L.M., 'Admission of the Lower Orders to Public Exhibitions', *The London Literary Gazette; and Journal of Belles Lettres, Arts, Sciences, &c.*, 15, 3 April 1819.

Lago, Mary, *Christiana Herringham and the Edwardian Art Scene*, London: Lund Humphries, 1996.

Lang, Andrew, *The Disentanglers*, London: Longmans, Green, 1902.

'Lectures at the Crystal Palace', *The Art-Journal*, III, 1 October 1857.

Lefebvre, Henri, *Rhythmanalysis: Space, Time and Everyday Life*, London: Continuum, 2004.

Levey, Michael, *Brief History of the National Gallery*, London: Pitkins Pictorials, 1967.

Lochnan, Katharine (ed.), *Seductive Surfaces: The Art of Tissot, Studies in British Art 6*, New Haven and London: Yale University Press, 1999.

Lubbock, Tom, 'Is Art Running Out of Ideas? Artists Forced to Explain Modern Art', *Independent*, 14 July 2008. Online at: http://uk.mc867.mail.yahoo.com/mc/welcome?. partner=bt-1&.gx=1&.tm=1267205172&.rand=951ld5vfje3f6.

Lubow, Arthur, 'Making Art Out of an Encounter', *The New York Times Magazine*, 15 January 2010. Online at: www.nytimes.com/2010/01/17/magazine/17seghal-t.html?_ r=1&pagewanted=all.

Macleod, D. Sachko, 'Homosociality and Middle-Class Identity', in A. Kidd and D. Nicholls (eds), *Gender, Civic Culture and Consumerism. Middle-Class Identity in Britain, 1800–1940*, Manchester: Manchester University Press, 1999, pp. 65–80.

Macleod, Suzanne, 'Civil Disobedience and Political Agitation: The Art Museum as a Site of Protest in the Early Twentieth Century', *Museum and Society*, 5.1, 2007. Online at: www.le.ac.uk/ms/m&s/Issue%2013/macleod.pdf.

Magherini, Gabrieilla, *La Sindrome di Stendhal*, Milan: Feltrinelli Editore, 1989.

Malraux, André, *The Voices of Silence* (trans. Stuart Gilbert), London: Secker and Warburg, 1954.

Marr, Andrew, 'The Magic Box', in Francis Morris (ed.), *Tate Modern: The Handbook*, London: Tate, 2006, pp. 12–18.

Marshall, Nancy Rose, 'Image or Identity: Kathleen Newton and the London Pictures of James Tissot', in Katharine Lochnan (ed.), *Seductive Surfaces: The Art of Tissot, Studies in British Art 6*, New Haven and London: Yale University Press, 1999, pp. 23–52.

Matheson, C.S., '"A Shilling Well Laid Out": The Royal Academy's Early Public', in David Solkin (ed.), *Art on the Line. The Royal Academy Exhibitions at Somerset House 1780–1836*, London and New Haven: Yale University Press, 2002, pp. 39–54.

Mauss, Marcel, 'Techniques of the Body' (trans. Bill Brewster), *Economy and Society*, 2, 1973, pp. 70–88.

McClellan, Andrew, *Inventing the Louvre: Art, Politics and the Origins of the Modern Museum in Eighteenth-Century Paris*, Cambridge: Cambridge University Press, 1994.

McClellan, Andrew (ed.), *Art and its Publics*, Oxford: Blackwell, 2003.

McKim-Smith, Gridley, 'The Rhetoric of Rape, The Language of Vandalism', *Woman's Art Journal*, 23.1, 2002, pp. 29–36.

Melton, Andrew, *Problems of Installation in Museums of Art*, Washington, DC: American Association of Museums, 1935.

Melton, Andrew, 'Visitor Behavior in Museums: Some Early Research in Environmental Design', *Human Factors*, 1972, pp. 393–403.

Merleau-Ponty, Maurice, *Phenomenology of Perception*, London: Routledge (first published 1945), 1962.

Merleau-Ponty, Maurice, *The Primacy of Perception* (trans. J.M. Edie), Evanston: Northwestern University Press, 1964.

Messinger, Gary, *Manchester in the Victorian Age. The Half-Known City*, Manchester: Manchester University Press, 1985.

Meyer, James, 'No More Scale. The Experience of Size in Contemporary Sculpture', *Artforum*, Summer 2004. Online at: http://artforum.com/inprint/id=6960&pagenum=0.

Miller, Edward, *That Noble Cabinet, A History of the British Museum*, London: Andre Deutsch, 1973.

Moritz, Carl Philipp, *Travels of Carl Philipp Moritz in England in 1782*, London: Cassell and Company, 10th edition, 1886.

Morris, Thomas, *An Historical, Descriptive and Biographical Handbook to the Exhibition of the United Kingdom's Art Treasures at Manchester*, Manchester, 1857.

Mount, Harry, 'The Monkey with the Magnifying Glass: Constructions of the Connoisseur in Eighteenth-Century Britain', *Oxford Art Journal*, 29.2, 2006, pp. 167–84.

'The National Gallery', *The Penny Magazine of The Society for the Diffusion of Useful Knowledge*, 31 October to 30 November 1836, pp. 466–72.

'The National Gallery', *The Times*, 25 November 1856.

Nead, Lynda, *The Female Nude Art, Obscenity and Sexuality*, London and New York: Routledge, 1992.

Nicholson, Timothy Richard Joseph, Pariante, Carmine and McLoughlin, Declan, 'Stendhal Syndrome: A Case of Cultural Overload', *BMJ Case Report*, 20 February 2009. Online at: www.ncbi.nlm.nih.gov/pmc/articles/PMC3027955.

Noordegraaf, Julia, *Strategies of Display. Museum Presentation in Nineteenth and Twentieth-Century Visual Culture*, Rotterdam: NAi Publishers, 2004.

O'Doherty, Brian, *Inside the White Cube, the Ideology of Gallery Space*, Berkeley: University of California Press, 1976.

Otter, Chris, *The Victorian Eye*, Chicago: University of Chicago Press, 2008.

'Our Royal-Academical Lounge', *Fraser's Magazine*, 5, July 1832, pp. 710–11.

P.I., 'The Exhibition Undressed', *The Art Treasures Examiner*, Manchester and London, 1857.

Pankhurst, Sylvia, *The Suffragette Movement: An Intimate Account of Persons and Ideals*, London: Longmans, 1931.

'Parson Lot' (pseudonym of Charles Kingsley), 'The British Museum', *Politics for the People*, London: John W. Parker, 1848.

Pascoe, David (ed.), *Charles Dickens: Selected Journalism 1850–1870*, Harmondsworth: Penguin, 1997.

Pergam, Elizabeth, *The Manchester Art Treasures Exhibition of 1857*, Farnham: Ashgate, 2011.

Pevsner, Nikolaus, *A History of Building Types*, London: Thames and Hudson, 1976.

Pickering, Paul A., 'Class without Words: Symbolic Communication in the Chartist Movement', *Past & Present*, 112, August 1986, pp. 144–62.

Poovey, Mary, *Making a Social Body. British Cultural Formation, 1830–1864*, Chicago: University of Chicago Press, 1995.

Prior, Nick, 'Having One's Tate and Eating It', in Andrew McClellan (ed.), *Art and its Publics*, Oxford: Blackwell, 2003, pp. 51–76.

Pullan, Ann, '"Conversations on the Arts": Writing a Space for the Female Viewer in the *Repository of Arts* 1809–15', *Oxford Art Journal*, 15.2, 1992, pp. 15–26.

Rachde Felley's Visit to th' Great Eggshibishun, Manchester, 1857.

Randolph, Adrian W.B. 'Gendering the Period Eye: Deschi da Parto and Renaissance Visual Culture', *Art History*, 27.4, 2004, pp. 538–62.

Rees Leahy, Helen, 'Walking for Pleasure? Bodies of Display at the Manchester Art Treasures Exhibition', *Art History*, 30.4, 2007, pp. 543–63.

Rees Leahy, Helen (ed.), *Art, City Spectacle, Special Issue of the Bulletin of the John Rylands University Library*, Manchester, 2009.

Rees Leahy, Helen, 'Watch Your Step: Embodiment and Encounter at Tate Modern', in Sandra Dudley (ed.), *Museum Materialities*, London: Routledge, 2010, pp. 162–74.

Rees Leahy, Helen, 'Watching Me, Watching You: Performance and Performativity in the Museum', in Tony Jackson and Jenny Kidd (eds), *Performing Heritage*, Manchester: Manchester University Press, 2010, pp. 39–52.

Repository of arts, literature, commerce, manufactures, fashions and politics, London: Ackermann, Vol. 13, June 1815.

Robinson, Edward S., *The Behavior of the Museum Visitor*, Washington, DC: American Association of Museums, 1928.

Robinson, Edward S., 'The Pyschology of Public Education', *American Journal of Public Health*, 23, 1933, pp. 123–8.

Rodgers, Charles, *Tom Treddlehoyle's Peep at t'Manchester Art Treasures Exhebishan, e 1857; an uthter wonderful things beside, at cum in hiz way i t'city at Manchister*, London, 1857.

Rogoff, Irit, 'How to Dress for an Exhibition', in Mika Hannula (ed.), *Stopping the Process? Contemporary Views on Art and Exhibitions*, Helsinki: NIFCA (The Nordic Institute for Contemporary Art), 1998, pp. 130–52.

Rogoff, Irit, 'Looking Away', in Gavin Butt (ed.), *After Criticism. New Responses to Art and Performance*, Oxford: Blackwell Publishing, 2005, pp. 117–34.

Ruskin, John, *The Times*, 7 January 1847, p. 5.

Russell, John, 'Healing a Disfigured Rembrandt's Wounds', *New York Times*, 31 August 1997. Online at: www.nytimes.com/1997/08/31/arts/healing-a-disfigured-rembrandt-s-wounds.html?scp=1&sq=Healing%20a%20Disfigured%20Rembrandt's%20Wounds&st=cse.

Sabbagh, Karl, *Power into Art*, London: Allen Lane, 2000.

Salmi, Hannu, *Nineteenth-Century Europe. A Cultural History*, Cambridge: Polity Press, 2008.

Schaub, Mirjam (ed.), *Janet Cardiff. The Walk Book*, Koln: Walther Konig, 2005.

Serota, Nicholas, *Experience or Interpretation: The Dilemma of Museums of Modern Art*, London: Thames and Hudson, 1996.

Siegel, Jonah (ed.), *The Emergence of the Modern Museum*, Oxford: Oxford University Press, 2008.

Silliman, Benjamin, *A Journal of Travels in England, Holland and Scotland, and Two Passages over the Atlantic in the Years 1805 and 1806*, Vol. 1, Boston: Wait, 1812.

Simmel, Georg, 'The Metropolis and Mental Life', in Donald N. Levine (ed.), *On Individuality and Social Forms*, Chicago: University of Chicago Press, 1971, pp. 324–39.

Smith, Dodie, *I Capture the Castle*, Boston: Little, Brown, 1948.

Sneed, Gillian, 'Tino Sehgal Presents a Work in Progress', *Art in America*, 30 April 2010. Online at: www.artinamericamagazine.com/news-opinion/news/2010-02-04/tino-sehgal-guggenheim-this-progress/.

Solkin, David (ed.), *Art on the Line. The Royal Academy Exhibitions at Somerset House 1780–1836*, London and New Haven: Yale University Press, 2002.

Solkin, David, 'Art on the Line – Reflections and Surprises', *Courtauld Institute Newsletter*, Spring 2002. Online at: www.courtauld.ac.uk/newsletter/spring_2002/08artonlineSP02.shtml.

Solkin, David, '"This Great Mart of Genius": The Royal Academy Exhibitions at Somerset House, 1780–1836', in David H. Solkin (ed.), *Art on the Line: The Royal Academy Exhibition at Somerset House, 1780–1836*, New Haven: Yale University Press, 2002, pp. 1–8.

Solnit, Rebecca, *Wanderlust. A History of Walking*, London: Verso, 2001.

Stanworth, Karen, 'Picturing a Personal History: The Case of Edward Onslow', *Art History* 16.3, September 1993, pp. 408–23.

Staton, James T., *Bobby Shuttle un his woife Sayroh's visit to Manchester: un to th' greight Hert Treasures Eggshibishun at Owd Traffort: written for Bobby Hissel, by th' editor oth "Bowton Luminary*, Manchester: John Heywood, 1857.

Stendhal, *Rome, Naples and Florence* (trans. Richard N. Coe), London: John Calder, 1959.

Thorpe, Vanessa, '"Gallery Rage" Mars the Tate's Record-breaking Gauguin Show', *The Observer*, 16 January 2011. Online at: www.guardian.co.uk/artanddesign/2011/jan/16/gauguin-tate-modern-crowds.

Tim Gamwattle's Jawnt E Ab-O'-Dick's Oth' Doldrums Waggin, Wi O Whul Waggin full O' Foak, Fro Smobridge to Manchester O Seein't Queene, Wi Just a Wap ut th'Eggsibishun, Manchester: John Heywood, 1857.

Trodd, Colin, 'Culture, Class, City: The National Gallery London and the Spaces of Education, 1822–57', in Marcia Pointon (ed.), *Art Apart: Art Institutions and Ideology across England and North America*, Manchester: Manchester University Press, 1994, pp. 33–49.

Trollope, Anthony, *The New Zealander*, edited by N. John Hall, Oxford: Oxford University Press, 1972.

Twain, Mark, *The Innocents Abroad*, London: Penguin Books (first published 1869), 2002.

Usborne, David, 'Oops, that's Torn it – Clumsy Art Student Rips £80m Picasso Canvas', *Independent*, 26 January 2010. Online at: www.independent.co.uk/news/world/americas/oops-thats-torn-it-ndash-clumsy-art-student-rips-16380m-picasso-canvas-1878809.html.

Valéry, Paul, *The Collected Works of Paul Valéry*, edited by J. Matthews, Princeton: Princeton University Press, 1960.

Veblen, Thorstein, *The Theory of the Leisure Class*, London: Unwin, 1899.

Waagen, Gustav, *Treasures of art in Great Britain: being an account of the chief collections of paintings, drawings &c, Volumes 1 – IV* (trans. Lady Eastlake), London: John Murray, 1854.

Waterfield, Giles (ed.), *Palaces of Art. Art Galleries in Britain 1790–1990*, London: Dulwich Picture Gallery, 1991.

Wendeborn, Frederick, *A View of England Towards the Close of the Eighteenth Century*, Vols 1 and 2, London, 1791.

Wheaton, Nathaniel Sheldon, *A Journal of a Residence during Several Months in London: Including excursions through Various Parts of England and a Short Tour in France and Scotland in the Years 1823 and 1824*, Hartford: Huntington, 1830.

Whitfield, Victoria, '"The Illustrious or Infamous Dead": The Portrait Gallery of the Manchester Art Treasures Exhibition', in Helen Rees Leahy (ed.), *Art, City, Spectacle: The Manchester Art Treasures Exhibition Revisited. Special Issue of the John Rylands Bulletin*, 87.2, 2007, pp. 39–54.

Williams, Nigel, *The Breaking and Remaking of the Portland Vase*, London: British Museum Publications, 1989.

Williams, Richard J., *The Anxious City*, London and New York: Routledge, 2004.

Wilson, David, *The British Museum*, London: British Museum Press, 2002.

Wolff, Janet, 'The Invisible Flâneuse: Women and the Literature of Modernity', *Feminine Sentences. Essays on Women and Culture*, Cambridge: Polity Press, 1990, pp. 34–50.

Wood, Catherine, 'The Rules of Engagement: Displaced Figuration in Robert Morris's mise-en-scène', in Anna Dezeuze (ed.), *The 'Do-it-Yourself' Artwork: Participation from Fluxus to New Media*, Manchester: Manchester University Press, 2010, pp. 115–31.

Wordsworth, William, *The Prelude*, edited by Jonathan Wordsworth, M.H.Abrams, and Stephen Gill, New York: Norton (first published 1850), 1979.

Žižek, Slavoj, 'Looking Awry', *October*, 50, Autumn, 1989, pp. 30–55.

Zola, Emile, *L'Assommoir* (trans. Leonard Tancock), Harmondsworth: Penguin (first published 1876), 1970, p. 90.

Zyman, Daniela, 'At the Edge of the Event Horizon', in Mirjam Schaub (ed.), *Janet Cardiff. The Walk Book*, Koln: Walther Konig, 2005, p. 11.

Index

Bold numbers refer to figures.

Abramović, Marina, *Marina Abramović Presents …* **86**, 86–89
Ackermann, Rudolph, *Repository of Arts* **119**, 118–119, 125n60
Aestheticism 121–123
Alfred, Lord Tennyson 66–67
Alken, Henry Thomas **37**, 32–35, 37–39
Altick, Richard 20, 29, 31, 42n6, 43n29, 43n33, 43n35, 43n49, 129, 136, 149n13, 150n22, 150n44, 152n91
anamorphism 67
Angerstein, John Julius 51
Art Journal 56
Art on the Line **114**, 115–117
Art Treasures Examiner **53**, 66, 82, 161
Art Treasures in Manchester: 150 Years On 114
attention, problematic of visitors' 4, 9, 14, 31, 36, 41, 46–47, 49–50, 52, 55, 57, 59–68, 74, 92, 97, 119, 130, 136, 166, 170, 181
Austen, Jane 66, 71n94

Bagnall, Gaynor 99–100, 123n10
Bal, Mieke 106, 124n29
balance 103, 110, 112, 141–142

Bateman, H.M., *The Boy who breathed on the Glass in the British Museum* **178**, 178–179
Baudelaire, Charles 97, 123n1
Baxandall, Michael 116, 125n49
Bazin, Germain 118, 125n58
Beecher, Henry Ward 136, 150n43
Bennett, Tony 16n13, 26, 28, 52, 69n30, 70n59, 99, 145
 'exhibitionary complex' 17n44, 20–22, 42n5, 42n8, 43n29, 71n103, 123n9, 152n89, 152n91
Bertolucci, Bernardo, *The Dreamers* 89
Blackwoods Edinburgh Magazine 134, 150n32, 180
Blanchot, Maurice 10, 135–136, 140, 150n38, 151n58
bodily (and corporeal) techniques 3, 5–7, 9, 11, 13–15, 86, 154, 167, 177; *see also* techniques of the body
Bodyspacemotionthings **105**, 104–105
de Bolla, Peter 6, 16n16, 16n18, 22, 42n14, 46–50, 68n11, 68n15, 69n24, 71n102
Borchardt-Hume, Achim 111, 124n29, 124n36, 124n37

Bourdieu, Pierre 4, 16n9, 16n24, 116, 125n52; and Darbel, Alain, 81, 94n36

Bourgeois, Louise, *I Do, I Undo and I Redo* 106–107

Bourriaud, Nicolas 106–107, 124n27, 124n32

Bowyer, Robert, Historic Gallery 22

Boydell, John, Shakespeare Gallery 22

Brewer, John 27–28, 42n26, 42n28, 68n1

Brigham, David R. 156, 174n3

British Institution 22, 118

British Museum 8, 13, 21–26, 36, 154, 174, 177–183
 admission charge 27
 admission of children 130, 169–172, 177
 Bateman, *The Boy Who Breathed on the Glass in the British Museum* **178**, 178–179
 behaviour of visitors 4, 130–132, 141
 Bob Tallyho and *Tom Dashall* **33**, 32–35, 37
 British Museum Act 1753 23
 conducted tours 26–35, 40–41, 46–47, 75, 85, 91, 156–157
 dress, visitors' (including dress regulations) 118, 157–158
 dust and dirt 159–160
 fatigue 14, 137
 fear of the public 24, 26–28, 130, 145–146
 Findlay, *The Present Fashions* **120**
 Forster, *Maurice* 183
 Gordon Riots 28, 145
 Great Court **180**, 179–180
 Kilburne, *At the British Museum* **169**, 169–170
 lack of guidebook 40
 lavatories 11, 140, 180
 MacGregor, Neil 179
 Portland Vase 133–134
 seating 91
 security 28, 134, 179–180
 statutes and rules 24–25, 134, 177–178
 ticketing **25**, 23, 25, 157
 tipping 34
 touching 141
 Treasures of Heaven 179

Bryson, Norman 16n10, 47, 59–60, 68n13

Buck, Elizabeth Gray 100, 123n12

Butler, Judith 100, 117, 123n11, 125n54

Candlin, Fiona 12, 17n40, 17n42, 125n63, 141, 151n64

Carraci, Annibale, *The Three Maries* 162

Carrier, David 7, 16n25, 116, 125n71

Cassatt, Mary 166–167, 176n54

Cash, Derek 28, 42n19, 42n21, 43n32, 152n92

Castiglione, Joseph, *The Salon Carré* **74**, 73–74

catoptric viewing 47, 68

Certeau, Michel de 80, 83, 94n28, 95n46

Charles X of France 148–149

Chartism 121, 145–146

children in the museum 2, 4, 20, 91, 102, 129–130, 153–156, 170–172, 174, 177

Classen, Constance 9, 12, 16n32, 17n40, 17n41, 94n17, 179, 183n5

Cobbett, Willliam 158

Collins, Daniel 67, 71n99

Compton, Michael 103

Coningham, William 158–159

connoisseurship 38, 45, 48–50, 118

Coope, Rosalys 76–77, 94n15

Cordess, Christopher and Turcan, Maja 143–144, 151n78, 152n81

Cox, David, *Interior of the Long Gallery, Hardwick Hall* **78**, 77–78

Crary, Jonathan 59, 66, 70n60, 70n62, 70n63, 71n89

Creed, Martin, *Work No. 850* **88**, 87–89
Cruikshank, George and Robert **40**, 39–40,
crying 5

Davidson, Thomas, *England's Pride and Glory* 170
Degas, Edgar, *Woman Viewed from Behind* **165**, 165–166; *A Visit to the Museum* **166**, 165–167
Department of Culture, Media and Sport (DCMS) 177
Dias, Rosie 23, 41, 42n12, 42n17, 44n84, 123n3
Dickens, Charles 10, 70n51, 81, 94n37
 Manchester Art Treasures Exhibition 52, 56–57, 70n47, 70n50, 99, 117, 123n6, 125n56, 131, 162
 'Please to Leave Your Umbrella' 135, 150n36, 180
dirt and dust 20, 28, 100, 154, 159–161
disability 11, 36n16, 145
Disraeli, Benjamin 81, 94n37, 123
distraction, problematic of visitors' 5, 41, 46–47, 50, 52, 55–56, 59–61, 63–68, 75, 84, 98, 136, 153
dizziness 13–14, 128, 135–137
dress 7, 38, 117–123, 147, 154, 157–158, 160–163, 166–170
Duchamp, Marcel 100–102, 117

Eastlake, Charles 160
effluvia 160–161
Egan, Pierce 10
 Life in London 33, 39, 44n74, 44n76
 Tom and Jerry craze 33
Elkins, James 5, 16n11, 139, 151n55
Elliasson, Olafur, *The Weather Project* **107**, 107–110
Ellis, Henry 91, 157, 171, 180
ER 67
escalator 89–90

exhibition reconstructions ('re-dos') 104, 112, 114–117
Exposition Universelle 1900 11, 90
Exposition Internationale du Surréalisme **101**, 100–101

Farington, Joseph 159, 175n20
fashion plates 118–120
fatigue 3, 11, 13–14, 38, 60–65, 73–74, 83, 90, 93, 128–129, 135–137, 180–181
female visitors and spectatorship 36, 41, 118–119, 140, 153–156, 162–170
First Papers of Surrealism **102**, 101–103
Fitzwilliam Museum, Cambridge 141–142
flâneur 79–80, 97, 165
flâneuse 165
Florence 14, 138–139
Forgione, Nancy 79–80, 94n19, 94n27
Forster, E.M, *Maurice* 183, 184n17, 184n19
Fournel, Paul 79
Fraser's Magazine 46, 50
Freedberg, David 143–144, 149, 151n76, 152n83, 152n88, 152n106
Frith, William Powell, *Private View at the Royal Academy 1881* **122**, 121–123, 125n68
fustian 121

gallery rage 181
Gamboni, Dario 140–141, 149n12
 'museum pathology' 13, 17n45, 129
 'threshold effect' 143, 151n62
Gaskell, Elizabeth 81, 94n37
gaze 4–5, 41, 45, 47, 50, 59–60, 67, 80, 136, 155, 166
Gemäldegalerie Alte Meister, Dresden 92
George III 21–22
Gidal, Eric 137, 150n46, 150n48

Giese, Lucretia 167, 176n53, 176n55
Gilman, Benjamin Ives **62**, 11, 17n46,
 60–63, 67–68, 70n66, 70n67, 70n72,
 74, 83, 95n47, 136, 181
 seating (tabouret) 92–93
 skiascope **63**, 61, 63
Gladstone, William 55, 69n39
glance 31, 47, 50, 59–60, 81, 103, 128,
 161, 164, 167
Godard, Jean-Luc, *Bande à Part* **89**,
 88–89
Goldgar, Anne 22, 26–27, 42n14,
 43n30, 149n16, 158, 174n6, 174n13
Gordon Riots 28, 145
Goss, Stephen 144, 151n80, 152n87
Gower, Ronald Sutherland 146, 152n97
The Graphic 173
Gray, John Edward 131–132, 134, 140,
 171, 180
Great Exhibition 1851 130, 159
Grosley, Jean-Pierre 10, 30–31, 43n39
Guggenheim Museum 1–2, 13

habitus 6, 12
Hallé, Charles 98
Hamburg Kunsthalle 84
Hampton Court Palace 135, 170
handling objects 12, 181
Harbison, Robert 84–85, 95n51
Hardwick Hall **78**, 77–78
Hawkins, Edward 141, 171
Hawthorne, Nathaniel 10
 Manchester Art Treasures
 Exhibition 55, 66–67, 69n42, 71n92,
 175n33
Hegel, Georg Wilhelm Friedrich 4,
 15n7, 179
Hemingway, Andrew 6, 16n20, 43n61,
 149n15, 175n41
Henry Moore Institute, Leeds **113**, 113
Herzog and De Meuron 92
Historic Gallery, London 21
history of the body 7, 9, 12, 79

Hoberman, Ruth 11, 16n35, 141,
 151n66, 183n5
Höller, Carsten, *Test Site* **109**, 108–110
Hoock, Holger 27, 42n13,
Howes, David 12, 17n40,
Hutton, William 30–34, 43n43

Ingold, Tim and Vergunst, Jo Lee
 78–79, 93n12, 94n18
International Exposition 1876 66–67

Jackson, Tony and Kidd, Jenny 102,
 124n20
James, Henry 10
 The American 17n48, 73–74, 83, 91,
 93, 93n1, 127–129
Jameson, Anna 141, 151n65
Jay, Martin 5, 16n17, 69n27, 94n25
Jevons, W. Stanley 75, 93n11
Jullian, Philippe 91, 95n62
July Revolution 1830 148–149

Kilburne, George Goodwin, *At the
 British Museum* **169**, 169–170
Kimmelman, Michael 182, 184n13
Kingsley, Charles 131, 150n23, 174
Kirshenblatt-Gimblett, Barbara 12,
 17n28, 74–76, 93n7, 106, 124n30
 'performing museology' 2–3, 15n4
 'object performance' 100, 123n14
Klonk, Charlotte 42n4, 51, 69n28,
 70n59, 92, 95n69
Königlichen Gemäldegalerie, Stuttgart
 92

Lang, Andrew 172, 176n73
Lavater, Johann Kaspar 163–164
Lefebvre, Henri 85–86, 95n56
Lenoir, Alexandre 112
Leonardo Da Vinci, *Last Supper* 182;
 *Leonardo Da Vinci: Painter at the
 Court of Milan* 182; *Mona Lisa* 142,
 144–145

Levey, Michael 12, 17n43
Lichtwark, Alfred 84
Long Gallery 76–79
Louvre **74**, **165**, **166**, **168**, 10, 13, 73–74,
 127–129, 136, 139–140
 Bande à Part **88**, 88–89
 July Revolution 1830 148–149
 images of women visitors 165–170
 installation of lift (elevator) 11, 90
 Mona Lisa 142, 144–145
 seating 11, 73, 93
Luxembourg Gallery 136

MacGregor, Neil 179
Mackenzie, Frederick **51**, 51
Macleod, Suzanne 147–148, 152n94,
 152n99, 152n102
Magherini, Graziella 17n47, 138–139,
 149n11, 151n52
Manchester Art Treasures Exhibition
 53, **98**, 5, 10, 11, 13, 14–15, 52–59,
 69n33, 97–99, 130–131
 150th anniversary exhibition 114
 catalogue 55
 dialect literature 57–58, 70n52, 99,
 121, 135
 Dickens, Charles 52, 56–57, 70n47,
 70n50, 99, 117, 123n6, 125n56, 131,
 162
 display 52–55
 exhibition prints 97–98
 flâneur 97
 guidebooks 56
 Hawthorne, Nathaniel 55, 66–67,
 69n42, 71n92, 175n33
 musical concerts 82, 98–99
 Prince Albert's support 54–55
 refreshment rooms 66, 131
 Shuttle, Bobby and Sayroh 57, 70n52,
 99, 121, 135, 162,
 walking at 75, 81–83
 women's presence 162–163, 165
 working class presence 161–162

Manchester Statistical Society 161
Marr, Andrew 108, 124n35
Marshall, Nancy Rose 164, 175n45
Matheson, C.S. 16n21, 26, 41, 44n75,
 44n82, 97, 123n4
Maty, Matthew 26, 157
Mauss, Marcel 6–7, 16n21, 93n8
Melton, Arthur W. 11, 61–65, 68, 71n73,
 71n77, 71n88, 75, 93n10, 129
Merleau-Ponty, Maurice 68n18, 106,
 124n15, 124n31
Metropolitan Museum of Art, New
 York 142
Milan 182
Moritz, Karl Phillip 10, 29–31, 40,
 43n34, 43n36, 137, 150n47
Morris, Robert exhibition at Tate
 Gallery **104**, 103–105; *see also*
 Bodyspacemotionthings
Mulcahy, William 133–134
Murillo, *The Immaculate Conception* 73
multi-media guides 181
Musée Royale des Monuments Français
 112
museum effect 4, 5, 128, 149n1
Museum of Modern Art, New York
 48, 48
music in exhibitions 12, 82, 98–99, 181

National Art Collections Fund 146
National Gallery, London **51**, 4, 12, 15,
 21, 54, 131, 164, 174
 100 Pall Mall 51
 admission of children 130, 158,
 170–172
 Angerstein, John Julius 51
 behaviour of visitors 19–20, 130,
 158–159, 171–173
 dirt from visitors 159–161
 eating and drinking 12, 172
 fear of the crowd 146
 *Leonardo Da Vinci: Painter at the Court
 of Milan* 182

Peel, Robert 19–20
Ruskin, John 51–52
security 134, 146
Velazquez, *Rokeby Venus*, attack on 146–148
ventilation 140
women copyists 164
National Gallery of Art, Washington, DC 91
Nationalgalerie, West Berlin 142
nausea 3, 13, 128–129, 135–136; *see also* sickness
Nead, Lynda 146, 152n98
Newton, Kathleen 169
Noordegraaf, Julia 16n15, 95n50, 123n13, 142, 151n71

object handling 181
odour (and smell) of visitors 12, 22, 140, 154, 160
O'Doherty, Brian 45, 48–49, 68n5, 69n20, 142, 151n73
Onslow, Hon. Edward 132–133
Otter, Chris 5, 15n6, 16n14, 68, 71n103, 80

Pan American Exposition 1901 99, 117
Pankhurst, Sylvia 146–147
Pankok, Bernhard 92
Paris 11, 74, 79, 90–91, 97, 100, 132, 148–149, 176n59
Peale, Charles Willson 155–156
Peel, Robert 19–20, 41n1, 41n2, 152n104, 154, 174n2
Penny Magazine 7–9, 16n27, 148–149, 157, 171
performance and performativity 1, 3, 6–7, 36, 80–81, 86–87, 93, 97–101, 106–108, 111–112, 114, 117, 119, 123, 162–163
period eye 116–117
phenomenology 47, 103, 106, 108, 112
Pickering, Paul 121, 125n64

Piero della Francesco, *Annunciation* 116
Point of Sight 7, 38, 45–47, 51, 68, 76, 116
Pollock, Jackson 67–68
Poovey, Mary 21–22, 42n10, 153, 174n1
Portland Vase, attack on 133–134
Prince Albert **143**, 54–55, 58, 69n41
proprioception 3, 106
Pullan, Ann 125n61, 164, 167, 176n50

rails 121, 142–143
Randolph, Adrian 116, 125n50
Raphael, *Sistine Madonna* 92
Read, B. 118–119
Real Life in London 32–35, 68n2
refreshment rooms 12, 57, 66, 82, 131
relational aesthetics (and art practice) 2, 100, 105–106
Rembrandt, *Danaë* 144; *Night Watch* 145
rhythm (of walking and viewing) 2, 5, 66, 75, 78–80, 82–83, 85–89, 100, 181, 183
rhythmanalysis 85
Richardson, Mary 146–148
Rijksmuseum, 145
Robinson, Edward S. 11, 60–65, 68, 70n64, 71n73, 75, 93n10, 129
Rodgers, Charles 10, 57, 70n52, 123n8
Rogoff, Irit 67–68, 71n97, 81, 94n34, 125n55
Rousseau, Jean Jacques 79
Rowlandson, Thomas **8**, **24**, 7–9, 91
Royal Academy of Arts **8**, **24**, **143**, 4–7, 10, 13–15, 22–23, 32, 41, 42n13, 42n15, 42n16, 54, 141, 154, 174
admission charge 27–28
Art on the Line **114**, 115–117
Bob Tallyho and Tom Dashall **37**, 33, 35–39, 45, 48
conversation among visitors 37
Corinthian Tom and Jerry Hawthorne **40**, 33, 39–40, 48, 75

exhibition catalogue 40–41
fashionable presence 121–123
female visitors and spectators
 163–165, 174
Frith, *Private View at the Royal
 Academy 1881* **122**, 121–123
odour 140
Onslow, affair of Hon. Edward
 132–133
seating 91–92
security 130, 142
visuality within 7, 21, 45–46, 50, 64,
 68, 76
Rubens Syndrome 182
rules and regulations 4, 7, 9, 24–25, 28,
 75, 129–131, 133–134, 141, 177–178
running 75, 87–89
Ruskin, John 48, 51–52, 69n29, 90,
 95n60

Salcedo, Doris, *Shibboleth* 109–112
Salmi, Hannu 138, 151n51
Saltaire 82–83
scopic regime 5, 44, 46–49, 68, 115
seating 11, 65, 73, 91–93, 136
Sehgal, Tino 14–15
 Kiss 1
 This Progress 1–4, 13
Semper, Gottfried 92, 95n66
Sense of Heaven **113**, 113
sensorium (or sensescape) 12
Serota, Nicholas 16n12, 92, 95n68
Shakespeare Gallery, London 21
Shee, Martin Archer 136
Sickert, Walter 167
sickness 128, 137–140; *see also* nausea
Silliman, Benjamin 31–33, 43n51
Simmel, Georg 97, 123n2
singles nights 182
Slow Art Day 181
Society of Arts 4, 16n16, 20–21, 129, 170
Solkin, David 22, 37, 44n66, 46

Art on the Line curation 115–117,
 125n45
South Kensington Museum 131; *see
 also* Victoria and Albert Museum
Smirke, Robert 177
Smith, Dodie, *I Capture the Castle* 182,
 184n16
Sneed, Gillian 2, 15n2
space (architectural) syntax 60, 83
spectatorship 3–4, 6–7, 9–11, 14–15, 20,
 23, 41, 46, 50, 59, 67, 76, 91–93, 100,
 112, 114, 119, 137, 154, 165, 167,
 169, 173, 181
Staton, James T. 10, 57, 70n52, 123n7,
 125n62
Stendhal (Marie-Henri Beyle) 14,
 17n47, 137–138, 150n49
Stendhal Syndrome 14, 137–140
suffragists 146–148

Tate Britain 87–89
Tate Gallery 103–105
Tate Modern 13
 Bodyspacemotionthings **105**, 104–5
 Gauguin: Maker of Myth 181
 health and safety 105
 I Do, I Undo and I Redo 106–107
 seating 92
 Shibboleth ('The Crack') **110**, 109–112
 Test Site **109**, 108–109, 111
 'trippers' 110, 141
 Turbine Hall 104–112
 The Weather Project **107**, 107–109, 111
talking 2–3, 9, 13, 15, 41, 98, 108, 112,
 163, 177; *see also* Royal Academy,
 conversation at
techniques of the body 5–7, 9, 13,
 15, 49, 168; *see also* bodily (and
 corporeal) techniques
Teniers, David, *Archduke Leopold's
 Gallery* **77**, 76–77
Thwaites, Lieutenant-Colonel 130, 134

Tissot, James,*Visiting the Louvre*
 167–170; *L'Esthetique* **168**, 168–170
touch and touching 3, 5, 8–9, 12, 15, 49,
 100, 108, 113, 135, 140–142, 159,
 171, 179, 181
Tower of London 91
Trodd, Colin 19, 42n3
Trollope, Anthony 158, 174n14
trottoir roulant (or travelator) 11, 90–91
Twain, Mark 66–67, 71n95
 'Mark Twain Malaise' 139–140

umbrellas 121, 134–136, 180
Uwins, Thomas 171–173

Valéry, Paul 10, 15n8, 127–129, 134,
 136, 149n2, 180
vandalism 129, 134, 140–149, 159
Vauxhall Gardens 27
Veblen, Thorstein 163, 175n43
Velazquez, *Rokeby Venus* **148**, 146–148
Versailles 118
Victoria and Albert Museum 84–85,
 113; *see also* South Kensington
 Museum
visitor studies 11, 60–66, 129

walking 1–6, 10–11, 14–15, 41, 49, 52,
 54–55, 57, 73–91, 97, 100, 115, 154,
 163, 177, 181, 183

walking sticks 127, 134–136, 180
Wallis, Henry, *The Death of Chatterton*
 58, 57–58, 162
Ward, John 28, 130
Wendeborn, Frederick 10, 36, 40,
 44n62, 140, 151n59
Westmacott, Richard *The Progress of*
 Civilisation 177
Wildsmith, John Peter 130, 171
Wheaton, Nathaniel Sheldon 134–135,
 150n34
white cube gallery space 48–50, 108,
 112, 142
Whitworth Art Gallery, Manchester
 86–87
Wilde, Oscar 121–123
Williams, Richard J. 179, 183n7
Wood, Catherine 103, 124n24
Wordsworth, William, *Prelude*
 136–138, 150n45
World's Columbian Exposition 1893 90
Wright, Frank Lloyd 1–2
Wyatt, J. 120

Žižek, Slavoj 67, 71n98
Zola, Emile, *L'Assommoir* 10–11, 16n34,
 80–81, 83, 86, 88, 99, 129